THE GROTESQUE IN
ART AND LITERATURE:
THEOLOGICAL REFLECTIONS

The Grotesque in
Art and Literature:
Theological Reflections

edited by

James Luther Adams
and
Wilson Yates

WILLIAM B. EERDMANS PUBLISHING COMPANY
GRAND RAPIDS, MICHIGAN / CAMBRIDGE, U.K.

© 1997 Wm. B. Eerdmans Publishing Co.
255 Jefferson Ave. S.E., Grand Rapids, Michigan 49503 /
P.O. Box 163, Cambridge CB3 9PU U.K.

Printed in the United States of America

02 01 00 99 98 97 7 6 5 4 3 2 1

Library of Congress Cataloging-in-Publication Data

The grotesque in art and literature : theological reflections /
 edited by James Luther Adams and Wilson Yates.
 p. cm.
 Includes bibliographical references.
 ISBN 0-8028-4267-4 (paper : alk. paper)
 1. Grotesque in art. 2. Art and religion. I. Adams, James Luther, 1901-1994.
II. Yates, Wilson.
 NX650.G7T49 1997
 261.5′7—dc21 96-49757
 CIP

In memory of James Luther Adams,
who knew that the grotesque could prepare us to
"recognize equally the power of the evil that always shall have
been with the power of redemptive ecstatic joy"

Contents

Acknowledgments

James Luther Adams and I want to offer belated appreciation to the early contributors to this effort: Jane Kingman, Alfred Barr, and Robert Doty. We want also to thank Cambridge University Library, the Minneapolis Institute of Art, and the Museum of Modern Art for special assistance with the project and, foremost, my colleagues at United Theological Seminary of the Twin Cities for their lively discussion and good suggestions regarding the introductory essay. Written responses by Mary Farrell Bednarowski, Clyde Steckel, and Carolyn Presslor were particularly appreciated. Tom Devonshire-Jones of Regents Park Church, London; George Pattison, Dean of Kings College Chapel, Cambridge; Mary Farrell Bednarowski of United Seminary's faculty; and Gayle Graham Yates of the University of Minnesota provided critical readings and helpful comments on the Francis Bacon essay. I am particularly appreciative of Gayle Graham Yates's continuing discussion of the work on a sabbatical we shared in Cambridge.

In July of 1994 James Luther Adams died at his home in Cambridge, Massachusetts. This volume is dedicated to him — a volume that I spent many delightful hours preparing in conversations with him. The volume is a tribute to his own important contribution to the theology and arts dialogue which he helped nurture through his writings and his students.

Preface

The grotesque is one of the most obvious forms art may take
to pierce the veil of familiarity, to stab us up from the drowse
of the accustomed, to make us aware of the perilous paradox-
icality of life.

ROBERT PENN WARREN

Over the past twenty years, a significant body of literature has been
published in the fields of theology and religious studies that explores
the complex relationship between art, spirituality, and religion. In that
literature little attention has been given to the grotesque and its importance
for theological and religious interpretation. This is made even more pro-
nounced by the fact that there has been a renewed interest in the grotesque
within art criticism, cultural analysis, and art history and, most impor-
tantly of all, a continuing creation of works that are rich in their use of
the grotesque as they treat matters of religious import — matters con-
cerned with the nature of the human condition, our understanding of the
holy, and our possibilities as a human community.

This volume is both a response to the limited material we have
available and an invitation for all to explore the relationship of the
grotesque, religion, and the literary and visual arts. Foremost the studies
examine how the grotesque reveals religious insights and how we might
reflect theologically on the insights it offers.

These essays begin with "An Introduction to the Grotesque: Theoretical and Theological Considerations" by Wilson Yates. The discussion focuses on contemporary theories of the grotesque and a theological approach to interpreting its meaning for the religious life. Two essays continue the theological exploration: "The Grotesque and Our Future" by James Luther Adams and "The Grotesque, Theologically Considered" by Roger Hazelton. There are four essays on the grotesque and the visual arts: Margaret Miles's "Carnal Abominations: The Female Body as Grotesque," Wolfgang Stechow's "Hieronymus Bosch: The Grotesque and We," John W. Cook's "Ugly Beauty in Christian Art," and Wilson Yates's "Francis Bacon: The Iconography of Crucifixion, Grotesque Imagery, and Religious Meaning." Three essays treat literature and the grotesque: "Grinning Death's-Head: *Hamlet* and the Vision of the Grotesque" by Yasuhiro Ogawa, "The Religious Dimensions of the Grotesque in Literature: Toni Morrison's *Beloved*" by Susan Corey, and "The Dramatic Version of *Ballad of a Sweet Dream of Peace: A Charade for Easter*" by Robert Penn Warren, with an introduction by Warren. (This latter work is published here for the first time.)

Throughout the individual essays, including particularly the introductory chapter, attention is given to theoretical concerns regarding an approach to the grotesque, the relationship of the grotesque to the religious life, and an approach to its theological analysis. The volume, therefore, will provide the reader with both an overview of the grotesque and of its importance for theological study, and an analysis of specific works from literature and the visual arts.

Books have a history, and this work is no exception. Its origins lie in a 1969 Arts, Religion and Contemporary Culture (ARC) meeting in New York when James Luther Adams proposed a conference on religion and the grotesque. Jane Kingman, an officer in ARC, took the idea to Alfred Barr, then curator of the Museum of Modern Art, who was quite enthusiastic. Barr knew an exhibit on the grotesque was coming to the Whitney Museum of American Art and, after conversations with Adams and Kingman, sent Kingman to talk to Robert Doty, curator of the Whitney. Doty extended an invitation and on February 7, 1970, the Conference on the Grotesque in the Arts and Literature was held at the Whitney. James Luther Adams chaired the conference, which was attended by theologians, artists, writers, and art curators. In a statement prepared for the conference, Adams

wrote the following words, which point to the importance of theology in exploring the meaning and purpose of the grotesque.

A special form of dissent can be observed today in the revival of what for centuries has been called "the grotesque" in literature and the arts. It depicts in exaggerated and distorted ways the frustrations and the violence of contemporary existence as they are manifest in the life of the individual and in suprapersonal institutional and social forces.

The "grotesque" in the arts calls attention to the monstrous, the absurd and the beastly — in the nature and consequences of mob violence, racial conflict, excessive sexuality, bureaucratism, pollution of air and earth, the technology of destruction, the megadeaths and carrion of Hiroshima, Nagasaki and Songmy. Satire is too feeble a word to characterize the purpose of "the grotesque" in literature and the arts.

How is "the grotesque" to be defined? What are the historical antecedents of the contemporary grotesque, its iconography, its morphology — in the Book of Revelation, in the temptations of St. Anthony, in the gargoyles of the medieval cathedral, in the art of "the waning of the Middle Ages," in the works of Raphael, Hieronymus Bosch, and Goya? What are its characteristic motifs today? What religious interpretation is to be placed upon the grotesque? What does the grotesque presage for the future? Is it only an accusation of our world? Or, in reminding us of our estrangement, does it point also to "essential human nature and even to a numinous ultimate reality"?[1]

Wolfgang Kayser, in the epigraph of his classic work *The Grotesque in Art and Literature,* suggests that, as cleavages develop in society, grotesque distortions appear as the harbingers of cultural renewal. Or, as Tillich would say, the artist "opens the eye to a truth which is lost in the daily-life encounter with reality"; precisely through the art form the artist avoids "simple fascination with the ugly" which merely succumbs to "negativity without hope."

Robert Doty likewise interprets the interest in the grotesque as a sign of the demand to reevaluate both individual life and society. "The artist," he says, "desperately seeks to engage the mind and spirit of the spectator

1. James Luther Adams, "Introduction," Annual Congress of the Arts, Religion, and Contemporary Culture program for Saturday, February 7, 1970, held at the Whitney Museum of American Art, New York City, p. 2.

to bring him to a state of awareness that will permit no evasion. He feels alienated, but does not relinquish hope."

Out of the conference came plans to publish certain of the papers delivered there along with new material, but a number of factors intervened and the work was never completed.

In conversation with James Luther Adams, I learned about the conference and the aborted efforts to publish a volume of essays. Out of that conversation and subsequent meetings, we began to create a new volume which would include several of the earlier essays but would in large part feature new material. The earlier essays are those by James Luther Adams, Roger Hazelton, and Wolfgang Stechow, and the work by Robert Penn Warren. The later works are those of John Cook, Susan Corey, Margaret Miles, Yasuhiro Ogawa, and Wilson Yates.

This volume represents the final fruits of our work and, more importantly, of the work of those whose essays are included. It is far removed from that early conference, but the impetus and ideas worked with there are still very present in this collection and in the larger academic community's debate over the meaning of the grotesque. As we invite readers to join us in exploring the grotesque, it is fitting to draw on two definitions of the grotesque: one by James Luther Adams and the second by Robert Doty. They set forth something of the nature of the grotesque that we want to consider.

In his essay "The Grotesque and Our Future," James Luther Adams writes:

> The authentically grotesque is something that deviates from the normal in a monstrous way. . . . Beginning as the name of a fantastic style of phantasmagoric exuberance, it developed into a depiction of the absurd, the ridiculous, the distorted, the monstrous. It is a mirror of aberration. In order to present aberration the artist of the grotesque . . . depicts a world where "natural physical wholes" are disintegrated and "the parts" are monstrously redistributed. He aims to project the full horror of disorder, the terrible and the terrifying, even the bestial, elements in human experience.[2]

Robert Doty's definition, prepared for the Whitney's catalogue, *Human Concern/Personal Torment, the Grotesque in American Art,* proposes that

2. James Luther Adams, "The Grotesque and Our Future," pp. 70-71 below.

The grotesque is a form of art, with certain common characteristics. First, the rejection of reason, its benefits, protection and institutions. Second, immersion in the subconscious and its offspring, such as fear, passion and perversity, which often elicits a strong interest in sex and violence and not infrequently a commingling of the two. Third, a clash of elements, an obsession with opposites which force the co-existence of the beautiful with the repulsive, the sublime with the gross, humor with horror, the organic with the mechanical. Fourth, emphasis on ridicule, surprise and virulence, through caricature, the deformation and distortion of salient characteristics. The grotesque threatens the foundations of existence through the subversion of order and the treacherous reversal of the familiar and hostile. Its value and vitality stem from the aberrations of human relationships and acts and therefore from foibles, weakness and irresistible attractions.[3]

It is of these matters that we write. It is of these matters that we would engage you in conversation.

JAMES LUTHER ADAMS
WILSON YATES

3. Robert Doty, *Human Concern/ Personal Torment: The Grotesque in American Art* (New York: Whitney Museum of American Art, 1969), p. 6.

Homage to JLA:
A Theologian and His Love of the Arts

WILSON YATES

This volume begins with a homage to James Luther Adams, whose recent death ended the long career of a major American theologian and ethicist. JLA, as he was fondly known by those of us who were his students and colleagues, lectured and wrote about the arts and taught his students their importance for the doing of theology and, perhaps more importantly, for the living out of a life of faith.

One of the most delightful and insightful stories about Adams and the arts is told by Frederick Carney, a former student and now a member of the faculty of Perkins School of Theology. George Beach quotes the remembrance in his introduction to Adams's collection of essays, *The Prophethood of All Believers.* Carney was a student at the University of Chicago at the time.

> I was aware that this man had been an astute and resourceful foe of Nazism, of racial segregation, of big-business paternalism toward labor, and of several other forms of institutionalized evil in modern society. I expected to hear in his lectures such institutional and moral analyses as would illumine and encourage social action. And I was not disappointed. What I was almost wholly unprepared for, however, was the rich texture

Originally published in *Arts: The Arts in Religious and Theological Studies* 6, no. 3 (summer 1994): 1-3.

of theology, philosophy, law, history, literature, music, and art in which ethics was presented. The precise event that stood out for me, then, and still stands out today, was a highly animated and largely spontaneous lecture of forty minutes on, of all things, the religious experience of looking at a Cézanne apple. Imagine that! Teaching ethics by employing a nineteeenth-century artist to communicate to his hearers a sense of the metaphysical reality of the world, of the divine mystery that undergirds it, and of the resulting seriousness of the moral life! I decided before that day was over that my doctoral field would be Christian ethics.[1]

On Tuesday morning, July 26, 1994, James Luther Adams passed away. His life spanned most of a century — he would have been 93 in November. As his name suggests, with its allusions to James of the New Testament, Luther of the Reformation, and Adams of our mythic beginnings, he was a man for all seasons. He was one of those rare human beings with renaissance sensibilities, an amazing breadth of knowledge, and an abiding sense that we are called to be citizens who will love the world and in loving it engage in transforming its broken structures into stages where even the angels will dance.

His contributions to the academic world of religion and ethics were extraordinary. A major theorist in the field of social ethics, he developed influential perspectives on human freedom, power, voluntarism, and the importance of institutional analysis for ethics and public policy. He was a major architect of interdisciplinary conversations between ethics and sociology, religion and law, and theology and the arts which he saw as crucial if theology and ethics were to adequately understand the faith and culture they were expected to interpret.

A student, colleague, and major interpreter of Paul Tillich, Adams provided the first major treatment of Tillich's understanding of the arts in his study, *Paul Tillich's Philosophy of Culture, Science, and Religion.* But he was also deeply involved with the arts in his own work. His essays continually used art works to express points of theological and ethical meaning and his writings focused on specific artists — Bach, Mozart, Giacometti, Bosch, van Gogh, Cézanne, Kollwitz, Stravinsky — in light of the religious, moral, and social significance and power of

1. Frederick S. Carney, "James Luther Adams: The Christian Actionist as a Man of Culture," *Perkins Review* (fall 1972): 15.

their work.[2] A primary focus for Adams was the prophetic role we are
called to live out — he spoke of the prophethood of all believers — and
the artist was considered by him to be a major prophetic voice in modern
society — prophetic both in the sense of judging the world's idolatries
and injustices and in pointing toward a new vision of hope and possi-
bility.

The themes that Adams explored in his theology — creation, the
human condition, evil, grace, human freedom, redemption and transfor-
mation, the imagination and its power to envision new creation, and the
capacity of creation to point to both beauty and holiness — are themes
that the arts not only treat but, for Adams, become realities through which
we can encounter the ontological meanings of these aspects of existence.

In an early paper (1955) on "The Arts and Society" delivered at the
Theological Discussion Group in Washington, D.C., Adams discusses art
in terms of its own nature as a form given to the expression of beauty.
But, he insists, beauty is related to "other aspects of the culture and in
turn affects the culture . . . and in this cultural process shows itself to have
'a heart full of service.'" By this he does not mean service in a narrow
utilitarian sense, but in the sense of helping the human community expe-
rience through particular concrete works of art insights into the reality of
beauty, the nature of our own existence, and the character of the trans-
formed life.[3]

In his own approach to the analysis of a work, he took seriously the
words of artists about their own vocation and intention in the making of
an artwork, and he listened carefully for signs of how artists experienced
religious yearnings and touched religious depths in their own lives. Thus
he could write with special sensitivity about their religious sensibilities.

> Van Gogh, out of "the desperate violence of his spiritual hunger" in the
> face of the ruptured meanings in human society, speaks of "a terrible
> need for — shall I say the word? — religion. Then I go out and paint

2. Major collections of his writings where his essays on the arts can be found include:
On Being Human Religiously, ed. Max L. Stackhouse (Boston: Beacon Press, 1976); *The
Prophethood of All Believers,* ed. George Beach (Boston: Beacon Press, 1986); *An Examined
Faith,* ed. George Beach (Boston: Beacon Press, 1991). See also Adams's study of Tillich:
Paul Tillich's Philosophy of Culture, Science and Religion (New York: Harper, 1965).

3. "The Arts and Society," in *An Examined Faith,* ed. George Beach (Boston: Beacon,
1991), pp. 255-56.

the stars." With blue and cobalt, he might have added, I try to paint the "dearest freshness deep down things" (Hopkins). Some people have asserted that the unbeliever Matisse turned to religious painting only in his old age. His answer was, "In my work I have always sung the glory of God and his creations. . . . The past sixty years had no other meaning than to lead me to this chapel" (at Vence). He might also point to those many paintings in which he has sought to uncover the intrinsic powers of sheer line and color. Like Chagall, he has sought to depict "Universal forms" "abstracted from nature" and "endowed with inexhaustible significance" (Chagall). In Cézanne we see the artist who in the face of the vitalities of nature attempts to fuse inner ontological vision with objective being which, in its form-creating power, is allowed to speak for itself.[4]

In much of the twentieth century, theologians were particularly drawn to what they consider to be the artist's revelations about the broken character of the world — about its fragmentation and alienation, its truck with evil. Adams was no less focused on "art of the fall," but theologically he did not stop there. Creation, the fall, and redemption, as the archetypal myths of Christianity, pointed to central aspects of the whole of human experience, and he readily saw in art expressions of all three. He explored the insights artists could give us in our own attempt to understand the mystery of creation. Indeed, he began his treatment of art with an appreciation of how art invites us into an exploration of creation and the nature of beauty. He also saw in art the power it has to point to evil in the world and respond with a prophetic voice. And art, for him, could both point to the possibility of redemption and serve as a means of such transformation. Thus Adams could identify art in the history of the human community as, in his words, art of creation, art of the fall, and art of redemption. Further he saw the capacity of a work to point to all three of these aspects of religious experience. As he wrote in reference to Stravinsky: "I would point to the music of Stravinsky, for example the *Symphony of Psalms,* where creation, fall, and redemption are all expressed. The redemption was intended from the foundation of the world, but also the redeemed shall always have been fallen."[5] Equally, in his treatment of grotesque art, he saw such art both as a new creation speaking against the created order,

4. "The Arts and Society," p. 259.
5. "The Arts and Society," p. 260.

often as "an art of protest against oppression," and as an art that pointed to the necessity of transformation if the new life — the redeemed life — was to emerge. In writing about Bosch's *Garden of Earthly Delight* he explores the matter of fall and redemption and how an encounter with that work can allow us to see the existential character of both evil and transformation:

> . . . the redemptive act does not return us to innocence (e.g., the Garden of Eden) but rather it releases us to a state that embraces the evil which always shall have been to one that accepts the horror which can break out at any moment. . . . The modern eschaton is the overcoming of the evil that is always there and can still burst out. This position validates the tears and the suffering . . . it authenticates the agony by pointing to a state that recognizes equally the power of the evil that always shall have been with the power of redemptive ecstatic joy.[6]

He was amazingly open to where art could take us and what it could reveal to us about ourselves and God. In an autobiographical essay, he speaks of a personal experience that may well say best how he knew and experienced the power of art. He writes about an occasion when he was a graduate student at Harvard and a member of the Harvard Glee Club.

> Nathan Soderblom has remarked that Bach's *St. Matthew's Passion* music should be called the Fifth Evangelist. So was Bach for me. One night after singing with the Club in the *Mass in B Minor* under Koussevitsky at Symphony Hall, Boston, a renewed conviction came over me that here in the Mass, beginning with the *Kyrie* and proceeding through the Crucifixion to the *Agnus Dei* and *Dona Nobis Pacem,* all that was esential in the human and the divine was expressed. My love of the music awakened in me a profound sense of gratitude to Bach for having displayed as through a prism and in a way which was irresistible for me, the essence of Christianity.[7]

For Adams, the intersections of theology and art were complex. Art could be the object of theological reflection, a source for understanding culture and faith, and it could be a sacramental means through which the depths of the religious life were experienced. For him art allowed the

6. *Theological Reflection on the Grotesque,* edited with Wilson Yates (unpub. mss.).
7. James Luther Adams, *Taking Time Seriously* (New York: Free Press, 1957), p. 15.

theologian to hear the religious and moral questions a culture raises, to encounter the prophetic word in all its form-negating and form-creating power, to explore the contours of religious faith in its own historical contexts and to experience the reality of creation and beauty, fallenness and transformation through its own symbolic power. The intersections of theology and the arts were, indeed, complex for Adams but a complexity to which he gave marvelous clarity.

With the death of James Luther Adams we grieve the loss of a teacher, a colleague, a friend. And yet our grief has its counterpoint, for if his death leaves us the lesser, his life gave us grace that we would not have known and insights that have marked well the paths we have travelled. His love of the arts taught us to love the arts. His appreciation for how art invites us into the experience of both beauty and holiness opened us to such encounter. And through art as well as through other structures of social existence — for art was only one cultural form with which he dealt — he prepared us to "recognize equally the power of the evil that always shall have been with the power of redemptive, ecstatic joy."

1. An Introduction to the Grotesque: Theoretical and Theological Considerations

WILSON YATES

I: HISTORY AND THEORY OF THE GROTESQUE

In the nineteenth century such writers as Georg W. Friedrich Hegel, Victor Hugo, John Addington Symonds, and John Ruskin made the grotesque in art and literature a subject of major critical attention. Fascinated by its strange and seemingly contradictory character, they explored its philosophical, social, and aesthetic significance and gave us the first systematic efforts to explain the grotesque.[1] In the latter part of this century, literary theorists have given renewed attention to the subject with a similar interest in explaining its meaning and purpose as an artistic and cultural form. In this discussion, I want to highlight that renewed interest and enter the current conversation with a twofold purpose: to examine major contem-

1. Works of these writers that treat the grotesque include: G. W. F. Hegel, *The Philosophy of Fine Art*, trans. F. P. B. Osmaston (London: Bell and Sons, 1920); Victor Hugo, *Préface du "Cromwell"* (1827), ed. Edmond Wahl (Oxford: Clarendon Press, 1909); John Addington Symonds, "Caricature, The Fantastic, The Grotesque," *Essays Speculative and Suggestive* (1890) (London: Smith, Elder and Co., 1907); John Ruskin, *The Stones of Venice* (1851-53) (London: New Universal Library, Routledge and Sons ed., 1907), vol. 3, chap. 3. See Arnold Clayborough, *The Grotesque in English Literature* (Oxford: Oxford University Press, 1965), chaps. 2-3, for a summary discussion of major nineteenth-century theorists of the grotesque.

porary theories of the grotesque and to offer a theological interpretation
of this unique and puzzling form of artistic expression.

Wolfgang Kayser begins his study *The Grotesque in Art and Literature*
with the observation that the "problem of definition" is a central issue in
the study of the grotesque.[2] Kayser's point is well taken, and I wish to
respond to it by offering a definition for our use in exploring the subject.
This understanding will inform our overall considerations and, particu-
larly, our theological analysis.

> Grotesque art can be defined as art whose form and subject matter
> appear to be a part of, while contradictory to, the natural, social, or
> personal worlds of which we are a part. Its images most often embody
> distortions, exaggeration, a fusion of incompatible parts in such a fashion
> that it confronts us as strange and disordered, as a world turned upside
> down.
>
> When we encounter the grotesque, we are caught off guard, we are
> surprised and shaken, we have a sense of being played with, taunted,
> judged. It evokes a range of feelings, feelings of uneasiness, fear, repul-
> sion, delight, amusement, often horror and dread, and through its
> evocative power it appears to us in paradoxical guise — it is and is not
> of this world — and it elicits from us paradoxical responses.
>
> The responses to the grotesque are diverse: We laugh at its comic
> features while sensing its dark implications; we are fascinated and at-
> tracted to its power while being threatened by it and compelled to
> repudiate it; we experience its denial of our canons of truth while
> glimpsing a truth that our canons deny us; we experience judgment that
> calls our conventional worlds into question while intuiting that the
> judgment may be prophetic; we are confronted with the demonic from
> which we wish to pull back while knowing that we must engage its
> power to maintain our well-being; we respond with alarm at its distor-
> tions and exaggerations, its fusing of organic and inorganic, human and
> animal aspects of reality, while gaining through those distortions insights
> into different ways of being and, perhaps, new possibilities for wisdom
> and wholeness. We experience how the grotesque distorts and ridicules
> the religious life while posing to us religious questions and the yearning
> for spiritual transformation. And beneath all of these possible responses

2. Wolfgang Kayser, *The Grotesque in Art and Literature,* trans. Ulrich Weisstein
(New York: Columbia University Press, 1981).

we experience the grotesque as a power *sui generis,* an embodiment of demonic or sublime forces — forces that have a double face of darkness and light depending on where we are in the process of appropriating their meaning — while realizing that the works are nothing more than the creations of the artist's imagination.

This understanding, which both describes the grotesque and our possible responses to it, is informed by the theories of the grotesque we will be examining, but its particular formulation also serves as a critique of those theories, as we shall see in our discussion.

Ironically, current discussion of the grotesque comes at a time when judgments differ as to its historical time frame and whether it is any longer a viable artistic form given the nature of our times when the bizarre seems to blend so easily with the conventional. This diversity of opinion can well be seen in the perspectives of those theorists whose work we will discuss: Ewa Kuryluk, Geoffrey Galt Harpham, Mikhail Bakhtin, and Wolfgang Kayser. Ewa Kuryluk limits the experience of the grotesque to "dominant European culture" beginning with the late Renaissance and ending with the nineteenth century. She insists that we cannot talk about the grotesque as a part of the twentieth century because there is no longer a single dominant culture in the twentieth century against which the "anti-worlds" that give rise to the grotesque can form.[3] Geoffrey Harpham acknowledges that the twentieth century makes the grotesque "less and less possible because of the pervasive, soupy tolerance of disorder, of the *genre mixte.*" In short, "the grotesque . . . having existed for many centuries on the disorderly margins of Western culture and the aesthetic conventions that constitute that culture, is now faced with a situation where . . . nothing is incompatible with anything else." But this does not mean for Harpham that the grotesque is being eliminated, for while it may present itself to us in "endless diluting forms," it "is always and everywhere around us for it has its own life."[4] Indeed, it appears not only in our own time but in the earliest times of human history — he sees evidence in neolithic cave drawings — and he sees it continuing into the future. Its forms will change, for cultures will provide their own "conventions and assumptions

3. Ewa Kuryluk, *Salome and Judas in the Cave of Sex: The Grotesque: Origins, Iconograpy, Techniques* (Evanston, Ill.: Northwestern University Press, 1987), p. 3.

4. Geoffrey Galt Harpham, *On the Grotesque: Strategies of Contradiction in Art and Literature* (Princeton, N.J.: Princeton University Press, 1982), p. xx.

that determine its particular forms," but it will remain a continuing part of the human drama. Mikhail Bakhtin, taking a quite different approach, identifies a specific historical moment in which the grotesque is manifest in its purist form: the carnivals and festivals of the medieval era. In turn, the depth and meaning of all other manifestations including contemporary expressions must be judged by the archetypal meaning provided by the medieval carnival.[5] Wolfgang Kayser locates the beginning of the grotesque with the Roman works discovered in the late fifteenth century and traces a long and rich tradition down through our own century with our own time, particularly, considered a period of powerful grotesque art.[6] And so the debates goes, with often sharp disagreement over the grotesque's historical periodization and its significance in our own age.

In this discussion, we will work with an understanding of the grotesque as not only a powerful historical expression but also as a vital form in our own time. While it is true that we live in an age of *genre mixte* where much of the homogeneous character of Western civilization has broken down, we also live in a world where coherent cultural and political centers create conditions whose faces wear grotesque masks and whose voices speak its words. Conditions related to matters of order and chaos, to violence and forms of oppression, to sexuality and the body, to birth and death, to cynicism and madness, to apocalyptic despair and utopian visions — all visit us in grotesque forms, and, given their deep embeddedness in our cultural and psychic experience, they shall remain a part of the human journey as they have from our beginnings.

A host of issues is part of the current debate regarding the grotesque, and we will touch only on major ones. Perspectives, for example, differ regarding its original source. Is it primarily ontologically rooted? Is it fundamentally an expression of the id and the mechanisms of psychological repression? Or a specific historical crisis? Or a subculture's life under the rule of a dominant culture? Or our need to recover links to our mythic consciousness? Or a manifestation of religious or moral crisis? Or the expression of the demonic? Or is it simply an idiosyncratic expression of the artist's imagination — an aesthetic anomaly as *tour de force?*

5. Mikhail Bakhtin, *Rabelais and His World*, trans. Helene Iswolsky (Cambridge: MIT Press, 1968).
6. Kayser, chap. 1.

There is also disagreement over the relatively positive or negative character of our encounter with the grotesque. Is it essentially a confrontation with the darker side of reality, the experience of which is horror and confusion, an encounter with the demonic that, at best, we can only hope to subdue? Or is it an experience of that which amuses, frightens, disorients, while becoming a catalyst for some profound liberation or transformation? Or both?

In this essay our interest is twofold: to enter the conversation about the structure, character, and experience of the grotesque through a summary account of different theoretical perspectives — in effect, to review recent theory; and to consider the theological importance of the grotesque with particular reference to major theological concerns of creation, the fallen condition of human existence, and human redemption and transformation.

History of the Concept

The term *grotesque* entered our language with the discovery of certain unusual images in the underground passages of the baths of Titus and the ruins of Nero's golden palace. Excavation of the ruins of Nero's palace, which had been destroyed after Nero's death in A.D. 68, occurred around 1480. The discovery included foremost the work of a Roman artist named Famulus (or Fabullus), who most likely drew on a style long established in Roman times, perhaps as far back as 100 B.C.[7] The works, once exposed to light, faded over time, but fortunately the eighteenth-century French

7. Axel Boethius, *The Golden House of Nero* (Ann Arbor: University of Michigan Press, 1960), pp. 116, 126. Boethius draws on Pliny 34.84 and 35.120 for comments on the artist Famulus, who is also called Fabullus. See chap. 3. Boethius quotes Pliny: "This is evidently part of the palace in which the painter Famulus, attired in a toga and dignified even on the scaffolding, spent the few hours of his working days painting. . . . By a curious mistake these utilitarian parts of the palace and their paintings have often been used to illustrate Neronian luxury. To a great extent they also become models for grotesque paintings" (p. 116; see Harpham, pp. 25-26 n. 1, 196). For selected examples of early expressions of the grotesque through the eighteenth century, see Anthony Griffiths, *The Grotesque: Ornamental Prints from the British Museum* (London: South Bank Centre, 1995). The volume includes works by Agostino Veneziano, Jacques Ducerceau, Antonio Fantuzzi, Juste de Juste, Arent van Bolten, Giovanni Bracelli, and others.

Fig. 1.1. Nicholas Ponce, from the Domu Aurea engravings in
Description des bains de Titus, 1786

engraver Nicholas Ponce created copies that show us something of what
they looked like.[8]

The design on the walls and ceiling, both *al fresco* and *al stucco,*
typically offered images of beasts fused with animal bodies and birdlike
wings, a fish's tail, human forms that fuse with leaflike patterns weaving
plant life, masklike human heads, and various mythological figures includ-
ing centaurs, fauns, and satyrs. These images were used as borders framing
white space or identifiable human figures and landscape done in classical
style. They were strange and absurd, suggesting an otherness in preposter-

8. Nicholas Ponce, *Description des bains de Titus* (Paris, 1786). Reproductions are
from the Ponce volume in the rare-books room of Cambridge University Library. Repro-
ductions of works in the Domus Aurea can be found in Nicoli Dacos, *La decouverte de la
Domus Aurea et la formations des grotesque a la Renaissance* (London: Warburg Institute,
University of London, 1969).

ous form and effecting in the viewer feelings of fascination, amusement, uneasiness, fear.

Because they were discovered in the buried tunnels of palace halls and later in other locations removed from Rome, such as Pompeii, they were identified as works from the caves or grottoes, for the passages were cavelike in their dark, subterranean world. The term that first came into common use was *grottesche*. Geoffrey Harpham observes that the term has a special fit: the Latin of *grotto* is probably *crupta*, or crypt, which derives from the Greek term for vault. Grotesque, then, gathers into itself suggestions of the underground of burial and secrecy.[9] Frances Barasch observes that the first documented use of *grotesque* in print occurs in a 1502 contract in which the artist Pinturicchio was commissioned to paint the Piccolomini Library of the Cathedral at Siena in the new *grotesque* style.[10] In the following decades artists, including Filippino Lippi, Perturchhio, Perugio, Signorelli, Giovanni da Udine, Raphael Ghirlandaio, Perino del Vaga, and Michelangelo, all became fascinated by the form and used it in the design of borders and patterns in their paintings. Raphael, commissioned by Pope Nicholas III to decorate his loggia, incorporated the *grottesche* in his panels. Giovanni da Udine was assigned to do the work and completed it in 1559. With such use of the form by major artists, the *grottesche* became a well-known motif in both the religious and secular art of the Renaissance.[11]

From its discovery, the grotesque was controversial, for it broke with the classical style and philosophy of art. It had been equally controversial at the time of its Roman origins, with Vitruvius Pollio attacking it in his influential *De Architectura* (27 B.C.), a work that gained a renewed significance in the Renaissance; and Georgio Vasari supporting it in his *Lives of the Great Artists* in A.D. 1650. Vitruvius wrote of this new art form:

> On the stucco are monsters rather than definite representations taken from definite things. Instead of columns there rise up stalks; instead of gables, striped panels with curled leaves and volutes. Candelabra uphold pictured shrines and above the summits of these, clusters of thin stalks rise from their roots in tendrils with little figures seated upon them at

9. Harpham, p. 27.

10. Frances Barasch, *The Grotesque: A Study in Meanings* (The Hague: Mouton, 1971), p. 21.

11. Barasch, chap. 1. In this chapter Barasch offers an excellent discussion on the development of the concept of grotesque and its early use in various national contexts.

random. Again, slender stalks with heads of men and animals attached
to half the body.

Such things neither are, nor can be, nor have been. On these lines
the new fashions compel bad judges to condemn good craftsmanship
for dullness. For how can a reed actually sustain a roof, or a candelabra
the ornaments of a bagel, or a soft and slender statue, or how can flowers
and half-statues rise alternatively from roots and stalks? Yet when people
view these falsehoods, they approve rather than condemn.[12]

Vasari praised the use of the grotesque by various Renaissance paint-
ers. For him, Vitruvius's classical architectural concepts, elaborated by
fourteenth-century artists, had been essential to the development of art.
In what Vasari called the third stage of great art, however, artists needed
to move beyond the concepts of the earlier periods. "There was wanting
in their rule a certain freedom . . . and their order had need of an invention
abundant in every respect . . . so as to reveal all that order with more
adornment."[13] Thus he speaks favorably of the use of the grotesque. Most
significantly he saw in the work of Michelangelo

> an ornamentation in a composite order, in more varied and more original
> manner than any other master of any time . . . , for in the novelty of
> the beautiful cornices, capitals, bases, doors, tabernacles, and tombs, he
> departed not a little from the work regulated by measure, order, and
> rule, which other men did according to common use after Vitruvius
> and the antiquities, to which he would not conform. That licence has
> done much to give courage to those who have seen his methods to set
> themselves to imitate him, and new fantasies have since been seen which
> have more of the grotesque than of reason or rule in their ornamentation.
> Wherefore, the craftsmen owe him an infinite and everlasting obligation,
> he having broken the bonds and chains by reason of which they had
> always followed a beaten path in execution of their works.[14]

12. Marcus Vitruvius Pollio, *De Architectura* (27 B.C.), trans. and ed. Frank Granger
(Cambridge: Harvard University Press, Loeb Classical Library, 1934), 2:105, quoted in
Harpham, p. 26. See also Clayborough, pp. 19-20.

13. Georgio Vasari, *Lives of the Most Eminent Painters, Sculptors, and Architects,* trans.
Gaston Du C. de Vere, 3 vols. (New York: Harry Abrams, 1979), 3:1879, quoted in
Barasch, p. 27, and Harpham, from different translations. See Harpham, p. 194 n. 2.

14. Barasch, p. 31; see her discussion on pp. 25-31.

The disagreement continues down to the present between those who find the grotesque a violation of the order and harmony that art provides in its classical form and those who find it a powerful expression of art and welcome it as an important artistic form for understanding aspects of human experience. Perhaps this is captured most boldly in John Ruskin's theory of the grotesque, in which he distinguishes between its noble and ignoble forms. The noble grotesque, which comes out of mental play, gives to us the terrible, but in the horror it evokes we experience a new feeling for nature and new appreciation of beauty. The ignoble grotesque, however, as seen in the "stones of Venice," treats the distorted recesses to no good end. Attacking the *grottesche* of the Roman ruins and Raphael's use of it, he writes:

> It may be generally described as an elaborate and luscious form of nonsense. Its lower conditions are found in the common upholstery and decorations which, over the whole of civilized Europe, have sprung from this poisonous root; and artistical pottage, composed of nymphs, cupids and satyrs, with shreddings of heads and paws of meek wild beasts, and nondescript vegetables.[15]

As the use of the *grottesche* or *grotesque* moved out of Italy into France and Germany, the term *grotesque* became the universally used category for works similar to though not necessarily identical with the style, content, or effect of the original discoveries and their development by Renaissance Italian artists. Perhaps most significantly, Hieronymus Bosch's works such as *The Garden of Earthly Delights* (1500-1505), *The Temptations of St. Anthony* (1500), and *The Haywain* (ca. 1485); and Pieter Brueghel the Elder's works including *Peasant Wedding Dance* (1566), *The Peasant Kermis* (1567), and *The Feast of Fools* (1568) were identified as grotesque art though the artists never used the term. This identification elaborated the corpus of works beyond the border patterns of fauna and animal grotesquerie and deepened the fledgling tradition in ways that indicated how the grotesque could carry profound religious and moral meanings.[16] In this process the imaginary became even more removed from the realm of

15. Ruskin, vol. 3, chap. 3, sec. 39, p. 150.
16. See Donald Polumbo, *Eros in the Mind's Eye* (London: Greenwood Press, 1986), chap. 1, and Barasch, chap. 1.

Fig. 1.2. Raphael,
detail from a pillar of the
Papal Loggia, ca. 1515

the strange and playful, taking on somber tones that spoke of the
monstrous and fearful.

In literature, Dante, Shakespeare, Rabelais, Cervantes, Johann Fis-
chart, Montaigne, and the creators of the commedia dell'arte used
grotesque imagery in their work, and by the eighteenth century a growing
body of art and literature had created a rich genre of grotesque work.[17]
In the late eighteenth century and into the Romantic period of the
nineteenth century, there was an extraordinary output of works that used
the grotesque form, including works of Francisco Goya, Henry Fuseli,
William Hogarth, Jacques Callot, E. A. T. Hoffman, Sir Walter Scott,
Edgar Allan Poe, and Victor Hugo.

17. See Clayborough, Kayser, and Barasch for discussions of major classical writers.
Bakhtin builds his theory on his reading of Rabelais.

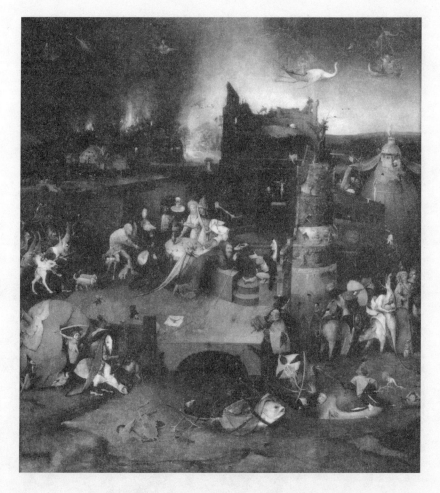

Fig. 1.3. Hieronymus Bosch, *The Temptations of St. Anthony,*
1500-1505, central panel

In the twentieth century, the works of Beardsley, the expressionists, the surrealists, the theater of the absurd, art brut; such artists as Edvard Munch, Francis Bacon, Leonard Baskin, and Rene Magritte; and writers such as Thomas Mann, Franz Kafka, Günther Grass, Flannery O'Connor, Eudora Welty, and Toni Morrison provide ample testimony to the continuing tradition. (That tradition is equally alive and dynamic in other art

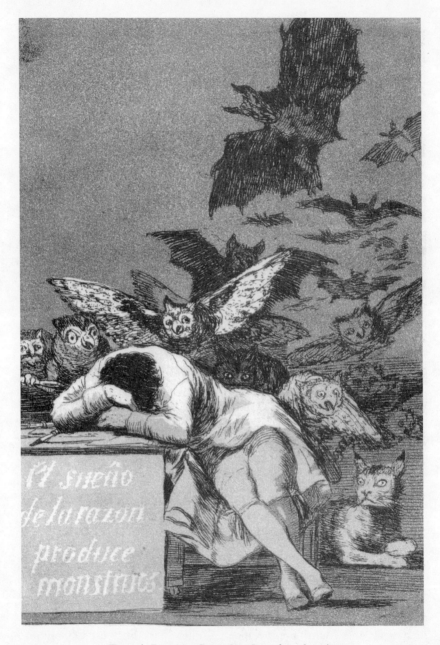

Fig. 1.4. Francisco Goya, *Los Caprichos,* plate 43:
"The Sleep of Reason Produces Monsters," 1799

forms including music, photography, film, and the popular forms of video and print media, which have extended its forms and availability.)

Theories of the Grotesque

There have been theories of the grotesque from Roman times to the present. I have referred to Vitruvius's commentary of the classical Roman period and Vasari's stance in the sixteenth century. They represented two opposing positions that influenced thought in France, England, and Germany as the grotesque spread out of Italy into other areas of Europe. Other terms for the grotesque were often used — for example, in England "antichke" and "chimera" (monster against nature) — but by the seventeenth century the term had become the defining category in dictionaries, encyclopedias, and essays of the period.[18] In the eighteenth century essayists wrote about and took sides on the value and significance of grotesque art, but not until the late eighteenth and nineteenth centuries did a significant body of theoretical work become available through the writings of Christoph Wieland, Friedrich Schlegel, Friedrich Hegel, Sir Walter Scott, Edgar Allan Poe, Victor Hugo, Charles Baudelaire, and John Ruskin.

In the discussion that follows, I will focus on the works of four contemporary theorists I made reference to earlier: Wolfgang Kayser's *The Grotesque in Art and Literature* (1957), Mikhail Bakhtin's *The World of Rabelais* (1968), Geoffrey Galt Harpham's *On the Grotesque: Strategies of Contradiction in Art and Literature* (1982), and Ewa Kuryluk's *Salome and Judas in the Cave of Sex: The Grotesque: Origins, Iconography, Techniques* (1987). They are representative of recent work and, in the case of Kayser and Bakhtin, have foreshadowed most all work done in the latter part of this century. This by no means exhausts the body of work available, however, for we could easily extend our treatment to more specialized studies such as Frances Barasch's *The Grotesque: A Study in Meanings* (1971), Arnold Clayborough's *The Grotesque in English Literature* (1965), William Van O'Connor's *The Grotesque as an American Genre* (1962), and Mary Russo's *The Female Grotesque* (1994), as well as

18. See Barasch, chap. 1; Clayborough, chap. 1; Kayser, chaps. 1-2 for discussions of definitions and developments of the concept of the grotesque as it spread out of Italy.

others.[19] All four of the figures we have chosen are concerned with
defining the grotesque, identifying its primary characteristics, interpret-
ing its meaning, and suggesting something of its importance for us in
understanding human existence. Most significantly, their insights, while
at points similar, yield different understandings of the origin and meaning
of the grotesque.

Our task is not to engage in a detailed analysis of their theories but
to review their treatment of major issues of the grotesque. This considera-
tion will, in turn, inform our later theological discussion.

Wolfgang Kayser

Wolfgang Kayser's *The Grotesque in Art and Literature* (1957) laid the
foundation for post–World War II treatments of the subject; most major
theorists of the modern period take his work into account. Kayser begins
his study by defining the grotesque, for he sees the lack of clarity regarding
what we mean by the term, and finds his solution through an etymological
study of the word from roughly the late fifteenth century to the present.

Kayser provides an overview of the history of the grotesque, but his
major focus rests on its reception into German and French literature and
art and its expression in the Romantic and modern periods. One of his
observations notes the link of the grotesque to the religious by virtue of
the word's meaning. He writes that the suffix *-esque* indicates "participation
in a spiritual essence. Apart from the realm of proper names, -esque and
-esco (as well as -isch) attach themselves only to those names which can
be regarded as spiritual essences. . . . Thus the word *grottesque* contained

19. A range of twentieth-century authors has contributed to the discussion of the
grotesque in addition to the four major works that are dealt with at some length. We have
referred to works by Frances Barasch and Arnold Clayborough. See also William Van
O'Connor, *The Grotesque as an American Genre* (Carbondale: Southern Illinois University,
1962); Lee Byron Jenkins, *The Ludicrous Demon* (Berkeley and Los Angeles: University of
California Press, 1965); Michael Camille, *Images on the Edge: The Margins of Medieval Art*
(Cambridge: Harvard University Press, 1992). Camille chooses not to use the term
grotesque, but he offers an insightful treatment of medieval grotesquerie. A recent study by
Mary Russo, *The Female Grotesque: Risk Excess and Modernity* (London: Routledge, 1994),
draws on the four theorists treated in this essay and is a further contribution to the literature
of the grotesque in the arts and a particularly important work in feminist thought on the
grotesque.

the latent possibility of designating more than the ancient grotto paintings and their modern equivalents, which had been originally intended for it."[20]

Kayser drew significantly on the work of Christoph Martin Wieland, who in 1775 published *Unterredun gen mit dem Pfarrer von . . .* , a work that made an important contribution to understanding the more serious nature of the grotesque. Wieland distinguished between three types of caricature: *true caricature* with natural distortions; *exaggerated caricature,* where the artist "enhances the monstrosity of the subject without destroying its similarity to the model"; and a third form, the purely *fantastic caricatures.* These latter caricatures he called "grotesques . . . where the painter, disregarding the verisimilitude, gives rein to unchecked fancy (like the so-called Heil Brueghel) with the sole intention of provoking laughter, disgust, and surprise about the daring of his monstrous creations by the unnatural and absurd products of his imagination."[21]

Wieland's perspective is important to Kayser's own theory. Kayser drew on the Renaissance understanding of the grotesque as a work that is from the dreams of the artist, *sogni dei pittori,* which contradicts "the very laws which rule over our familiar world."[22] The grotesque is not for Wieland or Kayser simply "humorous caricature (or) topical satire" as it had tended to become in French treatments of the eighteenth century. Rather, contradictory feelings are aroused by the grotesque, such as being amused while being appalled, and the basic feeling "is one of surprise and horror, unagonizing fear in the presence of a world which breaks apart and remains inaccessible." Kayser maintains that we have in the Renaissance the beginning recognition that the grotesque could carry a "hidden meaning" or a "measure of truth" that had not generally been sought in it before.

Out of his etymological analysis and historical survey, he identified three periods when the more serious and intense power of the grotesque comes to the fore: the sixteenth century with Brueghel and Bosch; the age which extends from the *Sturm und Drang* to Romanticism; and the twentieth century where both literature and the arts provide us powerful examples. In these periods and in their works the full force of what he calls the power of the "it" — a term he uses for the grotesque — intrudes as

20. Kayser, p. 26.
21. Kayser, p. 30.
22. Kayser, p. 31.

an "incomprehensible, inexplicable, and impersonal force" into our lives.[23] It should be noted that Bakhtin and others have criticized Kayser for generalizing to all periods the more ominous tones of the grotesque from the Romantic period, thus ignoring what they identify as a different character to many medieval and Renaissance expressions.

From his etymological and historical analysis, Kayser develops the foundational premises of his theory. He begins by stating that "the word grotesque applies to three different realms — the creative process, the work itself, and its reception."[24] The creative process relates to the artist. A grotesque work is the child of the artist's imagination, the *sogni dei pittori* that the Italians speak of. The artwork has its own structure — its own characteristics, motifs, and style — that gives it a type of autonomy and objectivity as a work. Some of the grotesque subjects Kayser identifies are monsters, animals, and particularly snakes, owls, toads, spiders, reptiles, vermin, insects, and, above all, bats, which are "the grotesque animal incarnate." Other subjects are drawn from the plant world, such as entangling vines or plants strange and haunting in character. The tools and technology that have sinister overtones — from the medieval rack to the nuclear bomb to imaginative but threatening self-propelling machines — as well as skulls and skeletons, are key images, as are "human bodies reduced to puppets, marionettes and automata, with their faces frozen into masks."[25]

Central to the representation of the grotesque is the fusing of different, incompatible parts: a person with the head of a bat, a plant with the teeth of an animal, a man with the torso of a machine. The fusion or combination of different elements is crucial to the grotesque from its earliest ornamental forms to the human machine to the fusions of surrealist artists.

The reception of the artwork is also quite important for Kayser, for he insists that the experience of the work as grotesque is a significant factor in claiming that it is grotesque. He insists that we should not define the grotesque "exclusively on the basis of its effect," but "in defining the structural perspective of the grotesque, we have to refer to its reception, with which we cannot dispense under any circumstances."[26]

23. Kayser, p. 185.
24. Kayser, p. 180.
25. Kayser, p. 183.
26. Kayser, p. 181.

Four basic premises are central to Kayser's theory: (1) the grotesque is the estranged world; (2) the grotesque appears to be an expression of an incomprehensible, inexplicable, and impersonal force; (3) the grotesque is a play with the absurd; and (4) the creation of the grotesque is an attempt to invoke and subdue the demonic aspects of the world.[27] Arthur Clayborough writes that "Only the first of these four statements is concerned with the representative side of grotesque art. The others are concerned rather with its expressive side, i.e., with the artist's point of view; we are told in each case about the attitude of mind, conscious or unconscious, which produces grotesque art."[28] Clayborough's point is well taken, but one can equally claim that the "receiver" of the work is able to experience the game with the absurd and the encounter with the demonic. Indeed, it is this power to affect us that Kayser is so concerned that we understand.

For Kayser the presentation of the grotesque is of an *estranged or alienated world.* By this he means a world that is a transformation of our world, a world in which the familiar and natural elements "suddenly turn out to be strange and ominous." There is a metamorphosis of reality and what we confront defies explanation; the world is upside down and the norms and logic we live by do not work. The artist has created a "fusion of realms which we know to be separated, the abolition of the law of status, the loss of identity, the distortion of 'natural' sign and shape, the suspension of the category of objects, the destruction of personality, and the fragmentation of the historical order" in such a fashion that the world we are given is strange and alien in its subject and content.[29] The effect it instills is the fear of life rather than the fear of death, for the life it offers is so horrifying in its "suddenness and surprise" that we wish to flee it.

The grotesque is experienced as *an incomprehensible force that has no name.* Kayser suggests that it is "objectification of the IT, the ghostly IT." We cannot relate this "it" to the world we know; we have no orientation to comprehend it. Indeed, if we could name it, it would lose its essential quality of grotesqueness. "What intrudes remains incomprehensible, inexplicable and impersonal." The artist creates out of dreams and day-

27. Kayser, pp. 184ff.
28. Clayborough, p. 64.
29. Kayser, p. 185.

dreams, out of "the twilight of our transitional moment." The images in and of themselves have no meaning; they are simply absurd.[30]

This idea is not well developed by Kayser. Clayborough presses him to identify the force, "it," with the id, but Kayser does not do so. He does suggest madness as a paradigm: "in the insane person, human nature itself seems to have taken on ominous overtones . . . it is as if an impersonal force or alien and inhuman spirit had entered the soul. The encounter with madness is one of the basic experiences of the grotesque which life forces upon us."[31] (One is reminded of Goya and *Los Capriccios* as a case study.)

Absurdity is a central aspect of the grotesque. Kayser differentiates the absurd in the grotesque from the absurd in tragedy, where we can see "the possibility of meaning" in the greatness of the hero or in suffering, or in fate. The absurd in the grotesque offers us no such meaning which we can derive from the unfolding of the work itself.[32]

The absurd is given to us by the artist, who has "played with the absurd" in such a way as to be drawn into it. Writing of Fischart's description of the dance of giants, Kayser states, "it began as a simple play with words but progressed to a point where language itself seemed to come to life and draw the author into its whirlpool. . . . Fischart begins to play a dangerous game, the same game which the graphic artists played in their capriccios."[33] This is the third premise of the grotesque: *the playing with the absurd* — a dangerous playing that can deprive the artist of freedom, of orientation, that may begin with laughter yet end in fear. It is an absurdity in which the "it" seems to take on its own life and in so doing inhabit the creator of the grotesque, and potentially the life of the receiver.

The final premise is that *the grotesque is an attempt to invoke and subdue the demonic aspects of the world.* Kayser insists that the grotesque, even as it appears to have overtaken the artist, still has not destroyed an element of the playful — of the ability of the artist and the receiver to respond. It is precisely this power of response that can lead to a secret liberation: "In spite of all the helplessness and horror inspired by the dark forces which lurk in and behind our world and have power to estrange it, the truly artistic portrayal effects a

30. Kayser, p. 185.
31. Kayser, p. 186.
32. Kayser, p. 186.
33. Kayser, p. 186.

secret liberation. The darkness has been sighted, the ominous powers discovered, the incomprehensible forces challenged."[34]

As suggestive as this understanding of the grotesque is, Kayser leaves us with much unanswered. What is the nature of the dark and demonic forces? To use the term "demonic" begs for elaboration that is not forthcoming. Is it evil or, as he also states, simply "the unimpassioned view of life on earth as an empty, meaningless puppet play or a caricatured marionette theatre." Is it a strong otherness whose incomprehensibleness threatens, or does it embody a force that threatens absolutely?

Kayser speaks of the demonic aspects of the world. Might this mean any aspect of experience, personal or social, that is threatening to the psyche, to relationships, to the community as a whole, or is it more related to the amorphous fears that flow from our unconscious and from which we seek release? Does experiencing and subduing the demonic primarily focus on a specific historical reality of the moment such as totalitarianism or oppression, or is it an experience that is more ontologically rooted and transhistorical in nature?

Kayser would appear at times to embrace both the idea of the grotesque as the dark forces that have no name, the demonic that has no historic referent, while at other times he seems to locate the referent as the absurd: "The various forms of the grotesque are the most obvious and pronounced contradiction of any kind of rationalism and any systematic thought," and he continues with observations about the particular historical forms of rationalism that have been opposed. These two accents are not mutually exclusive, but there is a need to define more specifically the dark forces — the demonic — with reference to both their historical and their ontological character.

The experience of the grotesque for Kayser is the experience of that which is negative, strange, and sinister. The positive aspect of the experience, insofar as it exists, is that one can, by invoking "it," take it in, subdue, and answer it. The process suggests Paul Tillich's treatment of the threat of nonbeing in which, through an act of accepting and taking in nonbeing, one engages in an act of being that answers the threat.[35] There is "silent

34. Kayser, p. 188.
35. Paul Tillich, *The Courage to Be* (New Haven, Conn.: Yale University Press, 1952).

liberation." But, finally, the grotesque itself has no positive role to play in life: it remains that which is to be overcome.

Other theories of the grotesque are more positive in their assessment of the experience itself. In these perspectives, the grotesque is not so much an absurdity that points to the demonic, but rather an absurdity that points to some new insight or aspect of existence that has been lost or some image of the new age or of spiritual transcendence. Bakhtin's perspective provides one such approach.

Mikhail Bakhtin

The twentieth-century Russian philosopher Mikhail Bakhtin (1895-1975) has become a strong voice in contemporary literary criticism and a major theorist of the grotesque. To understand his view of the grotesque, it is important to acknowledge certain major aspects of his literary theory and particularly note the place of language and dialogue in his thought.

Bakhtin approaches literature with the belief that it provides unique insight into human experience through the language it offers and that it politically influences the beliefs and practices of the community. In his analysis, he sought material that would give insight into his own understanding of dialogue and the dialogic imagination which are cornerstones of his literary theory. In his view of dialogue, he insists that all is and remains in process. The language we use is not complete but regenerative, corrective, and relative. Different images and insights come as we hear and interpret and revise what we thought in an ongoing process of "discourse." The "dialogic imagination" which he seeks to find at work in literature reveals to us both what is meant by dialogue and how dialogue takes place.

The enemy of dialogue is monologue. As Gary Saul Morson observes, "monologic utterance and situations are constructed so as to restrict or ignore this dialogic possibility."[36] Monologue constricts, abstracts, objectifies, casts the other into social roles, and presumes power over the other. It creates a closed world. By contrast dialogue creates a world that is open, responsive, unfolding.

In Bakhtin's understanding of dialogue, his notion of language is

36. Gary Saul Morson, "Dialogue, Monologue and the Social: A Reply to Ken Hirschkop," in *Bakhtin: Essays and Dialogue on His Work,* ed. Gary Saul Morson (Chicago: University of Chicago Press, 1986).

roughly the same as ideology. Working with a view of the self as essentially social in nature, he spells out how people carry on in their dialogue and language, in their discourse and voice, a complex social world that makes up the self. Thus the person is never a single isolated individual creating speech separately from his or her social context, but is always speaking out of that larger social world which is embedded in who the person is. Bakhtin argues, however, that the human being in the modern world is a victim of bourgeois culture, which has undercut a healthy understanding of the self as social creature and an appreciation of the power of dialogue to best reveal that social self. It has made people victims by perpetuating an atomistic, individualistic view of the self that assumes that authenticity lies beyond the social, freed of influence outside of itself.[37]

The atomistic view of the self; actions that create representation and objectification of the other; the values and social structures of hierarchy, dogmatism, formalism, and absolutism — all are the patterns of life sanctioned and reinforced by official culture. They all create a world that divides the self from itself, the other, the body, and the larger community, and they all undercut dialogue. In response, Bakhtin seeks a way to create or recover a world that provides a new way of being. This new world provides us with the social structures and philosophical understandings for realizing participation rather than representation; dialogue rather than monologue; equality rather than hierarchy; the social self rather than the individualistic self; the full body in communion with the natural world rather than the body abstracted and privatized. It is at the point of realizing this new world, of bringing it into being, that the grotesque becomes important for Bakhtin, for it provides a radical image of dialogue and

37. Bakhtin, *Rabelais and His World,* introduction. Wayne Booth, "Freedom of Interpretation," in *Bakhtin: Essays and Dialogue on His Work,* ed. Gary Saul Morson (Chicago: University of Chicago Press, 1986), provides an insightful statement regarding Bakhtin's view of the self in relationship to self, language, and meaning. "For him (Bakhtin) as for most orthodox Marxists, what I call my 'self' is essentially social. Each of us is constituted not as an individual, private, atomic self but as a collective of the many selves we have taken in from birth. We encounter these selves as what he calls 'language,' the 'voices' spoken by others. Languages are, of course, made not only of words; they are whole systems of meaning, each language constituting an interrelated set of beliefs or norms. 'Language' is often thus for him roughly synonymous with 'ideology.' Each person is constituted as a hierarchy of languages, each language being a kind of ideology-brought-into-speech" (p. 151).

participation; it carries the revolutionary vision and understanding of a new world freed from both bourgeois and totalitarian cultures.

Bakhtin's treatment of the grotesque appears in three of his literary studies: "Discourse in the Novel," *Problems of Doestoevsky's Poetics,* and *Rabelais and His World.* In this last work he develops his theory of carnival body and grotesque realism. The sources for the grotesque that he found in Rabelais' *Gargantua and Pantagruel* were carnival and folklore which, he maintains, reveal to us what is required for the reintegration of social life that official culture had destroyed.

In Bakhtin's theory carnival functions as an ideal, the Eden — the Saturnalian golden age — from which people have fallen. Bakhtin constructs this carnival in pure form and sets it forth as that which we should hope to realize again as a new alternative world. Its fullest historical expression is found in the medieval carnival and festivals with their peasants, clowns, fools, and rogues. But it also breaks through in other cultural forms, such as in the novel and in particular historical events. These forms provide glimpses of the fullness of carnival. They point the way, and insofar as we participate in their meaning, we experience something of the new life they offer: "the grotesque . . . discloses the potentiality of an entirely different world, of another order. The existing world suddenly becomes alien . . . precisely because there is the potentiality of a friendly world, of the golden age, of carnival truth. Man returns unto himself. The world is destroyed so that it may be regenerated and renewed. While dying it gives birth."[38]

To see the function of carnival vis-à-vis dominant culture, two statements are helpful. In *Problems of Doestoevsky's Poetics* he writes: "Nothing conclusive has yet taken place in the world, the ultimate word of the world and about the world has not yet been spoken, the world is open and free, everything is still in the future and will always be in the future."[39] This is an important guiding principle that has the character of a faith statement about the world. The role he assigns to carnival relates directly to this vision. He writes that carnival is "to consecrate inventive freedom, to permit the domination of a variety of different elements and their rapprochement, to liberate from the prevailing point of view of the world,

38. Bakhtin, *Rabelais and His World,* p. 40.

39. Mikhail Bakhtin, *Problems of Dostoevsky's Poetics,* ed. and trans. Caryl Emerson (Minneapolis: University of Minnesota Press, 1984), p. xxxix.

from conventions and established truths, from cliches, from all that is humdrum and universally accepted." Carnival provides a model of what should be and through participation in the carnival body an experience of what the new life is like. It provides a chance "to enter a completely new order of things."[40]

In contrast to Kayser, who saw the grotesque as a realistic way of grappling with the ongoing power of the demonic in our lives, it is easy to see how Bakhtin holds out a much more positive understanding of the grotesque, for through participation in the grotesque — the carnival body — we experience the new world — we participate in the golden age.

From Rabelais, particularly, Bakhtin derived his understanding of carnival body. Rabelais, Bakhtin maintained, drew primarily upon the festivals and carnivals of the Middle Ages, which turned the hierarchically closed world upside down and provided an experience to participants of equality, democracy, and a sense of the social world and one's full participation in it. This leveling of all value distinctions regarding class, age, gender, body, or status and this engagement of all in the drama as participants — as participants to dialogue rather than representation — is elaborated in this passage:

> Carnival is not a spectacle seen by the people; they live in it, and everyone participates because its very idea embraces all the people. While carnival lasts, there is no other life outside it. . . . It has a universal spirit, it is a special condition of the entire world, of the world revived and renewed, in which all take part.[41]

Rabelais dealt extensively with the body and the expression of both scatological and sexual activities. The orifices of the body are particularly important — ear, eye, nose, mouth, vagina, anus. The body processes of eating, spitting, sucking, pissing, and copulating are all lifted up with words played upon and juxtaposed for accent. Equally, birth and death are treated in as bawdy a fashion. In the imaging of the body, body parts are juxtaposed and connected, defying easy recognition and leveling any sense of one part as private or public, good or bad, repulsive or attractive. All parts are parts of the whole. But more, by the mixture of all the parts we link individuals to each other as parts of the larger whole.

40. Bakhtin, *Rabelais and His World,* p. 9.
41. Bakhtin, *Rabelais and His World,* p. 7.

A number of theoretical points can be made about Bakhtin's treat-
ment of Rabelais. Foremost, he is creating out of Rabelais' work a myth
of the people as a whole body with the body as symbol for the personal,
social, and natural; as metaphor for the cosmos to which we belong. In
so doing he mythologizes carnival. It is a myth of carnival rather than
actual carnival that finally informs Bakhtin's view of the cosmic body.

In this myth the focus is on the scatological and the sexually oriented
processes and parts of the body that have been privatized and degraded
by conventional culture. For Bakhtin, what have been made "private" and
"degraded" are to be accepted and celebrated. Until they are, we have a
body set over against itself, a body-spirit dualism in which the body is
made inferior, an alienated body that denies the unity and wholeness
essential to its true nature. The grotesque form, therefore, requires accep-
tance of what has been denied.

Further, in this "carnivalizing" of body, the body is reunited with
the earth from which history and, particularly, capitalism have severed it.
This is a crucial aspect of Bakhtin's thesis, for here he wishes to transvalue
our view of birth and death by linking them to nature and the earth: from
the human mother we are born, to the earth as mother we return to give
new birth. The sting of individual death is removed, for our death returns
us to the earth as source of its regeneration and the regeneration of the
species. About the carnival body of grotesque realism, he writes:

> In grotesque realism . . . the bodily element is deeply positive. It is
> presented not in a private, egotistic form severed from other spheres of
> life, but as something universal, representing all the people. . . . [T]his
> is not the body and its physiology in the modern sense of these words,
> because it is not individualized. The material bodily principle is con-
> tained not in the biological individual, not in the bourgeois ego, but in
> the people, a people who are constantly growing and renewed.[42]

Laughter is a central ingredient in understanding the grotesque and
its effect on people. Bakhtin distinguishes between carnival laughter, the
laughter of grotesque realism that is intrinsic to the medieval and Renais-
sance grotesque, and post-Renaissance expressions where laughter loses its
regenerative power and has more the effect of inciting terror. For Bakhtin
"the world of Romantic grotesque is to a certain extent a terrifying world

42. Bakhtin, *Rabelais and His World*, p. 19.

alien to man," far different from the grotesque's medieval and Renaissance forms.[43]

Michael Andre Bernstein observes that "directly linked to this burden of terror, of laughter as a response to dread, not exuberance, is a change in the literary question of madness."[44] As Bakhtin states: "in folk grotesque, madness is a gay parody of official reason, of the narrow seriousness of official 'truth.' It is a 'festive madness.' In Romantic grotesque, on the other hand, madness acquires a somber, tragic aspect of individual isolation."[45]

For Bakhtin, laughter in the carnival is freeing, liberating, healing. It is the point in the grotesque story and in the response of the reader when we enter into the world of the grotesque and experience spontaneously what it has to offer. Wayne Booth offers a summary of Bakhtin regarding the role and power of carnival laughter and how it relates to his view of the body.

> Carnival laughter, the intrusion of everything forbidden or slanderous or joyfully blasphemous into the purified domains of officialdom, expressed a complex sense that the material body was not unequivocally base: every death contains within it the meaning of rebirth, every birth comes from the same region of the body as does the excremental. And the excremental is itself a source of regeneration — it manures life. . . . References to the lower body were . . . used to produce a regenerative, an affirmative, a healing — finally a politically progressive laughter.[46]

In the redefining of the body and its processes; in reintegrating body and self, the individual body with the collective body, and the communal body of the people with the body of the cosmos; in accenting the ongoing link of birth, death, regeneration, and the metaphorical body of the community, Bakhtin is attempting to uncover a liberating and healing antidote to official culture. Official culture severed the whole, disembodied the self, abstracted life, and created authoritarian structures and status that

43. Bakhtin, *Rabelais and His World*, p. 38.
44. Michael Andre Bernstein, "When the Carnival Turns Bitter," in *Bakhtin: Essays and Dialogue on His Work,* ed. Gary Saul Morson (Chicago: University of Chicago Press, 1986), p. 99.
45. Bakhtin, *Rabelais and His World*, p. 39.
46. Booth, "Freedom of Interpretation," pp. 161-62.

deny the regenerative powers of nature. To enter into the carnival body, to experience grotesque realism and its laughter, exuberance, and joyful abandon is to recover that which has been lost. It is to experience healing and liberation. Bakhtin's image of the grotesque and its function in our lives offers his particular "word" and presence of life made whole.

For our interest, he makes a major contribution to the understanding of the grotesque by identifying, on the one hand, the carnival and its related forms of folk festivals, folklore, images of the fool, the clown, the rogue as primary sources for encountering the grotesque, and on the other hand, by exploring a view of the grotesque as a positive construct that can offer a liberating and transforming experience. The grotesque can provide a vision of a new age, a mythic image of a transformed "reborn" existence that is the foretaste of what should be. What the new age is — Bakhtin's or another — is not as important as the theoretical point that the grotesque can convey the elements of a vision and engage one in a process of change.

This understanding of the positive function of the grotesque offers a complementary stance to that of Kayser. For our purposes, both views are important. Kayser provides an understanding of the grotesque that invites us to explore theologically the reality of evil as an aspect of the human condition and the limited nature of finite existence. Bakhtin's paradigm invites us to explore the power of the grotesque to free us from forces that distort our true humanity and provide us a new vision of social existence. Whether a work of grotesque art does either one depends, of course, on our particular reception and participation in the work. But Kayser and Bakhtin provide us theories for framing and assessing our experience.

But what of Rabelais? A note needs to be added here. There is, it is fair to say, the Rabelais of Kayser, whom Kayser briefly alludes to; the Rabelais of Bakhtin, who is a primary subject and source in Bakhtin's work; and Rabelais the author, whose work should at least be acknowledged on its own terms. In his consideration of Fischart, who drew on Rabelais, Kayser sets forth a rather dark image of Rabelais' work. He contends

> that the abysmal and terrifying aspects of Rabelais's and Fischart's works are not restricted to the content of their language but also extend to the elusiveness of language itself. The familiar and indispensable tool suddenly proves to be arbitrary, strange, demonically alive, and capable of

dragging man into the nocturnal and inhuman sphere. The history of the style which makes such a violent appearance in Rabelais and Fischart is not written.[47]

We have written at length about Bakhtin's view of the grotesque, which he grounds in what he considers a Rabelaisian image of carnival. It is worth noting, however, that Rabelais' work is not about a carnival world. Rabelais draws on folktales and mythology and creates an epic story of the giants Gargantua and Pantagruel, but he does not present either scenes of medieval carnival or lift up as significant or particularly worthy carnival culture. Richard Berrong, in *Rabelais and Bakhtin,* argues that

> the function and position of popular culture [the carnival culture of the medieval world] in *Gargantua and Pantagruel* is by no means the unchanging, completely dominant monolith described by Mikhael Bakhtin. In *Pantagruel* popular culture operates on a par with, but not to the exclusion of learned culture. In *Gargantua* one can watch Rabelais exclude it from his narrative, until, with the Third Book he takes it out almost entirely, as of the Fourth Book, the author allows popular culture back into his narrative to a limited extent, but often with negative connotations, and almost always in association with his figures of power and authority.[48]

Rabelais exuberantly uses scatological and sexual language, bawdily tells of copulation and birth, and offers through his style of language and bizarre characterization of incidents fascinating considerations of death. The body in its processes and regenerative expressions is integral to his heroic tale. Pantagruel eats his cow mother; Gargantua's wife, while giving birth, swallows the pilgrims. He has extraordinary scenes of orgiastic drinking and eating, and the story of Gargantua's birth offers an amazing presentation of distortion and excess. Throughout the book, the church is mocked, its monks twitted, and its hierarchy buffooned. But in the midst of this there is also a balance of order. Furthermore, an idyllic world is spelled out, a new order, with freedom and pleasure which contrast sharply with the order of the dominant culture at the time he is writing.

47. Kayser, p. 157.
48. Richard Berrong, *Rabelais and Bakhtin* (Lincoln: University of Nebraska Press, 1986), p. 121.

But this utopia (bk. 1:52-57) is built on learning and love, will and freedom. Its rule is but one: DO WHAT THOU WILT; and it is based on the assumption that "men that are free, well-borne, well-bred, and conversant in honest companies, have naturally an instinct and spurre that prompteth them unto vertuous actions and withdraws them from vice, which is called honour."[49] In effect, the community is highly rational, orderly, and far removed from the excess of carnival. Equality also functions for Rabelais as revealed in his lists of Gargantua's ancestors, but the story as a whole is finally one of kings, princes, rulers, church officials, monks, and soldiers who live out a saga of chivalric rule and ordered structure with little question of the loss of traditional authority. Laughter is an important part of the book. Rabelais starts with a poem, ribald in nature, insisting that the work is an entertainment meant to amuse — and the work itself includes excessive scenes of laughter. But it is finally a laughter in response to an erudite poem and Latin phrases that show a more fluid link between traditional and nontraditional culture. In effect, the story is not finally the carnival body Bakhtin gives to us. Rather, it is at best a source for the creation of a myth which he, indeed, does weave out of Rabelais, but a myth other than what Rabelais intended.[50] (Bakhtin may

49. Francis Rabelais, *The Works of Mr. Francis Rabelais,* 2 vols. (London: Alexander Moring, Ltd., De La More Press, [1930s?]), trans. of 1653 edition, illustrations by W. Heath Robinson, vol. 1, chap. 57, pp. 162-64.

50. Katherine Clark and Michael Holquist argue in their work *Michail Bakhtin* (Cambridge: Harvard University Press, 1984) that Bakhtin's Rabelais is a response to the Soviet system and is created as a critical response to social realism. See also Michael Holquist, "Prologue," to Morson, ed., *Bakhtin,* pp. xiii-xxiii.

The architects of social realism saw folk culture as a source for understanding the proletariat. In fact, however, to the government, the body, sexual relations, and body functions from popular culture were taboo. Bakhtin, in lifting up the folk culture he saw in Rabelais, was dealing with the "folk" but with the part of their culture that was denied legitimacy by Soviet culture. Furthermore, Bakhtin found in the folk, as the Soviets had also sought, the force of constructive revolution, but again on close look the revolution they offered was quite contrary to Soviet belief, albeit at one with the ideal of communism. The official culture of Stalin had a parallel cycled through Rabelais: the closed, hierarchical, totalitarian medieval culture. The folk, through the popular culture of their festivals and carnivals, offered the true revolutionary vision of equality, unity, freedom.

Thus in a time of increasing regimentation, Bakhtin wrote of freedom. . . . At a time when literature was composed of mandated canons, he wrote of smashing all

have found in the visual arts works that better support his theoretical undertaking, such as those of Bosch and the Brueghels, elder and younger.)

Beyond the issue of Bakhtin's particular interpretation of Rabelais, however, is the more important contribution he made to the recovery of the festival and carnival as a primary source in treating the grotesque, and the contribution he made to seeing how the grotesque can serve a positive function in freeing people to experience what the conventional culture condemns.

Geoffrey Galt Harpham

A third major theorist of the grotesque is Geoffrey Galt Harpham. In his work *On the Grotesque: Strategies of Contradiction in Art and Literature* (1982), he draws on both Kayser's and Bakhtin's thought as well as that of earlier theorists including Kant, Hegel, Baudelaire, and Ruskin. His study is rich in the analysis of the visual arts, and his treatment of literary works, including Emily Brontë's *Wuthering Heights,* Poe's "The Masque of the Red Death," Mann's *Death in Venice,* and material from Conrad's writings, allows him to work out important points in his theoretical understanding of the grotesque.

Harpham is interested in defining the character of the grotesque, though he acknowledges that this task is not without pitfalls. The problem is captured in a comment he makes about Kayser's and Bakhtin's studies.

> Wolfgang Kayser's *The Grotesque in Art and Literature* and Mikhail Bakhtin's *Rabelais and His World* are deservedly considered the two most important [theoretical works on the grotesque]. Both are prodigiously well informed, carefully argued, persuasive accounts. And they manage to contradict each other utterly on the most basic premises. Authority is even more widely dispersed among the lesser lights, so that, in mastering the field, one watches it atomize into fine mist.[51]

norms and canons and ridiculed the pundits who upheld them. At a time when everyone was told to look "higher" and to deny the body and its dictates, he extolled the virtues of the everyday and advocated reveling in the basic functions of what he called the "lower bodily stratum." (Quoted in Berrong, p. 108)

51. Harpham, pp. xvii-xviii.

The problem is in part a lack of agreement on common features of the grotesque. Even ugliness, which many would consider at a minimum a common element, proves to be much more "a modern prejudice: the *grottesche* of the Renaissance was primarily intended to be simply beautiful." A beginning point, therefore, is to recognize that while "the grotesque has always been a given . . . it is up to the culture to provide the conventions and assumptions that determine its particular forms. Culture does this by establishing conditions of order and coherence, especially by specifying which categories are logically or generically incompatible with which others."[52] In effect, as culture experiences change, the elements of the grotesque change. This is an important point for this discussion's larger concerns because it accents the fact that the cultural context must be understood in order to understand the grotesque of a given culture.

Harpham identifies ways of approaching the grotesque which give coherence and order to the use of the concept. He observes, foremost, that the grotesque lies on the "margin." It has existed "for many centuries on the disorderly margins of Western culture and the aesthetic conventions that constitute culture." The margins may be confused in our own times when it appears that "the margina is indistinguishable from the typica," but it still maintains its locus as that which pulls the person to the boundary of human experience.[53]

There are several major premises with which he works that I want to lift up. The first relates to the perception of the grotesque form. He insists that grotesqueries can be recognized by the fact that they do not fit our standard categories of identification. They defy logical, physical, ontological categories that are used to make sense out of things:

> they stand at a margin of consciousness between the known and the unknown, the perceived and the unperceived, calling into question the adequacy of our ways of organizing the world, of dividing the continuum of experience into knowable parts. . . . As adjective, therefore, the grotesques have no consistent properties other than their own grotesqueness. . . . The word designates a condition of being just out of focus just beyond the reach of language. . . . it indicates that . . . portions of experience are eluding satisfactory verbal formulation.[54]

52. Harpham, p. xx.
53. Harpham, p. xx.
54. Harpham, p. 3.

It is a non-thing that doesn't fit our classification schemes for "real" things; it is ambivalent and anomalous in form. When we experience this non-thing we are affronted. It doesn't fit, and while we may begin to make it fit — we begin by classifying it as grotesque — its initial impact has been made.

Drawing on Baudelaire and Hugh Kenner, Harpham sees the grotesque as having a confused and incoherent energy and abundance — an extravagant, explosive, frenzied character. As such, it can be "fearsome or exuberant or both," and it inevitably inspires ambivalent emotional reactions.[55]

Harpham accents, as does Kayser, how the grotesque fuses that which otherwise does not belong in combination. Something is in something else, copresent with it, that should not be. Or in other cases it compresses things in time or size. The figure is old and wrinkled, young and smooth at the same time or, like Gargantua, disproportionate to the conventional world.[56]

A second major premise is that the grotesque "occupies a gap or interval." It lies between what has been and is becoming. It is known as part of a process. Drawing on Santayana, Harpham makes the point that "we can consider a given object either for its distortion of an ideal type or its 'universal possibility.'" If we encounter the first possibility "we enter a state of confusion," but if we take the second approach "we break through confusion to discovery," and the ludicrous may become the idea, the ugly the beautiful. It is the point in the encounter when we experience the distortion but are moving to new possibility that we exist in the "interval."[57]

He uses Thomas Kuhn's paradigm theory as an important point of reference. Kuhn holds that when a paradigm or theory breaks down in the face of data it cannot make sense of, there is a paradigm crisis — a time which will eventually be resolved by the emergence of a new paradigm that will adequately explain the anomalous reality at issue. "The paradigm crisis is the interval of the grotesque writ large."[58]

The process of experiencing the grotesque as interval is not easy. The

55. Harpham, p. 8.
56. Harpham, p. 11.
57. Harpham, pp. 14-18.
58. Harpham, p. 17.

person is led into it by the attraction of the "fragmented, jumbled, or corrupted" form. The experience may yield laughter and fantasy, fear and terror, the sense of absurdity, the encounter with the demonic. It is a moment of "the mind poised between death and rebirth, insanity and discovery, rubble and revelation." The person is also led out of it, for it generates the interpretative activity that seeks closure, either in the discovery of a novel form or in a metaphorical, analogical, or allegorical explanation. This view of the process parallels Kayser's approach in part, though the rational interpretative element is much stronger in Harpham.

Harpham's third premise is related to interpretation and deformation of the grotesque. The grotesque can be compared to paradox insofar as paradox turns

> language against itself by asserting both terms of a contradiction at once. Pursued for its own sake, paradox can seem vulgar or meaningless . . . pursued for the sake of wordless truth, it can rend veils and even, like the grotesque, approach the holy. Because it breaks the rules, paradox can penetrate to new and unexpected realms of experience discovering relationships syntax generally obscures. The sense of revelation accompanying a sudden enrichment of our symbolic repertory accounts for our experience of depth: it is very nearly synonymous with *profound.* But while we are in the paradox, before we have either dismissed it as meaningless or broken through to that wordless knowledge (which the namelessness of the grotesque image parodies), we are ourselves in "para" on the margin itself. To be in "para" then is a preludial condition which dissolves in the act of comprehension: like the grotesque, paradox is a sphinx who dies once its riddle is solved.[59]

Harpham's premises focus on the grotesque as a source of new insight, as revelatory of hidden truth. He takes seriously the revelatory character of the grotesque. Not all that is grotesque is of equal depth or significance in the meaning it expresses. But potentially it is an artwork pregnant with insight that may renew and free us whether through confusion, a wrestling with the demons, or joyful entrance into the sublime. It is "the interval of the grotesque that we must suffer through in the way to the discovery of a radical new insight."[60]

59. Harpham, pp. 19-20.
60. Harpham, p. 46.

In this analysis, Harpham returns to the origins of the grotesque in the West. He notes the discovery of the *grottesche* images in the excavation around 1480 of Nero's Domus Aurea and in the buried hallways' frescoes of the Roman painter Famulus.

The *grottesche* became an important style in Renaissance art once it raised questions about whether it was strictly decorative border — on the margins literally — or whether it contained meaning related to and often impinging on the center. Harpham writes: "all grotesque art threatens the notion of a center by implying coherence just out of reach, metaphors or analogies just beyond our grasp . . . [it] teaches us with intimations of 'deep' or 'profound' meanings. . . . Grotesqueries confront us as a corrupt or fragmented text in search of a master principle."[61]

The *grottesche* finally yields to the *grotesque* in Harpham's interpretation where the ornamental is related to the center and "synthesis itself [and] the reconciling of apparently incompatible elements, is the principle."[62] Grotesque is embodied in the act of transition ". . . of the margin swapping places with the center . . . in a transformation of duality into unity, of the meaning into the meaningful."[63]

To understand the grotesque as meaning-bearing, it is necessary to understand how the grotesque has mythical references and implications. From the moment of its appearance in Western culture, *grottesche* represented an invocation of "some other place of being," of a mythologized culture that had been lost. This is a crucial link in Harpham's theory, for he wishes to work with a primary assumption that "the grotesque consists of the manifest, visible, or unmediated presence of mythic or primitive elements in a non-mythic or modern context. It is a formula capable of nearly infinite variation . . . and illuminates the vast field of grotesqueries."[64]

In this proposition we live out of historical ways of thinking where logic and order through classification and metaphor function. Grotesque imagery links a mythic way of thinking in which metamorphosis is assumed — I can be both a horse and a person. This all rests on the principle of "cosmic continuum" in which "no realm of being visible or invisible,

61. Harpham, p. 43.
62. Harpham, p. 45.
63. Harpham, p. 47.
64. Harpham, p. 51.

past or present, is absolutely discontinuous with any other, but all equally accessible and mutually interdependent."[65] There is an echo of Bakhtin's notion of carnival with the awareness of one's participation in the community and cosmic body as well as the individual body. Indeed, Harpham draws on Lévi-Strauss's notion of the "law of participation" in which one takes on the identity of the other in certain cultures, though Harpham later uses the term "law of infinite metaphor" by which "everything is potentially identical with everything else."[66] He draws the conclusion that "at the margin of figurative metaphor and literal myth lies the grotesque, both and neither, a mingling and a unity."[67] The problem, of course, for the historical mind is that it avoids contradictions, it classifies, it orders, it discriminates, while myth fuses, places together "incompatible experiences, defies historical logic by ignoring it." The grotesque mediates between these two worlds.[68]

There are certain characteristics of myth and mythic thinking that are captured in its ability to make the divine unclean as well as pure. Christ is bloodied as well as transfigured. Or the common events of life: out of dung comes the creative force of regeneration. The historical mind attempts to distinguish and classify so that we know what is clean and unclean; the mythic mind crosses over these to conceive a unity. Here, too, the problem of death and life are caught up in the natural cycle in which life flows out of death. In Kayser's terms, they give to us an alienated world contrary to, yet linked to, our own.

Harpham introduces in his theory an important distinction not made in other twentieth-century theories: that a genuine affinity exists between the *grottesche* with earlier art from ancient and prehistorical grottoes or caves. In effect, the antecedents of our grotesque grotto-art are earlier forms of prehistoric cave drawings.[69] The earlier cave drawings are grotesque for Harpham because they reflect fusions of forms — animals with human parts and so on that carry mythlike meanings. The significance of his theoretical point is that of seeing the sweep of the grotesque transcending the Renaissance and its Roman antecedents — indeed, Western culture

65. Harpham, p. 53.
66. Harpham, p. 52.
67. Harpham, p. 53.
68. Harpham, p. 53.
69. Harpham, p. 65.

itself — and, in turn, seeing such non-Western forms as sources for understanding the character of the grotesque.

In developing the relationship of the grotesque to myth, he accents our mythic consciousness as "a permanent potentiality of the mind" that is "mostly suppressed, denied, or compromised" in our own day, yet is, nevertheless, "always vital."[70] It is through this consciousness that we are drawn into the grotesque, that we are attracted to it.

This mythic and unconscious awareness is called forth in our encounter with the grotesque. The grotesque impresses us with a remote sense that there is beyond the world in which we function a world that is "primary [or] prior" in which the grotesque elements may be "normative, meaningful, even sacred." It disturbs us because it gives credence to those thoughts, feelings, and ideas that there is "another kind of word," that which reveals our "word [to be] but one among many."[71] Those thoughts, feelings, and ideas call into question the values, theories, and paradigms by which we function in part because they cannot make sense out of the grotesque element and in part because they suggest to our mythic sensibilities that those elements have something of importance to reveal.

For Harpham, the heart of the matter is to see the grotesque as that which gives us a clue to our own situation in this world — a clue to the balance or lack of balance that is our lot, and insight into the world as a world of darkness and light, of corruption and renewal, of death and birth. Drawing on Auerbach's study *Mimesis,* Harpham notes that the classical world created a separation of the world through its styles: the sublime and elevated style and the low style — that which portrayed the state in its greatness and humanity in its nobility and that which portrayed ordinary life and the darker side of existence. The split created its own type of dualism and superior/inferior dichotomy that the grotesque turns upside down: "Grotesque is a word for that demonic state of low-as-ascending and high-descending."[72] People create systems of norms, of decorum, to protect against the threats of the low and the marginal, to keep them in their place whether they are political, cultural, or psychological in character. In so doing they tend to make themselves vulnerable to the "imps of the indeterminate," to ambivalence, to ambiguity, in life. This is the

70. Harpham, pp. 51ff., 66ff.
71. Harpham, p. 69.
72. Harpham, p. 74.

dilemma with which we are faced. It is in response to this that tyranny is born (excessive order) and revolutions occur (the search for a new order), and it is in the face of this dilemma that the grotesque appears warning us of our dilemma. Harpham observes that "One way to escape this dilemma is to develop a system of decorum with indeterminacy or ambivalence as the norm." Auerbach sees in Christianity such a system. He discovers a number of mutations of "the mingling of styles": in Rabelais' "promiscuous intermingling of the categories of event, experience and knowledge" which demonstrates the "vitalistic-dynamic triumph of the physical body and its functions"; in miracle plays in which the Passion and crude forces are directly juxtaposed; in the life of Saint Francis in Montaigne's fusion of "the concrete-sensory with the moral-intellectual."[73]

Where a world fails to combine the contrary elements, it invites the creation of the grotesque to call us to account and pull us onto its own ground. Once there it is possible to glimpse the darker side — Kayser's nightmare — or the vision of the new — the carnival joy of Bakhtin — and in so doing, know the possibility of liberation from and liberation to that which offers new insight into the way we are and the way we might be.

Harpham's interpretation is rich in theoretical insights and a valuable study for theological considerations of the grotesque. We will return to his ideas in our theological deliberations.

Ewa Kuryluk

The fourth writer is Ewa Kuryluk. She spells out her theory of the grotesque in *Salome and Judas in the Cave of Sex*. Her theory is less comprehensive than that of the other three figures, but she adds to our overall considerations important insights that extend the discussion in new directions. In her work she acknowledges her indebtedness to both Wolfgang Kayser and Mikhail Bakhtin, but identifies the world to which the grotesque speaks in different terms. She notes that both writers are correct in saying that the grotesque is "about a world standing on its head," but that "the German scholar limits his view to a mental asylum, a theatre stage, and a dream, and the Russian scholar confines his to the boundaries of carnivalistic monstrosities." These are important "anti-worlds" for her,

73. Harpham, p. 74.

but they are not encompassing of all that should be considered grotesque. As she writes:

> I accept the validity of the anti-worlds but add further ones: the anti-worlds of femininity as opposed to the world controlled by men; the anti-world of childhood as contradicted by the world governed by adults; the anti-world of the hidden, forbidden, apocryphal and heretical as different from the universe of the established and sanctioned, canonical and orthodox; the anti-world of Satan, hell, paganism, and damnation as distinct from the world of Jesus, heaven, Christianity, and salvation; the anti-world of sin, flesh, and death as divided from the cosmos of virtue, spirit, and eternal life; the anti-world of darkness and corruption, down below and to the left, as distinct from the world of light and purity, high up and to the right; the anti-world of apocalypse, war, and disintegration as contrary to the world of peace, order, and togetherness.[74]

For Kuryluk the grotesque treats foremost the erotic and heretical, the apocryphal and sacrilegious. She identifies the beginning of the grotesque's historical period with the Renaissance discoveries during the Roman excavations and ends it with the nineteenth century. During this period the grotesque reflects the anti-worlds of a "sub-culture that emerged at the end of the Renaissance and functioned in opposition to the official culture until the beginning of the twentieth century."[75] The official culture of which she speaks is the dominant culture of Christianity, the state, and that culture's primary beliefs and values. The subculture was made up of those groups and movements that were "against the canons of religion and the laws of the state, against academic art and sanctioned sexuality, against virtue and holiness, against established institutions, ceremonies, and officially celebrated history."[76] The works themselves, while influenced by antiquity and the Middle Ages, have their real significance in the sixteenth through the nineteenth centuries in the forms that reflect the era's subculture.

To appreciate Kuryluk's thesis, it is important to accent her view of the grotesque as reflective of a specific subculture over and against the

74. Kuryluk, p. 3.
75. Kuryluk, p. 4.
76. Kuryluk, p. 317.

dominant culture. It is not simply the use of distortions in art or fusing of contradictory parts or carnival excess that constitutes the grotesque. Rather, it is a specific form of portrayal, one that uses stylistic distortions and irrational combinations to contradict the norms of the controlling culture — norms such as those defined by Christian doctrine, the national piety of a society, a classical aesthetic, or a particular view of gender.

It is also crucial to recognize her periodization of the grotesque within her four centuries' time frame. In her analysis she recognizes that there were other periods when grotesque-type imagery was common, but there is no evidence that these works were actually interpreted by their contemporary viewers as grotesque. Examples can be drawn from antiquity and the world of classical mythology. Certainly the medieval era, when a flourishing of primary imagery existed is one crucial period. Indeed, the medieval material provides one tradition which, when joined with the tradition of the Roman grotto paintings, creates what is then called grotesque in the Renaissance and later. Kuryluk uses the term "fantastic" when analyzing medieval forms either from the actual period or as they are presented as primary features in the grotesque. But the grotesque and its subculture of anti-worlds has a fixed period of time that began after the medieval era and ends before the twentieth century.

The body of Kuryluk's study focuses on Aubrey Beardsley's use of the grotesque, but the part of her analysis that is of greatest concern in this study is the theoretical framework she creates for the study of the grotesque. She identifies the themes of death, the body, the anatomical theater, religion, sexuality, exotic travel, and the image of the cave as significant areas of exploration in understanding the grotesque. At points her themes are those of Kayser and Bakhtin; but more importantly, she adds to and elaborates the subject of the female as it is portrayed in the grotesque. While she examines the treatment of women most thoroughly in Beardsley, her overall treatment is one of accenting the way the female body and, more broadly, the erotic are central elements throughout the history of the grotesque. They are the means again and again by which the norms of church, state, and cultural values are satirized, ridiculed, or portrayed in exaggerated form.[77]

Reservations can be raised regarding her theory. Her periodization of the grotesque remains arbitrarily determined by her delineation of when

77. Kuryluk, p. 316.

dominant Western culture reigns and when it breaks down. She, in effect, controls how we shall understand the grotesque by making it that which expresses the particular anti-worlds she delineates vis-à-vis the ruling culture. Not unlike Bakhtin and to some extent Kayser, she brings to the grotesque a set of theoretical presuppositions that are used in determining and defining its character. Her theory, however, also invites us to ground the grotesque within a historical context so that it is seen as part of a community and is, finally, understood in reference to a particular culture's norms and experiences of alienation, and oppression.

These four theorists are representative of the theoretical work on the grotesque that is now going on. They more than any other single group have defined the character of the discussion and highlighted the questions we must attend to. The issue of definition, the problem of historical periodization, the importance of cultural context, and the power of the grotesque to reveal the margins or boundaries or forms alien to conventional life are all worked with. The extent to which our encounter with the grotesque is an encounter with a destructive force or transformative power or both and the capacity of the grotesque to bear meaning, to reveal insight, into our own historical situation are explored. In sum, these writers' theories give us common ground for understanding the grotesque even while they draw contradictory conclusions at crucial points in their interpretations. The theological treatment that follows draws on these theories in offering its own theological understanding of the grotesque.

II: THEOLOGICAL INTERPRETATION OF THE GROTESQUE

Images of the grotesque in the history of art have always drawn heavily on religious iconography. Perturcchio, Michelangelo, Signorelli, and Raphael worked directly with the newfound grotesques of the Roman caves, and works of Bosch and Brueghel were soon identified as grotesque. The medieval period provided one of the richest troves of grotesquerie in drawings, architectural detail, and carvings such as misericords and corbels, bosses and gargoyles, and the unfolding periods of the Renaissance and the Baroque further endowed the body of images. Medieval festivals and carnivals were an equally important source — masks, costumes, games,

and festival themes often became subjects for painting and literature, as in the works of Brueghel and Rabelais. The Romantic period introduced its own burgeoning imagery in its often dark, neogothic style, and the grotesque's tradition has continued down to the present with religious iconography remaining a major source for twentieth-century painters and writers.

Theological interest in the grotesque, therefore, naturally enters the discussion, given the extensive use of religious iconography in creating it. But our interest is also broader, for we are concerned with the content of the grotesque and the power it has by virtue of its imagistic form and symbolic character, whether it is expressed through explicit religious iconography or not.

Drawing on the definition set forth at the beginning of this essay, I want to develop a view of the nature and function of the grotesque.

Nature and Function

The grotesque is and is not of this world. The grotesque forms of Bosch or Francis Bacon, Rabelais or Toni Morrison are forms rooted in our common world, enough so that we can see in them that which they distort, while in their otherness they suggest a different world altogether. They are part of our "familiar world" — though transformed in images difficult to decipher, images that are foreign.

The grotesque refers to aspects of human experience that we have *denied* validity to, that we have rejected, excoriated, attempted to eliminate and image as a distorted aspect of reality. Because this reality belongs to our world, it cannot be destroyed. But it can be relegated to the underground. It can be literally and metaphorically hidden in the subterranean, in the cavernous world of our experience.

The reality the grotesque points to may be identified in a number of ways. Grotesque imagery may point to the denial of our own mythic consciousness and the need to recognize the power and validity of mythic insight, about which Geoffrey Harpham writes; or the demonic in human experience that Wolfgang Kayser speaks of; or the oppression we have imposed on social groups as Ewa Kuryluk insists; or the human body and its ideal relationship to nature and the larger communal body that Mikhail Bakhtin spells out; or the repression of psychic and emotional forces that

Arthur Clayborough alludes to; or the denial of a classical world and its rational ordering of things as Vitruvius indicated at the time the first Roman grotesque forms were uncovered. But whatever we identify as the underlying subject of the grotesque, it will inevitably be about some aspect of life that does not fit, that conflicts with the world as defined by our cultural norms, decorum, and values, by our acceptable ways of being. It will be about that which violates some aspect of the religious, moral, social, or natural world we have constructed and legitimated. In our denial of these aspects of reality, we have relegated them to the edge of our common experience, even though they are about something related to the core of our experience. We have banished the grotesque to the underground of our consciousness, though it remains related to our conscious world. Harpham speaks of the grotesque as on the margin but having to do with the center. We can equally speak of Tillich's image of the boundary. The grotesque exists on the boundary of human experience, removed from the center. It confronts us with questions about the nature and character of the world and the center that has exiled it. It poses the "boundary questions" about the world where we live.[78]

On the margin or boundary of experience, expressions of reality appear to us in grotesque form. They do not "fit" the world that has excluded them, but in their grotesqueness they do become a metamorphosis of it. They are our children, our cast-outs now returned not as prodigals but as monstrosities; and the artist is the midwife that brings them forth. They are children of strangeness that frighten, confuse, defy. They are not welcome. They have violated the way we have ordered and rationalized our world, and they continue to violate what we deem rational, good, appropriate. But, still, they are our children even as they return in masks, and in mockery, in defiance to disrupt our well-being.

The grotesque image in the poem, the story, or the painting reveals its reality at two levels. The work expresses that reality through its own *formal structure* and through its *iconography*, sometimes in sharp caricature, sometimes in amorphous form. In effect, it *literally* reveals in its formal imaging of composition and subject matter, in its exaggerated, comical, frightening, often inexplicable presentation, the reality of grotesqueness.

78. Paul Tillich, *The Religious Situation* (New York: Henry Holt, 1932). See James Luther Adams's discussion of the boundary concept in James Luther Adams, *Paul Tillich's Philosophy of Culture, Science, and Religion* (New York: Harper and Row, 1965), chap. 2.

It also *symbolically* reveals that which exists on the boundary as distorted reality. These two dimensions of the work are not incongruent or independent of one another. The literal experience of the grotesque as distorted form is symbolic of a reality that is itself distorted and deformed. The image as image speaks of the grotesque on its own terms, but it also can function as symbol that points beyond itself.

When, then, we treat the *grottesche* of the ornamental borders in the Roman grottoes and later Renaissance works, we are dealing both with an image of a wild natural world that literally confronts us as contradiction, fusion, or deformation, and with an image of nature contrary to the principles of both the art and culture of the classical world. It becomes a symbol of a different way of ordering reality, a way that may be considered threatening, disordered, and violating in its offer of a new expression of beauty or ugliness.

When we deal with Sequeiros' *Echo of a Scream,* with the horrifying scream of the infant emerging out of the mechanical rubble on a battlefield, we are dealing with a grotesque image of a human head fused to broken pieces of steel that shocks and disorients us at an immediate level of encounter on its own formal and compositional terms, but also engages us symbolically in the devastatingly brutal effect of war on innocent life.

This dual aspect of the grotesque is particularly important to us, for much writing on the subject has accented the literal level of grotesqueness without exploring as fully as it should its symbolic character. Theologically the symbolic dimension of the grotesque image is of great importance, for we are concerned with the religious and moral conditions or possibilities it points to through its imagistic form.

To elaborate on this matter, I want to treat its mythic character and the power it has to engage our own mythic consciousness. Ernst Cassirer has distinguished two forms of language: discursive and mythic.[79] Discursive language is the language of objective description, of science; mythic language is the evocative language of poetry and religion. The grotesque image is a primary example of a reality that speaks through a mythic "language" — that draws on image, metaphor, and narrative in such a way that it evokes ideas, feelings, and intuitions in an encompassing way. This is important to this discussion because mythic language is the language or

79. Ernst Cassirer, *Language and Myth,* trans. Susanne K. Langer (New York: Harper and Brothers, 1946), chap. 3.

Fig. 1.5. David Alfaro Sequeiros, *Echo of a Scream*, 1937

imagery that embodies symbolic ideas, and the grotesque in its use of mythic language becomes a symbolic form of reality. As such a symbol, the grotesque engages us in participating in that to which it points. If it points to a manifestation of evil, we can experience that evil. If it points to an experience of ecstasy, we can experience something of that ecstasy. We enter another world of experience and for the moment live within its meaning. If the grotesque image is monstrous or horrifying, we know that horror and its meaning in the moment of participation. The grotesque, then, is given to us by the artist, composer, or writer in a mythic form of language and image. It may point to that which is trite or that which has depth. Insofar as the latter prevails, we are dealing with matters related to ultimate meaning and purpose, with matters regarding the sacred and the profane, birth and death, good and evil, order and chaos, with matters of religious import.

Harpham speaks of the mythic character of the grotesque and its capacity to enliven at some level our mythic consciousness that links us to our archaic past as a human race. In this process we are drawn into a world of primary experience beneath the layers of rationality to the level of mythic reality. Using Rabelais, Bakhtin creates a myth of the medieval carnival that he uses to pull us into understandings of good and evil, authority and heresy, birth and death — all the core subjects of myths from the earliest times of human history. So it is generally with the grotesque. It engages our mythic sensibilities.

In the present age, many tend to explain away myth with the tools of technical reason and scientific investigation; to demythologize without an appreciation for the need to remythologize. As a consequence, our "mythic consciousness" is less trusted and our suspicion of mythic form and reality, even as we unknowingly depend on them, becomes very great. But myth and mythic language are still crucial to human existence both personally and socially, for they form a necessary lens for seeing the underlying truths of reality. Freud, probing into the depths of certain fundamental human experiences, was pushed back to myths such as Oedipus and Electra. Equally, Marx's idea of a classless society finally took on powerful significance as it took on mythic proportions. The grotesque expresses a mythic language and mythic exaggerations and proportions in its own form. It does not provide us a descriptive map of anything. It provides a set of evocative images through picture and word, sound and movement, that pull us, through its own symbolic power, into a world

where mythos reigns, into a world where eros and thanatos, chaos and order, good and evil, the exalted and the lowly, fulfillment and redemption, the sacred and the profane are juxtaposed, caricatured, satirized in fusions of new creation. It takes us into a realm where neither reason nor reasonableness rules, where vulnerability and ambiguity exist, where fears are triggered and uncertainty looms. In so doing, it uses mythic elements to thwart our common tools for explaining things. It disorients us, as Kayser observes, by presenting an alien world that baffles and threatens, but, in the process, it provides a world that engages us in the very treatment of its subject — the demonic, the sacred, suffering, death — with mythic reality that relates us to the primal experiences of life.

Goya's *Saturn* provides us a work rich in symbolic and mythic power. Goya draws specifically from the mythological story in which Saturn has been told that he will be replaced by one of his sons. Saturn responds by destroying them. (This is much different from Rubens's *Saturn*, which Goya had seen. In Rubens's work, painted for a hunting lodge, we have a relatively fanciful, sensual scene that demands little response to the actual myth's meaning.) In this work the diabolical Saturn, gargantuan in proportion, consumes his child, lilliputian in size, in a voracious consumption of the child's body. As a literal image it violates us by portraying human form in monstrous caricature in an act of viciousness foreign to our world of self-perception. But as we move more deeply into the life of the work, much more emerges. The symbol points to the reality of the action's savagery and to our capacity to embody it; to the deeply embedded father/son threat and antagonism that is concerned with worth, power, autonomy, control. It points to our capacity as human beings to destroy that which challenges our power, denies our immortality, questions our will to control. The mythic Saturn (or Chronos in the earlier Greek myth) is about a brutal, unleashed destructive force, the demonic incarnate within us. The experience, however, can also bring us to a place of new insight and response. Kayser sees the grotesque invoking the demonic, which we then attempt to subdue. This interpretation, however, suggests a limited and finally negative response to the possible outcome of the encounter, for to subdue the demonic is finally to engage in a struggle to defeat and cast again into the chambers of the cave that which violates. But there is more than subduing; there is accepting the capacity for demonic destruction that Goya's work points to. Goya brings the reality — our capacity for evil — out of the cave into the light that we might, paradoxically, be

Fig. 1.6. Francisco Goya,
*Saturn Devouring One of
His Sons,* 1820-23

able to confront and control the demons that rummage in our souls. We claim them and in the claiming experience freedom from their power to finally imprison us.

The grotesque moves us to the boundary and, if we do not flee, points us to that world of mythos. It places us on religious ground, moving us to the religious myths that carry insights about the nature of human existence; about its foibles and follies, its goodness and its evil; about its

forms of oppression and liberation, estrangement and wholeness. It is not insignificant that Freud relied more and more on myth to treat his subject as he attempted to interpret it for his own time. Or that Bakhtin finally presses back beyond either Rabelais or the medieval carnival to the creation of a carnival myth to reveal what the grotesque has to tell us. It is not insignificant that much of the grotesque has itself used iconography that relates to explicit religious myths.

When the grotesque is looked at from the perspective of theology, from the perspective of the Christian mythos, two questions emerge. First, does the grotesque take on a different meaning for one who creates and looks at it from within a faith stance and from within a world already well-formed by its own mythos? And secondly: what does the grotesque have to say to us about basic Christian perspectives such as the nature of creation, the human condition, the possibility of transformed life?

The Grotesque and the Role of Faith

In defining the relationship of faith to the grotesque, the key is to appreciate that the lenses of our particular faith stance affect our interpretation of the grotesque and, in turn, our attempt to understand what the grotesque says to us about the nature of the human condition, the character of the religious life, and our understanding of God.

Foremost, the perspective of faith sets the grotesque within a larger frame of belief. As foreign as the images are, they still speak to us about matters of human sin, judgment, and transformation within the larger context of Christian faith. Indeed, the horrifying character they take can itself speak both to and out of the context of the church. James Luther Adams, writing about Bosch as a Christian artist painting for the church, observes that

> Bosch could depict the full range of the grotesque precisely because he believed implicitly in God's power to overcome any evil, any horror, any monstrous condition; and likewise, he believed in God's power to deliver all people into an ideal utopia. In this framework, the more imaginatively Bosch was able to represent the grotesque and the demonic, the greater enhanced was the glory of God. That's the thinking behind the inclusion of such works by Bosch for use as altar pieces; and

very likely herein lies the reason contemporary expression of the grotesque is "flat" without "faith," artists are afraid to challenge directly the chaotic abyss.[80]

Goya's use of the grotesque also reveals works done by one inside an understanding of faith. His grotesque satirization of the church and its clerics in his series "The Disasters of War" ridicules the subjects, who appear both comical and monstrous. But the treatment of the subject remains that of one within the church who condemns the church's hierarchy, priests, and monks for their hypocrisies and oppression, for their failure to be compassionate protectors of the poor and those who suffer, which they are called to be.

One of the most powerful expressions of how a religious understanding can affect the interpretation of the grotesque is shown in a passage of Montaigne that Harpham uses in his study. Montaigne, who worked with the grotesque in his own writing, is writing about a child born greatly deformed.

> What we call monsters are not so to God, who sees in the immensity of his work the infinity of forms that he has comprised in it; and it is for us to believe that this figure that astonishes us is related and linked to some other figure of the same kind unknown to man. From his infinite wisdom there proceeds nothing but what is good and ordinary and regular; but we do not see its arrangement and relationship.[81]

Harpham's response to the passage is particularly insightful: he comments on both the significance of Montaigne's faith in his interpretation of the grotesque and the way in which the grotesque, while on the border of human experience, is nevertheless that which makes sense out of and is, finally, the center.

> Montaigne's sympathy to pied beauty doesn't compromise the center, but strengthens it, for it admits everything as a possible center, and admits that the true center is beyond our grasp. Faith in "God" is a faith in the hidden order of apparently disorderly things, the hidden

80. James Luther Adams, "Notes on Eschatology and the Grotesque," unpublished manuscript, p. 1. See also James Luther Adams, "The Grotesque and Our Future," chap. 2 in this volume.

81. Harpham, p. 76.

meaning of the apparently meaningless. For Montaigne, there was no true grotesque, because no absolute incongruity. And this is the final paradox: really to understand the grotesque is to cease to regard it as grotesque. Or as Coleridge says in the final line of "This Lime Tree Bower My Prison": "No sound is dissonant which tells of Life."[82]

In these examples, I do not wish to suggest that because one stands within a particular faith perspective the grotesque loses its edge. Quite the contrary is true. Both the artist and the viewer, precisely because of their own faith, are more able to see the truly monstrous and sublime reality with which the grotesque has truck. Indeed, I would propose that the more mature the faith, the more one can look into the abyss in all its horror, can take in the threat of nonbeing with all its sense of finality, can explore that which calls into question the most fundamental ways in which we view reality *precisely* because the forces the grotesque unleashes are not unknown but are the furies with which we have wrestled before and know are not themselves final or absolute in power or meaning. Artists may well be "afraid to challenge directly the chaotic abyss" because they have no larger religious framework within which to decipher its meaning. But human fear, suffering, evil, bafflement are no less real when the Christian engages them than when the non-Christian does.

What, then, of the grotesque and the way it engages the religious dimension of existence and a Christian understanding of life?

Theological Interpretation

It is important to recognize that not all grotesque art since the Roman images has religious significance. The early art of the Roman palaces most likely intrigued, delighted, or shocked its viewers without direct religious connotations. Eighteenth-century France produced clever, intriguing, and on occasion shocking works, but seldom were they religiously or morally demanding. The nineteenth-century images from Romanticism often had more to do with the melodramatic than the religious. Victorian imitations of gothic images were never too far from a domesticated world of playful imitation. The grotesque art that concerns us here, however, engages us

82. Harpham, p. 76.

in matters of ultimate meaning that pose religious questions and offer religious affirmations — that press us to the boundary where we might, paradoxically, confront the true nature of the center.

It is also important to recognize that there are works that are grotesque *in toto,* and works that use the grotesque as elements in what otherwise is a larger composition. Our interest remains the same for either presentation: the religious implications and meaning of the grotesque image.

Some works of the grotesque speak more powerfully to one aspect of the religious life than others. Traditionally the grotesque has been identified most powerfully with the underside of life — to the reality and power of the demonic, of evil, of death. Grotesque images, however, can also speak to matters of transformation and new life, as we have indicated earlier, as well as matters related to order, chaos, mystery, and creation. James Luther Adams treats the grotesque as that which speaks to all the major archetypal myths of Christianity, and they to the meaning of the grotesque. He writes in response to the question, What are we to do when faced with the absurd and chaotic in history? that the three overarching Christian myths become crucial sources in giving shape to our response:

> The myth of creation that maintains that God overcame the chaos originally by giving it form.
>
> The myth of the fall that represents humanity's fall *into* life, *into* consciousness from the undifferentiated state; humanity's fall from innocence into conscious awareness and participation in the human ambiguities of good and evil.
>
> The myth of redemption that asserts God will overcome the chaos a second time by reaching down to pluck the human being from the mire of human evil and suffering and "deliver the person from evil."[83]

The grotesque poses to us questions of ultimate meaning that are the subjects of Christian myth and theology. To explore the interplay of the grotesque and the religious, I want to examine the grotesque and its significance in light of these three myths.

83. Adams, "Eschatology and the Grotesque," p. 2.

Creation: Chaos and Order

Adams observes that in the myth of creation "God overcame the chaos . . . by giving it form." The grotesque is both creation and chaos. It is form that paradoxically encounters us as chaos. How then do we proceed to understand the grotesque in relationship to creation? Kayser speaks of the artist creating the grotesque out of dreams: *sogni dei pittori.* Imagination bears fruit: in the depths, in the dreams, in the cave, in the darkness of the artist's consciousness, the image of the grotesque takes form and we, its perceivers, behold it through the uneven light that our imagination allows. Whatever the sources of the artist's images in the interplay of the unconscious, dreams, fantasy, historical moment, the work is given: creation occurs. But the work of creation appears to us as chaos. The ontological structure of reality, the psychic ordering of life, the social organization of our world, the cultural and religious definition of the way life is and ought to be — the fundamental "forms" that serve as paradigms through which we make sense of reality — are threatened. The grotesque appears as "anomaly" that calls our paradigm into question.

Three aspects of this paradox are important in weighing its impact upon us: *bafflement, mystery,* and *creativity.* Each gives witness to the limits and possibilities of our finitude and our relationship to creation.

Bafflement

One of the major human problems religion speaks to is the experience of bafflement — bafflement about the nature of the world and our life and identity within it. In response to this experience, we construct and live out of worldviews, theologies, cosmologies in the hope that we will see the truth of the matter. We seek to create, by all the theories and methods at our disposal, an adequate explanation of reality, if not an eschatological time when "all will be made clear." The grotesque, however, offers that which is inexplicable, that which denies and turns upside down the propositions of our worldview and moral codes. It does so with images that call forth through their mythic power the sudden and unexpected sense of bafflement, of not knowing — indeed, of not even knowing how to start to know. There is the sudden introduction of chaos into our familiar and relatively knowable world. (Kayser writes of how suddenness and

surprise are a powerful aspect of our encounter with the grotesque. Nowhere is this more true than in the experience of bafflement.)

We are once again cast in the role of a Lilliputian with the cosmos its own Gargantua laughing at our presumption. Our response to its suddenness and surprising impact is often flight or repression or rationalization, all distancing the experience from immediate experience. But we may also respond by allowing ourselves to move into the experience and see beyond that which threatens to that which is revealed.

One aspect of the experience is recognition of the finite nature of all human creation, including our theories for understanding reality. The grotesque confronts us with such finitude precisely because the ideas, values, theories, logic with which we function in the world cannot appropriate the imagery in a way that makes sense out of the world it offers. We see the limits of our own creations. We see the limits of our own insights. We confront our peculiarly human problem that while we see, we see through a glass darkly; while we have the truth, we have it only partially. The grotesque, in suggesting that there is a world we cannot comprehend, indicates the limitation of our ways of perceiving, and *via negativa* laughs at our determination to enter the mind of God. In this process, however, it prepares us to recognize that God is beyond our creation. It prepares us to open ourselves to the holy, to the experience of the numinous in which our finitude is rooted and in light of which our finite world can be made sense of. Carl Skrade speaks to this in his study *God and the Grotesque:*

> The grotesque attests not only our experience of being agitated but also confirms that this experience is ours, present and now. . . . The grotesque attests the *viva vox,* the living voice, speaking in spite of our flights and our reasons. The God who is the ground of our being agitated is the God in time whose eternity is not the chronological timelessness of the cosmological or teleological arguments or the eternity of infinite primordial temporality. Rather, (God's) eternity is the "before" of the psalmist's "Before the mountains were brought forth, or ever thou hadst formed the earth and the world, from everlasting to everlasting thou art God" (Ps. 90:2). This before is that of creator before creature which is known not in a conceptual analysis of chronological time but in the harsh experience of the impossibility, the foolishness both of my flight from death and my necessary truths of reason.[84]

84. Carl Skrade, *God and the Grotesque* (Philadelphia: Westminster, 1974), p. 153.

Mystery

A second aspect of the encounter with the grotesque in light of creation is its indication of mystery in the world. The laughter of God is laughter over the assumption we make that mystery can be answered by acquiring new knowledge rather than seeing mystery as intrinsic to all of our knowledge. Again, Carl Skrade writes of this:

> Over against this dominance of death, beyond our ability to manipulate and manage there stands even today — especially today — the non-rational experience of the *mysterium tremendum et fascinans,* the more-than-rational experience of that which shakes and fascinates beyond our ability to pinpoint and analyze and define and control the source. The reality of this experience is attested in the extremities of our rationalism by the grotesque in the arts and literature of our age, an age in which this genre flourishes. A theology that is rooted in anthropology can not avoid attempting to come to grips with the grotesque.[85]

Roger Hazelton treats the question of mystery in his essay "The Grotesque, Theologically Considered" by acknowledging how both the grotesque and theology are concerned with the question of mystery about human nature. He writes: "The grotesque is an 'appropriately odd' disclosure of . . . mystery, benign or forbidding with which theology is necessarily concerned," and then he continues:

> The notion of mystery involved here ought to be made as clear as possible — a paradoxical assignment if there ever was one. It is not merely a name for residual ignorance which will be dispelled when science gets around to it. Nor can it be equated simply with what is unknown or unknowable, though experience of non-knowing often alerts us to the presence of what is mysterious. A secular culture wants, of course, to minimize if not to neutralize the horizon of mystery in human life and so tends to regard it as threatening but surmountable. Theology and grotesque art, on the other hand, find a certain affinity in the common persuasion that mystery is a real and radical feature of our existing in the world, not reducible to technical management, and so compelling quite different kinds of human acknowledgement. Gabriel Marcel's view of *mystery* as contrasted with *problem* is familiar; the gist

85. Skrade, p. 141.

of his thought is that in experiencing mystery the distinction between subject and object, what I am and what confronts me, breaks down. Hence there is no objective, problematic standpoint from which I can view such questions as those concerning freedom, destiny, evil, or God. Here I am inseparable from what I am asking. I have become in Augustine's words a question to myself.[86]

It is this sense of mystery that the grotesque reveals. The sense of mystery we encounter is not the impact of an unresolved problem that is a mystery only until we solve it. It is a sense of mystery that cannot finally be answered because it is itself a part of the nature of reality — a dimension of creation. The grotesque serves to remind us of this reality.

Creativity

There is a third aspect of the grotesque's implication for understanding creation, and that is the possibility it holds for human creativity. We are self-transcending creatures who in the freedom of our self-transcendence are able to create the new. Paradoxically, the grotesque, while pointing to the limits of our creation, gives witness to our power to create new images and configurations that can mediate new understandings of the center, or, indeed, the creation of a new center. It gives witness to the human capacity to create that which can break in on what is and provides clues for a new way of thinking and being. It becomes, therefore, a means through which we can see and respond to the world differently.

In this process the grotesque not only speaks to us about the power of the artist to create but of our own power to engage in the process of creation. We encounter the grotesque image, we stop, we pull back, we participate in an act of creating our own response; in the act of creating, we become the creator.

86. Roger Hazelton, "The Grotesque, Theologically Considered," chap. 3 of this volume. See also Kayser, p. 188.

Myth of the Fallenness of Life

If works of the grotesque can engage us in such a way that bafflement, mystery, possibility are all experienced, they can also evoke a sense of the fallen character of human existence. The fusion of organic and inorganic parts, the distortion of natural forms, and the exaggeration of fundamental aspects of life such as birth, sex, death, scatological processes, aging, size, and gender not only surprise and baffle us, they call forth a mixture of feelings, often contradictory, of fear, dread, and repulsion, of fascination, amusement, and derision that speak to us about the darker side of human nature.

In the myth of the fall we are perceived to be creatures who have fallen from our essential state of perfection into a state of finite existence with all of its existential ambiguities and vulnerabilities, anxieties and propensities for human evil. Yet we are also children of God, creatures who participate in the goodness of God and know that goodness. In the myth of the fallen angel, Lucifer, created good, "falls" from his goodness, becoming a distorted and deformed embodiment of his former self, becoming the embodiment of evil. In this myth evil is identified as distorted good. It is not a separate force in opposition to the good, but a corruption of the good that denies the human being's true and essential nature.

In our fallenness we are separated from God, from each other; we are broken and alienated, though still the children of goodness who can know and do the good. We are unable to accept ourselves as we have been created, seeking to become more than we can become or to be less than we are called to be. The litany is well known: we deny and distort our own power, knowledge, and virtue, claiming for them an absoluteness; we deny our own mortality and death as the finite boundaries of our existence; we distort the goodness of our sexuality, subjecting it to guilt and shame, violence and repression; we deny the unity of creation and fall into alienating dualisms of body and spirit, male and female, the individual and community; we deny the ambiguities of life, seeking a way of being that is controlled and perfect. We twist the fabric of our existence, justifying the violation and alienation we visit upon ourselves and others.

The language that names and describes human evil is also the language used to describe forms of the grotesque. Grotesque images distort, exaggerate, and present to us a world that is twisted and broken. They trigger in us a sense of the violation of the way the natural or human

Fig. 1.7. James Ensor, *Masks Confronting Death*, 1888

image is meant to be. They may be bizarre images with comical combinations of parts, they may caricature dignified human activities. They may simply be distortions that are inexplicably disturbing. But we experience them and, in the moment of encounter, know the strangeness of the world we have entered. We may in that encounter seek to deny them further entry into our consciousness, for they appear as harbingers of threat that we respond to with a sense of dread. If we allow ourselves to participate in their life, we enter a world that is foreign because it is a world we have denied. It is a world that mirrors the evil we do but rationalize, the evil we participate in but justify.

In entering this world, we experience violation of the world as we have constructed it. Grotesque imagery turns our world upside down just as in our own human sinfulness we turn our world upside down by covering our evil with the patina of piety and self-righteousness. The

grotesque takes us to the boundary of the world as we have created it, for the center we have created we have deemed righteous and the face of evil we have hidden. But in entering this world, the unmasking begins. For as we dwell with the grotesque of Sequieros' screaming child, we see the hidden face of human evil emerge. We see that the face of the grotesque is not so bizarre, so alien to our experience as we had thought in our first encounter, for the face of the grotesque is about the way we are. The grotesque reveals now not the boundary but the center, for the truth the boundary reveals is the truth of the center which is the truth of our own human sinfulness. In James Ensor's *Masks Confronting Death* we have rows of figures all in death masks. There is the image of the bizarre, unreal, yet frightening and monstrous. Sinister and cruel, they speak of all that we would deny. The dread comes not, finally, from the distortions of the masks. The dread comes from the inner awareness that the masks image our own fallenness that will be revealed when they are removed.

The subjects of the grotesque are many. The ones that speak to our fallenness treat areas of life where we are particularly anxious and in our anxiety subject to human denial and distortion of the good. They are images that treat mortality and death, bodily processes, sexual behavior, fecundity and birth, war and violence, distortions and denials of natural and human form — the fusion of a man's head on a mechanical body or a goat's head on a woman's body or breasts and vagina in place of eyes and mouth — the satirically brutal yet comical caricaturing of age, sex, race, status, nationality. These images confront us with the face of the demonic in our life and world. Roger Hazelton has written that "the images of the demonic are usually given a grotesque form because they express intrusions, and unwelcome ones at that, into what seems the normal orderly pattern of life. Only what is ludicrous, outlandish, or at least bizarre can do the trick." And so it is that the grotesque takes us into "the dark and eruptive" world of what Saint Paul called the powers and principalities.

In this encounter with the grotesque we can experience its prophetic powers, for it can judge the human community in its peculiar treatment of the demonic. Henry Moore's *Warrior* suggests a sympathetic portrayal of a sacrificial warrior but moves us quickly to a sense of horror as the figure — his limbs as stubs, his shield rendered useless, his primitive mask-like head slit in an expression of anguish — waits for the violent slash of

Fig. 1.8. Henry Moore, *Warrior with Shield*, 1953-54

the opponent's sword. All the brutality of war, the ambiguities of sacrifice, and the horror and pity of utter helplessness in the face of violence scream from the work. The judgment upon the human house of destruction is sweeping: the divine No is spoken.

Redemption and Transformation

If the grotesque confronts us with the face of evil, it can also engage us in the process of redemption. If it speaks of our fallenness, it plays its own role in saving us from the brokenness of our world. I have spoken earlier of how theories vary on the extent to which the grotesque offers a positive consequence in life, ranging from Kayser's more pessimistic view to Harpham's more positive one to the particular "eschatological" vision that Bakhtin sets forth. Within the context of Christian theology, I want to suggest that the grotesque can participate in human life in a transformative fashion, even though the nature of transformation may vary markedly in extent and insight. Certainly all of the theorists we have treated see in the grotesque a positive effect upon the one who truly engages it. I wish to perceive the nature of its role in redemption and transformation in terms of: *struggle and liberation; suffering and grace; vision and unity.* None of these aspects of experience is exclusive of the others and all are similar in positive effect, but each provides a different focus in appreciating the drama of transformation.

Struggle and Liberation

I have suggested that Kayser is more pessimistic than most interpreters of the grotesque. For him the grotesque confronts us with an alien and estranged world manifest as a cold objectified "it" that remains "incomprehensible, inexplicable and impersonal," a force that has no name. In our experience of the grotesque, we "play with the absurd" that it expresses, but our play soon becomes a threat to us, for the grotesque invokes "the demonic aspects . . . of the world." It calls forth all "the helplessness and horror inspired by the dark forces which lurk in and behind our world and have power to estrange it." But Kayser does not leave the matter there, for even in the description of this estranged world, which he reminds us is still "our world, which has been transformed," he insists that the "truly

artistic portrayal of the grotesque effects a secret liberation." The darkness has been faced, the ominous power discovered, the incomprehensible force challenged such that we not only have invoked but are engaged in "subduing the demonic aspects of the world."[87]

Kayser does not elaborate on the meaning of his concept of liberation, but if it is read within the context of his work as a whole, it suggests a subduing of that which is threatening to our "familiar world," making our world unreliable. It instills not "the fear of death but the fear of life," for life becomes frightening in this estranged and alien place.[88]

We have, then, in Kayser's interpretation a sense of transformation, but one that dwells more on liberation *from* than liberation *to*. According to Kayser, the demonic in being subdued allows us to return to normal life, but our personal or social world has realized no new ground, no place or way of being other than what we were before. We are taken to the boundary to overcome the demonic in order to return to the center as we were before, not to transcend, understand, and respond to the center from a new perspective. In effect, Kayser offers us only one level of encounter; one that I have suggested earlier has something of the character of what Tillich meant in his own articulation of our overcoming the threat of nonbeing by answering that threat through an act of being.

James Luther Adams offers an interpretation that encompasses Kayser's insight but goes beyond it. His position does offer us a way of seeing how the grotesque can point to a redemptive experience. It takes seriously, as does Kayser, the reality of the demonic, but it also sees the possibility of liberation flowing from the encounter with the grotesque that is redemptive in character. Adams writes:

> the redemptive act does not return us to innocence (to a mythic Garden of Eden) but rather it releases us to a state that *embraces the evil which always shall have been,* to one that accepts the horror which can break out at any moment. . . . The modern eschaton is the overcoming of the evil that is always there and can still burst out. This position validates the tears and the suffering. It does not say, as with the case of utopian idealism, your anguish was all illusion but now you are in the presence of God; rather it authenticates the agony by pointing to a state that

87. Kayser, p. 186.
88. Kayser, p. 185.

recognizes equally the power of the evil that always shall have been with the power of redemptive ecstatic joy.[89]

In light of Adams's statement, we can see liberation not simply as a battle won but as offering through knowledge of anguish and suffering — the struggle — the power of redemptive joy, the power of grace, in the midst of a world where evil is an inevitable dimension of life.

Suffering and Grace

Related to Adams's view of the redemptive act is the notion of grace; that the experience of the grotesque, though filled with dread or anguish, may nevertheless serve as an encounter through which grace is experienced. The grotesque may be "the dark night of the soul" through which one moves — must move — to experience the grace of reconciliation and new life. Flannery O'Connor expresses this in her oft-quoted statement from Saint Cyril of Jerusalem: "The Dragon is by the side of the road, watching those who pass. Beware lest he devour you. We go to the Father of Souls, but it is necessary to pass by the dragon."[90] This view draws heavily on the notion that the grotesque, in paradoxical fashion, can point to that beyond itself which it too participates in. It is symbolically rich; it invites us in to see and experience that which seems to contradict what first we see; it bears in its own expression some grain of new life such that we discover the new life the grotesque points to. The key is to see and accept it. Flannery O'Connor both wrote about and used the grotesque in her writing — misshapen bodies and lives, unexpected connections, morbid and macabre incidents, surprising juxtapositions of thoughts, and comical scenes that portray moments of brutality such that we know laughter and horror in the same experience. In one of her short stories, the protagonist is forcing a family, one member at a time, to jump off a cliff to their deaths. When he confronts the grandmother, she offers to pay him not to push her off. "Lady," the misfit responds, looking beyond her far into the woods, "there never was a body that give the undertaker a tip."[91] One

89. Adams, "Eschatology and the Grotesque," p. 2.
90. Flannery O'Connor, *Everything That Rises Must Converge* (New York: Faber and Faber, 1985), front page.
91. Flannery O'Connor, *The Complete Stories* (New York: Farrar, Straus & Giroux, 1968), pp. 131-32.

laughs and then recoils. Human selfishness, pettiness, and bigotry that are locked in her characters yield moments of revelation and reconciliation. In her story "Everything That Rises Must Converge" we see this unfolding in a powerful fashion. The story about a mother and son ends with the scene of the mother's death. Her son carries his own anger at her racism, her narrowness, her pettiness. The scene opens after she has had an encounter with a black woman and child on a bus ride. Her son, angered at the incident, leaves the bus with her. In the ensuing moments she suddenly falls — a fall that ends in her death. O'Connor uses grotesque imagery to suggest something about her, her death, and the horror of the moment of last encounter with her son:

> Stunned he let her go and she lurched forward again, walking as if one leg were shorter than the other. A tide of darkness seemed to be sweeping her from him. "Mother!" he cried. "Darling, sweetheart, wait!" Crumpling, she fell to the pavement. He dashed forward and fell at her side crying, "Mamma, Mamma!" He turned her over. Her face was fiercely distorted. One eye, large and staring, moved slightly to the left as it had become unmoored. The other remained fixed on him, raked his face again, found nothing and closed.[92]

In the story, O'Connor uses grotesque imagery and actions that play with us as they pull us into the truth she offers. The story ends with a passage in which she describes the son's own moment of awareness in which we see him passing into the "dark night" of the dragon's presence where he shall move beyond intellectual certainties and ideological arrogance to acceptance of life as one never removed from "the world of guilt and sorrow." He has moved, as Robert Penn Warren has said about the turning point on the human journey, from one who is uninitiated to one who is initiated into the morally ambiguous world of human experience.

> "Wait here, wait here!" he cried and jumped up and began to run for help toward a cluster of lights he saw in the distance ahead of him. "Help, help!" he shouted, but his voice was thin, scarcely in threat of sound. The lights drifted farther away the faster he ran and his feet

92. Flannery O'Connor, *Everything That Rises Must Converge*, pp. 22-23.

moved numbly as if they carried him nowhere. The tide of darkness seemed to sweep him back to her, postponing from moment to moment his entry into the world of guilt and sorrow.[93]

In his essay "Ugly Beauty in Christian Art," John Cook explores the grotesquely ugly and the nature of beauty in three works. One, the *Roettgen Pieta*, 1370, portrays Mary bent over Jesus' rigid body, her grief present in the posture of her body and expression on her face. The unknown artist provides us a "grotesquely ugly presentation of Christ [who] stands out by virtue of the contrast of the two figures and fulfills the medieval interest in concentrating privately on the evidence of [the crucifixion]." The exaggerated scale of the wound allowed in Good Friday services for the host to be placed within its opening, "thereby equating the consecrated bread of the Eucharist with the broken and bleeding body of Christ." The grotesque imagery in this work is finally one that pulls the believers into the awfulness of the crucifixion in the presence of Christ's suffering as the bread and wine are taken — the sacrament through which grace is bestowed.[94]

Whenever grotesque artworks are used as altarpieces, including Grünewald's Isenheim *Crucifixion* panel and Bosch's *Garden of Earthly Delight,* we are dealing with works that speak of horror, judgment, and suffering set within a liturgical setting in which one theological function of the work is to open us to the grace of God. Grünewald's altarpiece was commissioned by the Anthonites — the Order of Saint Anthony — for their abbey church in Isenheim. The Order of Saint Anthony was a hospital order concerned, particularly, with the care of people who suffered a disease similar to ergotism. In the illness, the body turns a cast of green and breaks into raw open sores accompanied by extreme pain — not unlike some forms of cancer more common to our own time. The disease had been rampant in the eleventh century and had come to be called Saint Anthony's Fire, or "holy fire," since Saint Anthony was identified as one who could enable healing from the disease. The altarpiece is a complex work, theologically, and its meaning is linked to a series of panels that treat a range of events from the life of Christ and panels of various saints, including those particularly identified with health: Sebastian, who warded off the plague, and John the Evangelist and John the Baptist, who were sought

93. Flannery O'Connor, *Everything That Rises Must Converge,* p. 23.
94. John W. Cook, "Ugly Beauty in Christian Art," chap. 6 in this volume.

for help with epilepsy. One theological interpretation the work invites relates to suffering from the "holy fire" for the grotesquely anguished body, green in cast and covered with open sores, offered to those dying in similar anguish the comfort that Christ suffered even as much as they suffered.[95] Through the grotesque figure came not only the theological promise but also the religious experience of grace. In treating one of the works of Bosch, Cook reminds us that an altarpiece — in our case Grünewald's — takes on special theological and liturgical meaning that gives its grotesque forms a positive meaning in the drama of the Eucharist.

Susan Corey, in her essay "The Religious Dimensions of the Grotesque in Literature: Toni Morrison's *Beloved*," notes how Morrison uses the grotesque as a source of prophetic judgment; and as a means of pointing "toward renewal and change by bringing healing and [spiritual] wholeness to what has been fragmented or alienated." She writes of how the characters reconnect with each other and the community through their encounter with the grotesque.

> Both Paul D. and Sethe have experienced the redemptive process of the grotesque. Individually and together they have confronted the repressed parts of their lives and memories and have experienced the breakup of a life they had felt was under control. They have suffered the isolation, pain, fear, and horror, but have ultimately been able to transform the grotesque experiences into a positive redemptive force through the process of memory, the unconscious, the body, and the community.[96]

Redemption comes when we experience through the acceptance of our own human brokenness the grace of transformation, renewal, the possibility of new life. The grotesque can involve us in opening ourselves to that possibility. The way it involves us may seem harsh, ugly, violent, frightening, but the experience of the grotesque — the experience of the hospice residents who identified with Grünewald's grotesquely formed Christ figure — may paradoxically provide the courage that transforms one from despair to hope, from isolation to participation.

95. See Georg Scheja, *The Isenheim Altarpiece* (New York: Harry N. Abrams, 1969), for an excellent study of the altarpiece and the range of historical and theological interpretations of the work.

96. Susan Corey, "The Religious Dimensions of the Grotesque in Literature: Toni Morrison's *Beloved*," chap. 9 of this volume.

Vision and Unity

The grotesque is most apt to treat the specific in staccato fashion: a single image bizarrely presented that shocks us, but shocks us into grappling with the particularities of life it points us to. In terms of a drama of redemption or salvation, its effect is more often that of confronting us with the dilemmas of the present world than with eschatological images of a new world. But acknowledging as much, it is also the case that the grotesque can engage us in a sense of a new age, a new way of being, that points to a new center rather than the old.

Bakhtin's theory, as we have discussed earlier, sees this possibility in the grotesque. He finds in the medieval carnival a world which has reversed the way of dominant culture, and he sees in Rabelais' works a grotesque realism that carries the spirit of the carnival. I have argued earlier that Bakhtin creates a myth — the carnival body — in which the fragmented aspects of life are brought together in a new unity. The body alienated from itself, from other people, from the community, from nature, from the cosmos is integrated and made whole again. The scatological and sexual activities condemned by the institutions and values of culture are affirmed; the hierarchy of authoritarian rule is undercut, giving way to a purely democratic world; bourgeois individualism which fragments and isolates us is transformed into communal identity which opens and unites us to a form of primal community we have lost.

The medieval carnival was a turning of the official world upside down. The carnivals or Christian festivals, including the Feast of Fools, the Feast of the Ass, the Black Procession, and the Kirmess (Kirkmess), were times when the lower became the higher — the monks became the hierarchy — when dancing, drinking, eating, copulating were engaged in without the restraints normally imposed; when people forsook their individual identities as men and women, young and old behind masks and in games and ignored their personal demeanor and decorum to participate in festival activity in a highly exhilarated fashion. Their lives became excessive, bizarre, and frenzied relative to what they normally lived and, particularly, the lives they would be expected to live out in Lent. The carnival was often the subject of paintings such as Pieter Brueghel's *The Feast of Fools*. These portrayals, however, tended to carry heavy overtones of moral judgment over the carnival excess. Bakhtin offers a counterview, for he sees in the carnival grotesque a ritual in which the fragmentations and oppressions the human being suffers are countered.

In effect, a counterculture is created that celebrates the abandonment and excess of bodily activity and a replacing of the "lower stratum" of body and peasant life normally denied recognition and acceptance. But more, Bakhtin thought that carnival activity created a reintegration of the body, which was alienated from itself. The bodily processes of eating, copulating, birthing, pissing, shitting, vomiting — the processes that were considered lower activities related to sin or sickness or excess — were integrated with the rest of the body and its activities, the individual body was integrated with the communal body, the higher status with the lower status. This new world pointed to in the excessive frenzy and bawdy activity of the carnival, paradoxically, pointed to a more sublime world of integration and equality in which unity and wholeness were experienced. Bakhtin's carnival body was certainly an attack upon "bourgeois individualism," which he saw as fragmenting, isolating, and destructive of the person and the community and most likely a veiled attack on Soviet communism, which was hierarchical, authoritarian, and restrictive of both body and community. The world he offers is not of this world. It is an eschatological vision of a new world offered to us, paradoxically, through mythic imagery that is grotesque in the eyes of this world. But his world was one we could know through participation in the carnival, and, in so participating, know that unity it pointed to.

A further use of the grotesque that relates to a vision of unity and wholeness is that found in the work of Marc Chagall. He often combines human and animal parts and activities, defies the laws of nature and natural habitat — people flying, fishes out of water, goats in trees, animals playing musical instruments — and in so doing creates a world that is strange, exaggerated, fascinating, bizarre though seldom horrifying or monstrous. (His studies for *Night of the Soul* are the exception to this.)

In his work *Time Is a River without Banks,* he paints a river flowing through a village that lies peacefully on its banks. The church steeple is in the distance, two lovers lie by the river, a man sits in a fishing boat — there is a sense of well-being that permeates the setting. In the center of the work, however, a large fish with wings hovers above the river. It plays a violin with a human arm and hand and holds a large wall clock with a pendulum marking the passing of time. The clock and the passing of time with the flow of the river suggest the finite world of which we are a part, and yet the total imagery suggests a way of life that ought to be. The lovers, the village, the steeple, the river, and the passing of time heralded by the flying fish provide the image of life as whole — an image in which

Fig. 1.9. Marc Chagall, *Time Is a River without Banks,* 1930-39

the grotesqueness of the fish in its fantasy form calls us from the boundary to the center of who we should be.

Redemption from our own fallen state, from our own brokenness and alienation, is served by the grotesque in its own fashion — even as revelatory of the way the world should be if it is to be whole.

Conclusion

Wherever the imagery of the grotesque plays a role in the drama of religious life, it does so by taking us out of everyday life and providing us with a different way of seeing the center — the center in its demonic manifestations and the center as the place alone where we can know the grace of God. It does so, paradoxically, for the grotesque is *of* but not *in* the center. It has come out of our world, been created by it, but is removed from it. It is on the border in the desert; it is in the bramble of wilderness beyond the place where we live; it is in the cave of our world, our mind, our soul where it calls us to confront the human condition. It is experience and event that we have denied or thought we had destroyed only to discover that they have never gone away. The grotesque will show us the anti-world that we have created out of our own passion to dominate and control. It will call forth the demonic which we must subdue to be free; it will pull us into the dimension of our mythic selves that defies rational explication and renews our claim on that mythic reality necessary for emotional health, for social well-being, for spiritual wholeness. It will turn our world upside down so that we can see the possibilities of a new world beyond the old.

History is the arena of the grotesque. What is grotesque is born from the world of which we are a part, and its particular subjects and forms will change as history so determines. But the grotesque will be there as it always has been, for, finally, the human community never so manages to live in that paradoxical world of freedom and order, good and evil, fallenness and redemption that it does not skew its world by distorting the balance it seeks. At times it will be a word that points to the mystery of life, at times to the fallenness of life, at times to our salvation. It will shake us with laughter and horror. It will prepare us to "recognize equally the power of the evil that always shall have been with the power of redemptive, ecstatic joy."

2. The Grotesque and Our Future

JAMES LUTHER ADAMS

What has the grotesque to do with an address commemorating the 1819 Baltimore Sermon Address of William Ellery Channing, and what has it to do with our future? The answer is that the address concerns crises, both past and present, that are nothing less than grotesque.

Henry Steele Commager has given us a pungent description of both Channing and Theodore Parker against the spurious authorities and social evils of their time.

> "I am surer that my rational nature is from God," said William Ellery Channing, "than that any book is an expression of His will." Here was a spiritual and intellectual declaration of independence from the authority of the scriptures, but not of the scriptures alone — a declaration of independence from the authority of the church and eventually of the state, society, and the economy. It was what Unitarianism and particularly transcendentalism was increasingly to be: an appeal from official and collective authority to the authority of conscience and reason.

> Dr. Commager presents also an urgent summons to us of a later generation to confront with equal boldness and imagination the corresponding authorities and social evils of our time. "We are confronted now," he says, "with crises deeper and more pervasive, and even more intractable, than those which Channing faced — more intractable even than slavery." Among these crises he mentions the destruction of the environment, overpopulation and hunger, biological and atomic warfare, and violence

69

and war itself. The evils are not only intractable; they are also monstrous, so monstrous as to be grotesque. To countenance them is to court, to play with, death. It is as grotesque as the evils themselves.

That word *grotesque* conjures up the long-necked gargoyles, the colonies of monstrous birds that hover and howl overhead in the buttresses and towers of a medieval cathedral. But the word has many connotations. Let me indicate the special meaning I attach to it for the nonce.

In Paris there is a "cabaret philosophique" called Nothingness (Le Neant), which for a certain kind of playful grotesquerie is probably unmatched in the world. Everything in this cabaret is designed to remind the customers of death, including their own. They sit at coffins instead of at tables, in a palatial room hung with skeletal remains and with various texts on the nature of death. A master of ceremonies dressed as a priest makes the rounds, reminding the customers individually about the ominous pallor of their complexions. One customer is generally persuaded to get into a coffin and be wrapped up to the neck in a shroud. What fun for the affluent society!

Whether this cabaret found its origin in a philosophical, "existentialist" brainstorm or was contrived simply for people of depraved taste who want to enjoy a novel kind of spree on the night out, I do not know. But it does approach the quality of the grotesque, even though it is not to be taken *au serieux*. In this respect it reminds one of a trivial "shocker" proposed several centuries ago, the recitation of the Lord's Prayer backwards, in order to conjure the devil.

An approximation to the seriously grotesque is better suggested by Anatole France's tale about a young man from the provinces who was taken by a city friend to see the Chamber of Deputies in action. Afterwards, the sophisticated host explained that the debate was an effort to determine the cost to France of the world war. "How much did they decide it was?" asked the provincial. "Three trillion francs," was the reply. "And what about the men lost?" — "Oh, they're included."

From these two examples, the cabaret and the Anatole France anecdote, we have our clue to a definition. The authentically grotesque is something that deviates from the normal in a monstrous way. As Santayana once observed, however, it is in the arts suggestively monstrous.

In the history of Western art the grotesque has been variously defined by writers and practitioners of the plastic arts since the time of the Renaissance — from Rabelais, Hieronymus Bosch, and Raphael to Edgar

Allan Poe and Tennessee Williams to van Gogh and the surrealists. Beginning as the name of a fantastic style of phantasmagoric exuberance, it developed into a depiction of the absurd, the ridiculous, the distorted, the monstrous. It is a mirror of aberration. In order to present aberration the artist of the grotesque (a Bosch, a Goya, or an Ingmar Bergman) depicts a world where "natural physical wholes" are disintegrated and "the parts" are monstrously redistributed. He aims to project the full horror of disorder, the terrible and the terrifying, even the bestial, elements in human experience. So was the grotesque for John on the Isle of Patmos.

> In appearance the locusts were like horses arrayed for battle; on their heads were what looked like crowns of gold; their faces were like human faces, their hair like women's hair, and their teeth like lions' teeth; they had scales like iron breastplates, and the noise of their wings was like the noise of many chariots with horses rushing into battle. They have tails like scorpions, and stings, and their power of hurting men for five months lies in their tails. They have as king over them the angel of the bottomless pit. (Rev. 9:7-11, RSV)

These are the nightmarish, sinister forces that emerge from the abyss of inhumanity. They are the progeny of spurious authorities. This is what William Faulkner had in mind when he said: "We shall never be free until we understand what we have done to the Negro."

From a theological perspective the grotesque in its darker spectrum turns out to be a table of contents corporate of Sin. As we shall see, Dr. Commager ventures to use that unpopular word.

In combating the evils of their time, Dr. Commager says, Channing and Parker began with presuppositions that were untenable and which they or their successors had to qualify — the idea of the divinity of man and the principle of individualism. They were compelled to acknowledge that "the real problem was not that of private sin, but of public — the problem of dealing with great agglomerations like corporations and governments." And this, he says, is precisely the reason for "that sense of desperate frustration that overcomes so many of us." It is the reason also for the widespread revolt of youth. We are all caught in "collective sin" where it is difficult to identify individual guilt and responsibility:

> nobody responsible for war; nobody responsible for napalm and the defoliating of millions of acres of land; nobody responsible for wasting

half of our total income on war and armaments . . . ; nobody responsible for blight and poverty and ignorance and disaster and crime. Needless to say, we are all responsible. Americans are the leaders and the pace-setters in almost all of these sins.

No other people, he says, "has destroyed so fast and as much as we are destroying; we are the vandals of the modern era."

We need not spell out here the current size and statistics of the grotesque powers that express Humanity and Destroyer today. The increasing disparity between the haves and the have-nots; the disparity in the national budget between the dollar-billions allotted to weaponry and those assigned to fight poverty; the, in Commager's words, "cities degenerating into massive slums, schools teaching nothing, hospitals overcrowded, racial injustice and mounting tension, demands for 'reparations,' and so on. These are all a part of us, and we a part of them. In the coming season I understand that they are to be dramatized in what is to be called 'the guerrilla theatre,' the theatre of the grotesque."

Life magazine recently offered some candid pictures of the grotesque in the large by providing photographs of the 242 men killed — "One Week's Dead" — "in connection with the conflict in Vietnam." The name of the magazine, at least for that "one week," is grotesque. "Normal men," says the British psychiatrist R. D. Laing, "have killed perhaps 100 million of their fellow normal men in the last fifty years," adding that he is no longer sure of the usefulness of the traditional categories of "well," "sick," "mad," and "sane."

Dylan Thomas, the Welsh poet, taking a close-up view and writing from America to his wife, epitomized this grotesquerie in a homely way: "The foodshops knock you down. All the women are smart, slick and groomed, as in the magazines — I mean in the main streets; behind lie the eternal poor, beaten, robbed, humiliated, spat upon, done to death." If we go around behind and visit Appalachia or any large city hospital, we learn that worms crawl out of the mouths of undernourished children when they are under anesthesia. Like a Salvador Dali painting of the grotesque, our condition is hard to look at for any length of time. Living with and under these aberrations, we collectively experience (and exemplify) the grotesque. We live in what the Welshman calls The Valley of the Monsters.

We shall not be able to deal with these problems "in our stride,"

business and government and church continuing "as usual." Nevertheless, in the present sea of turmoil our contemporaries, especially those who are the "haves," seem to insist on simply rowing with their hands, and only now and then, in order to get ashore. There is something typically and pathetically grotesque about the president's daughter tutoring two inner-city children at the White House. One should not be surprised to learn that Julius Hobson, a member of the Washington School Board, has attacked the White House for its "welfare colonialism": "If the President of the United States wants to educate the children of the District of Columbia, then he can do it through Congress by promoting Federal aid to education instead of cutting it back."

In the face of the crises he has described, Professor Commager stresses the crucial roles of a revitalized United Nations, an authentic university, and an ecumenical church, three forces that together "can create a counterweight to those formidable institutions that are dedicated to self-seeking and power."

What, then, are the mandates that lie upon our churches? When we consider the enormity of the forces that hold us in sway, we share with Commager the sense of desperate frustration. But at such a moment we can recall what Martin Luther said in response to the question, "What would you do if you were convinced that the world will come to an end tomorrow?" He responded, "I would go out and plant a tree." In this 150th anniversary year of the Baltimore Sermon (1969) we can find our first mandate in what Dr. Commager speaks of as Channing's declaration of independence of the state, society, and the economy, that is, in appeal to conscience and reason. For Channing and Parker this declaration was in the name of a power that transcends culture; indeed, transcends even what calls itself religion. For them awareness of the shadows of the grotesque was at the same time awareness of the light that is above the shadows. Thus the declaration of independence and the appeal to higher authority beyond the spurious authorities did not mean withdrawal.

We must next ask the question: How specifically do we declare independence of spurious authorities and plant a tree? Here we come to a second mandate. What I have just been saying is true enough, but it can readily take on the hue of inflated rhetoric. I choose therefore to shift into lowercase script, and to say that what happens to a denomination as a whole or a local parish depends upon a relatively small number of people, upon the small church in the large. The second mandate, then, lies espe-

cially upon these people; namely, to urge the achievement of consensus with regard to top priorities. Churches, like other organizations, can dissipate their energies by trying to do too many things. It is an axiom of theology as well as of psychology that both distortion and apathy are the children of lazy ambiguity, of ambiguity of purpose. The crucial question here is, What are the top priorities?

The surest way I know to deal with the question is to respond to those who have the greatest need and to join those who are battling against rank injustice. I venture to nominate, first, those who are protesting or struggling against war; second, blacks and poor whites; and, third, the youth in revolt. Among them we find a creative alienation from society, a declaration of independence in positive thrust. Just for this reason, greater power, greater responsibility in the denomination and in our churches should be given to these youths and to these blacks.

This leads to the third mandate: that we must overcome the moribund and routine conventions of activity in the parish and the denomination. Here the dynamics are already evident outside the churches as well as inside, in the professions and in the prophetic associations in the community.

All of these mandates are already burgeoning among us. But none of the strategies mentioned goes to the roots. The fundamental mandate is the renewal of covenant within the churches, the reaching down to the covenant of being itself where mutuality and sacrifice alone free us from the universal monstrosities, the reaching out to the promise making and promise keeping that constitute the substance of response to the covenant of being, the substance of faith and hope. And the greatest of these is love. The alternative is to batten on the grotesque. In short, the alternative is death, even though it be living death.

3. The Grotesque, Theologically Considered

ROGER HAZELTON

The art of the grotesque is peculiarly open and congenial to theological reflection. By showing us incongruity and even monstrosity in a great variety of forms, grotesque art can induce reflection upon the elements of distortion and disorder in our experience. When an imp makes its startling appearance in a column of stiffly sculptured angels in Lincoln Cathedral, a woman turns into a lioness in one of the Noh plays of Japan, or a crucified man with an ass's head stares out at us from the wall of a Roman catacomb, some taunting questions about human nature and destiny may be forthcoming. While it is true that theology may not be able to resolve questions like these, it has always had to face them. Both theology and grotesque art, in fact, serve to remind us of the mystery of being human in a world that has always left something to be desired by way of practicability and clarity. Hence I would suggest that the grotesque is an "appropriately odd" disclosure of that mystery, whether forbidding or benign, with which theology is also and necessarily concerned.

The notion of mystery that is in use here ought to be made as clear as possible — a paradoxical assignment if there ever was one. Mystery is not a synonym for residual ignorance which will be dispelled when the sciences get around to it. Neither can it simply be equated with the unknown or the unknowable, despite the fact that experiences of not-knowing may forcibly alert us to the presence of mystery in all experience. A secular culture wants of course to neutralize and minimize the horizon

of mystery in human life as much as possible, and so tends to regard it as threatening but surmountable. Theology and grotesque art, on the other hand, the one in terms of propositions and the other in terms of images, find a certain affinity in a common persuasion that mystery remains a real and radical feature of our existing in the world — something not reducible to the aims and methods of technical expertise and control, and thus compelling other kinds of human response and acknowledgment. Gabriel Marcel's view of *mystery* as contrasted to *problem* is familiar and pertinent here. The gist of his thought is that in experiencing mystery the distinction between subject and object, between what is within me and what is confronting me, breaks down completely. There is no objective, problematic standpoint available from which I can face such questions as those concerning freedom, destiny, evil, or God — at least insofar as they are my own questions. I am here inseparable from what I am asking; I have become, in Saint Augustine's words, a question to myself.

Whatever else grotesque art may intend or achieve, it does succeed by its juxtaposition of recognition and surprise in calling attention to the mysterious quality of our existence. Such art covers a very broad range of styles and subjects, from the whimsical to the terrifying. One is constantly tempted to identify it with one or another, like works of social protest or of violent horror, which are so familiar to us at the present time. Yet to condemn ugly happenings without shuddering before the mystery of human evil is not, I would submit, grotesque art at all. What is lacking in most current work being shown is just that sense of man at bay, caught in the play of dark, destructive forces, which animates the canvases of Goya or the novels of Mauriac, for example. In other words, the human mystery is here conspicuously absent.

I would not deny that pop art, caricature, or collage can become suitable vehicles of the grotesque — indeed, there is a dash of the grotesque in the very exaggeration or amazement conveyed by such works — but today this element is more obvious in technique than in content or meaning. I do insist, however, that such intimations of a truly grotesque style fall short of its potential impact and worth. Good reporting or simple anger is commendable enough when called for, as is technical facility, but they are no substitutes for a higher order of excellence in works of art. What Rico Lebrun called "speaking truly about the unmanageable design of our condition" points to this better way within the purview of the grotesque.

Yet my intention is not to scold contemporary artists for their deficiencies but to arrive at a conception of the grotesque that has theological import and interest. What really goes on here? Probably the earliest examples of grotesque art are those which graft animal figures on human or partly human ones. What does a centaur, a Sphinx, or a griffin actually say to us about ourselves? They say, I believe, that we are more than we know, that to be human is to embrace the universe from wherever we happen to be standing in it — so that although neither angel nor animal, as Pascal wrote, we share strangely in the nature of both. These hybrid creatures from the early grotesque suggest not our misery but our greatness — supernormal power, wisdom, or devotion — and thus point in the direction of human meaning complementary to that of violence and vulnerability under evil. In its own bizarre, backhanded way, therefore, grotesque art opens out upon the whole truth about the mystery of being human in an unmanageable world. Its themes and images are by no means restricted to deprecating or denouncing human existence.

Surely it should be remembered that no work of genuine art can be a bare statement of the case against humanity, if only for the reason that it is a human being who is making the statement. This, I think, is what is meant by the remark that "a sad song is still a song for all its sadness." To give aesthetic shape to one's sorrow is already to have moved beyond sorrow to its creative surpassing and deployment. It is the same with justifiable anger, such as might be generated by the alleged incident of the massacre of villagers by American troops in Vietnam. Much talk today about the artist functioning as social prophet sells the artist short by confining his or her role to that of "speaking out" without a proper recognition of the creative process and purpose involved.

The grotesquerie that often accompanies protest art may indeed be all that saves it from becoming merely earnest or enraged. Documentation and accusation are certainly understandable enough in present-day art, but without what Lucas Samaras calls "the strange pride in being visited by a catastrophe," they do not even make their moral point well. Traditional artists who deliberately avoid making what they call social or political commitments in their work sometimes complain that protest and dissent should be left to the cartoonists or to letters on the editorial page of a newspaper. Without defending their own escapist tendency, one can agree with them that vehemence or outrage alone do not produce works of art.

Grotesque art is a particularly arresting instance of that human

self-transcendence which operates in all art. Any enterprise of the creative imagination witnesses, sometimes in spite of itself, to the human being's inherent capacity for extending, reliving, evaluating ordinary experiences, so that the person is not merely the sum of the things that happen. It is by virtue of its close connection with fantasy that the art of the grotesque underscores this characteristic of art as such. Its statement of the human truth is a necessary overstatement in which reality as "normally" experienced becomes both questionable and questioning.

No discussion of the grotesque in a theological perspective would be adequate if it omitted reference to the demonic. Rollo May's essay on this subject, like Paul Tillich's inclusion of the same topic in his theological system, may be taken as establishing some important ground rules. Tillich, for example, speaks of the "divine anti-divine ambiguity" of the demonic, which in some way participates in the power of the divine while expressing this power in contradiction to it. Thus the demonic must be feared, but not worshiped. Christian theology has always understood that creation has its dark, menacing side. What God created is not what was intended. Whatever may be thought to have brought it about, this rift between the essential goodness of creation and the actual evils of existence here and now remains a "fact of life."

The images of dragons, gargoyles, or devils symbolize the presence of the self-destroying potentialities in being. They body forth the threatenedness of human existence, whether in terms of moral temptation, spiritual failure, or physical catastrophe. Encroaching evil, natural or human, is their recurring theme. They give voice and shape to the persuasion, as inescapable as it is intolerable, that something in being does not wish us well, seeks our destruction, and therefore must be contended against. Ionesco's rhinoceros materializing on the stage until it fills and stifles it is one dramatic example. The imagery of the book of Job also conveys what might be called the final irony of being: one does not catch whales with fishhooks or talk back to the sun.

But the demonic is a matter of existential, and so of aesthetic, concern only for those who have faith in the divine. Professor Stechow's fascinating paper in this volume mentions Hieronymus Bosch's altarpiece *The Garden of Lust*. From the standpoint of a Christian theologian the most interesting thing about this work may well be the fact that it was conceived for a sacral purpose. It was placed on the altar itself, at the very focus of faithful attention, close to the heart of the holy mystery of God's loving sacrifice

on our behalf. One is at once reminded of Santayana's witticism that it is easier to make a saint out of a libertine than out of a prig. Self-security, self-righteousness is the absolute antithesis of faith in a forgiving, saving God. Recalling Kierkegaard's admonition that before God one is always in the wrong, the theologian knows that an honest, unsparing awareness of our precariousness before evil, our vulnerability to its fascination and pleasurableness, belongs within the scope and reach of faith.

The presence of the demonic within the arts of the Christian church, involving as it does techniques and themes associated with the grotesque, says even more than this theologically. It says that the demonic is a minor, not a major, key within the full orchestration of a Christian rendering of the meaningful mystery of life. It says further that disorder and distortion are a genuine part, but only a part, of our existence "under God." A gargoyle, after all, is a waterspout to carry off excess rainwater. A dragon is to be borne in a procession to the temple. A devil ought to be properly frightening, a real menace to our salvation or fullness of being — but not unto death. Do we not therefore see in all representations of the demonic, at least the traditional ones in the great religions, an effort to contain what is evil in existence precisely by conveying it? The principle of the incarnation itself, that only that which is taken up can be healed, is here rendered in an especially compelling way. If, as Amos Wilder has observed, art is a "spell against death," is this not most emphatically true of Christian art?

Images and motifs of the demonic point us toward the dark, eruptive "principalities and powers" cited by Saint Paul — those tyrannical forces coming from God knows where that would enslave a person's spirit but cannot ultimately do so. They are generally rendered in a grotesque manner because they mean to express intrusions, and unwelcome ones at that, into the sane and orderly patterning of purposive life. And yet they are not symbols of a tragic protest or refusal. They belong rather to the middle zone of the tragicomic, like all art of the grotesque. That is to say, they are disclosures of a vital, insistent exuberance, of an imaginative fecundity, no less than of estrangement from the true source of our being.

In modern literature the stories of Rabelais and the satires of Swift are particularly telling examples of this tragicomic ambiguity involved in being human. Why does Rabelais' *Gargantua and Pantagruel* deserve the appellation "grotesque"? Not simply the gigantic size of the hero (or antihero), but even more the unbuttoned, obscene form (or lack of form) of the work itself — "not so much a book as a storm," observed D. B.

Wyndham Lewis — justifies this adjective. Through this huge, rambling, extravagant collection of outrageous tales there runs the Renaissance sense of heady adventure, flaming appetites, gratuitous cruelties. But there is also something more: the robust attack on monastic hypocrisy and scholastic piddling in the early chapters, and the later description of a kind of utopia for the liberated, rebellious spirit, the Abbey of Theleme with its motto, "Do what you please." One cannot help wondering at times whether the "social significance" of the work is tacked on, in the manner of a filmmaker today who adds just enough ostensible seriousness to get his product past the censors. Nevertheless, the serious element is there and gives to the whole a human density that is more than simply comic.

In part 4 of *Gulliver's Travels* the author has included a long fantasy called "A Voyage to the Country of the Houyhnhnms" in which the grotesque takes the form of a reversal of roles. In Swift's story the horse is the rational animal, gentle, perceptive, and disciplined, while the human being is the Yahoo-brute, unruly, violent, and ugly. If the story were to be rendered visually it would become decidedly grotesque, rather like the classic film *Planet of the Apes*. But this might lose much of the satirical quality of Swift's work, which is conveyed chiefly through a running commentary that calls in question the benefits of "civilization," defines us in unmistakably cynical terms, and envisages by contrast a state of human affairs "when party and faction were extinguished; judges learned and upright; pleaders honest and modest, with some tincture of common sense . . . wit, merit and learning rewarded; all disgracers of the press in prose and verse condemned to eat nothing but their own cotton, and quench their thirst with their own ink." Satire such as Swift's is obviously an apt vehicle for the tragicomic and so belongs to the genre of the grotesque.

Or we may choose other instances from the contemporary arts. The grotesque image bodies forth human misery and grandeur, both together, as in Picasso's *Corrida Crucifixion* where the victim and the victor, the *toro* and the *torero,* are fused into one complete symbol. So too in the rendering of Christ as a clown or a fool, familiar in the literature and painting of the past century, grotesque art moves freely and boldly in the tragicomic realm of lived reality. A particularly noteworthy example of this manner in art is the mime of Marcel Marceau, where the counterpoint of human fragility and sportive self-assertion is maintained by a controlling mood of compassionate playfulness.

Let me now attempt to draw these strands of thought together.

Theology today must give its first attention to the mystery of being human as the ground of any honest faith in God. It is chiefly in those experiences of transcending or being transcended that the occasions for such faith, as well as the obstacles to it, emerge and are to be articulated. These experiences also constitute the source material of the arts, which therefore invite and engage careful theological understanding. The open-ended ambiguity of all human existence is a datum for theology and art alike.

The art of the grotesque, while not forcing or foreclosing any theological issues, is valuable in recalling the precariousness of faith itself. The grotesque way of seeing humanity-in-the-world underscores the risk and hazard that are bound up with any vote of confidence given to reality. Theology, which is the enunciating of that abiding, confiding trust and loyalty called faith, should not be allowed to forget that faith is but one option among others — an option moreover that embraces not only contemplation but commitment, and demands that we can no longer easily be reconciled to the way things are with us.

4. Carnal Abominations: The Female Body as Grotesque

MARGARET MILES

The most ridiculous thing of all will be the sight of women naked in the palaestra, exercising with the men.[1]

[A woman] is more carnal than a man, as is clear from her many carnal abominations. And it should be noted that there was a defect in the formation of the first woman, since she was formed from a bent rib, that is, a rib of the breast, which is bent as it were in a contrary direction to a man. . . . And all this is indicated by the etymology of the word; for *femina* comes from *fe*, and *minus*, since she is ever weaker to hold and preserve the faith. . . . What else is a woman but a foe to friendship, an inescapable punishment, a necessary evil, a domestic danger, a delectable detriment, an evil of nature, painted with fair colors.[2]

A body is docile that may be used, subjected, transformed, and improved.[3]

1. Plato, *Republic* 452a.
2. *The Malleus Maleficarum of Heinrich Kramer and Jacobus Sprenger,* trans. Montague Summers (New York: Dover, 1971), pp. 41-48.
3. Michel Foucault, *Discipline and Punish: The Birth of the Prison* (New York: Vintage, 1979), p. 136.

O ne of the most popular travelogues of the later medieval period relates
the travels of Sir John Mandeville to exotic lands where he witnessed
prodigious marvels. "Sir John" reported not only what he claimed were
firsthand experiences, but also stories he had heard in the course of after-
dinner gossip, introduced by a phrase like "some men say." The land of
Amazonia, for example,

> is all women and no man . . . because the women will not suffer no
> men amongst them to be their sovereigns. . . . When they will have any
> company of man, then they draw them towards the lands marching next
> to them. Then they have their loves that use them and they dwell with
> them an eight days or ten, and then go home again. And if they have
> any knave child, they keep it a certain time and then send it to the
> father . . . or else they slay it. And if it be a female, they do away with
> that one pap with an hot iron.[4]

The women of Amazonia were marvels primarily because they had
devised a way to be independent of men without relinquishing the pre-
rogatives of childbearing and child rearing. They also eliminated one breast
— the left if they bore a shield, the right if they were trained to the
crossbow — in order to resist intruders and maintain their way of life. The
Amazons fascinated and terrified medieval readers, but they were far away;
no one claims actually to have seen them. They were a fantasy.

The daughter of Hippocrates was another female prodigy described
in *Mandeville's Travels;* she had been "changed and transformed from a fair
damsel into the likeness of a terrifying dragon by a goddess." The so-called
daughter of Hippocrates required only to be kissed — in her dragon form
— by a young man in order to return permanently to her human form.
Unfortunately, the brave knights who undertook this task consistently
died. The damsel still waits: "When a knight cometh that is so hardy to
kiss her, he shall not die, but he shall turn the damsel into her right form
and kindly shape, and he shall be lord of all the countries and islands
abovesaid."[5]

A third group of marvelous women represents yet another fantasy:
these women wear no head coverings, so, Mandeville says, men and women
are indistinguishable, except that married women

4. *Mandeville's Travels,* ed. M. C. Seymour (London: Oxford, 1968), p. 121.
5. *Mandeville's Travels,* pp. 17-18.

bear the token upon their heads of a man's foot in sign that they be under man's foot and under subjection of man. And their wives dwell not together but every of them by herself, and the husband may lie with whom of them that he liketh.[6]

These three kinds of women represent the range of variations within medieval male fantasies of women: first, the totally independent woman, capable of crimes against nature in order to maintain her autonomy; secondly, the woman who initially appears terrifying and horrendous but who needs only a man's love in order to be transformed into a beautiful and tractable woman; and finally, the completely colonized woman, wearing her docility on her head at all times for all to witness, uncomplaining when her husband flits from woman to woman at whim.

These women are all "prodigies," however; the text presents them as outside experience, exotic. How are they related to the actual women medieval men lived with and loved? Most of them lack the standard features of grotesqueness we expect: gargantuan size, a mixture of the body parts of different species, inversion, or unanticipated transmogrification. These women's lack of grotesqueness, in a text that specializes in titillating its readers with weirdness, suggests that it is not merely that some women were thought of as grotesque in socially defined, culturally specific ways, but that an element of grotesque is present in every woman. As the women in *Mandeville's Travels* illustrate, the creature closest to the male subject, but innately, disturbingly different, is ultimately more grotesque than are exotic monsters. "The grotesque world does not constitute a fantastic realm of its own," Wolfgang Kayser has said. "The grotesque world is — and is not — our world."[7] That which is familiar but alien is finally the most confusing and troubling, requiring figuration that reassures by indicating how the disturbing figure can and should be managed.

In Western Christianity, the primary opportunity for figurations of the grotesque has been verbal and visual descriptions of hell (fig. 4.1). In paintings of the Last Judgment, the blessed arrange themselves in neat rows on the right hand of Christ while the damned stream in twisted shapes, bodies elongated, flowing downward and mixing with the bodies

6. *Mandeville's Travels,* p. 190.

7. Wolfgang Kayser, *The Grotesque in Art and Literature* (Bloomington: Indiana University, 1963), p. 37.

Fig. 4.1. Giotto, *Hell*, from *Last Judgment*, Padua, Arena Chapel

of others. At the lower extremity of the painting, attacked by demons who stab, burn, and pull them apart, they lose all configuration and integrity. Particular crimes were punished in prescribed sequences of tortures, according to many medieval authors. In S. Francesca Romana's lurid fifteenth-century vision, hell was "a lurid and rotting uterus," where perjurers, blasphemers, magicians, doctors who hastened death by their ineptness, people who had made inadequate confessions, adulterers, and cheating shopkeepers all endured inventive and horrible torments.[8] The damned were tortured particularly in the organs involved in their sins; for example, "the breasts and abdomen of the lustful woman are sucked out

8. M. Pelaez, "Visioni di S. Francesca Romana," *Archivio di Societa Romana di storia patria* XIV (Rome, 1891), pp. 364-409; quoted in Piero Camporesi, *The Incorruptible Flesh, Bodily Mutation, and Mortification in Religion and Folklore*, trans. Tania Croft-Murray (New York: Cambridge University, 1988), p. 51.

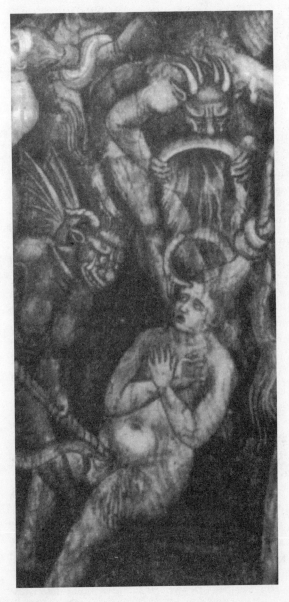

Fig. 4.2. *Lust,* from
Inferno, 1396, Citta di
San Gimignano, Italy

by toads and repulsive serpents."⁹ For medieval people, hell was grotesque as all human integrity, physical and social, was overwhelmed by chaos (fig. 4.2).

In this chapter I will first examine several definitions of the grotesque in order to identify the components of grotesque figuration; next, consideration of woman's affiliation with the quintessentially grotesque events of birth, sexual intercourse, and death will strengthen my thesis that, from the collective male perspective of the public sphere, the most concentrated sense of the grotesque comes, not from exotic but distant monsters, but from the figure "woman." I will then explore several devices by which a familiar world can become grotesque, asking how women's bodies and behavior, as represented in historical societies, related to these literary and pictorial devices. Finally, using several different genres of sixteenth-century literature, we will explore an example of the social function of figuring woman as grotesque.

The grotesque is notoriously difficult to define. In a recent study of the grotesque, Geoffrey Galt Harpham begins with this elusive definition:

Grotesqueries both require and defeat definition; they are neither so regular and rhythmical that they settle easily into our categories, nor so unprecedented that we do not recognize them at all. They stand at a margin of consciousness between the known and the unknown, the perceived and the unperceived, calling into question the adequacy of our ways of organizing the world.¹⁰

This definition is as loose and baggy as the grotesque creatures it attempts to classify. Confusion is intrinsic to the grotesque, and, as Harpham acknowledges, "It is always difficult to think clearly about confusion."¹¹ Both Harpham and his predecessor, Mikhail Bakhtin, interpret confusion positively, however. Harpham criticizes Bakhtin for his uncritical embrace of the grotesque: "Reading Bakhtin, we may be encouraged to feel that by embracing the grotesque we can regain fullness of meaning, purity of being, and natural innocence, lying breast to breast with the cosmos and with our fellow creatures."¹² But his own more measured

9. Adolf Katzenellenbogen, *Allegories of the Vices and Virtues in Midaeval Art* (New York: Norton, 1964), p. 58.
10. Geoffrey Galt Harpham, *On the Grotesque: Strategies of Contradiction in Art and Literature* (Princeton, N.J.: Princeton University, 1982), p. 3.
11. Harpham, p. xv.
12. Harpham, p. 72.

appreciation still maintains that "confused things lead the mind to new inventions [and] lie at the heart of all scientific discoveries of a revolutionary character."[13] "The grotesque implies discovery," Harpham concludes in the last paragraph of the book, "and disorder is the price one always pays for the enlargement of the mind."[14] Finally, the grotesque can be defined only in relation to the ideal, standard, or normative form; a grotesque figure is:

> an entity — an image, object, or experience — simultaneously justifying multiple and mutually exclusive interpretations which commonly stand in a relation of high to low, human to subhuman, divine to human, normative to abnormal, with the unifying principle sensed but occluded and imperfectly perceived.[15]

Bakhtin gives an example of grotesque conversion of the "high," or intellectual, to the "low," or physical. In a scene from the Italian commedia dell'arte,

> a stutterer talking with Harlequin cannot pronounce a difficult word; he makes a great effort, loses his breath, keeping the word down in his throat, sweats and gapes, trembles, chokes. His face is swollen, his eyes pop; "it looks as if he were in the throes of childbirth." Finally, Harlequin, weary of waiting, relieves the stutterer by surprise; the difficult word is "born" at last.[16]

13. Harpham, p. 17.
14. Harpham, p. 191. Analysts of the grotesque have found, within the breadth of these definitions, a great deal of room to critique their predecessors on the basis of a few well-chosen examples. Thus, Mikhail Bakhtin, in a chapter entitled "The Grotesque Image of the Body," reports G. Schneegans's analysis of the components of the grotesque, finding it ultimately a "narrow modern interpretation . . . typical but radically erroneous, . . . the complete neglect of a series of essential aspects of the grotesque" (Mikhail Bakhtin, *Rabelais and His World*, trans. Helene Iswolsky [Cambridge: MIT, 1968], p. 307). Harpham, while crediting Wolfgang Kayser's *The Grotesque in Art and Literature* and Bakhtin's *Rabelais and His World* as "prodigiously well informed, carefully argued, persuasive accounts," draws the starting point of his own argument from the fact that these two authors "manage to contradict each other utterly on the most basic premises." I hesitate to participate in this time-honored academic dynamic, but find it difficult to make my point without demonstrating that former definitions of the grotesque have missed one of its crucial components; namely, the essential role of gender in creating the quality of grotesqueness.
15. Bakhtin, p. 14.
16. Bakhtin, p. 304.

Bakhtin comments that

> a highly spiritual act is degraded and uncrowned by the transfer to the
> material bodily level of childbirth, realistically represented. . . . The
> gaping mouth, the protruding eyes, sweat, trembling, suffocation, the
> swollen face — all these are typical symptoms of the grotesque life of
> the body; here they have the meaning of the act of birth.[17]

Unremarked by Bakhtin, the debasement of the act is brought about
by a gender inversion, by the simple placement of the production of a
word in a reproductive body. Thus, the "highly spiritual act" is that of a
man, while its conversion to the comic occurs — must occur? — in the
body of a woman. The transfer to the material, corporeal, and sexual
requires woman's body as the catalyst of the conversion. The association
of the female body with materiality, sex, and reproduction in the female
body makes it an essential — not an accidental — aspect of the grotesque.
The socially constructed *différance* which means that male and female
bodies are not only physically different but are also hierarchically arranged
and asymmetrically valued underlies the literary use of woman's body as
the primary figure of debasement.

Grotesque figuration of the female body might be seen as benign or
merely descriptive if we fail to notice another feature of the grotesque. In
subverting order, rationality, and "reality" as socially represented, it signals the
insidious omnipresence of evil, the confusion of an orderly creation by an
irreducible undertow, a bleeding of "high" into "low" which is both achieved
and demonstrated by erratic matter's insubordination to form. The theology
of grotesque form was supplied for learned medieval literati by a late-classical
author, Boethius. Early in the sixth century Boethius extrapolated from
Christian Neoplatonism a description of the genesis of grotesque forms:

> anything which turns away from goodness ceases to exist, and thus . . . the
> wicked cease to be what they once were. That they used to be human is
> shown by the human appearance of their body which still remains. So it
> was by falling to wickedness that they also lost their human nature. Now,
> since only goodness can raise one above the level of human kind, it follows
> that it is proper that wickedness thrusts down to a level below humankind
> those whom it has dethroned from the condition of being human.[18]

17. Bakhtin, p. 309.
18. Boethius, *The Consolation of Philosophy* IV.3, trans. V. E. Watts (Harmonds-
worth, England: Penguin, 1978), p. 125; quoted by Harpham, p. 83.

Certainly, in the best-known instances of the grotesque, from the Paleolithic caves of southern France to medieval manuscript illumination and cathedral facades to Rabelais, Jonathan Swift, *Alice in Wonderland,* and Aubrey Beardsley, male as well as female bodies are subjected to grotesque figuration. Yet it was women's bodies, permanently shaped by Eve's sin, that symbolized the fact that humanity exists in a state of sinfulness and punishment. Furthermore, as grotesque, male bodies take on precisely the characteristics regularly attributed to female bodies; they lose form and integrity, become penetrable, suffer the addition of alien body parts, and become alternately huge and tiny. Like women's bodies, the grotesque male body is no longer "clearly differentiated from the world, but transferred, merged, and fused with it."[19]

Several factors insure the centrality of women's bodies to the grotesque. Grotesque figures, like other artistic figurations, were formulated and circulated in the public arena by a male collective. Women did not represent themselves in this arena, but they played a large role in reproducing both human beings and society. Yet women were constructed collectively as the figure "woman" and represented as objects in relation to the male subject. As Biddy Martin has written,

> If women have been marginal in the constitution of meaning and power in Western culture, the question of woman has been central, crucial to the discourse of man, situated as she is within the literary text, the critical text . . . and social texts of all kinds as the riddle, the problem to be solved, the question to be answered.[20]

The female, from the perspective of the collective male public, is constantly and frustratingly mobile between poles of similarity and alienness. Women's ability to overcome the limitations of their sex and achieve intellectual and spiritual accomplishments — to "become male" — was emphasized in the literature of martyrdom and asceticism in the early Christian churches. Women's difference from the normative male was, however, far more frequently noted in medieval Christianity. Male authors wondered frequently whether women have souls; women often seemed, to the men who represented them, to lack the subjectivity they associated with having a soul.

19. Bakhtin, p. 339.

20. Biddy Martin, "Feminism, Criticism, and Foucault," in *Feminism and Foucault,* ed. Irene Diamond and Lee Quinby (Boston: Northeastern University, 1988), pp. 13-14.

Figured as Eve, the perversely bent rib, every woman was seen as essentially grotesque, though the revelation of her hidden monstrosity could be prevented by her careful adherence to socially approved appearance and behavior. The function of this figuration was to identify, define, and thus stabilize a feared and fantasized object. Grotesque figuration contributes the bonus of laughter, permitting relief of tension; the simultaneously feared and desired object becomes comic. For women, in societies in which they were defined as "Eves," the perpetual threat was that their "true nature" would emerge. Only by constant labor could women establish and maintain their identification with images of the "good" woman, the docile, nurturing, obedient woman. Since the grotesque threatened to bleed into public view at any moment, constant vigilance was required, primarily by women but also by the men responsible for them.

Even with the most careful self-scrutiny and male surveillance, however, women harbored an irreducible element of monstrosity.[21] For it was not only female behavior — loquaciousness, aggressiveness, stubbornness — that could at any moment reveal a woman's identity with Eve, but her body itself. Some women were seen as personifications of the grotesque; prostitutes, for example, epitomized the penetrable body, the body shaped by lust, the permeable body that produces juices and smells. The prostitute's body is opposite to the closed, self-contained, controlled male body,[22] and the opposite of that of some virtuous women, especially of virgins, who were "gardens enclosed."[23]

One of the most prominent features of the grotesque is sexuality and the sexual organs.[24] Female sexual organs, sexual activity, and behavior are

21. Peter Stallybrass, "Patriarchal Territories: The Body Enclosed," in *Rewriting the Renaissance,* ed. Margaret W. Ferguson, with Maureen Quilligan and Nancy Vickers (Chicago: University of Chicago, 1986), p. 126.

22. Alain Corbin, "Commercial Sexuality in Nineteenth-Century France: A System of Images and Regulations," in *The Making of the Modern Body,* ed. Catherine Gallagher and Thomas Laqueur (Berkeley: University of California, 1987), pp. 209-19; see also Luce Irigaray, "Volume-Fluidity," *Speculum of the Other Woman* (Ithaca, N.Y.: Cornell University, 1985), pp. 229, 237.

23. Jerome, *Ep.* 22.25, To Eustochium; Nicene and Post-Nicene Fathers (hereafter referred to as NPNF), 32.

24. Sexuality is a prominent part of both Bakhtin's and Harpham's descriptions of the grotesque, but gender is not.

a central object of grotesque figuration. And female reproductive functions, as we will see, were the quintessential terror that must be "conquered by laughter."[25] Bakhtin identifies the three main acts in the life of the grotesque body as "sexual intercourse, death throes, and the act of birth."[26] "Birth and death are the gaping jaws of the earth and the mother's open womb."[27] Rabelais' hero, Pantagruel, emerged triumphantly from the body of his mother by killing her, "for he was so wonderfully great and lumpish, that he could not possibly have come forth in the light of the world without thus suffocating his mother."[28] Pregnancy and birth provide images of "natural" grotesqueness. "Woman with child is a revolting spectacle," Jerome wrote.[29] Pregnancy, like menstruation, reveals that woman's body is not the "closed, smooth, and impenetrable" body that serves as the symbol of individual, autonomous, and "perfect" existence. In menstruation, sexual intercourse, and pregnancy, women's bodies lose their individual configuration and boundaries. "The grotesque body," Bakhtin writes, "is a body in the act of becoming. It is never finished, never completed; it is continually built, created, and builds and creates another body"; the grotesque body "outgrows its own self, transgressing its own body."[30]

In Christianity, conception, birth, and sexual intercourse have frequently focused doctrinal or practical issues. Several brief examples will suffice here. Despite some Christian Gnostics' frequent use of female figures — like Eve — in positive religious symbolism,[31] other gnostic Christians

25. Bakhtin, p. 335; laughter has a special association with the grotesque: "That is why Baubo, who was able to make the goddess Demeter laugh, is represented as an inverted body: 'a woman's body without head or breast, on whose belly a face is drawn: the lifted dress surrounds this sort of face like a crown of hair' "; Freud, *A Mythological Parallel to a Visual Obsession,* quoted by Helene Cixous and Catherine Clement, *The Newly Born Woman* (Minneapolis: University of Minnesota, 1986), p. 33.

26. Bakhtin, p. 352.

27. Bakhtin, p. 329.

28. Rabelais, "Pantagruel," in *Great Books of the Western World* 24 (Chicago: Encyclopedia Britannica, 1952), p. 72.

29. Jerome, *Ep.* 107.11; NPNF, 6.194.

30. Bakhtin, p. 317.

31. Elaine Pagels writes, "Whereas the orthodox often blamed Eve for the fall and pointed to women's submission as appropriate punishment, gnostics often depicted Eve — or the feminine spiritual power she represented — as the source of spiritual awakening"; *Adam, Eve, and the Serpent* (New York: Random House, 1988), p. 66.

balked at the idea that God could have entered the human realm as a helpless infant, born like other human beings, from a woman's body. At the beginning of the third century, the North African orthodox Christian Tertullian taunted his squeamish opponent, Marcion, with the physical details of birth. Two centuries later, one of Jerome's many panegyrics on virginity celebrated the fact that virginity reestablishes the order of creation, before the fall. Although virgins are conceived from men's semen, he said, men are not born from virgins, just as Eve was created from Adam, not Adam from Eve: "A virgin owes her being to a man, but a man does not owe his to a virgin."[32] Similarly, proscriptions on contraception throughout the Christian tradition reveal, not only religious conviction, or even concern for patriarchal control of women's bodies, but also male identification with the helplessness and dependency of the fetus.[33]

Women's "natural" affiliation with bodies has also been accused of creating other problems for men. In Augustine's discussion of fallen sexuality in book 14 of *The City of God,* impotence — not sexual activity or even promiscuity — provided Augustine with an example of the male sexual organ's "insubordination" to the will. A different kind of text, the sixteenth-century witch persecution manual, the *Malleus Maleficarum,* lists first among the powers of witches the ability to cause impotence. With their accustomed precision, the authors define the kind of impotence caused by witches:

> When the [male] member is in no way stirred, and can never perform the act of coition, this is a sign of frigidity of nature; but when it is stirred and becomes erect, but yet cannot perform, it is a sign of witchcraft.[34]

32. Jerome, *Ep.* 48.2, To Pammachius; NPNF, 6.66.

33. S. Francesca Romana's vision of hell, quoted by Camporesi in *The Incorruptible Flesh,* included the detailed account of punishment for contraception or abortion:

> Those women who "by means of a beverage or some other method try not to conceive or to induce abortion, and those who were mother and have murdered their own babies," are drowned "in vats of boiling human blood" and then thrown in an "icy pool," their flesh being torn with "iron hooks," quartered by demonic butchers, their hearts opened and their entrails thrown into a "boiler full of bubbling pitch," but not before they have been roasted "inside the belly of a great bronze serpent of fire, where they howl in agony." (p. 51)

34. *The Malleus Maleficarum of Heinrich Kramer and James Sprenger,* trans. Montague Summers (New York: Dover, 1971), p. 56: "Witches who do such things by witchcraft are by law punishable by the extreme penalty."

Moreover, perennial accusations concerning the "insatiability" of women, though they may relate to an ancient belief that sexual intercourse is enervating and potentially damaging to men,[35] may also expose male anxiety. Like Jerome in the fourth century, the *Malleus Maleficarum* insisted that it was not only the flamboyantly grotesque woman, the prostitute, who is insatiable, but all women. Jerome wrote:

> It is not the harlot or the adulteress who is spoken of; but woman's love in general is accused of being ever insatiable; put it out, it bursts into flame; give it plenty, it is again in need; it enervates a man's mind and engrosses all thought except for the passion which it feeds.[36]

It seems at least worth considering whether men whose female sexual partners were not pleased with sex[37] may have projected on women their unwillingness or inability to give pleasure as evidence of female "insatiability."[38] In any case, women's identification with body in the patriarchal

35. Michel Foucault, *The Use of Pleasure*, chap. 3, "Risks and Dangers," trans. Robert Hurley (New York: Pantheon, 1985), pp. 117ff.; Aline Rouselle, *Porneia, On Desire and the Body in Antiquity*, chap. 1, "The Bodies of Men," trans. Felicia Pheasant (Oxford: Basil Blackwell, 1988), pp. 5ff.

36. Jerome, *Against Jovinian* 1.28; NPNF, 367.

37. Midwives and female physicians frequently reported women's sexual discontent; Helen Rodnite LeMay, "Some Thirteenth and Fourteenth Century Lectures on Female Sexuality," *International Journal of Women's Studies* 1 (1978): 391-99.

38. Some medical treatises in antiquity and the Middle Ages urged the necessity or usefulness of female sexual pleasure for conception; Aline Rouselle discusses the process by which female sexual pleasure came to be regarded as incidental to conception and thus unimportant. Greek women, as reported in the *Hippocratic Collection*, insisted that they could not conceive without reaching orgasm; however, "Aristotle discovered, or at least he was the first to state, that women would conceive even if they did not reach orgasm." Following Aristotle, Soranus and Galen held that "women conceived without feeling anything"; Rouselle, pp. 29ff. There is evidence, however, that the issue of the role of female pleasure in relation to conception was not settled by Aristotle's discovery; interestingly, his eleventh-century Arab follower, Avicenna, transmitter to the West of Aristotelian philosophy, "writes in some detail of how a woman may not 'be pleased by' the smallness of her mate's penis 'wherefore she does not emit sperm: and when she does not emit sperm a child is not made' "; Thomas Laqueur, "Orgasm, Generation, and the Politics of Reproductive Biology," in *The Making of the Modern Body*, ed. Catherine Gallagher and Thomas Laqueur (Berkeley: University of California, 1987), p. 9. Helen LeMay, writing on Anthonius Guainerius's early-fifteenth-century *Tractatus de matricibus* (Treatise on the womb), strongly advocates that women's pleasure contributes to conception, giving detailed instruc-

societies of the Christian West resulted in the apparently contradictory charges that they both caused impotence and were tirelessly lustful.

The grotesque, as we have seen, is difficult or impossible to define with precision, but it can be characterized. Three major rhetorical and pictorial devices contribute to grotesque presentation: caricature, inversion, and hybridization. Each of these devices has a specific connection to women, their bodies, and their behavior. The special affiliation of the female body with the grotesque is founded on the assumption that the male body is the perfectly formed, complete, and therefore normative body. By contrast, all women's bodies incorporate parts (like breasts, uterus, and vagina) and processes (like menstruation and pregnancy) that appeared grotesque to the authors and artists who represented women.[39] The female body is inherently volatile, the "source of change, disruption, and complication."[40] Twentieth-century analysts of the grotesque — Kayser, Bakhtin, Harpham — fail to notice the gender assumptions imbedded in grotesque art and literature, with the effect that they ignore a structural feature of this genre.

Ultimately, the function of gender in grotesque art and literature can be understood in detail only when their culturally specific interpretive associations — social and sexual arrangements, and class affiliations — are accurately identified. Gender roles and expectations within the society must also be taken into account. The same rhetorical or pictorial device, applied to a male figure, may take on a very different meaning and value when applied to a female figure. In societies, for example, in which women are considered beautiful only if they are small, thin, and fine-boned, caricature featuring monstrous size has quite different connotations when

tions on how a man should act to please his partner. In none of this learned debate is women's pleasure desirable in itself, of course, but only as an aid to conception; "Anthonius Guainerius and Medieval Gynecology," "Trotula: Women's Problems and the Professions of Medicine in the Middle Ages," ed. John Benton, *Bulletin of the History of Medicine* 59 (1985): 30-53.

39. For example, sinister and grotesque powers, associated with women's physical condition or spiritual commitments, were conjectured; menstruating, post-menopausal women, and witches were frequently accused of possessing a visual ray capable of poisoning the plant, animal, or person on which it falls; LeMay, "Lectures on Female Sexuality," p. 394.

40. Helena Michie, *The Flesh Made Word: Female Figures and Women's Bodies* (New York: Oxford University, 1987), p. 7.

applied to male or to female figures. Associated with men, monumental size, whether of the total body or of particular parts of the body, commands both respect and admiration. Thus the "magnificent" and hugely proportioned codpiece of Rabelais' hero, Pantagruel, carried a very different social meaning than that of the yawning vaginas of medieval sheelas. Massive male sexual organs are figures of pride, self-assertion, and aggression; massive female genitals, however, are likely to represent women's dangerous propensities for threatening men's self-control, autonomy, and power.[41]

The specific associations of a grotesque figure in relation to its society of origin, however, cannot always be reconstructed in detail. Historians frequently miss the joke, alerting us to the irreducible alienness of the society we study.[42] Nevertheless, agreement across the diverse societies of the Christian West on the symbolic valence of female nakedness as representation of sin — and the grotesque — is remarkable. Our attention in this essay is on the literary and pictorial devices by which these continuities were reproduced, often in surprising disjunction from fluctuations in women's roles, opportunities, and contributions within societies.

We turn now to examining three characteristic devices of grotesque figuration: caricature, inversion, and hybridization. Caricature often reveals, with economy and clarity, social consensus on what is to be avoided. The extreme example inevitably discloses what it is that socialization aims to prevent.

Caricature isolates and fetishizes parts of the body. In theological and medical discourse as well as in the popular arts of the Christian West, the vagina and uterus have frequently been an object of caricature, both in explicit and concealed ways.[43] Perhaps the most sublimated caricature of the uterus appears in paintings and writings in which hell is represented as uterus-shaped. Similarly, the vagina appears covertly in icons and paintings as the mouth of hell. The frontispiece of John Climacus's *The Ladder of Divine Ascent* shows monks who are climbing the ladder of ascent to God

41. For a detailed exploration of women as threatening in the works of Machiavelli, see Hanna Fenichel Pitkin, *Fortune Is a Woman: Gender and Politics in the Thought of Niccolo Machiavelli* (Berkeley: University of California, 1987), chap. 5.

42. Robert Darnton, *The Great Cat Massacre* (New York: Vintage, 1985), p. 5.

43. LeMay, "Anthonius Guainerius," pp. 320ff. John S. Haller and Robin M. Haller, *The Physician and Sexuality in Victorian America* (Urbana, Ill.: University of Illinois, 1974), pp. 8, 9; see also Ian Maclean, *The Renaissance Notion of Woman* (Cambridge: Cambridge University, 1980), pp. 40ff., for attitudes toward the uterus.

Fig. 4.3. Sheela on a Corbel, 1140s, Kilpeck, Ireland

being pulled by tiny demons; some of the monks fall into an open, sucking mouth/vagina on the earth's surface. Women's mouths, tongues, and speech have also frequently been correlated with the vagina — open when they should be closed, causing the ruin of all they tempt or slander.[44] The association of garrulousness with wantonness was part of a well-established polemic against women across many societies of the Christian West.

Popular culture shared with learned theological discourse a fascination and horror of female genital organs. Female grotesques and sheelas, often on the facades of churches, displayed their splayed vaginas (fig. 4.3), reminding viewers of the dangerous power of female sexual organs. Jørgen Andersen has documented the development of the sheela motif from French Romanesque corbels and capitals to its extensive use in England and Ireland during the later Middle Ages. This development evolved from naked female figures, "aggressively displaying their genitals," to horrific figures with skeletal ribs, skull-like heads, and a large genital hole in frontal exhibition. Commenting on the use of sheelas in religious architecture, Andersen shows his unwillingness to explore gender assumptions — his own or those of the societies in which sheelas were used in public church architecture — when he writes, "Devotion does not shrink away from showing the things that drag men down, grotesque shapes, frightening and ludicrous."[45] The "frightening, evil-averting influence of the *vulva*,"[46] according to Andersen, lies behind the continued use of these female figures for about three hundred years; the sheela was a "demonic figure yielding protection against the demons."[47] These figures were often placed

44. Stallybrass, examining sixteenth-century rhetoric on women's bodies, quotes Barbaro's treatise *On Wifely Duties:* "It is proper that not only arms, but indeed the speech of women never be made public; for the speech of a noble woman can be no less dangerous than the nakedness of her limbs." Stallybrass comments: "The signs of the 'harlot' are her linguistic 'fullness' and her frequenting of public space" (p. 127).

45. Jørgen Andersen, *The Witch on the Wall: Medieval Erotic Sculpture in the British Isles* (Copenhagen: Rosenkilde and Bagger, 1977), p. 37; compare the account in the third-century "Acts of Paul and Thecla" in which Thecla, condemned to death by wild beasts in the colosseum, repulses a lion by exhibiting her vagina; Elizabeth Clark, trans., *Women in the Early Church* (Wilmington, Del.: Messages of the Fathers of the Church, 1983); see also Saint Ambrose's citation of this incident: *Concerning Virgins* 3.19; NPNF, 10.361.

46. Andersen, p. 48.

47. Andersen, p. 121.

above doors to repel intruders.[48] Male fear of the vagina is evident, at least in Andersen's explanation and, if his explanation of sheelas' popularity is correct, in the Christian societies in which sheelas were portrayed: "Like the frontal face, [the vagina] has the power to ensnare the viewer's glance and hence capture his subjectivity or selfhood."[49]

The second device employed in grotesque presentation is inversion. Inversion refers to the reversal of an expected and pleasing appearance to produce a disturbingly inverted image. As many medical historians have shown, women's genitalia and reproductive organs were thought to be the precise inversion of men's.[50] Thomas Laqueur's article "Orgasm, Generation, and the Politics of Reproductive Biology," in *The Making of the Modern Body*, reproduces illustrations by Leonardo and Vasalius of the homologies of female and male reproductive organs. These drawings were prompted by arguments that go back to the earliest Greek treatises on female physiology. According to Aristotle's account, woman "is characterized by deprived, passive, and material traits, cold and moist dominant humors and a desire for completion by intercourse with the male."[51]

Aline Rouselle has discussed the origins of this construction of reproduction and female sexuality in Greek medical treatises like the *Hippocratic Collection*.[52] She writes, "Male doctors who had no knowledge of female anatomy or physiology, but fantasies only, used logical reasoning to construct a male science of the female body."[53] The vocabulary with

48. Andersen, p. 70.

49. Fascination and horror of the vagina not only are apparent in the Christian West, but appears cross-culturally in images of the *vagina dentata*, the vagina equipped with rows of sharp teeth capable of trapping and castrating the male who has intercourse with her. Erich Neumann describes the *vagina dentata* as "the destructive side of the Feminine, the destructive and deadly womb that appears . . . in the form of a mouth bristling with teeth." In cultures in which the *vagina dentata* plays a large role in mythology, "the hero is the man who overcomes the Terrible Mother, breaks the teeth out of her vagina, and so makes her into a woman"; Jill Raitt, "The *Vagina Dentata* and the *Immaculatus Uterus Divini Fontis*," *Journal of the American Academy of Religion* 48, no. 3 (September 1980): 415-31.

50. For descriptions of the female body from medical texts of the ancient, medieval, and Renaissance periods, see Maclean; Rouselle; and LeMay, "Anthonius Guainerius" and "Lectures on Female Sexuality."

51. Maclean, p. 30; Aristotle, *De generatione animalium* 1.2.

52. Rouselle, chap. 2; see also Maclean, chap. 3.

53. Rouselle, p. 26.

which female genitals were described demonstrates the assumption of the normativity of the male body. Except for the uterus and the cervix, the female reproductive system was described as the inverted equivalent to the male:

> The ovaries were testicles and the Fallopian tubes, which they described perfectly, were a *vas deferens*. They even spoke of female sperm. . . . [Male doctors] explained that "the internal genital organs surround the neck of the womb just as, in men, the foreskin grows around the glans."[54]

Galen wrote:

> Turn outward the woman's, turn inward, so to speak, and fold double the man's, and you will find the same in both in every respect. . . . You could not find [in the female] a single male part left over that has not simply changed its position.[55]

In short, female sexual and reproductive organs are male organs turned outside in. Physiological homologies, however, seem only to dramatize the difference and asymmetrical value of male and female bodies. Women lack the necessary heat, Galen says, to turn the sexual organs outward. Lacking heat, female physical organs cannot achieve the perfection of the male body. Moreover, relative heat defines one's ontological value:

> Humans are the most perfect of animals, and men are more perfect than women by reason of their "excess of heat." . . . The male is a hotter version of the female, or, to use the teleologically more appropriate order, the female is the cooler, less perfect version of the male.[56]

54. Rouselle, pp. 26-27; Oribasius, *Medical Collection* 24.32.

55. Quoted in Laqueur, "Orgasm," p. 5; Galen, *On the Usefulness of the Parts of the Body*, ed. and trans. Margaret May, 2 vols. (Ithaca, N.Y.: Cornell University, 1968), 2:640; this picture of the female body remained virtually uncontested until 1829 when Carl Ludwig Klose argued that "the uterus, woman's most important sex organ, has no analogue in man; hence the comparison with men's organs is worthless"; Londa Schiebinger, "Skeletons in the Closet: The First Illustrations of the Female Skeleton in Eighteenth-Century Anatomy," in *The Making of the Modern Body*, ed. Catherine Gallagher and Thomas Laqueur (Berkeley: University of California, 1987), p. 53.

56. Laqueur, "Orgasm," p. 4.

Moral consequences also attend the inverted female body. In the sixteenth century an Italian anatomist, Prospero Borgarucci, acknowledged the traditional thesis of female physical inferiority. He gave it a different interpretation, however, saying that women's physical equality with men was guaranteed by their inverted sexual organs. Because of women's moral inferiority, he wrote, they should remain in ignorance of their physical equality:

> Woman is a most arrogant and extremely intractable animal; and she would be worse if she came to realize that she is no less perfect and no less fit to wear breeches than man. . . . I believe that is why nature, while endowing her with what is necessary for our procreation, did so in such a way as to keep her from perceiving her sufficient perfection. On the contrary . . . to check woman's continual desire to dominate, nature arranged things so that every time she thinks of her supposed lack, she may be humbled and shamed.[57]

Different accounts of generation by various ancient, medieval, and Renaissance authors explain female lack in various ways. All, however, compare the female to the normative male and find the female body and/or "nature" deformed and defective. The uterus, which has no counterpart in the male body, was thought to be a woman's most important sex organ as late as the nineteenth century.[58] Thus, women's ills — from lack of appetite to hysteria — were diagnosed as attributable to malfunctioning of the uterus. Sex difference was usually reduced to biological difference, and biological difference was made to account, not simply for female inferiority, but also for female evil. Evidence that men found women different and dangerous is abundant throughout the history of Christianity.[59]

Clearly, woman was seen as inferior, but was she seen as monstrous? Theologians, philosophers, and medical authors discussed the question of whether woman is a "monstrous creation." Although Aristotle had said in the *Metaphysics* that women are not of a different species than men, his description of the birth of females as an incomplete generative act fur-

57. Quoted by Raitt, p. 422.
58. Carl Ludwig Klose, cited in Schiebinger, p. 53.
59. Page duBois, *Sowing the Body: Psychoanalysis and Ancient Representations of Women* (Chicago: University of Chicago, 1988), p. 184.

nished grounds for inferring the inferior status of women. Thomas Aquinas, in one text, casually assimilated individual women to "other monsters of nature," though he says that "in the general plan of nature," women are not monstrous.[60] That the question could be raised and discussed at all, that the monstrosity thesis could be posed and argued against in serious debate, may be astonishing. It perhaps becomes less so when we remind ourselves that it is the figure "woman," not the actual women of everyday experience, which was under discussion. Nevertheless, women in Christian societies were not unaffected by the public representation of them as defective in body and mind. A perennial open question as to whether women were human beings with souls, surfacing repeatedly in learned debate and popular caricature, cannot have failed to generate hostility toward women and, for women themselves, problematic self-images.

A third device for producing grotesque figuration is that of hybridization. The German artist Albrecht Dürer wrote: "If a person wants to create the stuff that dreams are made of, let him mix freely all sorts of creatures."[61] The grotesque body is a random combination of disparate parts, without functional integrity. Hybridization typically isolates organs and appendages of humans, animals, fish, and birds to reconnect them to other bodies at random. Some grotesques, however, "are not true hybrids at all in the sense that, in them, generic lines are not crossed." Bakhtin discusses one such instance, some terra-cotta figures of laughing, senile, pregnant hags. These figures, rather than conflating the parts of different bodies, conflate "the poles of the biocosmic cycle."[62] In other words, they exhibit the different stages or periods of woman's life — pregnancy and senility — in one figure; they represent birth and death simultaneously.

The female body, even without the usual device of hybridization, appears to be innately and simultaneously fascinating and terrifying. Even in the twentieth century, interest in isolated body parts is evident in advertising images as well as in pornography; in contemporary communication media, women are still encouraged to think of themselves as parts that must be evaluated, judged, and altered separately: "big thighs," small breasts, or skinny legs.

60. Thomas Aquinas, *De veritate* 5.9.d.9: "nisi ergo esset aliqua virtus quae interderet femineum sexum, generatio feminae esset omnino a casu, sicut et aliorum monstrorum."
61. Quoted by Kayser, p. 22.
62. Bakhtin, pp. 25-26.

Finally, a figure that deserves the label "grotesque" must be perceived as such by someone. "To be [grotesque]," in Berkeley's famous aphorism, "is to be perceived [as such]." No set of features, or lack of features, automatically qualifies a figure as grotesque. Kayser remarks, "The grotesque is experienced only in the act of reception. . . . it is entirely possible that things are regarded as grotesque even though structurally there is no reason for calling them so."[63]

Thus far, I have summarized the relationship of the female body to grotesque figuration, focusing on the long period of the Middle Ages. Aristotle's doctrine of woman as a misbegotten and deformed male crossed easily into Christian speculation about Eve and her secondary and derivative creation. Eve as "woman" was also identified with the physical enormities and deformities brought about by sin, menstruation, pregnancy, and childbearing. I have not attempted to relate the figure of woman, with its simultaneous fear and ridicule of her body, to the social roles and situations of actual women. Rather, I have reconstructed a composite and cumulative picture of a dominant literary and pictorial presentation of "woman." The figure "woman" carried remarkable continuity across medieval societies and appears to have relied very little on what actual women were doing. It is, in fact, very important to differentiate the figure Eve/woman from actual women in order to grasp the staying power of a figure which must have contradicted the experience of many men and most women. We can sometimes reconstruct the ways in which women were obliged to take "woman" into account, as this figure informed laws, religious ideas and practices, and intimate relationships. At the end of the medieval period, the sheer cumulative weight of "woman" insured that this figure survived the sixteenth-century social, ecclesiastical, and political upheavals. Although "woman" was never a completely monolithic image, it became the focus of an intense discussion at the end of the sixteenth century.

In 1595, a debate on the subject of "woman" was initiated by an anonymous German tract, *A new disputation against women, in which it is proved that they are not human beings.* The satirical tract was refuted and rebutted by various authors, and the debate became widespread in intellectual circles; the tract was repeatedly republished and published in trans-

63. Kayser, p. 181.

lation.[64] In Roman Catholic circles, the question of whether woman has a soul was still sufficiently unsettled so as to require discussion and a pronouncement — in affirmation that woman has a soul — at the Council of Trent.

In order to understand the gender politics involved in such discussions, it will be helpful to sample three kinds of sixteenth-century literature in which textual treatment of women reveals the presence of a conflict that reaches beyond the textual and into society. Devotional literature, sermons, manuals of manners, and satirical works all exhibit the "structural congruence" that indicates an agreement of the public culture on "woman."[65] These writings also reveal the identification of the grotesque female body with the figure "woman," and prescribe a governance of actual women appropriate to "woman's" characteristics.

Beginning in the sixteenth century, it becomes possible for historians to estimate the popularity and probable influence of particular books on the reading public. With the invention of printing presses at the end of the fifteenth century, information about the number of books printed and sold is usually available. One of the most popular devotional manuals of the sixteenth century, Erasmus of Rotterdam's *Enchiridion militis Christiani* (Manual of the Christian soldier), uses "woman" as a rhetorical figure with which to contrast the commitment, training, and courage of the Christian soldier. This book was published in thirty editions in the first twenty years after its initial publication in 1503; there were dozens more publications and six translations before the end of the sixteenth century.[66] Erasmus called his manual "a kind of hand dagger," a "little blade,"[67] that would help the reader to recognize that "mortal life is nothing but a kind of

64. Thomas's conclusion was too theologically nuanced to affect popular thinking on the issue. Thomas found that "Woman is made in the image of God insofar as image is understood to mean 'an intelligent nature'; but insofar as man, and not woman is, like God, the beginning and end (of woman), woman is not in God's image, but in man's image, being created *ex viro propter virum.*" For Augustine's and Thomas's conclusions on the question, see Maryanne Cline Horowitz, "The Image of God in Man — Is Woman Included?" *Harvard Theological Review* 72, nos. 3-4 (July-October 1979): 175-206.

65. Maclean, p. 12.

66. Ellen Messer-Davidow, "The Philosophical Bases of Feminist Literary Criticism," *New Literary History* 19, no. 1 (autumn 1987): 85.

67. *The Enchiridion of Erasmus,* trans. Raymond Himelick (Bloomington: Indiana University, 1963), preface.

perpetual warfare."[68] Throughout the manual, he says, he uses "woman" as a cipher for sensuality, doubt, and hesitancy; he uses "man" and "manly" to designate courage.[69]

According to the *Enchiridion*, lust is the most debilitating vice the soldier can indulge: "no evil attacks us earlier, pricks us more sharply, covers more territory, or drags more people to ruin."[70] When "filthy sensuality" inflames the mind, the "weapons" of certain thoughts should prevent the soldier from succumbing:

> First of all, think how foul, how base, how unworthy of any man is this pleasure which reduces us from an image of divinity to the level, not merely of animals, but even to that of swine, he goats, dogs, and the most brutish of brutes.[71]

The soldier should next think how transient and spurious sexual pleasure is, and how unworthy of the human body, the "temple of God." Contemplating the loss of his reputation should be his next "weapon" against lust. Examples of those who have resisted, moreover, should help the soldier to "stiffen your continence." But the primary device by which the Christian soldier can resist lust is to picture the female body as grotesque: "How unworthy and disgraceful it is to touch the disgusting flesh of a whore . . . to handle loathsome filth."[72] Erasmus's vivid language paints the prostitute's body as monstrous, a "stinking hog wallow of lust."[73] The ancient fear that sexual intercourse can damage health can also help to steel the soldier against lust, a fear that had fresh content at the beginning of the sixteenth century because of the virulence of the syphilis epidemic: "[Lust] destroys at the same time the vigor and attractiveness of the body. It damages health and produces countless ailments, all of them disgusting."[74] Finally, the soldier must consider how he must look to others:

68. *The Enchiridion of Erasmus*, p. 58.
69. *The Enchiridion of Erasmus*, p. 48.
70. *The Enchiridion of Erasmus*, p. 87.
71. *The Enchiridion of Erasmus*, p. 177.
72. *The Enchiridion of Erasmus*, p. 182.
73. *The Enchiridion of Erasmus*, p. 160.
74. *The Enchiridion of Erasmus*, p. 178; Erasmus also adds a graphic picture of the soldier wasted by lust; one thing leads to another: "once pleasure has been tasted it will cloud and beguile your reason in such a way that you will proceed from one nastiness to another until you blindly arrive at a depraved state of consciousness and, hardened in evil,

And imagine to yourself just how ridiculous, how completely monstrous it is to be in love: to grow pale and thin, to shed tears, to fawn upon and play the beggar to the most stinking tart, to croak and howl at her doors all night, to hang upon the nod of a mistress, to endure a silly woman's dominating you, flying at you in rage, and then to make up with her and voluntarily offer yourself to a strumpet so she can play upon you, clip you, pluck you clean! Where, I ask you, in such behavior is the name of a man? Where's your beard? Where is that high mind fashioned for the most beautiful things?[75]

Erasmus assures the soldier: once you have "proffered your miserable neck to Dame Lechery, you will cease to be your own master." The *coup de grace* to complete these thoughts and to conquer lust is the thought of unexpected, swift death. Throughout the *Enchiridion*, female figures — Eve, Dame Lechery, and prostitutes — signal potentially fatal enemies of the Christian soldier.

The *Enchiridion militis Christiani* knows only two types of women: "tarts" and wives. Instructions on how to love one's wife, like admonitions against consorting with other women, do not suggest that women have either subjectivity or unique personality characteristics. Warning against loving one's wife "only because she provides you with sexual pleasure," Erasmus urges instead that "you love her most deeply because in her you have seen the likeness of Christ, that is to say, goodness, modesty, sobriety, chastity." Only then will the reader "love her now not in herself but in Christ [and] in reality you love Christ in her; and so at last you love in a spiritual sense."[76] It is difficult to tell from these brief instructions whether Erasmus imagines that the repeatable traits of character which he says ought to be the object of love are simply pieces of Christ that can appear in many people, or whether the woman is to be valued and loved as a unique configuration of these virtues.[77] There is not, in any case, any

cannot leave off sordid pleasure even when it has already left you in the lurch — something we see happen in many cases, as when, with worn out bodies, raddled looks, rheumy eyes, men still itch without ceasing and are more scandalously obscene in their talk than they were once shameless in practice. What can be more monstrous and deplorable than this condition?" (p. 181).

75. *The Enchiridion of Erasmus*, p. 179.

76. *The Enchiridion of Erasmus*, p. 83.

77. Broadbent's reminder is relevant here: "To love the attribute is to evade the identity"; *The Body as Medium of Expression*, ed. Jonathan Benthall and Ted Polhemus

suggestion that heterosexual relationships might provide a format for mutual learning and growth; sex, even within Christian marriage, remains problematic at best:

> If you are married, think how admirable a thing is an undefiled bed, and try as hard as you can to make your marriage resemble the most holy wedlock of Christ and his Church, whose likeness it bears. That is to say, see to it that it has as little lewdness as possible, and as much fruitfulness, for in no status of life is it not most abominable to be a slave to lust.[78]

In religious literature like the *Enchiridion*, the female body, from the perspective of the male author, is a dangerous provocation for male lust. In *The Praise of Folly*, Erasmus evoked the supreme authority of Plato for an egregious misreading of *Timaeus* 91A: "Plato seems to doubt whether woman should be classed with brute beasts or rational beings."[79] If we look in other contemporary literatures, the "woman problem" appears in similar configurations. Exploring the composite image of woman in books of manners, sumptuary laws, and sermons, Peter Stallybrass has found the public image of the female body in the sixteenth and seventeenth centuries to be what he calls a "naturally grotesque body." The female body, seen as "naturally" unfinished, must be subjected to the constant surveillance advocated in books of manners, sumptuary laws, and sermons. According to legislators of social order in the sixteenth and seventeenth centuries, woman's tongue, like her body, must be strictly governed, and there is no surer sign of a woman who is sexually loose than that her speech is unrestricted, both as to quantity and to its exercise in the public sphere. "The signs of the 'harlot,'" Stallybrass says, "are her linguistic 'fullness' and her frequenting of public space."[80] Barbaro, in the treatise *On Wifely Duties*, warned that "the speech of a noble woman can be no less dangerous than the nakedness of her limbs."[81]

(London: Allen Lane, 1975), p. 306. See Martha Nussbaum's discussion of Aristotle's view of love between persons: *The Fragility of Goodness, Luck, and Ethics in Greek Tragedy and Philosophy* (Cambridge University, 1986), p. 357 and passim.

78. *The Enchiridion of Erasmus*, p. 182.
79. *The Enchiridion of Erasmus*, p. 31.
80. Stallybrass, p. 127.
81. Stallybrass, p. 127.

Stallybrass shows that a complex discourse surrounded the mapping of woman's body as the paradigm and site of the well-being or betrayal of the family economy and state. " '*Covert*,' the wife becomes her husband's symbolic capital; 'free,' she is the opening through which that capital disappears."[82] By means of surveillance, education, and, if necessary, violence, woman can become the exemplar of the well-governed state — orderly, silent, submissive, and closed. Ancient metaphors of woman's body as (re)productive earth[83] are, in this early modern discourse, extended to liken women's bodies to enclosed, cultivated, controlled properties, colonized terrain, the potentially valuable property of a father or husband.[84] In Kenneth Burke's words, however, "Property fears theft because it is theft";[85] thus a constant anxiety pervades this discourse of ownership, control, and training, especially since both medical and theological discourse of the time identified women with irrationality and irresponsibility,[86] voracious sexuality and heretical subversiveness. The grotesque, "unfenced" or wild, female is repeatedly painted in lurid terms as both opposite of the "closed and enclosed" woman and cause of the financial and moral ruin of her male owner.

Sixteenth-century perceptions of the dangers of the wantonly open, permeable, and unconfined body of woman must be seen in the light of the social function of such figures. Until the present century, "openness" has not been an honorific characterization of the individual or

82. Stallybrass, p. 128.

83. Discussed by duBois.

84. Stallybrass, p. 133.

85. Quoted by Stallybrass, p. 135.

86. Compare Boccaccio's statement, placed in the mouth of a young woman, with a twentieth-century parallel. The fourteenth-century author wrote: "Any young girl can tell you that women do not know how to reason in a group when they are without the guidance of some man who knows how to control them. We are fickle, quarrelsome, suspicious, timid, and fearful. . . . Men are truly the leaders of women, and without their guidance, our actions rarely end successfully"; *Decameron*, trans. Mark Musa and Peter Bondanella (New York: Mentor, 1982), pp. 15-16. The twentieth-century example is from *One Day at a Time in Al-Anon* (New York: Al-Anon Family Group, 1987): the story is told of a man, despairing over the alcoholism of his wife, who joined an Al-Anon group which happened to be all women. Finding it (understandably, the text implies) difficult to "identify with the problems of 'a bunch of gals,' " he was instrumental in getting several other men to join the group. "Finally everyone in the group gratefully realized that the men in the group gave it a stamina and workability it might never have had otherwise."

society. Rather, in societies in which cultivated earth was rarer and thus more valued, the unfenced, uncultivated, and wild did not play a twentieth-century role in the imagination. In twentieth-century North America and Western Europe, the frontier has long vanished and heavily appropriated earth predominates over wilderness. By contrast, in the context of a preponderance of wilderness, patriarchal societies used the female body to represent unconquered, ungoverned wilderness. Woman, precisely because she was thought to be so naturally averse to enclosure, represented the possibility of domestication. In intransigent surveillance and cultivation, woman's psyche and body could be shaped by patriarchal virtues. Agricultural metaphors described the necessary pruning, discipline, and hard labor by which women could train themselves, and be trained by their societies, to accommodate to physical and mental enclosure. She could then be recognized in the public sphere as a valuable property.

Modish female clothing of the sixteenth century also demonstrates the confinement of women's bodies. Stylish Renaissance dress "requires long, heavy skirts spreading out from below a tiny rib cage, encased in a meagerly cut bodice with high, confining armholes."[87] Sandra Clark, examining a similar literature to that used by Stallybrass — sermons, pamphlets, and books of manners — found a sustained polemic against women who were apparently wearing men's clothing, thereby enjoying greater freedom and ease, but also, according to these contemporary authors, threatening the very order and stability of society itself.[88] The 1620 anonymous pamphlet "Hic Mulier, Haec Vir" (The man-woman) reveals the connection between confining dress and the woman who is "closed," impenetrable to males other than her own jealous guardian. The pamphlet finds cross-dressing the "symptom of a more general social decadence" in that sexual differentiation in clothing was considered "natural" and "God-ordained." Predictably, the time-honored allegations that women who transgress the restrictions placed on them by patriarchal societies do so in order to indulge their unlimited sexual appetites are reiterated by "Hic Mulier." The author characterizes the behavior of women who wear men's

87. Anne Hollander, *Seeing through Clothes* (New York: Avon, 1975), p. 99.
88. Sandra Clark, " 'Hic Mulier, Haec Vir': The Controversy over Masculine Women," *Studies in Philology* 82, no. 2 (1985): 157-83.

clothing as "eyes wandering, lips bylling, tongue inticing, bared breasts seducing, and naked arms imbracing."[89]

By contrast, the "chaste and impregnable exterior" presented by the virtuous and well-guarded woman is described in the metaphor of a locked house, "having euery window closed with a strong casement, and euery Loope-hole furnisht with such strong Ordnance, that no vnchaste eye may come neere to assayle them."[90]

A similar evaluation of woman appears in a very different sixteenth-century literary genre. Rabelais' satire caricatures woman's "open body," as did medieval sheelas. In *Pantagruel,* book 2, chapter 15 reveals the combination of horror and fascination, and ridicule, with women's genitals we have noticed in an earlier period. Rabelais tells of a lion who, on seeing a woman's genitals, cries out, "O poor woman, who hath thus wounded thee?" Conferring with his friend the fox concerning this prodigy, the lion explains that:

> They have hurt this good woman here between the legs most villainously. . . . See how great a wound it is, even from the tail up to the navel, in measure four, nay five handfulls and a-half. This is the blow of a hatchet, I doubt me, it is an old wound.[91]

Rabelais combines standard devices of the grotesque — exaggeration, anthropomorphized animals — with the implicit assumption that the male genitals are normative while female genitals, by contrast, are grotesque. Horror is kept at bay by its debasement to ridicule. Ian Maclean concludes his description of the sixteenth-century discussion of whether women are monstrous with the observation that the number of sixteenth-century refutations of the female monstrosity thesis is itself significant, indicating, if nothing else, the intensity of the discussion.[92]

Images of the female body across the societies of the West from classical Greece forward must be examined both for continuities and for particularization in various times and places. Patriarchal cultures, across their enormous dissimilarities, share a common need to preserve what is thought of simply as "order." A central component of maintaining and reproducing social order is the management of women. The primary

89. Sandra Clark, p. 170.
90. Quoted by Sandra Clark, p. 170.
91. Rabelais, *Pantagruel,* p. 96.
92. Maclean, p. 31.

strategy for the control of women is their public representation. As Michel Foucault has argued, "strong power" has no need to resort to force; it operates by attracting most of the people most of the time to adherence to the values and behavior necessary to the society's perpetuation. Consequently, it is not surprising that images of and attitudes toward women's bodies show continuity across centuries in patriarchal cultures. These continuities should not be attributed to literary influence. Metaphors of woman as earth, real estate — house, garden, or field — for example, function within, and are intimately connected to, economic and political situations, as Peter Stallybrass and Page duBois have demonstrated for vastly different societies.[93]

Moreover, the texts that relay these figures of woman testify to their recognized capacity for directing women into the precise social locations in which they most adequately contribute to the reproduction of society — cultural and economic as well as literal reproduction. Figures of woman can effectively incite both women and men to adopt certain self-images, or attitudes, and behavior, even when the texts in which representations of woman appear are not addressed to women at all, but rather to men. Men must receive coordinated cumulative information about woman's nature and body if they are to manage women with the confidence that they understand their familial and social roles. In patriarchal societies, it is men who must supply the education or, if education fails, the force that insures that actual women will accept these roles. The tract "Hic Mulier" ended by calling upon men to "assert their superiority by withholding 'necessarie maintenance' from their womenfolk until they behave themselves and recover their proper sense of duty."[94]

Gender constructions play a crucial role in constructing the category of the grotesque and therefore must be a part of any analysis of what constitutes grotesqueness. Fear of women comes from men's need to control a similar but different being — one that is intimate but unknown. In the patriarchal societies of the Christian West, "woman" was mysterious and ultimately grotesque because women did not represent themselves; lacking conditions for self-representation — collective voice and access to the public sphere — women were represented by men's anxieties, fears, and fantasies.

93. See n. 21 above for Stallybrass, n. 59 above for duBois.
94. Sandra Clark, p. 172.

5. Hieronymus Bosch: The Grotesque and We

WOLFGANG STECHOW

As early as 1783, Karl Philipp Moritz remarked that "by means of the impersonal 'it' we seek to express that which lies outside of the sphere of our concepts and for which language has no name." In 1957, the late Wolfgang Kayser, in his fundamental book *The Grotesque in Art and Literature,* referred to this passage as he ventured his own definition of the grotesque as the objectification of the "it" in that sense, and he pointed out that "if we were able to name these powers [i.e., the demons, the apocalyptic beasts, etc.] and assign them a place in the cosmic order, the grotesque would lose essential qualities."[1]

Kayser's book contains a conscientious chronicle of the vicissitudes of the term *grotesque* throughout a long span of time, but it seems to me that with the "it" quality its author has indeed hit upon the most important bond between almost all those meanings. Even a Raphael grotesque, that harmless Renaissance resuscitation of an antique ornamental device, contains some germs of a substance which will not fit into the normal cosmic order,[2] and as Raphael's basically gay and unproblematic ornament was taken over and transformed by his Mannerist followers such as Agostino

1. Wolfgang Kayser, *Das Groteske, seine Gestaltung in Malerei und Dichtung* (Oldenburg, 1957), pp. 199, 226 n. 5; English ed.: *The Grotesque in Art and Literature,* trans. Ulrich Weisstein (Bloomington, Ind., 1963), pp. 185, 209.

2. Kayser, pl. 2.

113

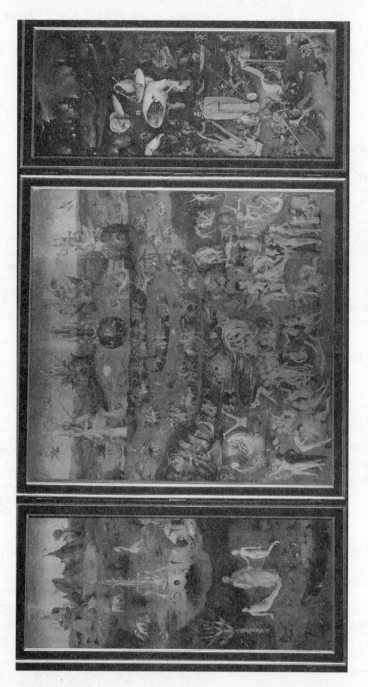

Fig. 5.1. Hieronymus Bosch, *The Garden of Earthly Delights*, ca. 1510

Veneziano,[3] that gaiety is rapidly replaced by a quality which even we, in the twentieth century, still sense to be weird and deeply disturbing: the nameless takes over from the well defined, and we are at once transposed into an ambience in which certain trends of fully developed Mannerism, of *Sturm und Drang,* of Romanticism and the magic isms of our time do indeed find themselves thrown together.

But even the Renaissance grotesque was preceded by the "absurdities" of Hieronymus Bosch, who died as early as 1516, and here we are confronted with an enigma which has occupied nearly all of us at some time or other and has seduced many good minds into indulging in absurd hypotheses. At the root of this enigma lies the fact that Bosch's art was the product of a thoroughly orthodox religious ambience which cannot be compared with that within which the later creators of the pictorial "it" worked. It is not the result of the kind of religious fervor we find in certain paintings by Pontormo, by Rosse, by El Greco; it has nothing to do with the explosive personal probings into the realm of the divine and the satanic undertaken by Fuseli; nor can it be compared with the basically subject-free world of the ornamental grotesque. Hieronymus Bosch painted his "absurdities" in *altarpieces* — altarpieces mostly destined for the conservative and certainly nonheretical patrons and congregations of a relatively small Netherlandish town, and there is not the slightest indication that they were considered unorthodox in the places for which they were made. How can this be explained?

The first author who attempted to find such an explanation wrote from the perspective of almost one hundred years, and it must be admitted that his work cannot be cited as source material, properly speaking. José de Sigüenza's extraordinary passages on Bosch,[4] many of whose works were intimately known to him through his activity in Philip II's Escorial, were written about 1603, the result of profound contemplation by a man who saw, at the same time, with the eyes of an art lover, a confirmed moralist,

3. Kayser, pl. 3.

4. The passages in the following paragraphs are from José de Sigüenza, *Historia de la Orden de San Jeronimo,* published in 1605 ("privilegio" dated 1603), pt. 3, bk. 4, chap. 17; new edition in *Nueva Biblioteca de Autores Españoles* XII (Madrid, 1909), pp. 635ff. The passage on Bosch was reprinted in full by F. J. Sánchez-Cantón, *Fuentes literarias para la historia del arte español* I (Madrid, 1923), pp. 425ff. The English translation used in the quotations here is my *Northern Renaissance Art, 1400-1600,* ed. H. W. Janson, Sources and Documents in the History of Art series (Englewood Cliffs, N.J., 1966), pp. 22ff.

and an astute historian. He certainly committed some errors of judgment which are rooted in the views of his time; for example, in his remark that Bosch embarked upon an unusual choice of subjects because "in many subjects Bosch had already been overtaken by Albrecht Dürer, Michelangelo, Urbino [Raphael] and others." But at least at one point he revealed an understanding of Bosch's art which to me seems unmatched in the vast literature on Bosch right down to our own day. This occurs when, after an exact and penetrating analysis of that most puzzling altarpiece by Bosch, the *Garden of Earthly Delights,* then in the Escorial, he continues as follows:

> One would wish that the whole world were as full of imitations of this picture as it is of the reality and actuality from which Geronimo Bosque drew his "absurdities"; for, leaving aside the great beauty, the inventiveness, the admirable and well-considered treatment which shows in every part (it is amazing that a single head can imagine so many things), one can reap great profit by observing himself thus portrayed true to life from the inside, unless one fails to realize that it is inside him and has become so blind that one is not aware of the passions and vices which keep him transformed into a beast, or rather so many beasts.

And even before, Sigüenza had said: "The difference which, to my mind, exists between the pictures of this man and those of all others is that the others try to paint man as he appears on the outside, while he alone had the audacity to paint him as he is on the inside."

It would be easy to object that this is the uninformed view of a mere moralist if Sigüenza had not shown over and over again his deep appreciation of the aesthetic qualities of Bosch's pictures. I believe that his remarks go indeed to the roots of Bosch's art. While that master's greatest love went to Saint Anthony, who was beleaguered by those forces of evil and sin and yet withstood them, he — and his patrons — did not hesitate in other cases to make the depiction of the forces of evil and sinful perversion the *main subject* of an altarpiece, apparently in the conviction that one does not teach and persuade and convert so much by *intimating* such things, or even by *contrasting* evil and good, as by exposing evil and sinful perversion as what they really look like in all their unadulterated inward ugliness — and even their outward beauty — exposing them fully to all who, as Sigüenza said, have not become "so blind that they are not aware of the passions and vices which keep them transformed into beasts."

The painter counts on the spectator's — the thoughtful, contemplative spectator's — realization of the repulsive qualities of sin. Sigüenza could still see and feel this; can we?

Maybe we can — again; but we have to realize that what Bosch showed here was not "it" to himself and his contemporaries as it is to us today. They fully *believed* in witches, in magic, in satanic beasts, and in the embodiment of evil in seductive shapes, and while they must have been deeply impressed — and frightened — by the visual reality of those hellish creatures as he depicted them, one cannot say that they existed "outside of the sphere of their concepts." They were a shock but not an "it" to them; it was only at a somewhat later time, in works by Hans Baldung Grien, Grünewald, and more clearly in some superficially Bosch-like works by Pieter Brueghel, that these creatures took on a more "it"-like quality for their own creators — *and* for us: Kayser's definition of the "it" specifically includes "the demons, the apocalyptic beasts, etc." Bosch's "it's" are a matter of historical perspective, not of historical truth.

But here we must revert once more to the *Garden of Earthly Delights* and ask ourselves whether we are really entitled to speak of it, as Sigüenza had done, as an interpretation of humanity at large seen "true to life from the inside" and "transformed into so many beasts." Has not Wilhelm Fraenger, in the only line he wasted on the Spanish writer in his famous book on *The Millennium of Hieronymus Bosch*,[5] shown that Sigüenza was "on the wrong track" and that, on the contrary, the middle panel of this triptych was a true paradise, the glorification of the "serene chastity," the "pure joy and bliss" of a heretical Christian sect for which it was painted — it would have "meant nothing" to the profane — and that it took the evil mind of the puritanical tradition to see it in terms of evil?

Fraenger's brilliant book has had unprecedented success with large sections of the reading public, and while I must totally reject its main thesis, I shall not fall into the error of overlooking the merit of some of its insights into the cryptic meaning of some of its details. True, even in that realm his interpretation often lacks clear support from literary sources of Bosch's time, but this is no less true of most suggestions made by other recent writers, although some helpful astrological, hermetic, and folkloris-

5. In German as *Hieronymus Bosch. Das tausendjährige Reich* (Coburg, 1947). English translation by E. Wilkins and E. Kaiser (Chicago, 1951), p. 8.

tic comments have been made in the discussion engendered by Fraenger's book. However — and this is a statement which is not new to most art historians but has apparently not reached large numbers of readers who have been deeply impressed by a sincere, well-written, and utterly seductive presentation — Fraenger's main thesis rests on the shakiest ground ever chosen for a daring interpretation of a work of art and can serve as a foremost exemplar of what Erwin Panofsky used to call a "boa constrictor." This is not the place to accumulate evidence for such a rejection; suffice it to state that Fraenger has not adduced a single proof that the sect of the Adamites, whose rites he saw depicted here, so much as existed in the Netherlands at the time of Hieronymus Bosch — his analogies are all taken from a period a hundred years prior to it — and that there is not the slightest indication of Bosch having belonged to any group but the highly respectable Onze Lieve Vrouwe-Broederschap in 's-Hertogenbosch (Bois-le-Duc)[6] and that he was employed by anyone but orthodox church authorities and perhaps an occasional princely patron for altarpieces and other religious panels with customary subjects. One would have to be blind and insensitive to deny that he painted them in a highly original style and with a highly original *interpretation* of his subjects; but there is no trace of evidence that those subjects as such lay basically outside the realm of a generally accepted iconography. The very thought of Philip II of Spain acquiring (in 1591),[7] and Sigüenza lavishly praising (in 1603), the kind of picture Fraenger saw in it is as absurd as the thought of the speculative circumstances he postulated for its *raison d'être*. But the attractiveness of his hypothesis persisted; surely the objections raised against it in the name of factual considerations — I mention the sober criticism of D. Bax[8] and of the authors of the catalogue and essays published on the

6. P. Gerlach, "Jeronimus van Aken alias Bosch en de Onze Lieve Vrouwe — Broederschap," in *Jheronimus Bosch, Bijdragen bij gelegenheid van de herdenkingstentoonstelling te 's-Hertogenbosch* (1967), pp. 48ff.

7. Professor J. K. Steppe, to whom we owe the fullest recent proof that the triptych belonged in 1517 to Hendrick III of Nassau at Brussels, considers it possible that this prince commissioned the artist to paint it; see his "Jheronimus Bosch. Bijdrage tot de historische en ikonografisch studie van zijn werk," in *Jheronimus Bosch, Bijdragen . . .*, pp. 5ff. Also E. H. Gombrich, "The Earliest Description of Bosch's *Garden of Delight*," *Journal of the Warburg and Courtauld Institutes* 30 (1967): 403ff.

8. D. Bax, *Beschrijving en poging tot verkaring van het Tuin der onkuisheiddrieluik van Jeroen Bosch* (Amsterdam, 1956).

occasion of the exhibition held at the master's hometown in 1967[9] —
availed nothing within the general public, while at the same time a host
of other fantasies were added to the existing mass of already confused and
contradictory suggestions.

This was the situation when Professor Gombrich, in 1969,[10] sur-
prised everyone with a preliminary report on his findings regarding this
puzzle and pleased those of us who had always felt that some kind of
"orthodox" solution of it simply had to exist as far as the basic subject of
the triptych of the *Garden of Earthly Delights,* and particularly of its central
panel, was concerned. The gist of his paper is most cogently expressed by
the new title he has suggested: *Sicut erat in diebus Noe.* The "Garden of
Lust" is the world as it appeared, human beings as they behaved, before
the flood. It is impossible to discuss here the many refinements that
Gombrich adduced to support this (even *prima facie* convincing) identi-
fication. Visual representations of the subject are known from sixteenth-
century prints[11] and will probably be traced back much further in due
time; several special features introduced by Bosch were shown to be derived
from impeccable medieval literary sources; the subject of the outer wings
turned out to be, not the creation of the world proper but the orb *after*
the flood, with houses still in evidence under the waters. But it was, after
all, a benign Creator who brought all this about; for the rainbow of
reconciliation guaranteed the continued existence of this earth even after
the flood, thus conveying a firm promise to Noah's progeny. But before
all, Gombrich has pointed out with well-placed emphasis that the people
before the flood were not aware of being in danger and perhaps only dimly
aware of being sinners. "Erant enim tunc comendentes et bibentes in
securitate: diluvium non timentes";[12] and "neque enim quia haec agebant,
sed quia his se tetes dedende Dei judicia contemnebant, aqua vel igne
perierunt": They perished through water and fire not because they acted

9. See the *Bijdragen* . . . cited in note 6 above and the exhibition catalogue published
on the same occasion (also in English) under no. 41. A very helpful summary is also found
in L. von Baldass, *Hieronymus Bosch* (New York, 1960), pp. 227ff.

10. E. H. Gombrich, "Bosch's 'Garden of Earthly Delight': A Progress Report,"
Journal of the Warburg and Courtauld Institutes 32 (1969): 162ff.

11. Gombrich, "Progress Report," pl. 17e and p. 167. The drawing by Dirk
Barendsz, now in Leiden, was reproduced in the catalogue of the exhibition Prisma der
Bijbelse Kunst, Delft 1952, fig. (not no.) 43; it must date before 1592.

12. Nicholas de Lyra, ca. 1500 (Gombrich, "Progress Report," p. 167).

that way but because they did not heed God's orders *(judicia)* by giving themselves so fully to these actions.[13] As already mentioned, Bosch did make life before the flood appear sinful and perverted to us, but he wisely showed the people themselves enjoying it, thus also suggesting how easy it is to fall into this satanic trap. The fact that this subtlety was overlooked partly explains why modern observers have been led astray.

Thus Sigüenza was correct again when he said that this is a mirror for all who are "so blind that they are *not aware* of the passions and vices which keep them transformed into beasts" (emphasis mine). This is what happened *in diebus Noe* — and could happen again to all of us on the day of the Last Judgment. It is interesting to note that Dirk Barendsz' representation of the same scene which Gombrich reproduced in his article[14] does have a companion piece with the *Life of Man before the Last Judgment*.[15] However, even before Sigüenza published his analysis of Bosch's triptych the didactic tendency of Bosch's and Dirk Barendsz' representations was about to be slighted by other artists. An engraving by Cornelis Galle after Gerrit Pietersz Sweelinck still has *Sic erat in diebus Noe* as its title and recognizable content;[16] but in another, very similar print by the same engraver after the same artist,[17] one finds, together with a slight modernization of costumes and musical instruments, a complete elimination of reference to sinful life, either before the flood or before the Last Judgment and, in its legend, a frank invitation to join the *dolce vita* (of the Prodigal Son?).

It was probably inevitable that a man of Fraenger's generation and background should have come forward with an interpretation of this panel as an apotheosis of innocent liberated sex and that he should have persuaded a large audience to follow his trend of thought. It was probably equally inevitable that this interpretation should have turned out to be a

13. Rabanus Maurus, early ninth century (Gombrich, "Progress Report," p. 167).

14. See note 11 above.

15. Listed in A. von Wurzbach, *Niederländisches Künsterler-Lexikon* I (Vienna, 1906), p. 60, no. 19.

16. F. W. H. Hollstein, *Dutch and Flemish Etchings, Engravings, and Woodcuts* (Amsterdam), vol. 7, p. 61, no. 375, with illustration.

17. Holstein, no. 376, with illustration. An almost identical painting by Sweelinck is owned by Professor Freedberg of Harvard University (Exhibition "Dutch Mannerism, Apogee and Epilogue," Vassar College Art Gallery 1970, no. 95 and pl. 29), possibly to be interpreted as a prodigal son.

chimera in our own days. For many, including many artists, sex has again become much too painful or at least too deadly serious a matter to be seen in Fraenger's glowing terms of liberation from Victorian prejudices. And this does seem to open the door for an interpretation of Bosch's center piece in terms of the grotesque more readily than did its interpretation as the happy — if serious and religion-bound — sex cult of the Adamites. But it must be emphasized again that such a view is as much a matter of historical perspective as was Fraenger's — however much closer to the truth. In spite of a hundred esoteric details and a vast array of recondite material, this, for the artist, was not an "it." For all his speculation on the subject and for all the abstruseness involved in them, he believed in it just as he believed in the monsters torturing Saint Anthony. It was still, as Sigüenza saw correctly, a matter of depicting life from the inside in the service of a moral aim. It was not "it."

But we are, after all, *entitled* to that slightly distorting perspective, and although we are in our day used to stronger stuff, Bosch's satanic creatures still send a shiver down our spines; not because we immediately recognize naked sin in them (as Sigüenza was still able to do) but because we now think we can see them as the epitome of the grotesque, of the "it" outside of *our* cosmic order, in which this kind of fantasy, the satanic monster and its perverted sin, does not belong, or only threatens to belong. Few modern artists who are concerned with the grotesque have completely escaped the orbit of Bosch, but some have made significant substitutions for his demonic phenomena. The monstrous combinations of animal forms, or human and animal forms, often still frightening enough in works by Bosch and Grünewald in particular, are now often — and often success-fully — replaced by masks, an indispensable requisite in modern art and on the modern stage which combines human and nonhuman, individual and stock features into a grotesque "it" of tremendous power. The works of James Ensor are outstanding examples of this power (although the device has now become ubiquitous and is already in danger of losing its grip on many onlookers). Animals of grotesque size or in frozen isolation are replacing active animals of grotesque forms (e.g., Magritte); mixtures of human and mechanical forms are replacing mixtures of human and animal forms, and this is significant in the light of our fear of technological invasions into the human realm. "Cool" representations of "hot" issues and emotions are similar adaptations of characteristics of Bosch's depic-tions of sin proper. They all establish a new "it," a new image of the

grotesque, and visual representations of such phenomena are still as important as their counterpart in literature, or even more so, and perhaps only a little less important than their counterpart in cinematography.

But what of their spiritual significance? Can it be compared in any way with what Bosch's art meant to his contemporaries?

In addition to calling the grotesque the objectification of the "it," Wolfgang Kayser also defined it as the estranged world — a very cognate concept — and made the important point that the grotesque deals, not with the fear of death but with the fear of life, with *Lebensangst*.[18] This, I submit, is very unlike Bosch indeed. He turned against sin, and fear of death cannot be separated from the fear of sin. In the modern grotesque — and starting in literature much earlier than in the visual arts — fear of life does play a decisive role. There is no need to list all the elements that have contributed to this state of affairs — from the breakdown of moral criteria, of religion, of a cohesive family life, to the atomic bomb. Groping about in the dark instead of following prescribed paths is certain to produce *Lebensangst;* the estranged world cannot but produce all imaginable forms of the grotesque, because only the familiar escapes the "it," the place outside the sphere of our concepts, for which the language has no name.

But Kayser has also (somewhat hesitatingly, to be sure) suggested that *Lebensangst* can perhaps even now be conquered by being transformed into a work of art.[19] With this concept we are of course even further removed from Bosch, at least as far as the customary equation of "self-expression" with "self-rescue" is concerned. This is not so new in literature (Robert Burton wrote, as he himself avowed, about melancholy in order to avoid melancholy);[20] in the visual arts it goes back at least as far as Goya; but its apogee came in the twentieth century. Is it destined to remain characteristic of the rest of the century as well? How meaningful is it to us today? To this group? Is the fact that the artist conquers his own *Lebensangst* a valid *raison d'être* for his existence? Has it not spawned vast areas of narcissism instead? On the other hand, is it unthinkable that the grotesque and *Lebensangst* could be transformed into an art that is more

18. Kayser, p. 199 (English ed., p. 185).

19. Kayser, p. 202 (English ed., p. 188).

20. Robert Burton, *The Anatomy of Melancholy,* ed. F. Dell and P. Jordan-Smith (New York, 1941; 1st ed. 1621), p. 16.

than self-expression and self-cleansing, that is responsible to larger issues and needs?

When José de Sigüenza said of Bosch's *Garden of Earthly Delights* that its onlooker "can reap great profit by observing himself thus portrayed true to life from the inside," he took — as we have seen — a frankly moralistic view of Bosch's art without failing to appreciate its aesthetic qualities; we have every reason to believe that Bosch had intended that effect, and today we are also much closer than before to realizing that the art of Pieter Brueghel was built upon similar moral tenets, although Brueghel was more keenly aware of the "it" than Bosch could have been. As we look for something comparable in the art of our time, we cannot but think of Picasso's *Guernica.* If any proof be needed that a great artist can, even in our time — if we may call 1937 our time — achieve more than purging himself of the "it," can erect an artistic monument to a moral issue that is *aere perennius,* here is that proof. When Picasso painted it he was *fighting mad* — not at himself and not at *Lebensangst,* but at a political and moral crime. We are not far away here from how Hieronymus Bosch must have felt when he contemplated the way Saint Anthony was attacked by satanic sin and put his vision of it down on a panel. Today the grotesque proper, the "it," is with us, and it may stay with us for a long time; what we desperately need is an art — that is, artists — who care about the "it" of others as much as about their own, either because they *want* to or — if I may venture that heretical thought — because they *have* to, in thick air, as it were, rather than in the thin air to which so many of them are lamentably accustomed. Could Bosch and Picasso tell us something about this?

There are certainly artists who are convincingly mad at our obsession with racism, money, sex, kitsch and speak to troubling social issues. But many of their works are strangely and ominously removed from those whom they ought to address. Hieronymus Bosch addressed the congregation or the patron for whom he worked; Picasso addressed the free world to which he belonged; both did so *on commission* or at least to the satisfaction of their patrons, and this seems to me to be a decisive point. Both responded, *however independently,* to a public charge. Where is this public demand now as far as works of "concerned" art are concerned? Can we expect the free market (if that is the right word for it) to do for the artists represented in a contemporary exhibition what the citizens of 's-Hertogenbosch did for Bosch and the officials of the Paris World's Fair

did for Picasso? Can we expect the affluent clients of the artists to be affected by their works in a way comparable to the impact made by Bosch and Picasso with their works, and, frankly, must it not be expected that the integrity of many of those unsolicited works is jeopardized by considerations of the kind of appeal which *militates* against the honest expression of the evil they were first intended to expose? The future of "concerned" art depends not on the artist's splendid isolation — or splendid company — but, on the contrary, on what we, the *concerned customer,* are going to do about it.

6. Ugly Beauty in Christian Art

JOHN W. COOK

Grotesquely Ugly Art

Ugly is an ugly four-letter word. Simply reading it leads one to hurry on to the following words, having received a negative signal. It sounds bad, too, therefore its visual appearance and its sound, when spoken in normal American English pronunciation, serve not only as referents but participate in the meanings to which they refer. It is a word whose look, sound, and meaning seem unusually cohesive. When an ugly-looking word refers to something that looks ugly, it participates strangely in that to which it refers. The relationship becomes more interesting when the thing that "looks ugly" is not a word but a work of art and, perhaps, even more interesting if the work of art that looks ugly relates specifically to the Christian religion; and not only to that religion but to works of art that were created to serve specific worship attitudes and pious functions within the religion. The works of art discussed here have formal characteristics that in themselves seem beautiful and subject matter that is, in some aspects, ugly. Therefore, the phenomenon under consideration has to do with ugly beauty in works of art created specifically for Christian purposes.

That which is ugly is contrary to that which is beautiful, and each distinguishes meanings in opposition to the other. Things categorically accepted as ugly are essentially different from things accepted to be categorically beautiful. In common discourse, meanings referred to by these terms are usually clear and uncomplicated. In the world of the visual arts, the categorically beautiful object is the stated preference of aestheticians

125

and critics and is considered normal for average viewing. In the world of the arts, the so-called high arts especially, we assume that, for the most part, we are dealing with various aspects of beauty.

There exists, nevertheless, a category of works that defy clear classification; namely, beautiful works of art that deal explicitly with aspects of the ugly. I am not, in this instance, referring to works of art that would be characterized as bad art, poorly executed, or, for a number of reasons, unsuccessfully rendered. Works of art that are bad or ugly by virtue of their materials, subject matter, and rendering would not engage aesthetic interest at any important level, and would remain therefore contrary to beauty. I am, however, referring to a category of works of art that deal with subject matter of a decidedly unattractive or ugly sort that, nevertheless, attract aesthetic attention and, for many other reasons, seduce the observer into an aesthetic experience with the work. The aesthetic experience to which I refer is that of a work of art in which one is engaged by the artwork in an acknowledged and meaningful manner, drawn into a conscious response, and found to have been "impressed" by the total work in such a way as to say that the work elicited an experience, a memorable experience, of the beautiful.

The experience of the beautiful to which I refer includes perception of the material form, style, and subject matter of the work. The aspect of that experience that is especially interesting here has to do with the nature of that experience when the subject matter of the work of art includes that which is contrary to beauty, for example, the ugly.

I am not suggesting that ugly subject matter can be tolerated if everything else is acceptable, that is, if the form and style are considered beautiful. I am considering examples of works of art that are generally perceived to be beautiful even though they include ugly subject matter. In such works the ugly is among the other discernible factors that make up the work's beauty. In other words: there are visual works of art that are beautiful that nevertheless include the ugly, and without that ugly factor the artwork would not be complete, and therefore not be beautiful.

A number of works of art from around the world and from all phases of history would qualify for this category, and the phenomenon appears in acknowledged masterpieces as well as lesser-known works.

The examples to which I refer here remind us, among other things, that all works of the visual arts from the Christian tradition do not intend to be pleasantly attractive. As the task is to discern the implications of the

ugly in works of art in the Christian tradition, perhaps it would be helpful at the outset to distinguish between the ugly and the grotesque in art, because the two terms are used interchangeably, and sometimes synonymously. For our purposes, a blurring of the terms will make the point obscure.

That which I address in the works of art discussed in this essay is best designated as having to do with grotesque ugliness rather than simply the grotesque. That which is grotesque in art usually has to do with imagery that appears odd, unnatural, bizarre, or absurdly incongruous. Formal definitions of "grotesque" suggest that, often, grotesque objects have to do with humor and the ribald. Terms such as *fantastic* or *abnormal* also come to mind. In Sheridan and Ross's book, *Gargoyles and Grotesques,* the following clarification is made: "A grotesque object [*sic*] is taken to be one representing something abnormal or normally impossible, such as a Centaur, half-horse half-man."[1]

My point is not to deal simply with the bizarre or abnormal, but to deal with normal narrative materials that are presented in such an exaggerated and grotesque sense that they make their straightforward points through visual imagery that is repulsive, shocking, and difficult to imagine. However, each image is a work of art that is artfully as well as grotesquely ugly.

Kees Bolle's article on myth in the new *Encyclopedia of Religion* reflects what is perhaps a general assumption when he observes that "grotesque is a term one might feel hesitant to use for sacred traditions."[2] However, attention to the traditions, and specifically the Christian tradition, suggests that hesitancy or timidity in this regard is perhaps a recent phenomenon born in the twentieth century and produced by traditions that have suppressed the reality of judgment, retribution, and pain in preference for comfort, conflict resolution, and therapeutic solutions.

It would be interesting to know, for instance, whether it is more difficult for the religious sensibilities of the twentieth century, more than any previous century, to grasp the significance of works of art that, being explicitly sacred, are nevertheless grotesquely ugly. Even though we cannot

1. Ronald Sheridan and Anne Ross, *Gargoyles and Grotesques: Paganism in the Medieval Church* (Boston: New York Graphic Society, 1975).

2. Kees Bolle, "Myth: An Overview," in *Encyclopedia of Religion,* ed. Mircea Eliade (New York, 1987), 10:261-73.

know that for sure, it seems fair to say that, given the range of average human capacities, we nevertheless cannot long abide that which is truly ugly. Generally, a human response to the actually ugly expresses itself as repulsion, outrage, anger, or fear. When that which is ugly is artfully rendered in a beautiful work of art, the art itself tends to be about that which is ugly, rather than ugly itself. The ugly in artfully beautiful works of art becomes art about the ugly, rather than ugly art, and makes the ugly artfully palpable. Something like this seems to have been in his mind when Paul Tillich wrote a description of Georges Rouault's painting *Christ Mocked by the Soldiers*. In describing the faces of the mocking soldiers who flank the figure of Christ in the composition, Tillich wrote:

> In the moment in which the ugly is used by a great artist as subject matter, it becomes beautiful, not by being painted as beautiful . . . but by leaving ugliness in these faces. Expressing their ugliness in an artistic form brings them into the sphere of beauty.[3]

The three works of art I have chosen to deal with refer to three central characteristics of the Christian tradition: martyrdom, crucifixion, and final judgment. Central to the history, theology, and liturgies of the Christian tradition, they are also recurring themes in the history of Christian iconography. Because they deal with major themes or events in the religion suggests the reason they continually appear in the visual arts. Each theme refers to personal, physical, and psychic experiences. When made literally visible in a work of art, each is naturally an unpleasant and unattractive subject. Contemplation of these subjects as real experiences — that is, placing oneself in that experience — is upsetting, at the least. Imagining someone else literally experiencing these events, or worse, inflicting any one of them on someone else, means to think about doing life-threatening things to another person. Contemplating these subjects as major factors in the Christian religion means contemplating brutal, frightening, and sorrowful facts. One finds examples of these subjects in artworks, however, that sustain one's attention in a fashion that one would call an aesthetic experience. Therefore, simultaneously, the grotesquely ugly and the beautiful are in the same experience of the work of art.

3. Paul Tillich, *On Art and Architecture*, ed. Jane and John Dillenberger (New York, 1987), p. 110.

Difficult Subject Matter

The crucifixion narratives in the New Testament include the details of the event that make explicit the human element of torture, lingering pain, and suffering. The crucifixion of Jesus, as reported in the Passion narratives, is an ugly scene that has been repeated thousands of times in the history of Christian art. Some of those paintings are compellingly beautiful while holding back nothing concerning the agonizing physical condition. It is in works like those that the observer can see the point clearly, and understand that the juxtaposition of the ugly and the beautiful in these instances can lead one to consider the nature of the event depicted within the context of an aesthetic experience. I mean to suggest that in the viewing of this category of works and the nature of these works one is drawn into an aesthetic experience that mediates something of the meaning of the event to which it refers. When the viewer receives the visual impact of the bonded ugliness and beauty of the work, the result refers to the historic event of crucifixion. This is not to say that every crucifixion scene will genuinely engage the observer nor that each one successfully bonds the ugly and beautiful to an aesthetically viable end. Some crucifixion scenes genuinely engage one and seduce one to a state of concentrated attention in part because they present the ugly and beautiful simultaneously, and they reflect on the nature of the crucifixion.

I should like you to consider three works of art in terms of their subject matter, their beauty, their function, and the nature of that which I have labeled the "grotesquely ugly." At the same time, I should like to consider these works within the context of their own time and place. These are three different types of art — one an illuminated manuscript, one a sculpture, and one an altar painting. They were executed for a worshipful, contemplative tradition and produced out of social contexts other than our own. First, the painting of the martyrdom of Isaiah appears as an illumination in a manuscript of the Vulgate Bible, this one produced in the middle of the thirteenth century.[4] Second, the sculpture of the Pietà is a painted wooden carving designed for a certain type of contemplation in the first half of the fourteenth century. Third, the altarpiece detail of the Last Judgment was painted by Hieronymus Bosch very early in the sixteenth century.

4. Ruskin Bible (manuscript of a Latin Vulgate of ca. A.D. 1250), Beinecke Rare Book and Manuscript Library, Yale University.

Fig. 6.1. *Martyrdom of Isaiah*, Ruskin Bible, ca. 1250

The *Martyrdom of Isaiah*

The work of art in which the martyrdom of Isaiah is represented appears in the text of a Latin Vulgate of the mid-thirteenth century known as the Ruskin Bible. It is painted in the lower left-hand corner of the vellum sheet set within the column of the text and extended into the left and lower margins. The format is a historiated initial, an elaborate capital *U* framed by lines and angles and accompanied by foliate motifs. The scene of the martyrdom is set within the initial itself. In this tight composition, consisting of three figures, the dominant central figure of the nude Isaiah is presented with arms spread in a manner suggesting a prototype of a crucified corpus. The two flanking male figures hold a large wood saw, the type used to fell trees. They appear in the act of sawing the body of Isaiah in half, making a cut from the top of the head down to the lower abdomen. The composition consists of a central slanted axis defined by the body of Isaiah, which is flanked by smaller figures

on the lower left and upper right that create a harmony of scale and a balance of elements within the tiny picture plane. The grotesquely ugly aspects of this shocking subject matter are narrated by the harmony and balance of the composition. The dismemberment of the body provides the controlling axis of the painting, and the contrasting colors of the body and clothing of the executioners are enhanced by the flashing brush strokes of red pigment that denote blood. The violence of the scene is contained artfully with the format of an initial that represents a style and technique of painting that is of the highest quality among thirteenth-century illuminated manuscripts.

Curiously, the story represented in the painting is not contained in the text on the page where the historiated initial appears, nor is it anywhere in the book. The literary source for this work of art is in the so-called *Martyrdom of Isaiah*, a story by a Jewish author from the first century A.D. that appeared as one of three stories in a collection from the latter half of the second century under the title *Ascension of Isaiah.*[5]

The execution occurred on the basis of charges made against Isaiah by a false prophet named Belchira, who accused Isaiah in the following manner:

> "They (Isaiah and the prophets who were with him) prophesy falsely against Israel and Judah and Isaiah himself hath said: 'I see more than Moses the prophet.' But Moses said: 'No man can see God and live': and Isaiah hath said: 'I have seen God and behold I live.' Know, therefore, O King, that he is lying." . . . and they seized and sawed in sunder Isaiah, the son of Amoz, with a wood-saw. . . . And when Isaiah was being sawn in sunder, he neither cried aloud nor wept, but his lips spake with the Holy Spirit until he was sawn in twain.[6]

Obviously, the scene is artistically introduced into the mid-thirteenth-century text as a natural expression of that period's interest in seeing the Hebrew scriptures in a Christian context, specifically as fulfilled within the incarnation of Jesus Christ. As is often noted in medieval exegesis, the prophets are seen as prototypes of the Christ in the New

5. For a complete description and full English translation of the text of the *Martyrdom of Isaiah*, see R. H. Charles, *The Apocrypha and Pseudepigrapha of the Old Testament* (Oxford, 1913), 2:155-62.

6. Charles, pp. 161-62.

Testament. The story of the martyrdom of Isaiah gained great popularity because it provided a type of crucifixion scene for the Isaiah text, and although the source was drawn from pseudepigrapha rather than the Hebrew scriptures, it nevertheless served the purposes of biblical interpretation. The painting appears to be a visual gloss on the text. The artist of the initial on f. 233 of the Ruskin Bible makes the reference explicit as the figure of Isaiah takes a cruciform shape while the elements of the composition respect the pseudepigraphical source. Theological and exegetical priorities overcame any hesitancy, had there been any, on the part of medieval book illuminators individually, and scriptoria generally, to avoid noncanonical references in the Vulgate.

In this painting, the grotesquely ugly is "part and parcel" of the artful work; therefore, it creates an excellent example of the Christian tradition intentionally producing ugly beauty.

We shall see, in the end, how the treatment of Isaiah in this illumination, which intentionally included as a motif a text in which the episode does not appear, carried great weight for those who studied and meditated on this scripture and interpreted it to others.

The *Roettgen Pieta*

On exhibition today in the Landesmuseum in Bonn, Germany, the *Roettgen Pieta* is a wooden figure from the third quarter of the fourteenth century. Nearly three feet in height, this sculpture originally stood in a side chapel or on a secondary altar in a church. It was created to be a devotional image, that is, an image before which one meditated upon the event which it depicts and the relation of that event to one's life. Such devotional images, known in Germany as "Andachtsbilder," flowered in the fourteenth century in northern Europe, and, among those that have survived, the Roettgen figure is considered the most graphic and grotesque.

Pietà, by far the most widespread subject represented in "Andachtsbilder," referred to Mary holding the dead body of Christ on her lap. The grief of Mary and the death of Christ were presented in order to kindle empathetic meditation on the part of one who prayed. They were venerated regularly, but special attention was given them during the season of Holy Week, especially Good Friday, and their primary purpose was for the faithful to contemplate the redemptive wounds of Christ.

The scene is not taken directly from the New Testament, but first appears in literature in the writings of a tenth-century Greek theologian, Simeon Metaphastes. He is the first, or among the first, to describe Mary holding the dead Christ on her lap when he wrote that Mary said to Jesus, "You have often slept on my lap the sleep of infancy, but now you sleep on my lap the slumber of death."[7] In Italian literature, the episode appears in the writings of an anonymous Franciscan monk in the second half of the thirteenth century in a text entitled "Meditations on the Life of Christ," and in Germany, Saint Mechthild of Hackeborn (1241-89) is said to have meditated on Good Friday on the wounds of the dead Christ as he lay on his mother's lap.

Eventually the scene became associated with the liturgy of vespers, specifically in relation to the Passion cycle in the Breviary, as it refers to Mary's last farewell in the Good Friday vespers.

Artistic rendering of the scene first appears in Byzantine art in the twelfth century and first in Europe in the thirteenth. Gertrud Schiller, in volume 2 of *Iconography of Christian Art,* says the first Pietà came into existence around 1300 in German convents and was first mentioned in liturgical texts in 1298.[8]

If we estimate the date of the *Roettgen Pieta* to be around 1370, as Schiller suggests, this work represents that tradition as it was expressed in Germany some seventy years after it first began to appear. The subject, liturgical setting, and function were well established prior to this artist's interpretation. We do not know the name of the artist who created this sculpture, but we become vividly aware of the expressive interpretation he brings to the task of creating it.

Bent sorrowfully over the rigid, emaciated body of Jesus on her lap, Mary is a study in grief expressed in the posture and attitude of her body as well as in the mask of twisted sadness that is her face. The artist captures the sense of a person whose body has gone limp on the moment that she contemplates the full awareness of what she has experienced and observed. In the original setting of this piece, the candlelight of the altar area in the chapel would have played directly on the face of Mary, and would have made even more vivid the sense of anguish in her face.

7. See Frederick Hartt, "Introduction," *Michelangelo's Three Pietas* (New York: Abrams, 1975).

8. Gertrud Schiller, *Iconography of Christian Art* (London, 1972), 2:179.

Fig. 6.2. *Roettgen Pieta,*
ca. 1350

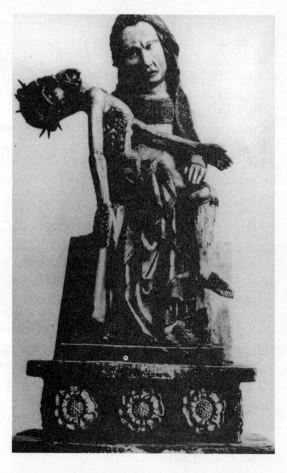

More important for the original purposes of such a piece is the Christ figure. As noted above, these figures "were venerated not primarily on account of Mary's grief, but for Christ's redemptive wounds."[9] As Mary holds the figure, she simultaneously displays it for our contemplation. The figure appears rigid, with the head fixed at an awkward angle. Exaggerated in size and grotesquely expressive in detail, the wounds in Christ's hands, feet, and side appear to gurgle with bloody details. Such placement, color, and scale of the wounds would have made them stand out ghoulishly in candlelight.

9. Schiller, p. 179.

Detail: Face of Mary

The overall composition of this piece is asymmetrical. The size and weighty volume of the head of Christ pull the composition off balance to the left, and Mary appears to struggle to hold him up. Such conscious disequilibrium enhances the impression the piece makes. One may be led to consider this piece as the creation of an inferior artist, that is, one who simply could not have done a better work. However, the detailing and finish of the work betray a master sculptor. For instance, the modeling of Mary's head and facial characteristics demonstrates the abilities of an accomplished craftsman who has manipulated the medium for the strongest results. Note, as well, the treatment of the drapery around Mary's head and the detailing of the folds that fall from her knees to the base.

The beauty of this work provides a background for the grotesquely ugly presentation of Christ. He stands out by virtue of the contrast between the two figures and fulfills the medieval interest in concentrating primarily on the evidence of his sacrifice.

One of the uses of this figure explains the exaggerated scale of the wounds. The one in Christ's side, elevated and slightly to the left of center in the composition, is an open hole. In the Good Friday liturgy, the host was placed in the wound, according to Schiller, thereby equating the consecrated bread of the Eucharist with the broken and bleeding body of Christ. One's experience with the expressionistic impact of this work became more empathetic and physical as the bread and wine were taken in its presence.

The juxtaposition of the ugly and the beautiful in the *Roettgen Pieta* challenges an observer with its graphic presentation of the grotesque while seducing one with its beautiful details and representation of human emotion. In its original setting, it must have served as a visible manifestation of a powerful cultic piety, and stood as an artistic gloss on the Passion narratives in the liturgy.

Not representing an episode from the New Testament, the popular figure filled a place in medieval religious sensibilities suggested by the liturgical texts. I refer to it as a gloss on the Scripture because, presumably, it led those who meditated on it to a deeper contemplation of the crucifixion and its meaning for their lives. This is yet another type of subject in the history of Christian iconography that was used to enhance the theological teachings and proclamation of the church that, while not originating in Scripture, exerted great influence on the culture in which it was produced. Its power was achieved in part by the manner in which the ugly beauty of it was presented.

The Musical Hell

Perhaps the most famous painting by Hieronymus Bosch is the three-panel altarpiece in the Prado Museum in Madrid entitled *The Garden of Earthly Delights*. When the altarpiece is open, the panel on the right side displays an imaginative view of hell. In the upper third of the right panel, the dark landscape is aglow with an eerie flame. In the center, exaggerated organic objects and small figures appear confounded on a dark lake. The lower

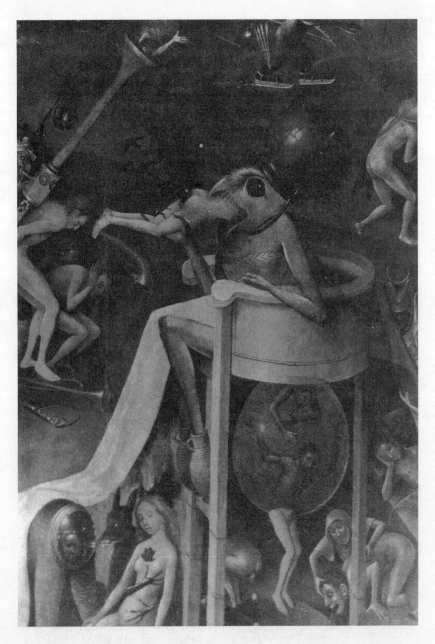

Fig. 6.3. "Musical Hell," detail, Last Judgement Panel, *The Garden of Earthly Delights* by Hieronymus Bosch, ca. 1510

third of the panel is the so-called Musical Hell, or the "Infernal Concert." Chaos ensues in a surreal environment around musical instruments. Enthroned to the right of the instruments is a bird-monster figure that observes and consumes the damned. James Snyder refers to this portion of the panel as "one of the most startling evocations of the diabolic known to painting."[10]

The bird-monster is a figure of Satan who sits on a strangely shaped throne. He wears a metal pot as a crown on his head, with the handle cupped under his chin like a strap, and his feet are stuck in small ceramic jugs. A long, narrow white cloth extends from his lap across a crouching figure to the ground. Rather than a royal train of some sort, it appears to relate to some function of the toilet. The faint trace of an arm and hand appears smudged on the surface of the cloth. As Satan stares impassively at hell, with a large, vacuous dark eye, he consumes the torso of a human figure, from whose anus a dark object emerges. Satan is enthroned on a toilet seat and, from below him, human figures are excreted in a large gaseous bubble and fall toward a hole in the ground. Around the hole one figure strains forward to vomit, while another excretes coins.

Peter S. Beagle, in his study *The Garden of Earthly Delights,* suggests that the offensive scene has a message.

> In Bosch's hell all is visual slang. . . . Punishment tends to fit the crime . . . a miser squatting by a pool of excrement illustrates a still-current Germanic saying about the nature of money, while gluttons swallowed by Satan on his foul throne become excrement themselves.[11]

Astonishing subject matter such as this, found on an altarpiece, would seem to offend Christian sensibilities; however, the opposite seems to be the case. The painting was praised at the court of Philip II of Spain, and the king's spiritual counselor, Fra José de Sigüenza, recommended the piece as a "powerful work of deep wisdom, worthy of close study."[12] Fra Sigüenza, who made extensive observations about Bosch's paintings in his *History of the Order of Saint Jerome* in 1605, wrote, "Would that the whole

10. James Snyder, *Bosch in Perspective* (Englewood Cliffs, N.J.: Prentice-Hall, 1973).
11. Peter S. Beagle, *The Garden of Earthly Delights* (New York: Viking Press, 1982), p. 53.
12. Beagle, p. 20.

world were filled with copies of this picture . . . men would gain much by contemplating it and then looking into themselves."[13] He also said,

> As I see it, the difference between the paintings of this man and those of others is this: the others seek to depict men as they appear outwardly; he alone has the audacity to depict them as they are inwardly. [His paintings are] not absurdities, but rather, as it were, books of great wisdom and artistic value. If there are any absurdities in them, then they are ours, not his; and to say it at once, they are painted satires on the sins and ravings of man.[14]

Several studies of this work have paid great attention to the depiction of hell in it, and it has been noted by a number of scholars that at least one literary source encouraged Bosch to depict such a monster. It is the vision in the text of "The Vision of Tundale," a long medieval literary piece in the tradition of a literary genre of the Middle Ages characterized by revealed visions of the future, which describes in great detail horrible experiences of human suffering in hell.[15]

Bosch's interpretation seduces the observer into an extended search for the many episodes in the painting, along with the bizarre shapes and events. His master skill as a painter and his vivid use of color present intricate detailing and a rich palette that attract the eye. Compositionally, the chaos is ordered and the elements read clearly in units.

The beauty of the work is achieved simultaneously as it reveals the depths of its own horror. Even that which is repulsive is strangely attractive. Charles de Tolnay recognizes this curious achievement of Bosch when he points out "the sovereign humor with which Bosch depicts his figures' evil, while the eye is delighted."[16]

Curiosity seems to be a factor in studying the complexity of this Bosch painting, and in seeking to understand how it was perceived by worshiping communities when it was new. The technical and aesthetic accomplishment, along with the visual seduction that takes place as one

13. Quoted in Robert L. Deleroy, *Bosch,* trans. Stuart Gilbert (New York: Crown, 1972), p. 106.

14. Beagle, p. 56.

15. On the vision of Tundale (or Tondulas), see Harrad Spilling, *Die Visio Trugdali, Münchener Beitrage zur Mediavistik und Renaissance-Forschung* (Munich, 1975).

16. Charles de Tolnay, *Hieronymus Bosch* (1966), p. 13.

roams the surface looking to decipher the code or interpret the enigmatic scenes, engages the viewer in the grotesque as well as the beautiful.

Since it is an altarpiece, the subjects disturb one at another level and, here, liturgical and theological factors emerge. Such a vision as a backdrop for the Divine Liturgy places a panorama of human foibles and sins up against the promise celebrated in the eucharistic texts. That from which one is rescued, or for which one is judged, occupies the work of art. An engaging yet sobering unity appears to have been achieved by the close proximity of such contrasting and contradictory visions that would have been experienced in worship where this work was a focal point.

Conclusion

Each of the works discussed here holds ugly and beautiful aspects together in a unified presentation of visual subject matter. Each represents a text that is not scriptural, but is related to and interpretive of Scripture. In this regard, I have suggested that each is a kind of visual gloss, that is, a reference to and interpretation of the truths of Scripture. Medieval texts of the Bible included "glosses" or commentaries on the text, sometimes printed in the margins or in parallel columns to the text of Scripture. These visual works of art seem to have served as a kind of commentary or gloss on the tradition, and in each instance, bring specific references to the setting for which they were created — Isaiah as a prototype of Christ, the Pieta as an aspect of the Passion, and the experience of damnation as a part of judgment.

It would be misleading to suggest that they simply gloss the tradition without stressing how they expand on the concepts or events to which they refer. These works complement and extend the message, the pious function, and the liturgical setting they serve. These works added greater weight to the theme and the Christian consciousness they addressed. They were not simply illustrations of something else, they also embodied and communicated truths that were important to the communities that commissioned them and the public that observed them.

A central factor in discerning the "weight" these works added to their constituencies is the nature of the ugly beauty one finds in each. That "nature" is an aspect of the gospel. It appears that the reason for the ugly beauty is found, in part, in the texts, but it is also the case that they, in

themselves, served an aesthetic, didactic, and liturgical need. They sought to embody a meaning in each case. That meaning is referred to in the juxtaposition of the ugly and the beautiful, and without their unity intact their impact would have been considerably diminished.

Karl Barth appears to comment on the sense of such a claim when, in reference to Christ's crucifixion, he observes:

> If we seek Christ's beauty in a glory which is not that of the Crucified, we are doomed to seek in vain. . . . In this self-revelation, God's beauty embraces death as well as life, fear as well as joy, what we call "ugly" as well as what we call "beautiful."[17]

The simultaneity of each seems natural and necessary under these circumstances rather than bizarre and inappropriate.

I would not suggest for a moment that these artists consciously set out to put the ugly and the beautiful together simply as an artistic exercise. They gave visible form to a gospel expressed in their subject matter. In their tradition, the gospel was good news that was revealed in Jesus Christ through suffering, martyrdom, and death, as well as judgment, resurrection, and hope. The characteristic of these works of art that is of central concern in this essay is that aspect of the gospel that is artistically expressed. In these works, aspects of the gospel are treated and given their context, subject matter, and form: the gospel factor accounts for that which we call ugly beauty. It is not unusual, therefore, to be astonished and engaged by works of art such as these. They appear to be not only acceptable as works of art but critically appropriate because they are ugly beauty.

17. *Church Dogmatics* II/1, p. 750.

7. Francis Bacon: The Iconography of Crucifixion, Grotesque Imagery, and Religious Meaning

WILSON YATES

John Russell has written that *Three Studies for Figures at the Base of a Crucifixion* is "the natural point of departure for any study of Bacon."[1] The painting was completed in 1944 and exhibited a year later at the Lefevre Gallery in London. In the Museum of Modern Art's 1990 retrospective of Bacon's work, a second version of *Three Studies*, completed in 1988, welcomed the viewer and dominated the exhibit. In a more recent retrospective — the 1996 exhibit at the Centre Georges Pompidou — the 1944 work was again the first work the eye saw on entering the gallery.[2] Bacon's treatment of the figures at the base of a crucifixion has become both the point of departure and the continuing point of reference for his work.

In this essay, the work is the point of departure for several specific reasons. Bacon uses religious iconography, employs a grotesque form of imagery, and confronts us with religious questions about the meaning of human existence. This interplay of subject matter, religious content, and

1. John Russell, *Francis Bacon* (London: Thames and Hudson, 1989).
2. Exhibition catalogue: Hirshhorn Museum and Sculpture Garden et al., an exhibition organized by James T. Demerion, *Francis Bacon* (Washington, D.C.: Hirshhorn Museum; London: Thames and Hudson, 1989). This catalogue has the full reproduction of the 1988 version of *Three Studies for Figures at the Base of a Crucifixion*. For a review of the 1996 exhibit in Paris see "Francis Bacon's Fumes" by Mark Hutchinson in the *Times Literary Supplement*, 2 August 1996, p. 182.

the use of the grotesque is what concerns us in this discussion. We will consider four works where the imagery of crucifixion is used: *Three Studies for Figures at the Base of a Crucifixion* (1944), with reference to the second version of 1988; *Fragment of a Crucifixion* (1950); *Three Studies for a Crucifixion* (1962); and *Crucifixion* (1965). There are other works where religious iconography is used, including *Crucifixion* (1933) and *Crucifixion with Skull* (1933); the series of more than twenty-five studies of *Portrait of Pope Innocent X* done in the 1950s; and *Triptych Inspired by the Oresteia of Aeschylus* (1981). These works are referred to in our treatment of the major crucifixions.

In approaching the analysis of these paintings, it is important that we set them in context. First a note on Bacon's own life and his relationship to religion.[3] Bacon was born in Dublin in 1909 to parents whose lineage claimed his sixteenth-century namesake. The family moved to London at the time of World War I, when he was five, but after the war returned to Ireland, where his father ran a horse stable near The Carragh. His childhood was difficult, marked by relatively poor health, a violence-prone father, and an unstable family life. In 1925 at the age of sixteen he left home for stays in London, Berlin, and Paris. In Paris and later in London he worked as an interior decorator, work that led to his entry into the art world. The Paris experience, however, was the turning point in his choosing to become a painter, for it was there that he saw the works of Picasso which so strongly influenced his decision. In 1933 he exhibited his first work, *Crucifixion,* his earliest treatment of the crucifixion theme. The study, bought by a major British collector, Sir Michael Sadler, was reproduced by Herbert Read in Read's publication *Art Now.* His works, however, received little notice until 1945 when, at the age of thirty-five, he exhibited *Three Studies for Figures at the Base of a Crucifixion* (1944) in a group show at the Lefevre Gallery. Throughout most of his career he lived in London, except for a period in the late forties when he resided at Monte Carlo and time spent in Paris, where he had a second home. He died on 28 April 1992, at the age of eighty-two, on a visit to Madrid. The coverage of his death was extraordinary, with

3. Russell provides an excellent overview of Bacon's life and the pivotal experiences in his development as an artist. See also: Ronald Alley and John Rothenstein, *Francis Bacon* (London: Thames and Hudson, 1964), for the first major study of Bacon. See Kryzysztof Cieszkowski in the Tate Exhibition Catalogue, *Francis Bacon* (London: Thames and Hudson, 1985), pp. 239-46, for an excellent bibliography of books, articles, chapters in books, exhibition catalogues, and films on Bacon.

background stories readily identifying him as the greatest English painter since Turner and a giant of twentieth-century art. More recently the complex and excessive side of his personal life has become the focus of biography.[4] He once said about his work as a painter, "I would like my pictures to look as if a human being had passed between them, like a snail, leaving a trail of the human presence . . . as the snail leaves its slime." In fact he left an indelible mark on the history of painting.

In a number of interviews Bacon talked about his life and particularly his early years and how they related to the sober themes with which he worked. In one such interview with Joshua Gilder in 1980, when Bacon was seventy-one, he gives this revealing commentary on his own life and its link to his exploration of violence, suffering, and death.[5]

JOSHUA GILDER: Do you think of your paintings as violent?

FRANCIS BACON: People always interpret them as violent, I'm certainly not trying to do that. I'm really trying to make them as real from my point of view as I possibly can. I mean, you've only got to think about life for just ten minutes, what it is really: it's a horror which I certainly wouldn't have the talent to be able to trap — the real awfulness of life. It's marvelous, but yet it's awful.

J.G.: Does painting that horror ever move you, emotionally?

F.B.: Emotion is such a funny word. What is emotion? It's a horrible thing to say, but what is emotion, really?

J.G.: Well, sometimes you're painting images of extraordinary pain.

F.B.: I've lived through two world wars, and I suppose those things have some influence on me. I also remember very well, growing up in Ireland,

4. Andrew Sinclair, *Francis Bacon: His Life and Violent Times* (New York: Crown, 1993). This work provides both an excellent introduction to the life of Bacon and, more importantly, an interpretation that traces the place of violence in his life and his times. Sinclair's interpretive comments about various works are fresh and engaging, linking the works to both the personal world of Bacon and the context out of which he works. See also Daniel Farson, *The Gilded Gutter Life of Francis Bacon* (New York: Pantheon, 1993). This biography is a journalistic treatment of Bacon and his personal life. The author knew the artist and provides personal insight and reflections on the seemingly contradictory and mercurial life of Bacon.

5. Joshua Gilder, "I Think about Death Every Day," *Flash Art*, no. 112, May 1983, pp. 17-21.

the whole thing of the Sinn Fein movement. I remember when my father used to say — this is when people were being shot all around — "if they come tonight, just keep your mouth shut and don't say anything." And I had a grandmother who was married to the head of the police in County Kildare and used to live with windows sandbagged all the time, and we used to dig ditches across the road so the cars would go into them.

After, when I left home, I was 16 or 17, I went to Berlin. That was the Berlin of the Weimar Republic, as it was just before Hitler came into power, and there was also a tremendous sense of unease. As I'm old now, I've lived through a period of tremendous upheaval and tension. Perhaps those things have affected me.

But most people never think about life. If you think of the way we live, we're on the compost of the earth. The world is just a dung heap. It's made up of compost of the millions and millions who have died and are blowing about. The dead are blowing in your nostrils every hour, every second you breathe in. It's a macabre way of putting it, perhaps; but anything that's at all accurate about life is always macabre. After all, you're born to die.

J.G.: But can't one live with a consciousness of death without being macabre?

F.B.: Ah, yes. You certainly can. But I don't think of my work as being in the least bit macabre. I think of it as being slightly truthful sometimes.

J.G.: Which contains that consciousness of death?

F.B.: I never go through a day without thinking sometime about death. It just comes into everything that you do. Into everything that you see. Into every meal you eat. It's just a part of nature.

These statements are about Bacon's own experiences and the subjects he treated. The themes of death, violence, suffering, alienation, cruelty, injustice appear over and over again as dominant concerns. They fascinated him, indeed, haunted him; they are the subjects of his painting.

In treating the religious aspects of his work, it is important to recognize his own relationship to religion. As a child, his link with the church was strong enough for him to absorb its basic tenets and symbols. He was baptized in the Church of Ireland and attended its services with his family, and his tutor was a Protestant chaplain, Lionel Fletcher. Further-

more, religion was itself a dominant part of the Irish landscape with tensions between Protestants and Catholics a ready part of his everyday fare. Bacon, therefore, experienced something of church life in his child-hood world and knew the rudiments of its religion and place in the life of his people. As an adult, however, he insisted that he was not a religious person and had no use for any form of religion. When pressed about his use of religious iconography, and particularly the crucifixion, he claimed that his treatment had nothing to do with a Christian understanding of the crucifixion. At the same time, Bacon used religious imagery, such as the crucifixion, mythological figures, portraits of individuals, the study of the body, and recordings of human experience to confront us with questions of ultimate meaning and destiny — to pull us into that labyrinth of experience that is the stuff of religious concern. He worked in a style that is highly charged in its power to move us into deeper levels of meaning; he spoke about his work as studies that attempt "to unlock the areas of feeling which lead to a deeper sense of the reality of the image — to unlock the valves of feeling and therefore return the onlooker to life more violently"; he said he wanted to record "the factual," to record "the truth" of life and the conditions of our mortality; he probes the reality of death, suffering, evil, of vulnerability, tenderness, our search for meaning; he offers in his work powerful testimony to his understanding of the human situation. To consider the religious dimension of his work, therefore, is to consider his "recording of what is factual" about those matters that are of ultimate significance to human life. It is to open ourselves to what his works says about the nature and reality of human existence.

The sources Bacon draws upon in his studies are diverse. They range from images of everyday life found in newspaper photography to works of major artists; from the plethora of images of people and places in his own memory to medical textbooks about the human body; from specific films, poems, sculptures, and paintings to archetypal religious forms such as the crucifixion and figures from Greek mythology. These sources are used to help him work through technical and aesthetic problems; but, more significantly, they provide images of human life that record the "facts" or truth of life and trigger in Bacon the sensations that inform his own statement of these facts. The *Oresteia* trilogy by Aeschylus with its Erinyes, or Furies, and the crucifixion (including, specifically, the Cimabue cruci-fixion) are two major sources for his work. *Triptych Inspired by T. S. Eliot's Poem Sweeney Agonistes* (1967), which was painted at the time he was

reading Eliot's poetry, provides insights into the understanding of life that Bacon was drawn to. Lines from Eliot's poem *Sweeney Agonistes* are often lifted up as particularly consonant in meaning with Bacon's works generally. Sweeney speaks to Doris:

> You'd be bored.
> Birth and copulation and death.
> That's all the facts when you come to brass tacks:
> Birth and copulation and death.
> I've been born, and once is enough.
> You don't remember, but I remember,
> Once is enough.[6]

The Waste Land is closely identified with Bacon's study *Painting* (1978), while Picasso, the one artist Bacon acknowledges having influenced his technique, is of particular importance to *Three Studies for Figures at the Base of a Crucifixion* (1944). The affinity can be seen in Picasso's sculpture of the 1920s. Velasquez's study of *Pope Innocent X* is the direct source for Bacon's obsessive reworking of the Velasquez image. Van Gogh, through both his paintings and letters, has also been a peculiarly rich source and subject for Bacon, as the van Gogh portraits testify. In sum, Bacon has always had a rich dialogue with artists who have gone before him, and a study of his work soon engages one in an appreciation of that dialogue.

The importance of photography and film to Bacon's studies and to Bacon's own sense of what art after the rise of photography must do, is great. Two photographic sources are of particular importance. Eisenstein's film *The Battleship Potemkin* (1925) offers the famous image of the screaming nurse, which is a moment of high dramatic power and great importance for Bacon's use of the scream.[7] More broadly, the photography in Muybridge's 1887 study of *Male and Female Figures in Motion* and K. C. Clark's work *Position in Radiology* (1929), are sources for his imaging of the human body, its anatomy and its possibilities for movement.[8] All of these works,

6. T. S. Eliot, "Sweeney Agonistes," in *Collected Poems* (New York: Harcourt, Brace and Co., 1936), p. 150.

7. Sergei Eisenstein, *The Battleship Potemkin*, 1925 film.

8. Edward Muybridge, *The Male and Female Figures in Motion* (New York: Dover, 1984), a collection of sixty photographs from *Animal Locomotion* (1867); K. C. Clark, *Position in Radiology* (1927).

as well as the everyday images of current time and memory, play into his paintings.

Bacon's style of painting, which invites the viewer to explore the religious dimension of the image's meaning, is not easy to define. He calls himself a realist, which for him means a style that gives us the truth of reality. He once said, "I believe that realism has to be reinvented. . . . This is the only possible way the painter can bring back the intensity of the reality he is trying to capture."[9] The highly suggestive connection with surrealism is certainly present, and in his comments about art he shares a strong appreciation for the role of the unconscious in both the act of making art and in the revelation the artwork offers. He was influenced by the 1936 International Surrealist Exhibition, and while not considered enough of a surrealist to exhibit in that show, his *Three Studies for Figures at the Base of a Crucifixion* (1944) led many critics to identify his work as surreal. Certainly, the expressionistic element is quite dominant in his desire to pull us into an experience of feeling, to move us through the distortion of form and into the world that lies beneath the surface image. But, finally, he does not belong to his own era's expressionist schools.

Bacon is emphatic in his insistence that his work is nonnarrative. If this is his intention, however, the effect can be quite different, for many works do call forth narrative — his use of Aeschylus, Cimabue, Eliot; studies of van Gogh; images of his friend George Dyer and other figures he does portraits of; as well as the provocative character of his work generally, invite us into the weaving of story. But if we are led to narrative, there is, still, an immediacy in experiencing his images that triggers feelings before "story." It is not the intellect the work confronts first, but a more visceral emotional dimension of ourselves. The form "works upon sensation and then slowly leaks back to the fact," to the truth of the image, at which point intellect becomes more complexly involved in interpretation.[10] As Bacon on occasion suggests, "I don't want to avoid telling a story, but I want very, very much to do the thing that Valery said — to give the sensation without the boredom of its conveyance. And the moment the story enters, the boredom comes upon you."[11] There is a process

9. David Sylvester, *Interviews with Francis Bacon* (London: Thames and Hudson, 1985), p. 8. This volume is extraordinarily rich in the insights it offers into Bacon's thinking.
10. Sylvester, p. 56.
11. Sylvester, p. 65.

that unfolds in Bacon's creation of his art that I want to sketch, for it gives us insight into what he sees happening in the making of a work and in what a work finally is and does. In commenting on Picasso, in his interview with David Sylvester, he says,

> I've had a desire to do forms as when I originally did three forms at the base of the Crucifixion. They were influenced by the Picasso things which were done at the end of the 'twenties. And I think there is a whole area there suggested by Picasso, which in a way has been unexplored, of organic form that relates to the human image but is a complete distortion of it.[12]

While Bacon, as Sylvester observes, did more work in a figurative manner than he did with organic forms, the statement implies that the creation of form as grotesque distortion of the human image is necessary to get at what he wishes to reveal about the human. Certainly, when we consider the grotesque dimension of the work, we are dealing with a distortion taken to such an extreme that we are forced to deal with the violence both to the image and to that to which the image points.

The beginning point for Bacon is with an image of some concrete reality — a person or object — which he wishes to portray or, as he suggests, "record" and "trap" in the painting. But the task is not one of reproducing an image of that reality as a photograph would — the surface image that the eye would normally see, but a transforming of the image — a transformation that will inevitably involve distortion. He states: "What I want to do is to distort the thing far beyond the appearance, but in the distortion to bring it back to a recording of the appearance." The appearance for Bacon is its truth or what he calls the factuality of his subject. Wolfgang Kayser, in his study *The Grotesque in Art and Literature,* observes that the grotesque appears alien to the familiar world but is in fact a metamorphosis of it.[13] Bacon provides us with such a metamorphosis of the reality he is portraying.

In this distortion, then, the subject's surface image is distorted to the end that we actually see the inner truth of the image more clearly, that we gain "a deeper sense of the reality of the image."[14] This "distortion" might

12. Sylvester, p. 8.
13. Wolfgang Kayser, *The Grotesque in Art and Literature,* trans. Ulrich Weisstein (New York: Columbia University, 1981), p. 184.
14. Sylvester, p. 86.

better be conceived as an altering of the outer image to reveal the true nature of the inner reality. John Russell, in discussing the portraits, suggests that the studies "offer superimposition of states, in which certain characteristics of the person concerned appear with exceptional intensity, while others are obliterated."[15] There is risk in this, for how can he be certain that the "facts" are captured? The answer, of course, is that he can't. But it is a necessary risk. There is risk, too, that his studies will appear to degrade the subjects, to caricature them, and he acknowledges that the people he paints can perceive "that the distortions of them are an injury to them." His response is simply that he does not intend to do injury to them personally, but "who today has been able to record anything that comes across to us as a fact without causing deep injury to the image?"[16] In a later conversation with Sylvester, he offers a somewhat different way of treating the question of whether they do damage.

> Whether the distortions which I think sometimes bring the image over more violently are damage is a very questionable idea. I don't think it is damage. You may say it's damaging if you take it on the level of illustration. But not if you take it on the level of what I think of as art. One brings the sensation and the feeling of life over the only way one can.[17]

The beginning point, then, is with the image and the fact — the truth of the image he wishes to give us. How this unfolds in the creative process is unpredictable. Certainly the act of creating a painting is not simply a rational process. Chance, accident from "involuntary marks on the canvas which may suggest much deeper ways by which we can trap the act you are obsessed by," occurs. And he continues:

> If anything ever does work in my case it works for the moment when consciously I don't know what I'm doing. I've often found that, if I have tried to follow the image more exactly, in the sense of its being more illustrational, and it has become extremely banal, and then out of sheer exasperation and hopelessness I've completely destroyed it by not knowing at all the marks I was making within the image — suddenly I have

15. Russell, p. 124.
16. Sylvester, p. 11.
17. Sylvester, p. 43.

found that the thing comes nearer to the way that my visual instincts feel about the image I am trying to trap. It's really a question in my case of being able to set a trap with which one would be able to catch the fact at its most living point.[18]

There is, then, an irrational dimension to the process:

an extraordinary irrational remaking of this positive image that you long to make. And this is the obsession: how like can I make this thing in the most irrational way? So that you're not only remaking the look of the image, you're remaking all the areas of feeling which you yourself have apprehensions of. You want to open up so many levels of feeling if possible.[19]

And again he speaks about the irrational chance aspect of painting, about "why it is that if the formation of the image that you want is done irrationally, it seems to come onto the nervous system much more strongly than if you knew how you could do it."[20]

But if there is the irrational — the given power of the unexpected, the play of chance — there is also a continuity maintained with the image, with an ordering that is brought to the canvas. He observes: "Perhaps one could say it's not an accident, because it becomes a selective process which part of this accident one chooses to preserve. One is attempting, of course, to keep the vitality of the accident and yet preserve a continuity."[21]

Accident and continuity in a dialectical dance. The accident, the markings, the brush strokes unexpected — the unexpected effect of the markings or brush strokes in turn controlling. There is "a selective process which part of this accident one chooses to preserve." And there is a sense in which "one is to set a trap . . . to catch the fact at its most living point."[22] He responds to what is there, and the power to order continually plays itself out.

Order, then, is important in this process. He writes: "I think great art is deeply ordered. Even within the order there may be enormously instinctive and accidental things. Nevertheless, I think that they come out

18. Sylvester, p. 54.
19. Sylvester, pp. 27-28.
20. Sylvester, p. 104.
21. Sylvester, pp. 16-17.
22. Sylvester, p. 54.

of a desire for ordering and for returning fact onto the nervous system in a more violent way."[23]

Chance and order, therefore, interact. Both are essential. Perhaps he is clearest in his understanding of how this interaction should take place when he states: "I want a very ordered image but I want it to come about by chance."[24]

There is also a kind of dialectical interaction that emerges between the painter and the painting. The painter is autonomous, the painting becomes so. It takes on "a life completely of its own. It transforms itself by the actual paint." The relationship is dynamic, and out of the relationship and interaction of the painter and the painting comes the completed work. It is the recording of the work's fact on many levels "where you unlock the areas of feeling which leads to a deeper sense of the reality of the image, where you attempt to make the construction by which this thing will be caught rare and alive and left there and, you may say, finally fossilized — there it is."[25]

The work as image, "rare and alive" — the work as a power *sui generis* — has a basic purpose in relationship to the viewer which is not simply that of providing aesthetic satisfaction. It is rather there to "unlock the valves of feeling and . . . return the onlooker to life more violently."[26] It is to provide an encounter between the viewer and the painting that opens the viewer to feelings conveyed by the image — feelings that carry the essence of the individual's experience of the painting, feelings so powerful that they return us to life more violently aware than before.

In speaking of how the image conveys feelings, it is important to respect Bacon's insistence that he is not always certain whether the image does convey something of what he hopes it will nor, indeed, that he necessarily knows, himself, what it conveys. The process is neither so linear nor so predictable as to assume that the image will yield a given response. At one point Bacon insists: "I'm just trying to make images as accurately off my nervous system as I can. I don't even know what half of them mean. I'm not saying anything. Whether one's saying anything for other people, I don't know."[27] But he does say something. His works can lead us to

23. Sylvester, p. 59.
24. Sylvester, p. 56.
25. Sylvester, p. 66.
26. Sylvester, p. 17.
27. Quoted by Demerion in exhibition catalogue of the Hirshhorn Museum, p. 7.

experience his imaging of the deeper recesses of human experience, and these recesses into which we are invited are those of the darker side of human existence. His is a disturbing vision of who we are and what we are about, and our encounter with that vision through the images he offers will lead us to confront the poignant, frightening underside of our own selves.

Bacon and Religion

As I observed earlier, Bacon is nonreligious in any traditional sense, a nonbeliever in any theistic sense. God is not, or if God is, God is not accessible to us: there is no tradition or archetypal myth that can endow our life with ultimate purpose or meaning. He observes that this has not always been the case. In speaking of Rembrandt and Velasquez, he comments that they had certain types of religious possibilities in their world that, in some fashion, shaped their own attitude toward life and, consequently, their paintings. But, he insists, what they had is not our situation. What they had has been canceled for us.[28] In making such a case Bacon does not deny that people do live within and out of religious traditions in our own time, but it is not truth but falsehood by which they live.

> I think that most people who have religious beliefs, who have the fear of God, are much more interesting than people who just live a kind of hedonistic and drifting life. On the other hand, I can't help admiring but despising them, living by a total falseness, which I think they are living by with their religious views.[29]

But if a traditional religious vision is rejected by Bacon, a vision about the ultimate nature of existence is a deep and central part of his own self-understanding, his work as an artist, and the artwork he creates.

In a particularly insightful discussion with David Sylvester, Bacon sets the boundaries of his perspective. "I think of life as meaningless; but we give it meaning during our own existence. We create certain attitudes which give it a meaning while we exist, though they in themselves are

28. Sylvester, p. 29.
29. Sylvester, p. 134.

meaningless, really."[30] In this statement the tension between meaning and meaninglessness is resolved temporarily by the fact that we can create meaning but judged ultimately to be a meaning that is transitory, indeed, meaningless in any final sense. The meaning we create is a "supreme fiction," to use Wallace Stevens's term, and yet it is a fiction that can be sustaining. This possibility of creating meaning is all we have between the boundaries of birth and death, and yet it is what we have; it is, therefore, our beginning point in the human drama. "[One] believes in for nothing — but believes in. I know it is a contradiction in terms; it's nevertheless how it is. Because we are born and we die, but in between we give this purposeless existence a meaning by our drives."[31]

Central to Bacon's anthropology is the interplay of order and freedom. We depend on order in our lives, yet we are free to act upon that order, to alter it, to reinvent it, at least within limits. At the heart of this process is the factor of chance. Chance is the unexpected, the unpredictable event, the intrusion of something that requires a response. In painting it may be the accidental mark on the canvas that creates a new direction for the work, as we have discussed above. It is often for Bacon the impetus for action, the catalyst for exercising freedom. This recognition of the unpredictable, the accident, the chance moment is not a negative occurrence but an opportunity. (Bacon was a gambler attracted to the whole process of anticipation and response to what the dice yield, the cards offer.) It is an opportunity because we can interact with, manipulate, accept, deny, work with the new reality that is presented. In effect, we can respond out of our own freedom, allowing it to act upon us and we upon it. Bacon notes, "[O]ver a great many years I have been thinking about chance and about the possibilities of using what chance can give, and I never know how much it is pure chance and how much it is manipulation of it."[32] And again, "I feel that anything I've ever liked at all has been the result of an accident on which I have been able to work."

This understanding implies a high view of freedom. If chance were seen as a continually overwhelming reality destroying the order and binding us to a life of disrupting uncertainty, we would be little more than pawns in a game, predetermined, paradoxically, by the inevitability of a

30. Sylvester, p. 133.
31. Sylvester, p. 134.
32. Sylvester, p. 52.

malevolent force of chance. But chance is seen as the moment of possibility. It is "luck," as accident, that opens up options or provides a gift of new reality that was unexpected but can be turned to a creative end. To conceive it as such, however, is to imply that one has the freedom to act upon the chance occurrence in such a way that one serves the ends of order.

There are other dimensions of life that Bacon speaks of as crucial in our decision making. He observes that when free interaction with chance is allowed in painting, the unconscious is given a freer rein to inform the work and, for Bacon, the unconscious is a positive source of creativity.[33] Furthermore, he has a strong sense of "our drives or instincts," our underlying vitalities, and their action upon us. He also recognizes the interplay of chance and the critical sense in creating a work. The process of creating is "only kept hold of by the critical sense, the criticism of your own instincts about how far this given form or accidental form crystallizes into what you want."[34]

I spoke earlier about Bacon's insistence on the importance of the irrational in the creative process. He uses this term to refer to the whole process in which intuition and the unconscious interact with chance beyond the primary control of reason. It is a process in which the "flow" of creativity takes place and sensations and feelings "bounce" off the nervous system to provide us with a receptivity and responsiveness that is uncluttered by the rational, by the imposition of reason's own ideas. The critical sense, however, does engage reason, and it is through critical reflection that reason becomes a participant in the creative process. Thus, again, we have a dialectic for Bacon with both reason and non-reason affecting the act of creation.

All of this is to suggest that his own anthropology of human activity, drawing on his understanding of how art is created, is one in which a multiplicity of factors — chance, intuition, feeling, the unconscious, reason — pose to the human being the opportunity of choice, and from the exercise of such freedom flows the sustaining and changing, reinventing and transforming of the order which is foundational for life.

These factors we have spoken about and which he speaks about in his interviews and paintings — order, freedom, chance, and so on — frame his anthropology. Bacon, however, denies that he is attempting to define human nature or give us a single understanding of the human situation. But he also

33. Sylvester, p. 120.
34. Sylvester, p. 102.

insists that he is attempting to record the facts about existence that will allow us to see into the deeper recesses of human experience. And when we both listen to his words and study his work, it is not difficult to see that he provides us images of human existence that are coherent and consistent in their articulation and, taken together, suggest a rather well-defined view of the human condition. The view is a dark one. We are creatures with a unique propensity for violence and inhumanity who are anxious and despairing, isolated and alienated, who live in the shadow of death and the awareness of the ultimate futility of life itself. We are, finally, creatures who are flawed, who do not realize the nobility, the love, the goodness that we imagine ourselves embodying. These are the "facts" he reveals. Eliot's lines

> Birth and copulation and death.
> That's all the facts when you come to brass tacks:
> Birth and copulation and death

not only fit the three panels of the *Triptych Inspired by T. S. Eliot's Poem Sweeney Agonistes,* but serve as threads running throughout his work. We are born, an act not of our making, we copulate — we act out our passions whatever they may be — and we die, our mortality haunting us from birth.

In recognizing this view of our situation, it is important not to flatten Bacon's thought into a one-dimensional understanding of cynicism or nihilism. His understanding is much richer than that. Foremost there is ambiguity in the "facts" of existence and our own situation. His *Painting* (1978) is a case in point. A figure in a bare room reaches with his foot to turn the key in a door. The body, sculpturelike in form, strains, unbalanced, in an act that offers no resolution. Will he turn the key, will he go out or let someone in, will he lock the door or open it? A figure superimposed appears outside on a stairs: is the door and key an action in relation to him? Bacon acknowledges the work was in response to Eliot's *The Waste Land:*

> *Dayadhvam:* I have heard the key
> Turn in the door once and turn once only
> We think of the key, each in his prison . . .
> Only at nightfall, aethereal rumours
> Revise for a moment a broken Coriolanus.[35]

35. Eliot, *Collected Poems,* p. 276.

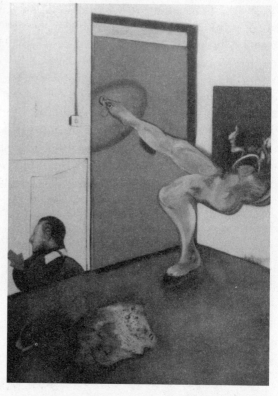

John Russell observes that Bacon gives us in this image "one of the most haunting of all presentations of ambiguity."[36] Such ambiguity is a key to understanding his work. He opens us up to the unknown of that which we are experiencing. He gives us powerfully and directly the facts of our mortality, our caughtness, our passion as unequivocable parts of our lives, but at the same time he pulls us into a recognition that we know and do not know what they finally mean.

Further, Bacon's vision does not prevent him from presenting poignant images of tenderness and grief. Nowhere is this more powerfully done than in the triptych of George Dyer's death and the paintings of Dyer that follow. Nor do his figures fail to reveal powerful personalities, noble in presence, indicative of life that has endured with dignity, as in

36. Russell, p. 152.

his treatment of the image of Isabel Rawsthorne. Furthermore, his treatment of sexual passion is as moving in its statement that we are creatures with a passionate vitality for life and an erotic reach for union as it is suggestive of sexual desperation and violent forms of coming together. Various works treat couples in sexual union, and he speaks in his interviews of the human need for friendship. Indeed, his works affirm the need for love, closeness, for the release of passion in compassionate union. But, finally, they do so only hauntingly. The portraits of people, while revealing elements of dignity, touch more on their vulnerability and despair. And the images that do portray grief and tenderness are still lined with the futility they come out of and lead us into. Ambiguity remains the most optimistic of the shadows that haunt his figures. We are never allowed to escape the ambiguity and sadness of our condition.

Bacon's human beings are "fallen" creatures. There is in the imprint of their forms the legacy of an original flaw working as the sin that simply is, that taints us all. It is a part of our mortality. We are free and there is nobility in our freedom, we love, we grieve, we have passion and the power to act, but we never escape our own brokenness in a world that we never finally understand.

Bacon's religious explorations, then, treat a range of theologically significant issues regarding creation, freedom, destiny, human evil, but the religious question that informs his treatment of our existence most profoundly is that of death, which, for him, our mortality mirrors. Acknowledging to David Sylvester that people "have a feeling of mortality about my paintings," Bacon states:

> But then, perhaps, I have a feeling of mortality all the time. Because if life excites you, its opposite, like a shadow, death, must excite you. Perhaps not excite you, but you are aware of it in the same way as you are aware of life, you're aware of it like the turn of a coin between life and death. And I'm very aware of that about people, and about myself too, after all, I'm always surprised when I wake up in the morning.[37]

Quoting Cocteau, he says, " 'Each day in the mirror I watch death at work.' This is what one does oneself."[38] He observes that at seventeen he became aware that he, too, would die: "that here you are existing for

37. Sylvester, p. 78.
38. Sylvester, p. 133.

a second, brushed off like flies on the wall."[39] And throughout life, "You feel the shadow of life passing all the time."[40]

These, then, are the boundaries: birth and death. And our only purpose is that of creating a meaning that will sustain us and give some significance to the vitalities and passions of our own existence.

And what of art? In classical language it is a source of revelation about the way we are. It provides us imprints of the truth which we need to know. It invites us to encounter our own feelings and experiences of the deepest dimensions of our lives through our apprehension of the feelings the painting objectifies. It is not insignificant that for Bacon this is the primary purpose of art. He readily insists throughout his interviews that the end of art is to provide us with the fact, the truth of who we are. In an interview with Hugh Davies, he observes that "great art is always a way of concentrating, reinventing what is called fact, what we know of our existence — a reconcentration . . . tearing away the veils that fact acquires through time. Ideas always acquire appearance veils, the attitude people acquire of their time and earlier time. Really good artists tear down those veils."[41] But to what end? Is it simply to "record," to "report," and that in itself is enough? I think the answer for Bacon is more complex. It is for the artist to connect with his or her own deepest feelings, and it is to provide a means for us to experience our own deepest feelings that we might know in a way we didn't know before, that we might be exorcised of the experience's destructive nature, that we might be healed through revisiting them via the mediation of the work of art, that we might experience a catharsis that will free us.

From an interview with Bacon in 1952, Sam Hunter wrote the following about the artist: "Bacon has admitted . . . that one of his goals is to meet the challenge of a violent age by reviving in a meaningful modern form the primal human cry and to restore to the community a sense of purgation and emotional release associated with the tragic ritual drama of Aeschylus and Shakespeare."[42] Thus the work of art takes on an additional significance. It is not simply a "recording of the truth" but an invitation

39. Sylvester, p. 133.

40. Sylvester, p. 81.

41. Hugh Davies and Sally Yard, *Francis Bacon* (New York: Abbeville Press, 1986), p. 81.

42. Sam Hunter, "Francis Bacon: The Anatomy of Horror," *Magazine of Art* 45, no. 1 (January 1952).

to respond to that truth. The artwork thus becomes a means to insight and purgation, to some sense of release and freedom. As Hunter states in a 1988 interview: "(Bacon) believes that for the authentic and incorruptible artist, impervious to social hypocrisy, the only available transcendence from man's poignant and vulnerable condition is achieved through the experience of art."[43]

Bacon speaks to this process in his response to a question about his frequent treatment of two figures making love. He comments about the death and love that the "remaking or reinventing" of a couple calls forth, and he speaks of the need to be exorcised of the grief or suffering of love. He insists that you obsess about it in life and then in the many images on the canvas. There is a drive to record the fact he wishes to set forth, and in his recording he does, in Suzanne Langer's words, "objectify feeling" or experience, so that it can be known and experienced both by him and by the viewer. What we do with it one cannot know or control, but the implication is that it will deepen our own sensibility about life, will allow us to transcend the experience that is called forth, to take it in and free us from our caughtness within it. There is, then, a certain "sacramental" power attributed to art in which art becomes a means of purgation and transcendence.

In talking about Eliot and Yeats and their works' effect on him, Bacon observes that "you would find the whole of Eliot and Yeats and everything and practically every other poet, in Shakespeare, who just enlivens life, no matter how futile you think it is, in a way that nobody else has ever been able to do. He [Yeats] just opens it out in such an extraordinary way. He enlivens it both by his profound despair and pessimism and also by, you may say, his humour."[44]

So with Bacon and his own works. He gives us his studies to enliven our life by engaging us in an encounter with the depth of life's experience. He has said that his painting is concerned with "exhilarated despair." For Bacon our life is enlivened when we come to terms with the fact that we are never free from the reality of despair but are free to take it in and, in so doing, respond to it. Art becomes a means to this end.

Important to understanding our encounter with his work is his

43. Sam Hunter, "Metaphor and Meaning," in exhibition catalogue of the Hirshhorn Museum, p. 33.
44. Sylvester, p. 118.

judgment that in the moment of encounter we are returned to life "more violently."[45] The work shakes us profoundly, and we are confronted with the truth of our own condition. It turns the fact "onto the nervous system in a more violent way," in such fashion that we can't screen, rationalize, flee to places of emotional or critical distance before we see the heart of the matter. Bacon, in a discussion about why he prefers art that is non-illustrational in form over that which is illustrational, observes that "an illustrational form tells you through the intelligence immediately what the form is about, whereas a non-illustrational form works first upon sensation and then slowly leaks back into the fact."[46] It is not insignificant or surprising that because of this understanding he has little use for much of abstract art, for such art never moves beyond the aesthetic level: "[It] is an entirely aesthetic thing. It always remains on one level. It is only really interested in the beauty of its patterns or its shapes."[47] Art is about the facts of human existence, and profound art is ordered in such a way that we are able to encounter those facts.

Bacon creates art, then, which he hopes will grasp us, shake us, to the end that we may encounter more fully the reality the work points to. In Paul Tillich's terms he wishes us to stand at the boundary and know that because we have been there we will never see in the same way again.

The Element of the Grotesque

In making a work of art that is able to engage us in the experience of such "factuality" about life, Bacon distorts form, at times in grotesque fashion. David Sylvester has written that Bacon's works show how people "behave in an extreme situation and (we are) to judge them in that light." John Russell observes that "very few people can stand before one of his pictures and not feel that it stands for a human activity pushed to its limit."[48] This correlates with the use of the grotesque, for the effect of the grotesque presentation of form is itself extreme; it demands a response beneath the rational and unleashes reservoirs of feeling within us that unsettle and create in us an inner

45. Sylvester, p. 59.
46. Sylvester, p. 56.
47. Sylvester, pp. 58-59.
48. Russell, p. 77.

violence of response. Bacon acknowledges often that his images are violent in the distortion he has made of the subject. It is this violence, this violating, that gives his forms grotesque proportions and character.

Bacon gives us the grotesque in a number of different images: the biomorphic combination of animal and human forms in one creature; the treatment of gesture or aspects of the body that have strong emotional content in such a way that the content is heightened beyond normal possibility; the creation of surrealistic settings in a way that is disturbing, frightening, wrenching; the use of the orifice, particularly in the creation of the scream; the creation of monstrous figures that are sinister in expression. For some artists the use of the grotesque can be fantastic and playful in its capacity to disturb, as in Bosch's works, or satirical as in works of Goya, or melodramatic as in the drawings of Fuseli, or romantically surreal as in Dali. With Bacon the darker, more disturbing use of the grotesque pervades, and the shock we experience is dramatic and harsh.

In the religious works that concern us, the grotesque is employed with an uncommon intensity. Bacon has long used the scream as a motif in his work. He once said that Poussin in *The Massacre of the Innocents* (1630) created the most grotesque scream in painting. He was equally drawn to Eisenstein's screaming nurse in the film *The Battleship Potemkin* (1925). In his *Study after Velasquez's Portrait of Pope Innocent X* (1953), the scream becomes an electrifying image, as it is in one of the grotesque heads of *Three Studies* (1944).

Bacon's use of meat as a symbol of death and crucifixion shocks in its grotesqueness, as in *Crucifixion* (1962 and 1965). The painting of sides of meat also has a history in art, wherein hanging beef is portrayed in such a fashion as to suggest the crucified form, as with Rembrandt or Goya, or Soutine in our own time. It is a major subject for Bacon.

Bacon also creates figures in which contradictory parts are fused that may well be some of the most grotesque forms in art. They are most powerfully presented in *Three Studies* (1944), where they appear as a blend of both animal and human forms. This type of grotesque image has a long history from the medieval age to the present, though few works achieve the savagery or agony of Bacon's figures. He also creates grotesque effects in his environments when he uses frames around his figures suggesting a cage or enclosed room that has no exit, or shadows that become sinister patterns exaggerated in their forms. The grotesque, then, is crucial in Bacon's studies, functioning as a means of pushing us beneath the surface reality to a deeper

Fig. 7.2. Nicholas
Poussin, detail from
Massacre of the Innocents,
1630-31

dimension. It becomes in a given work an essential aspect of the work's
capacity to "trap" the truth Bacon wishes to reveal and enable us to encounter
that truth "more violently" in our own experience.

A Note on Bacon's Use of the Crucifixion Image

In discussing his use of the crucifixion, Bacon insists that he approaches
it as a nonbeliever only interested in what it says about "a way of behaviour
to another."[49] Down through the history of European art, the crucifixion
has been "a magnificent armature on which you can hang all types of
feeling and sensation." It is a specific religious symbol, but, for Bacon, it
is also a powerful cultural symbol laden with complex meanings that
provoke diverse feelings; a symbol so deeply embedded in the collective
consciousness of a civilization that an artist does not have to be Christian

49. Sylvester, p. 23.

Fig. 7.3. Sergei Eisenstein, detail of nurse from *Battleship Potemkin,* 1925 film

to use it as a subject for the exploration of deep and evocative feelings and experience. Indeed, Bacon suggests that the pervasive cultural power of the symbol may have attracted many artists who painted great crucifixions but who otherwise may have been nonbelievers.[50]

One must respect Bacon's disclaimers that he is neither a Christian nor an interpreter of Christian theology. But this does not end the matter, for while he did not choose the icon because of its Christian meaning, it did allow him to explore the undercurrents of human feelings and actions that have religious import — feelings of anger, grief, hatred, horror, and guilt; and while he did not choose to paint the image of a crucifixion to focus our attention on a peculiarly Christian event, he did choose an image that carries an inevitable reference to the religious experience. It is fair to

50. Sylvester, p. 44.

Fig. 7.4. Francis Bacon,
detail from third panel of
*Three Studies for Figures
at the Base of a
Crucifixion*, 1944

say, therefore, that his works make no effort to interpret the meaning of the cross as the crucifixion of Christ, but it is also important to recognize that he chose the cross, a symbol laden with its historical, cultural, and religious meanings, to explore more deeply and more fully the religious dimension of human experience. James Thrall Soby offers an insightful comment on Bacon's choice of the crucifixion as image in his painting.

[I]t was not until 1945 that the theme of the Crucifixion once more gave Bacon the creative impetus he needed. At that time Graham Sutherland was making the preparatory studies for the large Crucifixion he had been commissioned to paint for the Church of St. Matthew in Northampton, England. There can be no doubt that Sutherland's example acted as a catharsis on his younger colleague. Indeed, Bacon himself confirmed this fact when in a recent interview he said that "all his life he had been looking for some help to find a 'Theoretical Back-

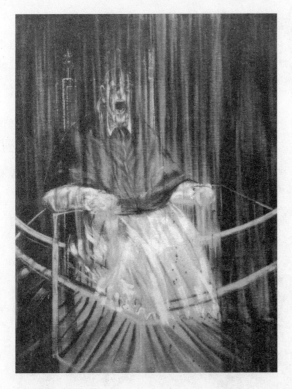

Fig. 7.5. Francis Bacon, *Study after Velasquez's Portrait of Pope Innocent X,* 1953

ground' for his painting." He added: "Once in [his] life he hoped Graham Sutherland might provide him with it."[51]

Bacon draws on Greek religious mythology in a similar fashion. He is not attempting to examine the meaning of the Erinyes, or Greek Furies, of the *Oresteia* (Bacon sometimes speaks of the Eumenides of Aeschylus but has later said he meant the Erinyes),[52] but to use them and the mythic power and meaning they have to inform his own study and the meaning he wishes to explore.

Bacon, then, like Freud, has little positive truck with religion, yet when he chooses to explore certain truths that are at the heart of human

51. James Thrall Soby, "A Trail of Human Presence," *MoMA Members Quarterly* 2, no. 4 (spring 1990).

52. Richard Francis, *Francis Bacon* (London: Tate Gallery, 1985), p. 6.

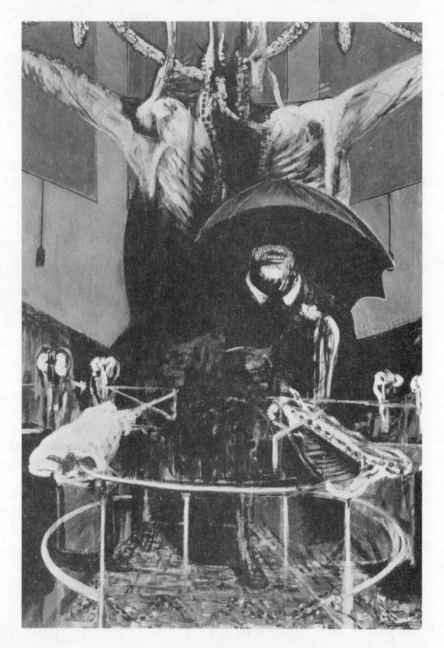

Fig. 7.6. Francis Bacon, *Painting*, 1946

experience, he draws on religious myth and image. Goya chose Saturn, Freud chose Oedipus and Electra, and Bacon chose the Erinyes and Christ for the exploration of human experiences that are, finally, religious in their significance and meaning.

Three Studies for Figures at the Base of a Crucifixion (1944), with Reference to the 1988 Version, and the *Triptych Inspired by Oresteia of Aeschylus* (1981)

Three Studies was painted in 1944. His first use of the crucifixion theme, however, was in 1933 when he painted three works, two entitled *Crucifixion* and one *Crucifixion with Skull*. In these works, he gives us images of Christ on the cross. Bacon once observed that "one of the things about the Crucifix is the very fact that the central figure of Christ is raised in a very pronounced and isolated position, which gives it, from a formal point of view, greater possibilities than having all the different figures placed on the same level."[53] In the 1933 studies the figure hangs as an isolated figure. One crucifixion is framed with lines suggestive of a room. Such framing later plays more boldly in his work — a room that closes the figure away from the outside. The image of Christ appears at points diffuse with limbs like sticks, human yet equally insectlike, with a pinhead and straight limbs.[54] In this study we have the metamorphosis of the human image in which the distortions lead to forms that incorporate or at least suggest animal-like features more organic than human in form. Here are the beginnings of his biomorphic forms. The second study shows Christ with a straining torso staring at a skull, the skull reminiscent of the medieval artist's portrayal of the skull placed at the base of Christ's cross. At one level these works appear to be more studies in form and space, with the masklike face and the whole structure of the body suggestive of Picasso's forms. At a level of symbolic power, however, these crucifixions are studies that speak of mortality and isolation, of death. They herald, as Hugh Davies and Sally Yard have observed, "Bacon's tendencies to confront the

53. Sylvester, p. 46.
54. Lawrence Gowing, "Francis Bacon: The Human Presence," in exhibition catalogue of the Hirshhorn Museum, p. 42.

Fig. 7.7. Francis Bacon,
Crucifixion, 1933

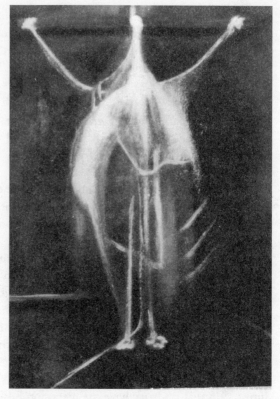

grimmest realities of 'human existence' in his crucifixions. They offer no
hope or transcendence or image of meaningful suffering."[55]

In *Three Studies,* for which these early works set the stage, the accent
on formal motifs gives way to a strong expressive statement, surrealistic in
feel, which remains true throughout his treatment of crucifixions. This
work gave Bacon his first large audience. Painted in 1944 with Europe
nearing the end of the war, it was exhibited at the Lefevre Gallery in April
of 1945 in a show that included Graham Sutherland and Henry Moore.
Russell observes that many of the works in the show spoke of the spirit
of hope and optimism that emerged at the end of a long and brutal war.
Evil, as powerful as it was, had been answered, and the possibility of a
humane and free world seemed again a possibility. As Russell observes,

55. Davies and Yard, p. 89.

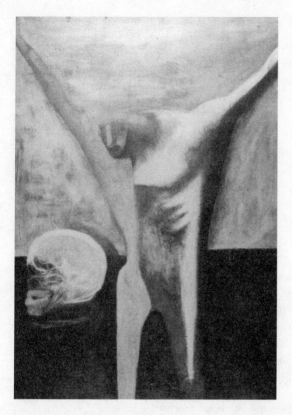

Fig. 7.8. Francis Bacon,
Crucifixion with Skull,
1933

"Nobody wanted to believe that there was in human nature an element that was irreducibly evil."[56] Bacon's jarring and frightening images, however, seemed to scream just that. The nightmare that framed the war was present again in three panels.

If the war is an important reference for placing the work, it is finally not a work about the war, nor should we reduce it to simply a response to the war. The war is rather the particular historical context out of which it came; the work is about a universal aspect of human existence.

In the work, Bacon takes the crucifixion as the iconographic point of reference, though he points out it is not *the* crucifixion, and he introduces through its three images at the base of the cross Greek mythological figures from Aeschylus's *Oresteia*. The figures are the Erinyes, who are the

56. Russell, p. 1.

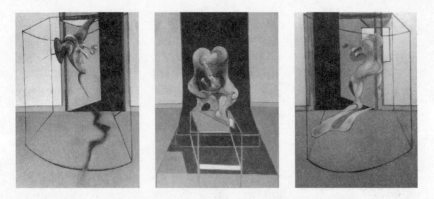

Fig. 7.9. Francis Bacon, *Triptych Inspired by Oresteia of Aeschylus,* 1981

Greek Furies or goddesses of vengeance. In Aeschylus's tragedy, which includes the three plays *Agamemnon, The Libation Bearers,* and *The Eumenides,* an act of murder leads to vengeance and a further murder. Agamemnon, in the buildup to the Trojan War, kills his and Clytemnestra's daughter Ephigenia in an act of human sacrifice. At the end of the war, victorious over the Trojans, Agamemnon returns, only to be led by Clytemnestra unsuspectingly to his death on the "dark red tapestries."

> "Let there spring up into the houses he never hoped
> to see, where Justice leads him in, a crimson path."[57]

The tapestry carpet, metaphorically suggestive of blood, leads to his palace and his death at the hands of Clytemnestra. Having avenged her daughter's death, her life, in turn, is taken by her son Orestes for the killing of his father. Orestes then flees to the Oracle of Delphi pursued by the Erinyes, or Furies. The killings of a daughter, a husband, a mother unfold, and blood sacrifice, revenge, and murder build one upon the other. Bacon was well acquainted with this tragedy, having been influenced both by the play and W. B. Stanford's *Aeschylus in His Style: A Study in Language and Personality* (1942). He would turn again to the Erinyes in later works, including *Fragment for a Cross* and, particularly, *Triptych Inspired by Oresteia*

57. Aeschylus, *Agamemnon,* trans. David Lattimore (Chicago: University of Chicago, 1959), lines 910-11, p. 62.

of Aeschylus (1981). This later work deserves brief attention, both to its use of the Furies and the grotesque.

In this triptych Bacon returns to *Oresteia* as a subject for painting at a time when he is again reading the tragedy. The panels seem to refer to incidents from the plays. The first panel is of a door that is open, perhaps for Clytemnestra to welcome Agamemnon home from the war. At the top of one of Bacon's cagelike structures hangs a birdlike bat creature, grotesque and lurid, an image that may be one of the Furies. Blood flows under the door, which is echoed in the second panel where the flowing red tapestry becomes the carpet upon which sits the royal dais and the form of the murdered body of Agamemnon, the king, now on his throne, now no more than a spine-contorted form, carcasslike in imagery. The third panel shows a door with a human figure, not fully formed, moving out. Sam Hunter has observed about this panel:

> The third panel evokes both victim and oppressor and may stand for the tragic hero Orestes as well as the undefined shapes and darkness of unformed life (the elan vital or libido) lifting the chilling painting to an even higher level of allegorical meaning.[58]

The movement outward may certainly point to the murder by Orestes that is to come offstage and lead to the flight of Orestes and the Furies' pursuit. Dawn Ades has commented that

> Each image in the triptych condenses sensations which can thematically relate to several scenes in the play, but which like Aeschylus' own imagery are to do with observed and generalized emotions: fear, prophecy, defiance, desire.[59]

But, to return to *Three Studies.* The crucifixion is not visually a part of the work. Rather, what we see are the three figures at the foot of the cross. Bacon has said, as I have noted, that the crucifixion is a good "armature" for exploring feelings, for it has culturally accrued meanings that are about the depth of human experience. But there is need to pause here. While the work may be about *a* crucifixion rather than *the* crucifix-

58. Hunter, "Metaphor and Meaning," p. 34.

59. Dawn Ades, "Web of Images," in *Francis Bacon,* exhibition catalog (London: Tate Gallery and Thames and Hudson, 1985), p. 20.

ion, and the Furies have mythological reference removed from any cultural reference to crucifixion, the triptych is still about figures at the foot of a cross, which in Western culture will necessarily invite the viewer to bring to the work some sense of the crucifixion of Christ and the figures related to that event. This does not mean that Bacon is providing a theology of the cross in spite of or unbeknown to himself. (He would abhor the idea.) Rather, it means that in our own approach to the work, we will necessarily engage in experiencing the work and interpreting it with some awareness of the Christian story and its meaning. Who, then, are the grotesque creatures at the foot of the cross? The Erinyes of *Oresteia*? Yes, but more. The Erinyes are themselves armatures for exploring certain types of experience — experiences of evil and hatred, vengeance and cruelty. And in their representation here, as the figures that embody such reality, they become the ones over against the figures being crucified — the ones who crucify or who embody the emotions that feed the vengeance and cruelty of the act of crucifixion. One does not have to turn this study into a narrative in order to identify the bearers of evil. Stephen Spender has written that

> These appalling dehumanized faces, which epitomize cruelty and mockery are of the crucifiers rather than the crucified. And this remains true of Bacon's work until now. His figures are of those who participate in the crucifixion of humanity which also includes themselves. If they are not always the people who actually hammer in the nails, they are those among the crowd which shares in the guilt of cruelty to the qualities that are — or were — beneficently human, and which here seem to have been banished forever.[60]

As are the Erinyes, who epitomize cruelty and mockery and seek Orestes to crucify him, and as are those who mocked at the crucifixion of Christ and are, therefore, party to the crucifixion, so are all who epitomize cruelty and mockery and are the crucifiers of those who "are beneficently human." Hugh Davies in a 1983 interview with Bacon records that Bacon sees the Erinyes as an "image of disaster" and that the Erinyes take the

60. Stephen Spender, quoted in James Thrall Soby, "A Trail of Human Presence: On Some Early Paintings of Francis Bacon," MoMA, *Members Quarterly* 2, no. 4 (spring 1990): p. 10.

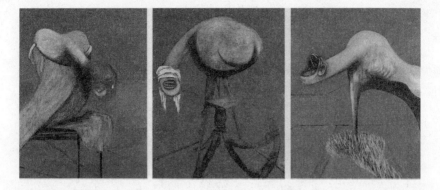

Fig. 7.10. Francis Bacon, *Three Studies for Figures at the Base of a Crucifixion,* 1944

form of our "private Demons."[61] The images themselves, biomorphic in character, are uniquely distorted forms that owe something to Picasso.

As such organic forms, they take on hideously grotesque features set against an empty, flat, bloodred background broken only by lines that create a boxed-in, cagelike place. Bacon has insisted that these geometric frames in his work are only there to help us "see the image, no other reason." But they readily take on symbolic power, as they do in other works. There are, then, in the unyielding organic bloodred geometric patterns powerfully demanding frames for encountering the images which are harsh, sterile, stark in their ash grayness.

In the first panel, we have a legless figure with curved, bonelike extensions for arms, balanced on a tablelike structure. Her face, profiled at the end of an elongated neck, is hidden by the swirl of hair that seems to function as a straitjacket holding her back from attack. Yet this figure, crouched as she is, becomes, in her crazed, trapped, and helpless form, the figure of one who mourns without a sense of why — abject submissive mourning without reason or meaning.

The central panel offers an image of a creature that is birdlike in form, ostrich-shaped, with its long neck thrust downward and turned to us in an anguished grimace. Lips and teeth dominate its visage; the eyes are covered by a bandage. The creature stands in a corner behind a four-legged base that formally echoes the Furies' own alarm in the closed-in

61. See Davies and Yard, pp. 95, 97.

"room." The expression is jeering; the teeth reflect an unmediated hatred. Aeschylus describes the Erinyes as "like no seed ever begotten, not seen ever by the gods or goddesses, nor yet stamped in the likenesses of any human form."[62] They have no wings, nor can the creature see. Trapped, it screams its own depth of antipathy and inhumanity.

Davies and Yard suggest that while the bandaged figure "is probably derived from Grünewald's *The Mocking of Christ,* the snarl may well have been triggered by news photos of Nazi harangues."[63] Bacon had such photographs on the wall in his studio.

The right panel continues the grotesque form of imagery with the body of the creature not unlike a powerful dog with an elongated neck and grotesque, primatelike head with no eyes, large ears, and an enormous mouth opened in a brutal, agonizing scream. The one leg and foot of the beast (the front side of the body facing us offers only a stump for the other leg) is rooted in what may be a patch of grass or a board of nails, reflecting in its balancing of the body the harshness of the scream itself. Here the scream appears in its earliest formulation. It is the essence of horror, ambiguously encountering the viewer as an anguished cry of unleashed pain or fear or hatred that shrieks of destruction; grotesque in form, violent in image, it confronts one violently.

The panels, void of all sensibility of any emotion that suggests human grief, or compassion or guilt, portray in their rawness the face of the demonic in the guise of what Russell has called "a needless voracity, an automatic unregulated gluttony, a ravening undifferentiated capacity for hatred. Each was, as if cornered, and only waiting for the chance to drag the observer down to its own level."[64]

Here in this work is an absolute imaging of life so distorted — so fallen — as to leave us stripped of all awareness of the good. It frightens us — it is the face at the boundary of all that is hideous and evil, cruel and destructive; and it shakes us, thrusting before us in grotesque fashion the power of the demonic. Bacon achieves what he says he wishes to do. He "unlocks the valves of feeling and . . . returns the onlooker to life more violently."[65] In this work, we become more violently aware of the force of

62. Aeschylus, *The Eumenides,* trans. David Lattimore (Chicago: University of Chicago, 1959), p. 149.
63. Davies and Yard, p. 16.
64. Russell, p. 10.
65. Sylvester, p. 17.

evil that stalks human life and defies any sense "of qualities that are . . . beneficently human," which the cross, unseen in the panels, silently, offstage, is reference for.

The work offers, from a religious perspective, a theological judgment that evil is a reality manifest among us in forms of revenge, mockery, hatred, voracity, fear, cruelty. And in their extremes they point to the furthest alienation of life from any relationship to the good. Indeed, if evil is simply the distortion of the good, then the extremes of the distortion are to be encountered in these images.

Bacon, as I have noted, denies any relationship between his work and the crucifixion of Christ beyond a certain appreciation for its power to serve as an "armature" for the elicitation of powerful feelings. Yet Bacon's work may, in its own fashion, give us some sense of the power of evil embodied in the world that the crucifixion is supposed to answer. And, paradoxically, he may raise in us the question of what power this God on the cross has over those forces of evil and what power we have over them as forces not beyond us but within us. Thus Bacon poses the ultimate question about the reality of evil in human nature and the depth of its power which any Christian understanding of the crucifixion must attempt to account for.

Bacon would return to *Three Studies* and produce the second version of the triptych in 1988. The same images remain, but the color is less red-orange and more dark red and the figures are set back with the left and right images less centered in their panels. The central panel's figure is set upon a tapestry flowing down into a carpet much as in the Oresteia triptych. The creatures also take on a more sculpted form, with the tables or stands upon which they sit more dominant, and the geometric lines, which tended to compress the figures in a caged fashion in the 1944 work, now demarcating a room. The stand or stool of the center panel now suggests a seat on the red royal dais. The images also have a softer, almost satinlike quality. The work's immediate power tends to be reduced by its greater attention to formal concerns. We see the face of the creature on the left appearing to look at the central figures, and the figure on the right seeming to relate more directly to the central panel. One has a sense of the figures as sculpted forms in the room of a museum, allowing us an element of distance and control over them. But if the rawness and immediacy is tempered, they still speak of the awfulness of the reality which they originally conveyed.

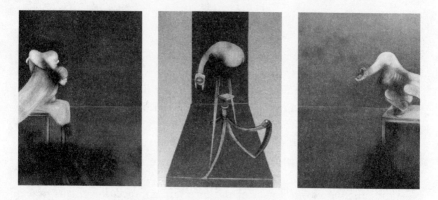

Fig. 7.11. Francis Bacon, *Second Version of Triptych 1944,* 1988

The French poet and friend of Bacon, Michel Leiris, has written of Bacon's work:

> that feature in a Bacon canvas which is immediately apprehended and asserts itself unequivocally of any sense of agreement or disagreement — whatever the elements brought into play, and even when the theme of the work puts it on the level of myth rather than everyday reality — is the kind of *real presence* to which his figures attain, even though this presence has no connection at all with any kind of theology. Through the agency of the figures, the spectator who approaches them with no pre-conceived ideas, gains direct access to flesh and blood reality. (italics mine)
>
> Far from producing a mere surface excitement or picturesque effect, Bacon's work continues to disturb, to charge . . . with good and evil, the always surprising moment of their initial apprehension.[66]

It is the real presence of evil that Bacon gives us in *Three Studies,* a real presence with which theology is concerned as it is with the real presence of Christ.

66. Michel Leiris, *Francis Bacon* (New York: Rizzoli, 1983), p. 14.

Fragment of a Crucifixion (1950)

Bacon was next to treat the crucifixion theme in a 1950 work, *Fragment of a Crucifixion*. In this work we have the crucified form on a black cross and a second figure at the top of the T-shaped cross reaching down. The work points iconographically to a descent from the cross, and Davies suggests a link with Rubens's study of the descent. One could add, also, the parallel with Rembrandt's works of the descent. Davies observes:

> The open mouth of the terrified victim, the T-shape of the cross, and the figure leaning over the crossbar link Bacon's painting with Rubens' *Descent of the Cross* in the Courtauld Institute Galleries, London. But the mouth loosely opened by death in seventeenth-century painting is taut in Bacon's image. The legs folded out of view and the left arm passively stretched by Rubens are transposed by Bacon into violent motion, flopping wildly up and down.[67]

The figure at the top of the cross might point to the doglike form of the Erinys in the third panel of *Three Studies*. It appears ambiguously waiting either to leap down and ravage or release the crucified form, and the suggestion of blood dripping from the creature's head onto the body seems to link them. Bacon often quotes Stanford's translation of the Furies' speech at the point where they find Orestes: "The reek of human blood smiles out at me."[68] Perhaps here the line of blood provides the sinister connection between the two figures.

The crucified image is not the Christ figure suffering for the sake of redemption or reconciliation, but a figure in the throes of unbearable pain that screams from an exaggeratedly anguished mouth. The mouth and its scream hark back to the scream in the right panel of *Three Studies*, to *Painting* (1946), and to *Head IV* (1949), but perhaps even more, to Eisenstein's nurse in *Battleship Potemkin*, to which Bacon was so deeply drawn. The right eye of the nurse's face is damaged, with blood flowing from around the mouth and dripping from the chin. In Bacon's image there is the movement of the blood flowing from the eyes and running round the mouth of the face. The body is writhing, the motion captured

67. Davies and Yard, p. 22.
68. Aeschylus, line 253, p. 144. In the Lattimore translation the line reads: "The welcome smell of human blood has told me so."

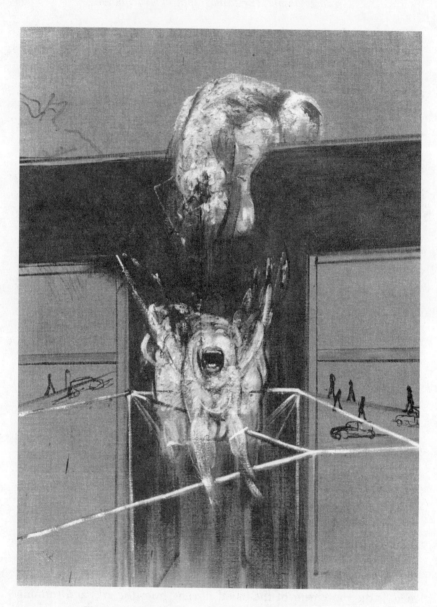

Fig. 7.12. Francis Bacon, *Fragment of a Crucifixion*, 1950

by different images of the moving arms, and reflects well Bacon's fascination with the motion of the body. The writhing is that of one before the final moment of death. The scream dominates the image; through it we find desperation, agony, pain. Intersecting the body and the vertical forms of the cross are the tubular forms that create the geometry of a box, and the large cross seems to open as if its lines are those of a door, with both images suggesting that the rushing fall of the body, the descent, will be finally trapped and contained.

In sharp disjuncture with this brutal crucifixion is the distant background which shows people, streets, cars by the sea, all present in an everyday fashion untouched by the event we are beholding. There is in the work a reminder of early Renaissance crucifixions that place the event against an otherwise orderly world of common life. Bacon was later to say that he wished he had not put them in the background scene.

It is a secular crucifixion with a focus on the suffering of the victim, without any sense of transcendence. The work pulls us into the depth of spiritual agony and human suffering, into some sense of the brutal destruction that evil visits upon its victims, contrasting that brutality with the world that moves in its own way without reference to such suffering. Bacon rejects the notion that his work is narrative, and yet it is difficult to avoid the narrative character of this work in which figures seem to act out some dramatic moment in a tabloid of tragic action.

A further point can be made regarding the content of the painting and its relationship to *Three Studies,* and that is that the work becomes a part of his unfolding treatment of the crucifixion as a means of exploring the darker dimensions of human reality. *Three Studies* presents us with the presence of hatred, alienation, viciousness as aspects of human response to the suffering of those who are crucified. It gives us the *real presence* of the evil we can do captured by the mythic interplay of figures from Greek tragedy and the event of crucifixion from religious history. *Fragment of a Crucifixion,* in turn, moves us to fix upon the consequence of the evil done, on the victim of hatred and revenge, on the raw unyielding experience of pain and the death that waits the ending of the scream. In turn, the world, introduced in the background scene, plays out the capacity of the human community to see no evil, hear no evil, speak no evil, even though the event is planted in the midst of everyday life. But Bacon does not do this as a morality tale, the meaning of which we are to deduce

from a narrative told through images. Rather, he does it in a visceral affront in which "our nervous system reacts violently" (our soul?), and only then do we play out the meaning it offers in some cognitive engagement with the painting.

Theologically, the crucifixion points to a fundamental set of meanings regarding the death of Christ. But also, theologically and experientially, because of the crucifixion of Christ the cross has over the centuries become a cultural reference that points to and pulls us into an encounter with the reality of suffering, whether focused on the crucifixion of Christ or not. Bacon's crucifixion images do this in shocking fashion and in so doing move us to experience the facts of evil and suffering and their reality as a continuing part of human existence. Bacon, who has no interest in moving us onto Christian ground, nevertheless draws on Christian symbols and moves us onto that religious ground of human experience that Christian theology seeks to understand and respond to.

Three Studies for a Crucifixion (1962)

The third treatment of the crucifixion theme comes with his *Three Studies for a Crucifixion* (1962). In this triptych we have the use of carcasslike figures — the raw meat images that Bacon drew on during the fifties and sixties. In an early work, *Painting* (1946), we have a study in which a side of beef is stretched out in the form of a crucifix, beneath which a figure, suggesting perhaps the image of Mussolini, sits with an umbrella, cruelly grimacing. As I have noted earlier, the use of the butcher's carcass of beef suggestive of a crucified form is not uncommon in art. Rembrandt's *Slaughtered Ox* (1655) is one such example. Bacon, however, acknowledges that he works out of a specific understanding of the meat and crucifixion. He tells David Sylvester:

> I've always been very moved by pictures about slaughter houses and meat and to me they belong very much to the whole thing of the Crucifixion. There have been extraordinary photographs which have been done of animals just being done before they were slaughtered; and the smell of death. We don't know, of course, but it appears by these photographs that they're so aware of what is going to happen to them, they do everything to attempt to escape. I think these pictures were very

much based on that kind of thing, which to me is very, very near this whole thing of the Crucifixion. I know for religious people, for Christians, the Crucifixion has a totally different significance. but as a non-believer, it was just an act of man's behaviour, a way of behaviour to another.[69]

And later in his interview, Sylvester observes that

The conjunction of the meat with the Crucifixion seems to happen in two ways — through the presence on the scene of sides of meat and through the transformation of the crucified figure itself into a hanging carcass of meat.

To which Bacon responds:

Well, of course, we are meat, we are potential carcasses. If I go into a butcher's shop I always think it surprising that I wasn't there instead of the animal. But using the meat in that particular way is possibly like the way one might use the spine, because we are constantly seeing images of the human body through X-ray photographs and that obviously does alter the ways by which one can use the body.[70]

The thematic intersections are evident. Meat and crucifixion are about death, about the body as dead, and the carcass of a side of beef shocks one into a recognition of that death, but more, it pushes us back to a primal awareness of death's own ever-present reality, of the way life itself is dependent on death, of the way creatures feed off other creatures to sustain themselves. As he states: "When you go into a butcher's shop and see how beautiful meat can be and then you think about it, you can think of the whole horror of life — of one thing living off another." Meat or the body, then, becomes in its own way a concrete means, a symbolic way, of perceiving the essential reality of death as a part of life. Lawrence Gowing has noted that

over the years Bacon has proved himself a voluptuary of the flesh, like Rubens, Watteau, or Soutine in their distinctly different ways, and in

69. Sylvester, p. 23.
70. Sylvester, p. 46.

his later years, he seems most like the aging Rembrandt. Flesh is for him the essential material of being and of things, life's basic substance.[71]

In the panels of *Three Studies for a Crucifixion* (1962), we have the play of orange-red colors as background broken only by black forms of door and windows. Against that backdrop, the action unfolds. In *Fragment of a Crucifixion* there is interaction between grotesque images of the figure at the top of the cross and the figure on it. In the 1962 work there seems to be an even tighter linking of the figures across the three panels: two men in the left panel, and beneath them birdlike creatures; the central panel of a bloodied human creature coiled on a bed; and the third panel with its inverted crucifixion more expressed as raw meat than human. The crucifixion is not the central panel; rather, the overall movement is from left to right. Bacon insists that there is no relationship between the figures, there is no unified story. But the images, nevertheless, appear linked insofar as the gestures in one panel point us to the actions in the next across the sweep of the whole triptych.

The two figures in the first panel are ambiguous figures. Both look out at us: one figure, his right arm in motion, pointing toward the next scene with his left arm, which ends in a bare, protruding stub. They could be onlookers who are simply calling us to the awful event that has occurred; they could be the ones who control the event, the malevolent directors of a drama of cruelty who have ordered the crucifixion to occur. Their presence, however, whatever the meaning we attribute to it, is ominous, and they offer us no relief from what has happened. The two creatures at the bottom of the panel could well be the Erinyes once again playing out their role as those who have come to mock, to stamp the scene with the presence of that which speaks to us of evil. The room offers no way out, the blackness of the window and doors accenting the intensity of the room in its harsh interplay of reds. The second panel — the head with blood from the eye and the remains of a scream, the face toward the third panel — is, like the first, circular with three windows with black shades drawn. On a bed in the center of the room is a mutilated, blood-splattered figure drawn up into a fetal position, a victim, we might surmise, of brutality. The figure's head, captured in the injured bleeding eye and taunt, grimaced mouth and teeth, is twisted around toward the form in the third panel

71. Gowing, p. 37.

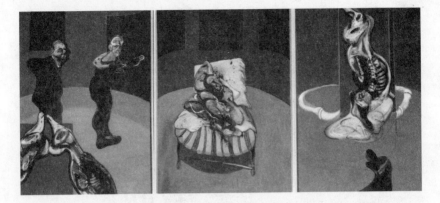

Fig. 7.13. Francis Bacon, *Three Studies for a Crucifixion,* 1962

and moves our eye to the central action of the work. This third panel is of the crucifixion. Bacon links his treatment to Cimabue's *Crucifixion* (1272-74) in Florence. In conversations with Sylvester, he states: "You know the great Cimabue *Crucifixion*? I always think of that as an image — as a worm crawling down the cross. I did try to make something of the feeling which I've sometimes had from that picture of this image just moving, undulating down the cross."[72]

The figure is carcass in form with the skeletal structure of the rib cage exposed, and while the undulating movement is not unlike that of a worm, the identification of death, meat, crucifixion is what is most striking. Animals and humans in death share most in common. The flesh and blood of one is bound in death to a common fraternity with the others. Unlike the Cimabue figure, who reflects a Byzantine Christological image of the serene yet sorrowful, transcendent savior, Bacon's figure offers the last scream before death, the moment of absolute pain when any sense of meaningful suffering has ended. It is an image of what crucifixion does finally to the human being. Speaking about the painting of a crucifixion, he insisted that "you're working them about your own feelings and sensations, really. You might say it's almost nearer to a self-portrait. You are working on all sorts of very private feelings about behaviour and about the way life is." In doing this work, Bacon said he had had a lot to drink, which "sometimes loosens you, but again I think it dulls

72. Sylvester, p. 12.

Fig. 7.14. Giovanni
Cimabue,
Crucifixion, 1272-74

other areas. It leaves you freer, but on the other hand it dulls your final judgment of what you hold."[73]

This work points us back to Bacon's own dark personal vision of life. The image he creates bounces off the "nervous system more violently and more poignantly" as an image of death. But more, it is a death that comes at the hands of a world that manifests injustice, hatred, cruelty. Both of these realities, these "facts," come together and are recorded in the crucifixion. The figure in the third panel is not simply moving from life to death. He is dying, embodying the suffering and agony of a death at the hand of cruelty. There is the *real presence* of death visited upon the victim by the forces of evil. Thus Bacon's crucifixion plays out his image of the world. Death is our lot, but even more, a world given to duplicity, hatred, brutality often makes death itself a violent and horrible end. The two realities come together in his cross. He gives us the "facts" of our existence. But there is also more in Bacon's vision. Sam Hunter observes that Bacon does not finally leave his work simply as a statement of the "facts" about human existence. Rather, he gives them to us that

73. Sylvester, p. 46.

we might in our own encounter and recognition that "that is the way it is" respond to our condition.[74]

In this work we are dealing with the mythic form of the crucifixion in a fashion that has for Bacon the power of tragedy that one finds in Aeschylus and Shakespeare. It is not finally a matter of Christ on the cross or Christ's taking in the suffering of the world that the world might be saved. It is a figure whose agony, suffered at the hands of a violent age, is given to us that we might participate in the reality of its suffering and death so that we might be purged and released from our condition. The religious character of the work, it seems to me, manifests itself in these terms: God is dead, or beside the point, but the human spirit remains capable, if given the means by which the truth can be known, of experiencing expiation and release from its bleak situation.

In the panel of the crucified figure the screaming head is cradled in a black, amorphous form that is echoed in the black form at the base of the cross. In turn, that form is balanced by the two grotesque images in the first panel. The blackness is in sharp contrast to the harshness of the red in each of the panels, and the blackness of the form beneath the head and beneath the cross may in their presence become the presence of death, but death that releases the figures from agony, that finally offers relief.

The drama of the work ends there. The crucifixion once again serving as the armature of feeling reveals Bacon's own religious vision of human existence, and the work of art itself becomes the means of transcending one's situation. The transcendence may be little more than the expurgating scream of recognition of our situation's truth, but that moment of identity and awareness can still place us beyond simply the experience of suffering.

Crucifixion (1965)

The last of the crucifixion paintings, *Crucifixion* (1965), is a triptych with a crucified form returned to the central panel. The backdrop of the action uses red-orange for the wall, black for a door opening, and brown for the floor. In the 1962 work each panel shows a rounded room linked only by repetition of the round forms and colors. In this work the red wall, beginning in the first panel, appears to run continuously through each of

74. Hunter, "Francis Bacon."

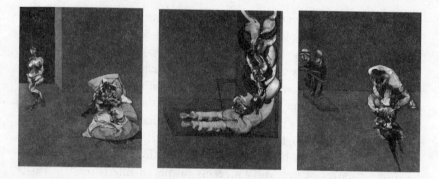

Fig. 7.15. Francis Bacon, *Crucifixion*, 1965

them, unifying the action of the whole work. In the first panel a mostly naked woman is across the room from a naked man lying on a cot. The man's body is taut, his arm wrapped around a pillow, his mouth offering a grotesque stare at the woman. He appears, at first, injured and bleeding but then, when we look closely, he appears dead. Perhaps the presence of eros and thanatos together? We are pulled into a scene uncertain in meaning but full of tension that prepares us for the crucifixion.

The right-hand panel has two scenes of action. Two men in the upper left-hand part of the panel are at a bar rail (or altar rail?) with the rail moving away from them into the central panel until it reaches the base of the cross. Their dress is modern, with wide-brim hats; they look out with no emotional response, no seeming interest beyond that of curiosity or satisfaction. Perhaps they are Bacon's own play upon the pious-appearing donors that appear in Renaissance crucifixions, though here they suggest expressions more of alienation than participation. In the bottom right-hand section of the panel, the almost frozen presence of the two men at the rail is contrasted with a powerful struggle between two figures locked in combat. The one figure, more powerfully portrayed, seems to be strangling the other. Prominent on his arm is a Nazi swastika arm band. This rather bold introduction of the swastika, which is such a powerful symbol of evil, Bacon later said he regretted. He insisted that the band was there for purely formal reasons: "I wanted to put an armband to break the continuity of the arm and to add the colour of this red round the arm."[75]

75. Sylvester, p. 64.

Why then the swastika? he was asked. "Because I was looking at that time at some coloured photographs that I had of Hitler standing with his entourage and all of them had these bands round their arms with a swastika."[76] But the band is there and the swastika is, certainly, in Western culture a fundamental symbol of evil. Davies suggests that a further play on war symbols, in this case the RAF symbol, is present in the rosettes found on the dead figure in the left panel and the figure being struggled with in the right panel. This gives the struggle a World War II cast, with the forces of evil seeming to prevail. If one sees in the dead or dying figures the two thieves who were crucified with Christ and links them in this painting with the RAF insignias, the whole drama is heightened. But such an analogy must be made with caution. There is a quite obvious contrast of characters: the contrast between the woman in the left panel and the two men at the rail in the right panel who appear to be about their own business without understanding or caring about the corpse or the struggle or the crucifixion that inhabits their world. They hark back to the figures in *Fragment of a Crucifixion* (1950) that move about their daily life with no involvement in the central struggle of the crucifixion.

The central panel holds the crucified figure. It has a carcasslike form that curves down off the base of the cross frozen in its death. The limbs are wrapped as a butcher might wrap a leg of meat with splints to hold it together; it might also reflect the broken body futilely bandaged. The image has a grotesque interplay of the slaughtered, mutilated creature with the sensuality of soft lines of flesh. The color, more white than red, and the moon shape of all three provide images of death; the crucifixion binds them together. They are about death: the smell of death that seems to rise from their bodies and the relationship of these deaths to evil once again play out Bacon's vision of the brokenness that defines the human condition. The use of the grotesque seals the relationship with a horror that moves us into the alienated world of violence, and destruction. Perhaps no more grotesque, horrifying image of crucifixion has ever been seen in the history of art.

76. Sylvester, p. 65.

Conclusion

In these four works, Bacon explores in an extraordinary way the boundaries of human existence. Vengeance, hatred, helplessness, alienation, evil, violent death are given to us unmediated. They are facts, records, truths of the human situation. To give us these truths, Bacon has drawn on religious myth, on the *Oresteia* of Aeschylus, on the crucifixion. Bacon calls upon the very elements of religion, to which he otherwise denies validity, as a means of revealing the truths he wishes to explore. He has often been identified with Nietzsche, who on the one hand expressed a nihilistic pessimism and, on the other, found solace in the Greek ideal. Certainly, the nihilism is there, and it can assume a romantic character that cautions us to beware. There is, too, in these works a judgment that the relational world — the social world — is a destructive world. Bacon's own radical existentialism brings us into the land of despair, for it is a vision that sees the truth of us all finally located in our libidinal needs, our savage impulses, our survival instinct, our encounter with death, our propensity for evil that make up our individual selves. But, as he has said, it is an "exhilarating despair," and his invitation to us is to explore it, to take it in, and in so doing to answer it. The nothingness he sees is answered by an act of being, an act of creating art that takes in the threat and an act of perception given to us who engage the work.

Bacon's own use of the grotesque is not limited to the crucifixion studies we have examined, but it plays a particularly powerful role in these works. The biomorphic forms; the distortion of all forms; the particular use of the scream and the carcass; the use of color, light, and darkness; the exaggerated expression of images that evoke horror, repulsion, fascination, denial all interweave in his creations, and the grotesque imagery itself contributes to the power of the work to bounce off our nervous system more "poignantly and violently." The imagery of the grotesque becomes an imagery that moves us to the religious depths of ourselves.

For the theologian, Bacon's power rests in what he records about the images of alienation, violence, and death that haunt the human soul. He speaks to us about where we are, not where we should be or might be. In telling us where we are, he shakes us violently and, having shaken us, invites us to begin our journey. If we choose to live with his images, our journey shall be a religious one and we shall know it to be an exhilarating one, for he will speak to us about creation and sinfulness, about loneliness

and alienation, about injustice and suffering in a manner that shall challenge our own efforts at making theological sense of the broken world into which we have been cast. The fact that love, hope, and transcendence elude his works does not invalidate the depth of insight into the vision of ourselves that he provides — a dark vision that must be faced if we are to find that transcending reality from which hope might spring.

8. Grinning Death's-Head: *Hamlet* and the Vision of the Grotesque

YASUHIRO OGAWA

In its perennial phase tragedy is a metaphysics of death, death seen preeminently as eternity, silence, that is to say, as mystery. The individual "pass[es] through nature to eternity" (1.2.73)* and "the rest is silence" (5.2.358). These memorable phrases from *Hamlet* sound like a resigned acceptance of the common human condition of death, which makes us realize that the concern of tragedy is coming to terms with death — the final mystery. Yet the philosophical acquiescence will come only after *Todesschmerz* — if we may be permitted to appropriate the term coined

*I have amended the original text of this essay, which appeared in *The Northern Review* (The English Department, Hokkaido University, Hokkaido, Japan) 8 (1980). All Shakespearean references are to *The Riverside Shakespeare,* ed. G. Blakemore Evans (Boston: Houghton Mifflin, 1974). I have taken the liberty of removing all the parenthetical additions that are found in this edition.

In addition to those I have adduced directly in the notes I would like to acknowledge my indebtedness to the following important studies for understanding the grotesque: G. Wilson Knight, *The Wheel of Fire,* pp. 160-76; Robert Eisler, "Danse Macabre," *Traditio* 6 (1948): 187-225; Vivian Mercier, "Macabre and Grotesque Humour in the Irish Tradition," in *The Irish Comic Tradition* (Oxford: Oxford University, 1962), pp. 47-77; Lee Byron Jennings, "The Term 'Grotesque,'" in *The Ludicrous Demon: Aspects of the Grotesque in German Post-Romantic Prose,* University of California Publications in Modern Philology 71

by a famous thanatologist in analogy with *Weltschmerz*[1] — is experienced to the utmost in its most agonizing fear and trembling and is made, figuratively speaking, analgesic.

The way *Hamlet* dramatizes this *Schmerz* is impressive; "the subject of *Hamlet* is death"[2] to the extent that this cannot be said of any other Shakespearean tragedy. But the peculiarity of this play in respect to this theme does not so much spring from the singleness of vision concerning it as from the curious fact that it is a rendering of a particular mode of thinking that is preoccupied with *"being dead."*[3] The thinking is pursued in terms of "the dread of something after death" (3.1.77), and this "something" involves not merely "the soul's destiny" but "the body's" as well.[4] The solicitude for the body's destiny after its shuffling off of the mortal coil takes on an obsession with its imaginary transformation into something loathsome, reeking, and despicable.

Hamlet portrays the dead Polonius as suffering an ignominious fate. According to Hamlet's quaint, cynical imagination, Polonius is now "At supper. . . . /Not where he eats, but where 'a is eaten; a certain convocation of politic worms are e'en at him" (4.3.17-21). The corpse of the late lord chamberlain has fallen a prey to wily fornicating worms. We may callously

(Berkeley: University of California, 1963), pp. 1-27; Howard Daniel, *Devils, Monsters, and Nightmares: An Introduction to the Grotesque and Fantastic in Art* (London: Abelard-Schuman, 1964); Frances K. Barasch, *The Grotesque: A Study in Meanings* (The Hague: Mouton, 1971); Philip Thomson, *The Grotesque,* The Critical Idiom Series (London: Methuen, 1972); Richard M. Cook, "The Grotesque and Melville's *Mardi,*" *ESQ* 21, 2d Quarter (1975): 103-10; Frederick Busch, "Dickens: The Smile of the Face of the Dead," *Mosaic* 9 (summer 1976): 149-56; Richard M. Cook, "Evolving the Inscrutable: The Grotesque in Melville's Fiction," *American Literature* 49 (January 1978): 544-59; M. B. van Buren, "The Grotesque in Visual Art and Literature," *Dutch Quarterly Review* 12 (1982): 42-53; Geoffrey G. Harpham, *On the Grotesque: Strategies of Contradiction in Art and Literature* (Princeton: Princeton University, 1982).

1. Jacques Choron, *Death and Modern Man* (New York: Macmillan, Collier Books, 1964), p. 163.

2. C. S. Lewis, "Hamlet: The Prince or the Poem," in *Studies in Shakespeare: British Academy Lectures,* ed. Peter Alexander (London: Oxford University, 1964), p. 211.

3. Lewis, p. 212.

4. Lewis, p. 212.

say that perhaps this is an instance of retributive justice meted out to a Machiavellian of Polonius's caliber. (May not this imagined scene remind us of the one in which Julius Caesar was assassinated by "a certain convocation of political" men led by Brutus? In *Hamlet,* which is the immediate successor to *Julius Caesar* — these two have always been companion plays — we learn on Polonius's own avowal that, as a university student, he used to play the role of Julius Caesar in dramatic performances mounted by the university [the University of Wittenberg, Hamlet's alma mater?], the Caesar who he expressly adds is to be killed by Brutus [3.2.98-104]. Julius-Polonius is being assaulted by a party of political human-worms.) The pitiable condition is, however, not solely Polonius's. Hamlet makes a generalization.

> Your worm is your only emperor for diet: we fat all creatures else to fat us, and we fat ourselves for maggots. (4.3.21-23)

We fatten ourselves by eating all other living things which we fatten for that purpose, but all this is finally for the ingestion of us as prey by maggots. As far as dietary business goes, "Your worm" is supposed to hold sovereign sway.

Nevertheless, *pace* Hamlet "your worm" cannot be said to be the absolute victor in this process. It will be eaten by a fish, of which Hamlet himself is by no means unaware. Hamlet accompanies the statement by a variation upon the theme.

> A man may fish with the worm that hath eat of a king, and eat of the fish that hath fed of that worm. (27-28)

Dull-witted King Claudius, to whom all these remarks of Hamlet are directed, is stupefied: "What dost thou mean by this?" (29) But is the meaning of this statement so difficult to grasp? It seems to us to be fairly obvious. Let us put aside for a moment "a king" and replace it with "a human being." Then a totally disquieting situation arises: human-eating maggots are eaten by fish, which will in turn be eaten by humans. In Shakespeare and other Elizabethan playwrights worms do eat dead human bodies. However, in *Hamlet* the eating does not stop there; it goes on endlessly, forming something like a vicious circle.

Note the uroboric shape the formula takes. The person who initiates this voracious movement finally meets fish-eating humans. Through the carnivorous process, the initial person becomes, in the last analysis, part

of other people's flesh. What is thrust upon us is virtual cannibalism. If the spectacle of an individual's corpse being devoured by maggots alone must arouse a sense of the grotesque within the minds of the spectators, the eerie sensation will be immensely increased by Hamlet's fantasy of a cannibalistic state of things.[5]

The imaginary situation assumes implications of *lèse-majesté* — in case we interpret Hamlet's saying in its original phraseology. For not only an ordinary human being but also a king is subject to the predatory cycle, and it is specifically "a king" to whom Hamlet refers. Hamlet sticks to "a king." In the face of King Claudius, he says, "your fat king and your lean beggar is but variable service, two dishes, but to one table — that's the end" (23-25). At last Hamlet's intent is revealed. What he has been driving at all along is, in his own words, "Nothing, but to show you [Claudius] how a king may go a progress through the guts of a beggar" (30-31). Hamlet's language is dangerously charged. A king is vulnerable to murderous aggression and may be forced to tread the way of all flesh, which will take the form of a procession, an incomparably impoverished one at that, "through the guts of a beggar." A royal progress to be carried out with pomp and circumstance will transmogrify itself into an anti-progress, something unimaginably demeaning. Hamlet's view uncrowns, being radically democratic; it is a perverse version of the notion that death levels all people. Or it may be closer to the mark to say that death creates a sort of festive moment, turning the world upside down. The elevated are superseded by the humble. By the simple process of eating a fish which has incorporated "a king," "a beggar" puts the king under absolute subjugation. He is immeasurably superior to the fish-king.

I resume, human-eating worms will be eaten by fish that will conversely be eaten by human beings. . . . Ad infinitum and ad nauseam. The conceit of this circular migration originates in our hero's all-too-curious, idiosyncratic, even pathological habit of thinking — a major factor in making this play markedly different from other Shakespearean tragedies.

5. In his treatment of *Elizabethan Grotesque* (London: Routledge and Kegan Paul, 1980), p. 42, Neil Rhodes mentions the provocative use that Thomas Nashe and François Rabelais made of "grotesque food imagery" for portraiture of the protean body: "sharply aware of the body's capacity for mutation, both Nashe and Rabelais use grotesque food imagery to remind us of the essential similarity between our own flesh and the flesh we feed it with: the devourer is devoured." In our opinion, what amplifies the grotesque ambience is the endless cyclical reciprocation of eating mobilized by death.

Hamlet establishes a special perspective in which death is viewed as an occasion for bodily putrescence feeding maggots, thus ushering in the obscene natural system of preying among people, maggots, and fish that will include resultant cannibalism. The topic of this "cannibalism feeding on putrefaction" can be best described as "grotesque nonsense."[6]

Another unexpected dimension may lend itself to the sense of the grotesque when those human-eating maggots are correlated with those the sun breeds in a dead dog. Hamlet abruptly broaches the matter:

HAMLET: For if the sun breed maggots in a dead dog, being a good kissing carrion — Have you a daughter?

POLONIUS: I have, my lord.

HAMLET: Let her not walk i' th' sun. Conception is a blessing, but as your daughter may conceive, friend, look to 't. (2.2.181-86)

In the cryptic and disjointed discourse that might resemble a passage from a metaphysical poem, the extraordinary force derives from Ophelia's being likened to a dead dog that bears maggots. Like the dead dog or "a good kissing carrion," Ophelia will breed; she will breed persons who, when dead, will be food for maggots. (In a Russian cinematic version of *Hamlet* and a Japanese literary work which is a rehashing in a novelistic form of the same play, Ophelia is pregnant.) The ultimate source of conception is traceable to the sun. Conception is far from being a blessing: it entails death that brings about putrefactive cannibalism by mediation of maggots that the sun causes to be bred. Can not the very conception be corruption? — "the sun is a powerful agent of corruption."[7] We recall Hamlet's petulant rejoinder to Claudius: "I am too much i' the sun." (1.2.67). Seeing that Claudius, as a king in Renaissance England, may be made to figure as the sun on earth in the archetypal mystique surrounding kingship that may conceivably have been still a sector of lived ideology at that time, Hamlet's complaint rings perilously defiant.

Hamlet, and through him we, vicariously, inhabits an unredeemed world in which "an ineradicable corruption [inheres] in the nature of life

6. Eleanor Prosser, *Hamlet and Revenge,* 2d ed. (Stanford, Calif.: Stanford University, 1971), p. 205.

7. Richard D. Altick, "*Hamlet* and the Odor of Mortality," *Shakespeare Quarterly* 5 (spring 1954): 168.

itself,"[8] the world unshunnably impregnated with "the thought of foulness as the basis of life."[9]

At this juncture, we are also reminded of an unusual dialogue that occurs several lines before the passage pertaining to the sun-bred maggots, To Polonius's somewhat ridiculing query, "Do you know me, my lord?" Hamlet answers promptly: "Excellent well; you are a fishmonger" (2.2.173-74). Taken at literal value, this baffling fling leaves a weird reverberation.[10]

8. M. M. Mahood, *"Hamlet,"* in *Shakespeare's Wordplay* (London: Methuen, 1957), p. 112.

9. G. Wilson Knight, "The Embassy of Death: An Essay on *Hamlet*," in *The Wheel of Fire: Interpretations of Shakespearian Tragedy* (1930; London: Methuen, 1972), p. 22.

10. Eric Partridge, *Shakespeare's Bawdy* (1948; rev. ed., New York: Dutton, 1969), informs us that in the age of Shakespeare, the word "fishmonger" had the bawdy connotation of "a procurer; a pimp." It was synonymous with "fleshmonger," or "wencher," and was apparently made on the analogy of a "whoremonger." Polonius is a Pandarus. As a matter of fact, he looses his daughter Ophelia to Hamlet with a view to sounding the mystery of the prince's behavior. In their confrontation Hamlet bursts out to his former sweetheart in an uncontrollable bout of anger: "Get thee to a nunn'ry. . . . / Go thy ways to a nunn'ry" (3.1.120, 128-29). This is equally an innuendo. Partridge says that " 'nunnery' . . . bears the fairly common Elizabethan slang sense 'brothel.' " Hamlet has detected Polonius's scheme. By no means will he be taken in by a whore Ophelia set on by a whoremonger Polonius.

On the other hand, we can take the passage in another sense, quite literally. That is to say, Hamlet is trying to confine Ophelia's disturbing sexuality, darkly associated with death and decomposition through maggots, to an institution where it may be safely contained. As the sight of Celia shitting dumbfounds Swift's ingenuous persona, Ophelia's liability to conception (whose causation may be thought to be her seductive beauty, irresistible carnal attraction) repels and saddens Hamlet. He blames Ophelia ruthlessly, "why wouldst thou be a breeder of sinners?" (120-21). Conception is never a blessing; it is the damnable act of breeding a sinner. Conception as the fruit of sinful sexuality — so it seems to our hero — can be regarded as perpetual reproduction (in the economic sense of the word, as well) of sin, since daughters of Ophelia will successively be breeders of sinners. Procreation is a practice of eternal return.

Defining himself as a sinner, he catalogues a number of his faults, the defects that flesh is heir to. His agony culminates in a self-denunciation: "What should such fellows as I do crawling between earth and heaven?" (126-28). Hamlet thinks of himself as a vile creature crawling between heaven and earth, a kind of reptile wriggling its way on earth, unable to find any meaning for his herpetological existence. (Without much offending the susceptibility on the part of the audience, a Hamlet actor could, if he would, adopt here a grotesque reptilian posture of prostrate crawling.)

With maniacal tenacity Hamlet urges Ophelia: "Get thee to a nunn'ry, farewell. . . .

To a nunn'ry, go, and quickly too. . . . To a nunn'ry, go" (136-49). Like any sexually unruly woman, Ophelia must be excluded from a conjugal life. At least Hamlet wants to shun the yoke, for unlike a fool who only is fit for marriage, he is wise enough to know what a "monster" Ophelia will make of him (138-39). The "monster" refers, admittedly, to a cuckold, a man growing horns on his forehead on account of his wife's infidelity. Hamlet is congener with the comic protagonist Panurge in Rabelais's novel who takes such aversion to becoming a *cocu* that he goes on quest for the wondrous means to avoid the infamous destiny and with Othello, who is demonically concerned with "this forked plague" (*Othello,* 3.3.276). Marriage is a civilized institution geared to production of male monstrosities. Many a monster (a grotesque conglomeration of man and beast) dwells in Venice, Iago whispers gleefully to the wretch Othello (*Othello,* 4.1.62-64).

Speaking of marriage, it turns out another species of monster. Taking his leave for his journey to England, Hamlet accosts Claudius:

> HAMLET: Farewell, dear mother.
> KING: Thy loving father, Hamlet.
> HAMLET: My mother: father and mother is man and wife, man and wife is one flesh — so, my mother. (4.3.49-52)

The biblical proposition is given an accursed exegesis. It is interpreted to the letter by deploying irrefutable syllogism, and in the event Claudius is passed off as Hamlet's mother. What an extraordinary and yet funny logic it is! (As we will see in due course, Hamlet is a fool, a talented one at that. Only a fool has propensity for such unpredictable verbal ingenuity. In passing, the fool Hamlet and the whore Ophelia are specular images of their prototypical counterparts in one of the sources of *Hamlet.*) Being a man-wife, Claudius looms up as a double-gendered aberration, an anamorphic case, a teratological phenomenon. . . .

A modern student of depth psychology would find fitting material for his or her study of the so-called primal scene in the fantastic union of Hamlet's father and mother. Enormously offensive is Hamlet's prurient, even voyeuristic depiction of the scene.

> Nay, but to live
> In the rank sweat of an enseamed bed,
> Stew'd in corruption, honeying and making love
> Over the nasty sty! (3.4.91-94)

In their sexual life that Hamlet daydreams and actually verbalizes in the presence of his mother, Claudius and Gertrude appear as satyrs (Claudius is, as a matter of fact, called "a satyr" on the same occasion) — mythically conceived beastly figures endued with inordinate lust.

Hamlet has no right to pry into, still less reveal, the most private, secret part of his parents' marital life. Still their marriage causes another disturbance to Hamlet. Their incestuous union seems to have affected a sound family relationship. "My uncle-father and aunt-mother" (2.2.376), once Hamlet so called Claudius and Gertrude, respectively. It is a question of civil register. And how would anthropology deal with this anomaly in kinship structure? How would it resolve this exceptional case of mixed familial appellation? "A little more than kin, and less than kind" (1.2.64-65) — Hamlet's riddling reply to Claudius's

These "appalling jokes about worms and maggots"[11] are anticipatory of the Graveyard Scene (5.1), where Hamlet asks the grave-digging Clown about the length of time "a man will lie i' th' earth ere he rot" (164). His curiosity about "the tempo of decay in corpses"[12] is characteristic enough. The information it elicits is forbidding and slightly funny: "Faith, if 'a be not rotten before 'a die — as we have many pocky corses, that will scarce hold the laying in — 'a will last you some eight year or nine year. A tanner will last you nine year. . . . His hide is so tann'd with his trade, that 'a will keep out water a great while, and your water is a sore decayer of your whoreson dead body" (165-77). The debate coalesces with the episode of putrefaction that triggers the wry imaginary ecology of the predatory human-maggot-fish-human cycle.

Still, much more horrifying is the gaze of the skull over which Hamlet proceeds to contemplate upon the vanity of all vanities. The gruesomeness of "the skull which has shed the final mask of humanity and wears only the perpetual grin of death"[13] is stunning. Death that the skull emblematizes is itself gruesome. The idea of death that Mathew Winston unfolds in his discussion of black humor is seminal.

Death is the final divorce between body and spirit, the ultimate disjunction in a form that dwells on violent incongruities. Often it is reduced to its physical manifestation, the corpse, which is man become thing; *rigor motris* is the *reductio ad absurdum* of Bergsonian automatism.[14]

greeting words "my cousin Hamlet, and my son" (63) might remain unamenable to facile explanation.

"Empson, *Some Versions of Pastoral,* p. 5: 'There was a performance of *Hamlet* in the Turk-Sib region which the audience decided spontaneously was farce' " (Norman O. Brown, *Closing Time* [1973; New York: Vintage Books, 1974], p. 50).

Or if it is genre that matters, we could surmise that an item on the impressive list Polonius has compiled is eligible for generic nomenclature applicable to our play: "tragical-comical-historical-pastoral" (2.2.398-99). And will this miscegenated qualifier strike us as grotesque?

11. Prosser, p. 205.

12. G. R. Elliott, *Scourge and Minister: A Study of* Hamlet *as Tragedy of Revengefulness and Justice* (1951; New York: AMS Press, 1965), p. 164.

13. Nigel Alexander, *Poison, Play, and Duel: A Study in* Hamlet (London: Routledge and Kegan Paul, 1971), p. 162.

14. Mathew Winston, "*Humour noir* and Black Humor," in *Veins of Humor,* ed. Harry Levin, Harvard English Studies 3 (Cambridge, Mass.: Harvard University, 1972), p. 283.

The skull is a localization of the corpse that is the product of physical *reductio ad absurdum,* which deathly rigidity partakes of the Bergsonian automatism of the comic.[15]

The gaze of the skull is awfully repulsive, and at the same time it holds irresistible fascination. We may be drawn to the ineffably expressive visage. Its intense visual fixation may make us wonder whether life itself be not the "grave joke of death,"[16] for, being a didactic property of emblematic significance, the skull serves as a grim reminder of the end of all human endeavors. An agonizing intuition seizes us that death has instituted grotesque comedy, or what Mathew Winston prescribes as black humor that dictates the world of human beings who must be finally turned, in absurd reduction, into the grinning skull.

The skull exudes the uncanny, which emanates supposedly from the grin with which it is so inextricably bound up that that particular type of laugh has become its sole epithet. The skull is part of an individual become dead matter and yet this lifeless, nonhuman object, despite its lifelessness and nonhumanness, is apparently intent upon the live, quasi-human gesture of grinning. The grotesque may gestate in this discrepancy. To formularize, the picture of an inanimate object beginning to look like a man or woman or vice versa gives the impression of the grotesque; it shows the reversible concourse of categorically disparate things.

The skull secretes the grotesque because the dead matter is tinged with the illusion of human agency. There is a palpable complexity, which resides in the genesis of the skull. It is not necessarily dead matter per se. It is the physical wreck of its former living self. It was originally a human being that has returned to a lifeless object. In this respect, the grin is a resuscitation of the grin that the very human being may have expressed during his lifetime.

It is suggestive that Hamlet is offered by the grave-digging Clown "this same skull . . . Yorick's skull, the king's jester" (5.1.180-81). (How could the gravedigger identify the skull from among the numerous others scattered around the churchyard? But we had better bypass such a question

15. Henri Bergson, "Laughter," in *Comedy,* ed. Wylie Sypher (Garden City, N.Y.: Doubleday, Anchor, 1956).

16. Alexander, p. 163: "one of the most vital moments in the play is when Hamlet, examining the 'chap-fall'n' skull of Yorick, appears to accept that the end of all the playing, and all the painting, must be the last grave joke of death." I have stretched Alexander's idea in my favor.

that realism's demand for verisimilitude will raise.) The grinning was presumably Yorick the court jester's professional tact of behavior. In a grinning, seriocomic vein, the king's jester may have hinted darkly at the reality of nothingness, the truth of morality, the essential vacuity of mundane kingly pomp and pride when contemplated *sub specie aeternitatis*. We can even imagine a prank of his, his showing up before the king and his courtiers, wearing the mask of a skull. At least Hamlet can think of such a practical joke Yorick was prone to. Talking to the skull of Yorick scoffingly, Hamlet presses him: "Now get you to my lady's chamber, and tell her, let her paint an inch thick, to this favour she must come; make her laugh at that" (192-95). But Yorick has outlived his "flashes of merriment"; "Not one now" is left "to mock your own grinning — quite chop-fall'n" (190-92). "A fellow of infinite jest, of most excellent fancy" (184-85) is dead and has become the skull wearing the eternal grin. "And now how abhorr'd in my imagination it is! my gorge rises at it" (186-88). The grin Yorick wears now proves to be his last "σπουδαιογέλοιον"or "serious joke." We are convinced that "the skull is the first and one of the most important components of Shakespeare's *memento mori* episode."[17] In conjunction with the motif of the Dance of Death that we will examine later, the skull constitutes the Renaissance carryover of medieval *Weltanschauung*, a worldview indigenous to that age of *contemptus mundi*, that is, the contempt of the world.[18]

17. Harry Morris, "*Hamlet* as a *Memento Mori* Poem," *PMLA* 85 (October 1970): 1037. The skull of Yorick signals that which has been irremediably lost in the passage of time, and it immediately propels Hamlet to retrieve it. What a Shakespeare critic terms "the myth of memory," which is, incidentally, one of the most important themes in Proust's monumental novel *Remembrance of Things Past* (1954) in 3 vols., trans. C. K. Scott Moncrieff and Terence Kilmartin (1981; New York: Vintage Books, 1982), is inscribed in the impassioned episode; see James P. Hammersmith, "*Hamlet* and the Myth of Memory," *E.L.H.* 45 (winter 1978): 597-605: "The issue of time and its relationship to memory in *Hamlet* is raised in its most problematical aspect by the *memento mori*, the skull of Yorick" (p. 597).

18. For this subject in our play, see D. R. Howard, "Hamlet and the Contempt of the World," *The South Atlantic Quarterly* 58 (spring 1959): 167-75. In it Howard points out "the popularity during Shakespeare's time of the Dance of Death and of *memento mori* devices, both of which reflect contempt of the world," and argues that "motifs in popular and religious art seem to have been employed with a certain mild humor as a popular convention which traditionally, though perhaps not very effectively, reminded men of the brevity of life and the need for repentance" and that "no doubt a certain amount of

Hamlet's confrontation with the skull leads to flighty reveries on the vanity of human wishes. His imagination locates "the noble dust of Alexander till 'a find it stopping a bunghole" (203-04):

> Alexander died, Alexander was buried, Alexander returneth to dust, the dust is earth, of earth we make loam, and why of that loam whereto he was converted might they not stop a beer-barrel? (208-12)

The way in which the dead Alexander is reduced to a loamy gadget to stop a beer barrel is undoubtedly ludicrous. "Imperious Caesar" is not exempt from this sort of comic degradation.

> Imperious Caesar, dead and turn'd to clay,
> Might stop a hole to keep the wind away.
> O that that earth, which kept the world in awe,
> Should patch a wall t'expel the winter's flaw! (213-16)

Hamlet's doggerel-like poem narrates jocular metamorphosis that might take hold of Caesar — is this Caesar Julius or Octavius? — in his afterlife, which might be equally the lot of Alexander. These two peerless personages representing the classical Graeco-Roman world are forcibly put to "base uses" (202). Broadly speaking, this is a variety of Lucianic humor brewed in the dialogue with the dead which Rabelais and his most brilliant literary successor Swift loved. In a parodic form of spiritual peregrination in the other world the protagonist encounters historical celebrities who have descended into incredibly undignified circumstances — I am to blame for my deliberate imprecision about details. In the fabulous otherworldly journey that he himself fabricated, Hamlet drops in with the risible ruin of imperious, awe-inspiring Alexander and Caesar. The abject vicissitude that befalls them, presented with gelastic overtones, induces Hamlet's deepest reflection upon the very substance of earthly glory, which is worth contempt. (Such a sentiment would be supposed to be in unison with the mental readiness for the contempt of the world.) Alexander's beer-barrel

Weltschmerz attached itself to them" (p. 168). Human-devouring worms and the dusty or clayey fate that awaits a person after death, which we will subsequently discuss, are to be fixed in this tradition: "man's body was called worms' meat or food for worms, and his life was likened to dust or ashes, clay, smoke, fire, wax, and so on" (p. 169).

stopper and Caesar's hole filler are blatantly debasing images indicative of absurd reduction.

Horatio counters Hamlet's overingenious view: " 'Twere to consider too curiously, to consider so" (205-6). Possessed of extraordinary capability of such an extreme logic that explodes with irreverent, provocative truth,[19] Hamlet is a veritable Shakespearean fool. It was not for nothing that in his boyhood he saw Yorick as a kind of surrogate father: with nostalgic feeling Hamlet recollects that "He hath bore me on his back a thousand times" (185-86). Our hero is the jester's disciple. He has profound affinity with the latter.

There is, however, one thing that Hamlet finds unbearable about Yorick. Hamlet is obliged to interrupt the remembrance of things past in which he steeps himself, on account of a physical problem that has survived Yorick: "Alas, poor Yorick!" You stink! Disgusted by the stench the skull gives forth, Hamlet hastily puts it down with revulsion. Forces of putre-faction are formidable; universal decay is inescapable for the dead thing. Yorick's skull is now being ravened by microbic worms, emitting insuffer-able odor. "Alas, poor Yorick!" (184).

As we have seen, it is the grave-digging Clown who has informed Hamlet of the identity of Yorick's skull. Now, who on earth is this strange figure? The grave-digger performs his job nonchalantly, even joyously, croon-ing a snatch of ballad about sweet bygone love, which leads Hamlet to suspect total absence of "feeling of his business" (65). "Custom hath made it in him a property of easiness" (67-68), Horatio chimes in. Hamlet examines in a derisive manner "the pate of a politician . . . one that would circumvent God," that of an affable, yet vilely wistful "courtier," that of "a lawyer" who, while he was alive, exploited and prevaricated with his display of vertiginous vocabulary, employing such legal jargons as "his quiddities . . . , his quillets, his cases, his tenures, . . . his tricks, . . . his statutes, his recognizances, his fines, his double vouchers, his recoveries . . . indentures . . . conveyances" — all these grotesquely technical words were unable to fend off death and some of them are subjected to our hero's parodic treatment through punning. What astonishes Hamlet is that "the mazzard," "the sconce" of each of these very important persons, receives merciless and disrespectful blows from "a

19. Apropos of logical ultraism, Arthur Clayborough treats Swift in terms of "The Fantasy of Extreme Logic" in his study *The Grotesque in English Literature* (1965; rpt. with corrections, Oxford: Clarendon, 1967), pp. 112-57.

dirty shovel" of "a sexton's spade," "as if 'twere Cain's jaw-bone, that did the first murder." Indeed, "Here's fine revolution," says Hamlet (75-112). After such a scrutiny, Hamlet speaks to the fellow:

HAMLET: Whose grave's this, sirrah?

1 CLOWN: Mine, sir. . . .

HAMLET: I think it be thine, indeed, for thou liest in't.

1 CLOWN: You lie out on't sir, and therefore 't is not yours; for my part I do not lie in't and yet it is mine.

HAMLET: Thou dost lie in't, to be in't and say it is thine. 'Tis for the dead, not for the quick; therefore thou liest.

1 CLOWN: 'Tis a quick lie, sir, 'twill away again from me to you.

HAMLET: What man dost thou dig it for?

1 CLOWN: For no man, sir.

HAMLET: What woman then?

1 CLOWN: For none neither.

HAMLET: Who is to be buried in't?

1 CLOWN: One that was a woman, sir, but, rest her soul, she's dead. (117-36)

Paronomastic playing with "lie," "quick," and "man" is involved. Even if it is too much to say that this is a textual conundrum, this is a fairly difficult passage that we cannot hope to decipher completely. A tentative reading will be:

It is a lie to say that a grave belongs to a person who happens to be within it for digging, since it is essentially for the dead, not for the quick [the living], that is, its true tenant is only someone deceased for whom it was dug. On the other hand, one is deceived to think that one has nothing to do with it, since it will be one's inevitable habitation sooner or later. It is a deceptive idea that the living tend to hold, which will be quickly belied to the very living. Here gender does not matter, as

man and woman are equally destined for the grave. And strictly speaking, we can not say that a grave is a man's or woman's even though he or she is to be buried in it; the most correct way of putting it is that it is that of "One that was [a man]" or of "One that was a woman." Death forbids the use of present tense for a man's or a woman's being.

The wit combat Hamlet was forced to fight drives him to despair: "equivocation will undo us" (138). Only by going through this exhausting conversation ruled by labyrinthine wordplay do we learn that the grave in question is Ophelia's.[20]

We happen to discover an interesting item in the curriculum vitae of this Clown.

> **HAMLET:** How long hast thou been grave-maker?
>
> **I CLOWN:** Of all the days i' th' year I came to't that day that our last king Hamlet overcame Fortinbras.
>
> **HAMLET:** How long is that since?
>
> **I CLOWN:** Cannot you tell that? every fool can tell that. It was that very day that young Hamlet was born — he that is mad and sent into England. (142-48)

Of all the days, the Clown became a sexton on the very day of the year that the Danish nation reached the apex of glory by the late King Hamlet's defeat of Fortinbras. It is also the day when our Hamlet was born, the prince most immediate to the glorious throne of Denmark. Both Denmark's future and Hamlet's career have been ominously clouded.

Apart from Danish destiny, the days of Hamlet were numbered. On the strength of this state of affairs, G. R. Elliott speculates that "maybe he [the Clown] is Death."[21] Willard Farnham is of the same opinion; what he has to say, recognizing the Clown for what he is, is insightful and profitable:

20. Because of the suspiciousness of her dying, Ophelia is allowed only the "maimed rites" (5.1.219), at which Laertes utters forth imprecations accompanied by a supplication "from her fair and unpolluted flesh / May violets spring!" (239-40). Ophelia's supplicated passage into floral being may remind us of Ovidian metamorphoses which are occasionally marked by the grotesque. But I am not sure whether it has a shade of the Ovidian grotesque. Her "mermaid-like" (4.7.176) death may sound equally Ovidian.

21. Elliott, p. 164.

And in medieval terms the clown with his spade does what the figure of Death does in the Dance of Death. The Dance traditionally has that figure as a human being already dead who points one of the living the way to the grave. In pictorial representation he is a decaying corpse or a skeleton who comes from the grave and calls, one by one, upon living figures ranging in rank from pope or emperor down to natural fool or innocent child, to prepare for death and follow him. The grave-digging clown in *Hamlet* takes the place of this corpse or skeleton. He occupies a grave he claims as his at the same time that he makes it for Ophelia. In it he is Death itself and from it he can speak to Hamlet of bodily dissolution with grotesque authority. To debate whether the grave he digs is his or Ophelia's is pointless. It belongs to him because it belongs to Everyman, alive or dead. The word-twisting that goes on over whether he "lies" in the grave that he says is his and whether it is for the quick or the dead finally brings a riddling summons from the clown, as Everyman-Death, to Hamlet, whose tragedy has drawn near to its ending in death: "'Tis a quick lie, sir; 'twill away again from me to you."[22]

The Clown, who lies in the grave and indulges there in a bantering dialogue with Hamlet, is Death ringleading the Dance of Death. It may be said that, as such, he invites Hamlet "to join the dance [that] means to die";[23] he virtually points Hamlet the way to the grave as he is nearing his end at the close of his tragedy. Hamlet's encounter with the Clown may be considered a teleological one. At the end his purpose was fulfilled. This is the be-all and end-all of his life's quest. It seems as though the Clown-Death had been shadowing Hamlet ever since the very day that he came into the world, somewhat in the same way that the "*son of a whore* Death," in a version of the Dance of Death from volume seven of *Tristram Shandy*, perpetually ferrets Tristram out.[24] The Clown-Death has overtaken Hamlet. Hamlet is doomed.

22. Willard Farnham, *The Shakespearean Grotesque: Its Genesis and Transformations* (Oxford: Oxford at the Clarendon Press, 1971), pp. 116-17. The focal scene appears to be imbued with "fear of death and humour." According to Earle P. Scarlett, "The Dance of Death," *The Dalhousie Review* 37 (winter 1958): 384, "the very incongruity of these two things" is characteristic of a design of the Dance of Death.

23. James M. Clark, *The Dance of Death in the Middle Ages and the Renaissance* (Glasgow: Jackson, 1950), p. 105.

24. Thomas M. Columbus, "Tristram's Dance with Death — Volume VII of *Tristram Shandy*," *The University of Dayton Review* 8 (fall 1971): 3-15.

Granted that the Clown is Death in the Dance of Death, it is undeniable that Hamlet himself impersonates Death. He "has above all that preternatural aptitude for mocking each man according to his station and peculiar folly which was the distinguishing mark of Death itself in the Dance of Death."[25] A student of the Dance of Death instructs us that " 'Death' in the Dance of Death has been variously styled — 'la railleuse par excellence — variée à l'infini mais toujours boufonne' — and as exhibiting a 'cynisme railleur.' "[26] According to G. Wilson Knight's testimony, Hamlet is not innocent of "the demon of cynicism," "the cancer of cynicism," and "the hell of cynicism."[27] Another Shakespearean scholar concludes that Hamlet's responses are "the jests of Death" and that the diseased wit which is admittedly Hamlet's (3.2.321-22) is "Death's own."[28] Even if "Death is not the only character whose qualities Hamlet has inherited,"[29] it is a preponderant aspect of Hamlet's makeup. Hamlet is a principal persona in this drama of the Dance of Death, a macabre medieval

25. Paul Hamill, "Death's Lively Image: The Emblematic Significance of the Closet Scene in *Hamlet*," *Texas Studies in Literature and Language* 16 (summer 1974): 258.

26. Leonard P. Kurtz, *The Dance of Death and the Macabre Spirit in European Literature* (New York: Columbia University, 1934), p. 1.

27. Knight, pp. 27, 30, and 41, respectively. Incidentally, in respect to inordinate death-consciousness, Knight links Hamlet with Stavrogin in Dostoyevski's *The Possessed* (or *The Devils* (1870-72) (p. 35). When we focus on the problematics of suicide, however, Hamlet appears to be more akin to Kirilov, that extraordinary, superhuman proponent of the philosophy of suicide. Anyway, these three men are coordinated in a triptych; Hamlet shows a striking proclivity for suicidal imaginings, while, like Kirilov, Stavrogin kills himself. As Eleanore Rowe says in a chapter called "Dostoevsky and *Hamlet*," in her book *Hamlet: A Window on Russia* (New York: New York University, 1976), p. 87, "The theme of suicide seems to evoke Hamlet for Dostoevsky."

To continue the comparison between Hamlet and Dostoevsky, our hero also reminds us of "the underground" man of the Russian writer's creating. Hamlet's correlative to the Dostoevskian "underground" is the "nutshell in [which] I could be bounded, and count myself a king of infinite space — were it not that I have bad dreams" (2.2.254-56). Another name for both Hamlet's "nutshell" and Dostoevsky's "underground" is the "grotto" in our diction: their claustrophile, reclusive way of living is "grotto-esque," that is, grotesque. For exciting discussion of the sympathy between these antiheroic protagonists, see Stanley Cooperman, "Shakespeare's Anti-Hero: Hamlet and the Underground Man," *Shakespeare Studies* 1, ed. J. Leeds Barroll (1965): 37-63.

28. Hamill, p. 258.

29. Hamill, p. 259.

legacy. It may be said that Hamlet plays Death in the status of a jester, albeit officially he has no cap and bells.

In this context Hamlet's "antic disposition" (1.5.172) poses itself. Contrary to the notion that it denotes assumed madness with "antic" being synonymous with"mad, crazy, or lunatic," lexicographical investigation of the word "antic" reveals that the phrase signifies something like "grotesque demeanor" since the most fundamental meaning of the word current at the date Shakespeare composed our play corresponds to "grotesque." The etymological explanation that *The Oxford English Dictionary* (2d ed. on CD-ROM) gives is cogent: "appl. ad. It. *antico*, but used as equivalent to It. *grottesco*, f. *grotta*, 'a cauerne or hole vnder grounde' (Florio), orig. applied to fantastic representations of human, animal, and floral forms, incongruously running into one another, found in exhuming some ancient remains (as the Baths of Titus) in Rome, whence extended to anything similarly incongruous or bizarre: see grotesque." The word "antic" comes from the Italian "*antica*" (*la manièra antica,* i.e., the antique fashion) but in its actual usage, historically it referred to "[*la manièra*] *grottesca,*" literally rendered, "the manner of the grotto." In any theoretical consideration of the grotesque its basic connection with the Italian "*grotta*" in its derivation is unanimously recognized. Hence "antic" as denotative of "grotesque." (We may be given to venture a hypothesis that the "antic" fashion, the ancient way, could have impressed those exposed to it with a sense of regression into the remotest primordial world peopled by phenomenal, phantasmagoric images, where human beings, animals, plants, and even inanimate objects merged in natural confusion and profusion, the world as symbolized, in a manner, by the grotto. In the psychoanalytic language of evolution this immemorial world is translated as the unconscious. In our idiom manifestation of such a regression is grotesque.) Let us further found our argument on the Oxford dictionary, this time for its definition (we want to omit historical illustrations):

"A. *adj.*
1. *Arch.* and *Decorative Art.* Grotesque, in composition or shape; grouped or figured with fantastic incongruity; bizarre.
2. Absurd from fantastic incongruity; grotesque, bizarre, uncouthly ludicrous.
3. Having the features grotesquely distorted like 'antics' in architecture; grinning. *Obs.*"

It is noteworthy that for the adjectival meaning, the *OED* (2d ed.) lists only these three items. The substantive usage perfectly reflects the adjectival one so that we do not think it worthwhile to cite it as a whole. Suffice it to heed the fourth definition: "4. A performer who plays a grotesque or ludicrous part, a clown, mountebank, or merry-andrew." Quotation from a Shakespearean text in its subdivision is more to the purpose:

"b. *transf.* and *fig.*
1593 Shakes. *Rich. II,* iii. ii. 162 There [death] the Antique sits, Scoffing his state, and grinning at his Pompe."

Parenthetical addition of "death" in the quotation is that of the *OED*. Fuller citation of the passage would have made the meaning unmistakable:

KING RICHARD: . . . for within the hollow crown
That rounds the mortal temples of a king
Keeps Death his court, and there the antic sits,
Scoffing his state and grinning at his pomp.

The *OED* supplements the quotation above with reference to a fascinating illustration, which, unfortunately, we could not verify: "1631 A death's head grins like an 'antic.' "

The foregoing perspective is also set forth by Eleanor Prosser in her succinct formulation regarding the usage of the word "antic" in Hamlet:

Hamlet's choice of words, "antic disposition," is significant. In Shakespeare's day, "antic" did not mean "mad." It was the usual epithet for Death and meant "grotesque," "ludicrous." The term is appropriated for the grinning skull and the tradition of Death laughing all to scorn, scoffing at the pretenses of puny man.[30]

The term "antic" covers the whole range of the grotesquerie that death gives rise to. It connotes the grinning skull and the traditional motif of the macabre Dance of Death with which our play implodes. Its semantic consideration allows us to apply it to the grave-digging Clown whose speech is replete with grotesque sporting with death.

When it comes to characterization of our hero, the "antic disposition" he decides to put on proves to be a grotesque mask he wears, a mask

30. Prosser, p. 151.

designed to conceal his true colors and befuddle his enemies with a view to executing his revenge more conveniently. His ludicrous simulation of madness is to be necessarily overshadowed by Death, for whom "antic" as meaning "grotesque" served as the usual epithet in the age of Shakespeare. Hamlet is the titular protagonist of the antic hay that this tragedy is geared to.

The characteristic melancholy, the mythical sorrows of Hamlet that often end up in detracting from his personality, can be deemed a form of such "an antic disposition" (even if it is an involuntary one) redolent of death. Melancholy is traditionally associated with Saturn, which is "symbolic of the sad tranquility of death."[31] Hamlet's brooding melancholy partakes of Saturnian death. If we may go further and attend to a literary convention that Saturn is a patron-god for satirists and to the satiric temper that informs Hamlet to a certain degree, Hamlet's character will be delineated like this: Hamlet as melancholiac and satirist (the satirist in English Renaissance literature was almost invariably a melancholiac) is under Saturn's influence.[32] And that is the price of his being a genius as revealer of dark truths.

The world of *Hamlet* is probably presided over by Saturn, who makes such problematical epiphany in Chaucer's *The Knight's Tale,* which has prompted A. C. Spearing to link the pagan god to the absurd of the sort that Samuel Beckett creates and Jan Kott's literary criticism envisions.[33]

31. Raymond Klibansky, Erwin Panofsky, and Fritz Saxl, *Saturn and Melancholy: Studies in the History of Natural Philosophy, Religion, and Art* (London: Thomas Nelson, 1964), p. 197.

32. I found the following studies greatly stimulating: Oscar James Campbell, "What Is the Matter with Hamlet?" *The Yale Review* 32 (1942): 309-22; the same author's *Shakespeare's Satire* (1943; rpt., Hamden, Conn.: Archon Books, 1963); Lawrence Babb, *The Elizabethan Malady: A Study of Melancholia in English Literature from 1580 to 1642* (East Lansing: Michigan State University, 1951); Alvin Kernan, *The Cankered Muse: Satire of the English Renaissance* (1959; rpt., Hamden, Conn.: Archon Books, 1976); Robert C. Elliott, "Saturnalia, Satire, and Utopia," in *The Shape of Utopia: Studies in a Literary Genre* (Chicago: University of Chicago, 1970), pp. 3-24; Bridget Gellert Lyons, *Voices of Melancholy: Studies in Literary Treatments of Melancholy in Renaissance England* (New York: Norton, 1971).

33. *The Knight's Tale* from *The Canterbury Tales,* ed. A. C. Spearing with introduction (Cambridge, Eng.: Cambridge University, 1966). Spearing concludes his introduction with this observation: "The twentieth century can perhaps legitimately see in this fourteenth-century poem a view of the human condition as neither comic nor tragic but absurd

Under Saturn the world is "antic" and absurd. Saturn alias Cronos (mistaken, in etymological confusion, for Chronos ["time" in Greek] devouring his own children, drawn by Goya with his consummate artistry, is emblematic of the absurd nature of Time, who blindly annihilates what he has begotten. Time is a bodeful presence suffused with the spirit of death. The melancholy, death-heralding Father Time in Thomas Hardy's *Jude the Obscure* who appears invested with naked allegory is a grotesque composite figure whose actual boyhood is wholly blighted by his untimely physical corrugation and spiritual incorrigible volition of not living. He kills Jude's children as well as himself.

Probably Saturn is identical to Death, and Hamlet's "antic disposition" is ultimately Saturn's machination. . . . Hamlet is Time's fool.

Be that as it may, Hamlet's rage for punning can be taken for manifestation of the same pattern of deportment that we are discussing. A pun can even be personified. "[A pun] is an antic which does not stand upon manners, but comes bounding into the presence," thus Charles Lamb in *Elia,* which the *OED* supplies as another example of the transferential or figurative meaning of the noun "antic," no. 4 (parentheses in the quote added by the *OED*). A pun is an antic, that is, a grotesque, clownish creature who, intruding as a nuisance, breaches courtesy in decent speech. A recidivistic pun maker, Hamlet can be labeled (or libeled) as pun incarnate. It is fruitful to take a glance at Willard Farnham's idea expressed in his book devoted to the exploration of *The Shakespearean Grotesque:*

> In its grotesqueness the pun is a monstrous union of incompatible things that has at times a complexity carried beyond doubleness. Its wholeness built of incompatibility is prone to be incompatible with and defiant of dignity.[34]

An apposite instance may be Hamlet's utterance "I am too much in the sun," which is supposed to comprehend ventriloquistic undertones of

— a view of life similar to that expressed by a modern writer such as Samuel Beckett and found in Shakespeare by a modern critic such as Jan Kott. The poem's view of life does not seem to me to be that of orthodox medieval Christianity, nor is it necessarily Chaucer's own total and final view. . . . Perhaps the world is ruled by Saturn: this is the hypothesis into which The Knight's Tale invites us to enter, and it is all the more challenging and disturbing a poem because its view of human life is not pure but dubious and mixed" (p. 79).

34. Farnham, p. 61.

"I am too much in the son."[35] The phrases that will exemplify the case are legion. But we want to refrain from analyzing them. Suffice it to remark that in his antic disposition Hamlet is addicted to making the pun that is an antic, that is to say, grotesque figure of speech in its monstrous yoking together of incompatible things, the pun that, like the joke of which it is a prominent component, partially discloses the dark recesses of the human mind.[36]

The skull not only of Yorick but also of the God-circumventing politician, the cannily sycophantic courtier, the tergiversating lawyer, and the grave-digging Clown is equivalent to Death in the macabre Dance of Death and Hamlet himself, who is, as practicer of antic disposition, a character distinguished by the grotesque. *Hamlet* is a gallery of grotesque figures, the gallery which mirrors the inferno that the world has become, for "through the depiction of grotesque characters" Shakespeare, just like Bosch, "shows us Hell, the Hell of man's making."[37] Anyway, the gallery accommodates other characters than these. For example, Osric. To begin with, his name has an unpalatable resemblance to "ostrich," which sounds, at the least, ludicrous.[38] Farcical naming notwithstanding, he "comes, *like some grotesque angel of death,* to announce to Hamlet his fate, and to announce it in the strangest and most distorted language of all, a language which Hamlet gleefully parodies."[39] Osric was apparently dispatched to Hamlet to claim him on behalf of "this fell sergeant, Death, [who] / Is strict in his arrest" (5.2.336-48).

And Claudius. In mythical terms he is the Serpent that corrupted the Garden of Eden, Gertrude being a fallen Eve. The poison resorted to by him to murder his brother in the garden and his stealthy steps in committing the crime accord with the surreptitious, poisonous wiles that the Archenemy

35. Bernard Grebanier, *The Heart of Hamlet: The Play Shakespeare Wrote,* with the text of the play (New York: Apollo Editions [Thomas Y. Crowell], 1960), p. 321, scrutinizes the son-sun quibble, demonstrating six ways of interpreting it.

36. Sigmund Freud, *Jokes and Their Relation to the Unconscious,* trans. James Strachey (1960; New York: Norton, 1963).

37. Guy Mermier, "The Grotesque in French Medieval Literature: A Study in Forms and Meanings," *Genre* 9 (1976/77): 381.

38. Maurice Charney, *Style in* Hamlet (Princeton, N.J.: Princeton University, 1969), p. 69.

39. Norman N. Holland, *"Hamlet,"* in *The Shakespearean Imagination* (2d ed., Bloomington: Indiana University, 1975), p. 176. Emphasis added.

used to tempt Eve and eventually to bring about humanity's fall from paradise. In both cases death has ensued from the malefactory activity. (Is it workable, in an experimental production of the play, to have the Claudius role speak in hissing, sibilant intonation?) The world has now drastically changed from its prelapsarian state. "Something is rotten in the state of Denmark" (1.4.90). Denmark is at present ruled by a king embodying corruption in its multifarious ramifications. If Denmark is, to say nothing of a hell, "a prison" (2.2.243), as Hamlet declares, Claudius has to do with it (we may even suspect that Claudius's reign is that of terror, with his people being forced to live in an incarcerate environment, always insidiously watched, under strictest policing). The world is decisively not what it used to be. Something alarmingly fatal has happened. "Then is doomsday near" (238), so Hamlet thinks. Hamlet's elegiac monologue tells of the world that is now "an unweeded garden, / That grows to seed" "Possess[ed] merely" by "things rank and gross in nature" (1.2.135-37). The paradisiacal garden has degenerated to a garden burdened with rank and gross vegetation apparently endowed with demonic vitality. "That it should come to this!" (137). The world has already, let us dare to say, grotesquely changed. In our view, the grotesque is a sign of the tremendous, catastrophic alteration of the world occasioned by original sin.

But we have to tone it down a bit. What is more interesting about Claudius is the fact that he is frequently the butt of Hamlet's satiric attacks. In Hamlet's opinion or prejudice, Claudius is "a satyr," a lecherous humanoid being, the fabulous hybrid of human-beast in stark contrast with his brother who is comparable to "Hyperion" (140). The distinction is all the more striking, as Hamlet praises, in the interview with his mother, his deceased father hyperbolically, even in mythical apotheosis, itemizing "Hyperion's curls, the front of Jove himself, / An eye like Mars, to threaten and command, / A station like the herald Mercury / New-lighted on a heaven-kissing hill" (3.4.56-59), whereas on the same occasion Hamlet calls his uncle Claudius, vituperatively and ridiculingly, first a "mildewed ear, / Blasting his wholesome brother" and then:

A murtherer and a villain!
A slave that is not twentieth part the tithe
Of your precedent lord, a Vice of kings,
A cutpurse of the empire and the rule,
That from a shelf the precious diadem stole,

And put it in his pocket —
A king of shreds and patches, — (64-65, 96-102)

Hamlet even sketches him in the image of the devil. In his denunciation of
Gertrude's incestuous remarriage Hamlet exclaims: "What devil was 't / That
thus hath cozen'd you at hoodman-blind?" (76-77). The devil may refer to
Claudius as well as to devilish lust that urged Gertrude to an infamous union.
Taking into account these circumstances, Paul Hamill argues that Claudius's
deed is reminiscent of "the pranks of Vice on stage and of Death in the Dance
of Death," that "in the Dance of Death, when Death steals valuables or plays
with crowns, he is thief not only of material goods but of honor and pride
— as here Claudius has stolen kingship — of life, and sometimes of grace"
and that "finally, this [Claudius] is 'a king of shreds and patches' — a detail
that associates him again with death and the devil, both of whom may wear
the rags of harlequin."[40] There is a sense in which the enormity of regicide
and Cain-like fratricide, "the offense [that] is rank [and] smells to heaven, /
[Which] hath the primal curse upon't, / A brother's murther" (3.3.36-38)
that Claudius is guilty of is intelligible within the framework of the so-called
"allegory of evil" and "comedy of evil."[41] Hamill's conclusion is that
Claudius "is a grotesque parody of the first [King Hamlet]."[42] (Renovation
of production may be encompassed by having these two parts doubled,
which is technically possible since these two persons never appear simul-
taneously on the stage.) *Hamlet* is a dramatization of the myth of two
brothers who are antipodally distinct from each other. Half-brothers Edgar
and Edmund (the quasi-alliterative similarity of their names is noticeable),
who engaged in mythical sibling rivalry in the Gloucester subplot of *King
Lear,* conform to the configuration. The mythical (or melodramatic) com-
position opens up a horizon of Manichaean opposition between the forces
of good and evil, God and the devil.

One of the most salient facets of irony in *Hamlet* is that King Hamlet,
who is, again in Hamill's view, "not a god, of course, but a representation

40. Hamill, p. 253.
41. On my mind are the two fascinating Shakespeare tomes: Bernard Spivack,
*Shakespeare and the Allegory of Evil: The History of a Metaphor in Relation to His Major
Villains* (New York: Columbia University, 1958); and Charlotte Spivack, *The Comedy of
Evil on Shakespeare's Stage* (Rutherford: Fairleigh Dickinson University Press/London: As-
sociated University Presses, 1978).
42. Hamill, p. 253.

of godly perfection in man,"[43] approximates, in his advent to this world, what his extremely inferior brother, who may be termed his "counterfeit" (3.4.54), supposedly impersonates. The comedic form Hamill supposes for Claudius is inapplicable to King Hamlet. Still the latter appears as the devil and Death. Left uncertain about the true identity of the Ghost, Hamlet's mind misgives him that "The spirit that I have seen / May be a dev'l, and the dev'l hath power / T' assume a pleasing shape, yea, and perhaps, / Out of my weakness and my melancholy, / As he is very potent with such spirits, / Abuses me to damn me" (2.2.598-603). Horatio is sceptical about the intention of the Ghost so that he dissuades Hamlet from following it lest at a certain dangerous spot it should "assume some . . . horrible form" and precipitate him into derangement (1.4.72-74). Death bulks large when King Hamlet emerges as a visitant from the land of the dead. In spite of the critical disagreement as to its true nature,[44] this much can be said, that the Ghost, apparently surrounded with the strange aura of death, is its dreadful messenger, for what he recounts to Hamlet is "his foul and most unnatural murder" (1.5.25) by his own brother and what he enjoins him to do is to revenge it, which is tantamount to slaying the murderer. He is forbidden to, but could, tell the secrets beyond the grave that are suggested with sensational vividness. Pertaining genetically to Senecan revenge tragedy, Hamlet is laden, to a certain degree, with crude, sadistic, horror-inspiring scenes. Horrors of Gothic nature color the play. "Blasts from hell" (1.4.41) are blowing through it.

No less frightful is the revolting physical deformation of King Ham-

43. Hamill, p. 252.

44. On the Ghost a great number of studies are available. The following seem to be typical: John Dover Wilson, "Ghost or Devil?" in *What Happens in* Hamlet (1935; rpt., Cambridge Eng.: Cambridge University, 1970), pp. 51-86; Madeleine Doran, "That Undiscovered Country: A Problem concerning the Use of the Supernatural in *Hamlet* and *Macbeth*," *Philological Quarterly* 20 (July 1941): 413-27; I. J. Semper, "The Ghost in *Hamlet:* Pagan or Christian?" *The Month* (April 1953): 222-34; J. C. Maxwell, "The Ghost from the Grave: A Note on Shakespeare's Apparitions," *Durham University Journal,* n.s. 17 (March 1956): 55-59; Sister Miriam Joseph, "Discerning the Ghost in *Hamlet*," *PMLA* 76 (December 1961): 493-502; Niels L. Anthonisen, "The Ghost in *Hamlet*," *American Imago* 22 (winter 1965): 232-49; Eleanor Prosser, "Enter Ghost" and "Spirit of Health or Goblin Damned?" in *Hamlet and Revenge,* pp. 97-117 and 118-43; Robert H. West, "King Hamlet's Ambiguous Ghost," in *Shakespeare and the Outer Mystery* (Lexington: University of Kentucky, 1968), pp. 56-68.

let because of the "leprous distillment" poured by his brother in "the porches of my ears." The "effect" of the "juice of cursed hebona in a vial . . . / Holds such an enmity with blood of man" that coursing throughout the body,

> with a sudden vigor it doth posset
> And curd, like eager droppings into milk,
> The thin and wholesome blood. So did it mine,
> And a most instant tetter bark'd about,
> Most lazar-like, with vile and loathsome crust
> All my smooth body. (1.5.62-73)

(In view of this striking bodily change that the King has suffered, it is puzzling that nobody seemingly suspected a foul hand in his death.) The story of his death will be reproduced in the play within a play in fulsome reference to "Thou mixture rank, of midnight weeds collected, / With Hecate's ban thrice blasted, thrice infected, / Thy natural magic and dire property / On wholesome life usurps immediately" (3.2.257-60).

The scene of Hamlet's encounter with the Ghost is haunted by apprehension and brain-racking mystery; Hamlet's query is desperate:

> O, answer me!
> Let me not burst in ignorance, but tell
> Why thy canoniz'd bones hearséd in death
> Have burst their cerements? why the sepulchre,
> Wherein we saw thee quietly inurn'd,
> Hath op'd his ponderous and marble jaws
> To cast thee up again. What may this mean,
> That thou, dead corse, again in complete steel
> Revisits thus the glimpses of the moon,
> Making night hideous, and we fools of nature
> So horridly to shake our disposition
> With thoughts beyond the reaches of our souls?
> Say why is this? wherefore? what should we do? (1.4.45-57)

The Ghost, a "dead corse" whose "canoniz'd bones [were] hearséd in death," turns up in a clap, "Making night hideous" and pushing Hamlet off into radical interrogation about the wherefore of this visitation. Hamlet is right, "There are more things in heaven and earth, Horatio, / Than are

dreamt of in your philosophy" (1.5.166-67). In your philosophy, that is, in your physics, natural science.

The Ghost is a completely unexpected intruder from "The undiscover'd country, from whose bourn / No traveller returns" (3.1.78-79) and how he could and why he did return from it remain only a mystery in the ultimate sense of the word. Hamlet has been pestered from the very outset by radical uncertainty due to his inability to unveil the Ghost. Is it "a spirit of health, or goblin damn'd"? does it "Bring with [it] airs from heaven, or blasts from hell"? are its "intents wicked, or charitable"? and so on (1.4.40-42). Mystery lingers on till it is finally resolved in the play within a play in which the Ghost's revelation tests true. The interval is permeated with painful insecurity that is almost beyond our hero's endurance. Irresolvable, disconcerting ambiguity exists up to a certain stage, giving birth to perception of the grotesque, as the world is left incapable of rationality and orderly dispensation. Chaos is come again. In the words of Wolfgang Kayser, a major scholar of the grotesque, "what intrudes remains incomprehensible, inexplicable."[45]

And "impersonal," so Kayser adds.[46] Indeed, the neutral, impersonal mode perseveres when it comes to mentioning the Ghost; the Ghost is called "this thing" ("What, has this thing appear'd again to-night?" [1.1.21]), then "this dreaded sight" (25) and thenceforth "it" several times consecutively. Kayser's theory that the grotesque is prescribed as "the objectivation of the 'It,' the ghostly 'It'" is strangely relevant here.[47]

The considerable fear with which this nondescript presence strikes the guard prompts an inverted qui-vive. Indeed, the play begins with a question "Who's there?" that Bernardo, coming to relieve the guard, hurls at Francisco, the other sentinel who has been on duty there. Needless to say, it's the other way around; it is Francisco who should have challenged Bernardo. Apart from its being inverted, the question itself is rather gratuitous, for who else should be there but Francisco as someone standing on watch? The inversion and gratuitousness of the question prefigure the fearful secrecy that "the ghostly 'It'" foments.[48]

45. Wolfgang Kayser, The Grotesque in Art and Literature, trans. Ulrich Weisstein (1963; rpt., New York: McGraw-Hill, 1966), p. 185.

46. Kayser, p. 185.

47. Kayser, p. 185. Emphasis added.

48. For description of this paragraph, I am indebted to Harry Levin's excellent study The Question of Hamlet (London: Oxford University, 1959). The dominant theme and

Confronting himself with the Ghost, Horatio questions it: "What art thou that usurp'st this time of night . . . ?" (46-49). In spite of the personal pronoun "thou," the ominous, sinister quality of the revenant does not mitigate itself. The Ghost and the atmosphere it brings with it, together with the dreadful chill and alienating darkness that govern the scene, can be meaningfully designated as "numinous."[49] What Hamlet experiences on this occasion is καιρός, a supreme movent that will have far-reaching consequences upon the ontological phase of a man concerned, transforming his being utterly. The chronological sequence of an everyday way of being is disrupted; a crisis comes to Hamlet. Hamlet's "antic disposition" is due to his exposure to such a climactic, timeless moment.

The Ghost "usurp[s] this time of night," yet it is not only a usurper of this specific time of night but of time in general, time itself, for it is the past incarnate who has intruded upon the present and by this intrusion

atmosphere of mystery in our play are ably discussed by: Maynard Mack, "The World of Hamlet," *Yale Review* 41 (September 1951): 502-23 (rpt. in *Tragic Themes in Western Literature*, ed. Cleanth Brooks [New Haven, Conn.: Yale University, 1955], pp. 30-58); Mahood, *Shakespeare's Wordplay;* West, *Shakespeare and the Outer Mystery;* Robert G. Hunter, *"Hamlet,"* in *Shakespeare and the Mystery of God's Judgments* (Athens: University of Georgia, 1976), pp. 101-26; John Arthos, "The Undiscovered Country," in *Shakespeare's Use of Dream and Vision* (London: Bowes and Bowes, 1977), pp. 137-72. Mahood's contention in this respect deserves special attention (pp. 111-12): "To the Elizabethan audience, it [*Hamlet*] must have been primarily a mystery drama in the cinema-poster sense of the word. It is a detective story: almost everyone in it is involved in some form of detection. . . . *Hamlet* is also a mystery play of a deeper kind. It is a mystery play in the medieval sense and its background of a Catholic eschatology keeps us constantly in mind of something after death. Murder and incest are unnatural acts; but behind and beyond the discovered crimes lies an evil which is supernatural. . . . Philosophy, however (as Hamlet tells Horatio), does not comprehend mysteries of this order. Hamlet's own insight into such mysteries sets him apart from friends and enemies alike. Everyone else is concerned in the unmasking of legal crimes. Hamlet alone, surrounded by the politic ferrets of a Machiavellian court, knows that the action in which he is involved is 'not a story of detection, of crime and its punishment, but of sin and expiation.'"

49. The numinous constitutes the idea of the holy that Rudolf Otto developed in his epoch-making study *The Idea of the Holy: An Inquiry into the Non-rational Factor in the Idea of the Divine and Its Relation to the Rational,* trans. John W. Harvey (1923; rpt., London: Oxford University, 1979). For the germaneness of the numinous with the grotesque, see Carl Skrade, *God and the Grotesque* (Philadelphia: Westminster, 1974), passim. I feel grateful to the late James Luther Adams for having directed my attention to Skrade's interesting book.

it has infringed the inviolable law of time; it has disintegrated the solid coherence of time. It seems as if the Ghost had been cast up not so much from "the sepulchre" as from the rift of time. . . . "The Time is out of joint" (1.5.188), Hamlet cries out after the Ghost disappears. Kayser tells us that the grotesque amounts exactly to the sense of this sort of out-of-jointness *(Aus-den-Fugensein)*.[50] "O cursed spite, / That ever I was born to set it right!" (188-89), Hamlet grieves. It's a shame that Hamlet has to redress the grotesque reality.

The grotesque "contradicts the very laws which rule our familiar world."[51] The Ghost has violated the very law of temporal irreversibility that dictates our everyday reality. Another Kayserian precept that "the grotesque is 'supernatural' "[52] has a singular vibration: the Ghost should be said to be above "nature" (temporality), since by dying it has "pass[ed] through nature to eternity." And that it has not reached "eternity" underscores the paradoxical nature of it. The paradox is parallel to the grotesque. The Ghost occupies an epistemological interstice.

The abrupt apparition of the Ghost surprises Hamlet and others. "Suddenness and surprise are essential elements of the grotesque."[53] Its unexpected emergence that engenders horror, mystery, and the sense of "the time" being "out of joint" causes us to share in "the basic feeling" . . . of surprise and horror, an agonizing fear in the presence of a world which breaks apart and remains inaccessible."[54] The feeling is admittedly indicative of the grotesque.

Listening to the subterranean voice that the Ghost has uttered, Hamlet observes pejoratively: "Well said, old mole! canst work i' th' earth so fast? / A worthy pioneer!" (162-63). The "old mole" is, as Norman N. Holland suggests so perceptively, retrospective of Hamlet's earlier dictum "some vicious mole of nature" (1.4.24) which will court as "the dram of ev'l" (36) the final collapse of integrity in humanity.[55] The Ghost, being

50. This is one of the most vital ideas in Kayser's theory of the grotesque.
51. Kayser, p. 31.
52. Kayser, p. 31.
53. Kayser, p. 184.
54. Kayser, p. 31.
55. Holland, p. 172, says: "That fatal revelation is the disease, the rottenness, at the core of the play. Early on, Hamlet speaks of the tragic flaw that a man may have: he calls it 'the dram of e'il,' 'some vicious mole of nature,' and later he calls the Ghost 'old mole.' Indeed, the Ghost is the walking blemish of the land, the figure who proves by his

an "old mole," is associated with the devil, who, like the subterranean creature mole, is an inhabitant of the netherworld. The Ghost as "worthy pioneer" mines or undermines our familiar world. Being perhaps, metaphorically speaking, *mors ex machina,* it is "an alien force that has taken hold of"[56] Hamlet and, through him, other characters of this play. In the hands of this antic force "they have lost their confidence and their orientation."[57] "The characters are all watching one another, forming theories about one another, listening, contriving, full of anxiety. The world of *Hamlet* is *a world where one has lost one's way,*" says C. S. Lewis in his celebrated essay on our play.[58] *Angst* predominates in *Hamlet.* "THE GROTESQUE IS THE ESTRANGED WORLD," Kayser asseverates in a capitalized aphorism, which seems to hold true of the world of *Hamlet.*[59]

As in *The Tempest,* we see in the world of *Hamlet* that metamorphosis is consequent upon the sea experience. Our hero's sea journey to England leads to a remarkable alteration of his personality. No doubt "a sea-change" (*The Tempest,* 1.2.401) visits him.

This change is qualitatively different from his former self-imposed transformation of character, the "antic disposition" that has embarrassed so irritably those around him. His voyage to a foreign country may have contributed to his heightened awareness of national identity. "This is I, / Hamlet the Dane!" (5.1.257-58), Hamlet asserts, plainly and resolutely, to Laertes and to the rest of Ophelia's mourners.[60] Hamlet has attained this simplest truth about his own self that has been hitherto a cause of existential malaise to him. Just before the fatal duel Hamlet apologizes sympathetically to Laertes for his "madness," to which he attributes the outrageous deed done to the Polonius family. Hamlet confesses — we should not necessarily take it for a crafty self-justification on his part —

very presence that 'Something is rotten in the state of Denmark.' The Ghost turns this blight, this disease, onto Hamlet himself, so that Hamlet becomes, in the words of the King, 'the quick of the ulcer,' the living, growing part of the disease."

56. Kayser, p. 15.

57. Kayser, pp. 14-15.

58. Lewis, p. 212. Emphasis added.

59. Kayser, p. 184.

60. James L. Calderwood finds this self-definition that our hero attains to be of pivotal significance for *Hamlet;* see his study *To Be and Not to Be: Negation and Metadrama in* Hamlet (New York: Columbia University, 1983). Calderwood's Shakespeare volume is one of the major contributions to the study of *Hamlet* in our modern time.

that "His madness is poor Hamlet's enemy" (5.2.239). And now Hamlet has vanquished this ruthless opponent. *Terribilità* of the morbid, obsessive vision that "this distracted globe" (1.5.97) of his had created has left him. His passion is spent. He is seized with serene perception:

> . . . there's special providence in the fall of a sparrow. If it be now, 'tis not to come; if it be not to come, it will be now; if it be not now, yet it will come — the readiness is all. (5.2.219-22)

The redundant, tautological allusion to the maturation or eventuation of the unspecified "it" discloses the self-evident, inevitable property of that which "it" implies. After all is said and done, "the readiness is all." That's why, despite foreboding misgivings, "defy[ing] augury" (219), Hamlet accepts the invitation of the deadly duel that Osric, emissary of Death, delivers him.

In the catastrophic *dénouement*, which is too well known or notorious (in truth, it is too Senecan for the tragedy not to be vitiated as an artistic form), Hamlet meets his death, leaving his beautiful dying words, "the rest is silence" (358). It is as if grace had come, all of a sudden, undeservedly, like a miracle. "In this play, perhaps the noisiest of Shakespeare's tragedies, the shock of silence stuns."[61] The mysterious silence Hamlet confronts is numinous.

The eternal pun-maker Hamlet might have dropped a hint that the "rest" includes repose.[62] It may be paradoxical that this particular *anagnorisis* is conveyed by words. In any event, the recognition is tragic in that it involves the mystery of death as "silence" and, by extension, eternity.[63]

61. Prosser, p. 238.

62. I owe this idea to Norman N. Holland, p. 171: "and he [i.e., Hamlet] dies on a pun: 'The rest is silence' — 'rest' as either 'repose' or 'remainder.'"

63. Shakespeare's idealistic view of silence and eternity (as in "Passing through nature to eternity") is not immune to deflating commentary, which is provided by Tom Stoppard in his *Rosencrantz and Guildenstern Are Dead* (New York: Grove Press, 1967):

> But no one gets up after death — there is no applause — there is only silence and some second-hand clothes, and that's — death — . (p. 123)

> Death followed by eternity . . . the worst of both worlds. It *is* a terrible thought. (p. 72)

Stoppard's dramatic work, whose title is a quotation from *Hamlet* (5.2.371), can be called a meta-*Hamlet* play, living on *Hamlet* and constituting critique of it.

But we must admit that, finally, the vision has been wrested from Death through the unflinching stare at the skull. Given that in the world of Rabelais as elucidated by Mikhail Bakhtin, the grotesque functions as immunization against the fear of death through the essential homogeneity of "comicity" and "cosmicity,"[64] macabre engagement with the skull has domesticated Death for Hamlet. Tristram's antic dance with Death eventuates in its transfiguration into a dance of life in which "he rather confounds Death by no longer fearing him."[65] In Tristram's case, "thus he must dance off; but it is a festive, not a macabre, dance."[66] The *Todesschmerz* that had been rankling in Hamlet's heart seems to have undergone a healing, which has been accomplished only through homeopathic procedure.

By dying in the process of eventually fulfilling the mandatory revenge, Hamlet has to die no more. "Death destroys death," which "was a common conceit" in Elizabethan tragedy.[67] "So shalt thou feed on Death, that feeds on men, / And Death once dead, there's no more dying then," so the poet in *The Sonnets* asserts in a metaphysical concept.[68] "And fight and die is death destroying death," a character in *Richard III* encourages the then crestfallen Richard (3.2.184).

At the moment of his dying, Hamlet requests Horatio to tell a story that will vindicate his career:

> If thou didst ever hold me in thy heart,
> Absent thee from felicity awhile,
> And in this harsh world draw thy breath in pain
> To tell my story. (5.2.346-49)

Hamlet is in a resigned position to regard death as "felicity" that he persuades Horatio to defer when the latter shows a willingness to commit suicide in order to follow him. Our hero has achieved spiritual maturity;

64. See Mikhail Bakhtin, *Rabelais and His World*, trans. Hélène Iswolsky (Cambridge, Mass.: The MIT Press, 1968). I borrowed the notion of the convergence of "comicity" and "cosmicity" from Farnham, p. 50.

65. Columbus, pp. 14-15.

66. Columbus, p. 14.

67. Theodore Spencer, *Death and Elizabethan Tragedy: A Study of Convention and Opinion in the Elizabethan Drama* (New York: Pageant Books, 1960), p. 155.

68. William Shakespeare, "The Sonnet 146," in *The Sonnets*, ed. William Burto (New York: New American Library, 1964), p. 186.

he has reached a completely new stage nurtured even by religious tranquility. A horizon of transcendence is in prospect. "Now cracks a noble heart. Good night, sweet prince, / And flights of angels sing thee to thy rest!" (359-60), Horatio voices a touching epitaph in honor of him.

We should say that throughout the tragedy of *Hamlet* what Herman Melville describes as "the knowledge of the demonism in the world"[69] has been consistently addressed by our hero. "The demonic, that force of chaos which annihilates all order, whether it be religious, social or psychological, and which manifests itself in the whiteness of the whale or the ash heap vision of *Endgame* or any world turned inside out upon itself, is integral to the concept of the grotesque."[70] But as Kayser has the last say in this matter, "in spite of all the helplessness and horror inspired by the dark forces which lurk in and behind our world and have power to estrange it, the truly artistic portrayal effects a secret liberation."

> The darkness has been slighted, the ominous powers discovered, the incomprehensible forces challenged. And thus we arrive at a final interpretation of the grotesque: AN ATTEMPT TO INVOKE AND SUBDUE THE DEMONIC ASPECTS OF THE WORLD.[71]

What Hamlet has performed may be assessed as this invocation and subdual of the demonic residing in the world.

Hamlet is dead. And yet closure of *Hamlet* does not necessarily synchronize with the titular hero's death. Horatio's story of Hamlet remains to be told. As he promises Fortinbras, the Norwegian prince, who pops up at the very end of this tragedy as its final victor, Horatio will give an account

> Of carnal, bloody, and unnatural acts,
> Of accidental judgments, casual slaughters,
> Of deaths put on by cunning and forc'd cause,

 69. Herman Melville, "the Whiteness of the Whale," in *Moby-Dick*, A Norton Critical Edition, ed. Harrison Hayford and Hershel Parker (New York: Norton, 1967), p. 169.
 70. G. Farrell Lee, "Grotesque and the Demonism of Silence: Beckett's *Endgame*," *Notre Dame English Journal* 14 (winter 1981): 59.
 71. Kayser, p. 188.

And, in this upshot, purposes mistook
Fall'n on th' inventors' heads. (381-85)

Horatio's recapitulation undoubtedly reflects a weighty side of a tragedy in which our hero has played a principal part. Still, isn't it a rather distorted version? Can it be said to do justice to our hero's potential tragic stature? Would the recently departed Hamlet be satisfied with it? "The grotesque is more cruel than tragedy" — Jan Kott's perspicacity is tremendous as ever.[72]

In a post-Hamlet world tragedy ceases to be viable. (It goes without saying that in a sense the tragedy of *Hamlet* itself is a verdict of death delivered upon tragedy. But that is another matter.) Whether intentionally or not, Horatio will try to deprive Hamlet's story of its (vestigial) tragic quality of pity and terror, consigning it to the genre of revenge play as launched eponymously by Seneca, pervaded with "carnal, bloody, and unnatural acts," from which *Hamlet* has descended in terms of genre. Horatio's future narrative will be an atavistic reproduction of Hamlet's tragic story. There is no denying that "my story" will sustain a kind of *reductio ad absurdum*.

Horatio deconstructs Hamlet's originally tragic story. Now that the parties to the affair have all perished, nobody could possibly interpolate the authority with which he spins the yarn. It is hardly possible for anybody to object to Horatio's authoritative narrative performance. We cannot eradicate a suspicion that "all" those events that he says he can "Truly deliver" (385-86) with the eager Fortinbras and "the noblest" of his court as the "audience" (387) may be easily manipulated in such a way as to be built in the mechanism of consolidation of power that the Norwegian prince will certainly set about. Hamlet's dying voice for Fortinbras regarding the next Danish throne, which Hamlet has also entrusted to Horatio (355-58), together with Fortinbras's own claim of "some rights, of memory in this [Danish] kingdom" (389), will be conducive to the legitimation of power. Fortinbras might capitalize on this opportune story, emphasizing the unspeakable corruption and monstrous atrocity that dominated the bygone regime of "this kingdom," the quondam Danish court, and thus enhancing the justice of his rule of the realm. Horatio, assigned the task

72. Jan Kott, *Shakespeare Our Contemporary*, trans. Boleslaw Taborski, with preface by Peter Brook (London: Methuen, 1965), p. 67.

of storytelling at the end of the tragedy — etymologically, his name stands for "oratorical recitation" — might be deliberately made to negotiate with the newly established power in a way inauspicious to "my story." "Horatio, I am dead, / Thou livest. Report me and my cause aright / To the unsatisfied" (338-40). Contrary to Hamlet's keenest wish, "my cause" will be irretrievably misrepresented. How sad! Alas, poor Hamlet!

Whatever the case may be, tragedy is over. The final *Hamlet* landscape that an eminent Shakespearean critic depicts is awful. After referring to the "sound" of the "musings and indecision of Hamlet" that "have been a frantically personal obbligato in the Senecan movement of revenge," Thomas McFarland closes his existentialist reading of the play with this statement: "Now at last [the] sound is stilled, *the skulls grin,* and the play moves toward its universal night."[73] The "universal night" that the critic assumes for the play's final tableau could be apocalyptic. Perhaps apocalypse is intrinsically grotesque. And in our modern time we will be exposed to such an apocalyptic scenery. In his enormously provocative and problematical tirade, Lucky in Beckett's *Waiting for Godot,* a grotesque parody of "man thinking" as he is,[74] betraying glossolalia and logorrhea, talks compulsively and ceaselessly about "the skull the skull the skull the skull" that supposedly abounds in the universal graveyard that his visionary reflection reveals our entire world has become. Lucky's antic discourse is, as he himself paradoxically avers at its temporary end, left "unfinished. . . ."[75]

73. Thomas McFarland, *Tragic Meanings in Shakespeare* (New York: Random House, 1966), p. 59. Emphasis added.

74. In reviewing *Waiting for Godot* (17 January 1953), Jacques Lemarchand evaluates Lucky's *tour de force* thinking performance as "a remarkable recital of the parodic, baroque monologue of 'man thinking' ": *Samuel Beckett: The Critical Heritage,* ed. Lawrence Graver and Raymond Federman (London: Routledge and Kegan Paul, 1979), p. 92.

75. Samuel Beckett, *Waiting for Godot* (New York: Grove Press, 1954), p. 29b. For explication of Lucky's monologue see my article " 'In the Muddle of the Sounddance': Lucky and His Tirade in Beckett's *Waiting for Godot," Gengobunka-bu Kiyo (Bulletin of the Institute of Language and Culture Studies)* (Hokkaido University, Hokkaido, Japan) 24 (1993): 95-130.

9. The Religious Dimensions of the Grotesque in Literature: Toni Morrison's *Beloved*

SUSAN COREY

> Wherever the human mind is healthy and vigorous in all its proportions, great in imagination and emotions no less than in intellect . . . there the grotesque will exist in full energy.[1]

Any list of twentieth-century writers will certainly include a number whose work has been associated with the grotesque: Flannery O'Connor, Günther Grass, Nathanael West, Franz Kafka, William Faulkner, Sherwood Anderson, and Samuel Beckett, to name a few. Used and recognized at least since the end of the sixteenth century, the grotesque has become increasingly prominent in twentieth-century literature as a means to express the fragmentation and complexities of modern life.[2] Critic

1. John Ruskin, as quoted in Geoffrey G. Harpham, *On the Grotesque: Strategies of Contradiction in Art and Literature* (Princeton, N.J.: Princeton University Press, 1982), p. 77.

2. For a detailed discussion of the history of the grotesque, see Geoffrey G. Harpham's work, *On the Grotesque,* or Frances Barasch, *The Grotesque: A Study in Meanings* (The Hague: Mouton, 1971). Fritz Gysin's work, *The Grotesque in American Negro Fiction* (Bern: Francke Verlag, 1975), includes a detailed study of German work on the grotesque

Robert Scholes has even called it "the logical form of the novel in the twentieth century."[3] Although the grotesque may be used to create a variety of literary effects, writers have found it especially effective as a tool to evoke the religious dimensions of a work of fiction.

Flannery O'Connor, the American writer best known for her conscious use of the grotesque to create religious meaning, emphasizes its ability to evoke the mysterious, larger world and meanings that exist beyond the range of everyday human experience.[4] The writer who uses the grotesque, she claims, will be one who believes that "life is and will remain essentially mysterious." Such a writer is never satisfied with what appears on the surface, but will write fiction that is "always pushing its own limits outward toward the limits of mystery."[5] Although she continually uses terms such as "vision," "mystery," or "the unknown" in describing such writing, O'Connor in no way devalues the importance of concrete sensory details. For her, the grotesque is a tool for exploring the mysteries of God and the universe by way of the surface details of life, a way of initiating the reader into what she calls "the holiness of the secular."[6]

This capacity to evoke a mysterious world or a hidden dimension of reality is one of the principal religious functions of the grotesque in literature. It is a feature that links the grotesque with the process of redemptive change or renewal through contact with the nonrational, the body, the unconscious, or the imagination.[7] A second religious function

as well as commentary on its use in the work of Ralph Ellison, Richard Wright, and Jean Toomer.

3. Robert Scholes, *Structuralism in Literature* (New Haven: Yale University, 1974), p. 138, as quoted in Anne Campbell, "The Grotesque as a Critical Concept: A Question of Cultural Values," *Seminar: Journal of Germanic Literature* 15, no. 4 (November 1979): 252.

4. Flannery O'Connor, "Some Aspects of the Grotesque in Southern Fiction," *Mystery and Manners: Occasional Prose,* ed. Sally Fitzgerald and Robert Fitzgerald (New York: Farrar, 1969), p. 41. For significant work on O'Connor, see Marshall Bruce Gentry, *Flannery O'Connor's Religion of the Grotesque* (Jackson: University Press of Mississippi, 1986), and Gilbert H. Muller, *Nightmares and Visions: Flannery O'Connor and the Catholic Grotesque* (Athens: University of Georgia, 1972).

5. O'Connor, p. 41.

6. Flannery O'Connor, as quoted in Muller, *Nightmares and Visions,* p. 11.

7. See Mikhail Bakhtin, *Rabelais and His World,* trans. Helene Iswolsky (Blooming-

is the ability to bring a moral or prophetic critique. The grotesque enables a writer to challenge conventional ideals, values, and structures; and to expose evil or oppressive social institutions and practices. Thus the grotesque assists a writer to present a paradoxical vision of a world "held largely by the devil,"[8] yet infused with moments of grace and hope for renewal through contact with a larger world of meanings.

Perhaps because of these dual functions, the grotesque has been especially prominent in the works of contemporary women writers whose subjects are frequently the struggles and spiritual journeys of female characters toward a more integrated experience of self. The grotesque allows them to present and critique those social realities that contribute to the alienation of their characters; at the same time, it sets in motion the possibilities for a redemptive experience of wholeness and spiritual liberation. One of these writers is Toni Morrison, whose work *Beloved* will provide the focus for this essay.

What Is the Grotesque?

I will use the term *grotesque* to refer to an aesthetic phenomenon that encourages the creation of meaning and the discovery of new connections through its effect of shock, confusion, disorder, or contradiction. The grotesque breaks the boundaries of normalcy in some way and always points toward the mysterious and inexplicable. Confronted with the abnormal in the midst of the normal, the reader is stimulated to find new meaning. Geoffrey Galt Harpham calls it "a phenomenon which inhabits forms as an element, a species of confusion, that is defined and recognized in common usage by a certain set of obstacles to structured thought."[9] William Van O'Connor notes its capacity to disrupt one's sense of reality: "The grotesque affronts our sense of established order and satisfies or partly satisfies our need for at least a more tentative, a more flexible ordering."[10]

tin: Indiana University, 1984), pp. 21, 47-50, for a discussion of the regenerative functions of the grotesque and the importance of the body.

8. Flannery O'Connor, *Mystery and Manners,* p. 112.

9. Harpham, p. xxi.

10. William Van O'Connor, "The Grotesque: An American Genre," *The Grotesque and Other Essays* (Carbondale: Southern Illinois University, 1962), p. 19.

The grotesque has the effect of challenging or crossing over conventional boundaries, undermining the established order[11] and exposing oppressive systems, whether economic, racial, religious, or gender-based. It pushes the reader to look for meanings on the margins of our meaning systems.

What Does It Do?

The grotesque allows the writer to challenge any final or closed version of truth, to raise questions about what has been lost or omitted from a particular view of reality, and to explore the paradoxical, ambiguous, mixed nature of human life.[12] It connects with a mythic dimension, opening the reader to a wider experience of life that affirms the body, the human rootedness in nature, and the cycle of death and rebirth.[13] Russian scholar Mikhail Bakhtin says that "it discloses the potentiality of another world, of another order, another way of life."[14]

Theologian Carl Skrade suggests that the grotesque is a means of confronting the numinous or the holy, described by Rudolf Otto as "the object of religious awe or reverence . . . [which] cannot be fully determined conceptually; it is nonrational."[15] This nonrational character of the grotesque presents a challenge and a counterbalance to an overly rational religious or social reality.[16] The grotesque acknowledges the reality of estrangement and evil in the world, but fosters the recovery of wholeness out of fragmentation and reconnection with those aspects of self or experience that have been repressed or out of touch.

Two principal scholars of the grotesque, Wolfgang Kayser and Mik-

11. Madonna C. Kolbenschlag, "The Female Grotesque: Gargoyles in the Cathedrals of Cinema," *Journal of Popular Film* 6 (1978): 328.

12. Harpham, p. 191.

13. Geoffrey Galt Harpham discusses the mythic dimension of the grotesque, claiming that it allows for the juxtaposition of "the mythic or primitive elements in a nonmythic or modern context." *On the Grotesque,* p. 51.

14. Bakhtin, p. 947.

15. Rudolf Otto, *The Idea of the Holy,* p. 74, as quoted in Carl Skrade, *God and the Grotesque* (Philadelphia: Westminster, 1974), pp. 72-73.

16. Skrade argues that "the eruption of the grotesque . . . is a renewed call for the recognition of the non-rational as a real and valuable aspect of man and thus, perhaps, of man's experience of God." *God and the Grotesque,* p. 18.

hail Bakhtin, offer contrary perspectives on the function of the grotesque. Kayser emphasizes the use of the grotesque to "invoke and subdue the demonic aspects of the world,"[17] focusing on the grotesque as an expression of human feelings of estrangement: "the expression of our failure to orient ourselves in the physical universe."[18] Bakhtin, on the other hand, emphasizes the capacity of the grotesque to incorporate rather than "subdue" what has been feared or lost into a new experience of wholeness. He describes his view of the grotesque as "completely gay and bright" in contrast to Kayser's "negative grotesque."[19]

The grotesque operates in literature in a number of ways — principally through exaggeration, contradiction, and degradation. The grotesque *degrades* by bringing an elevated ideal or an abstract quality to the physical level, reconnecting an overly spiritualized ideal with its roots in the material world.[20] In his work on O'Connor, Marshall Bruce Gentry describes this effect as a process of undermining an ideal in order to reform it, often producing "images of degraded physicality with the effect at once humorous and disturbing."[21] When the grotesque is employed in literature, then, we can expect to find many shocking bodily images, deformed, freakish, or eccentric characters' violent events, or images of bodily or physical transformation such as birth, death, or the seasons.

The narrative structure itself may reflect the grotesque by mixing genres, supplying an ambiguous, "unfinished" ending, or by creating a sense of dissonance rather than classical order. Bakhtin points out that the grotesque novel frequently seems to be "a battleground where rebellious characters fight for what they sense as truth in opposition to standards supported most of the time by the narrator."[22] This process of degradation and focus on the physical and material is in harmony with such religious views as "creation theology" which emphasize the ongoing creativity of the universe and the goodness of creation. The grotesque, particularly in Bakhtin's interpretation, values the body and the physical and sets in

17. Wolfgang Kayser, *The Grotesque in Art and Literature*, trans. Ulrich Weisstein (Bloomington: Indiana University, 1963), p. 188.

18. Kayser, p. 185.

19. Bakhtin, p. 47.

20. Bakhtin, pp. 20-22.

21. Gentry, *Flannery O'Connor's Religion of the Grotesque*, p. 10.

22. Bakhtin, as quoted in Gentry, *Flannery O'Connor's Religion of the Grotesque*, p. 8.

motion the reconnection or integration with these nonrational, nonverbal aspects of existence that function outside of rationality or language. In religious terms, the grotesque is a tool that assists a writer to break through dualistic categories and offer a holistic view — for example, the integration of body and spirit.

Scholars suggest that the grotesque has been especially prominent during times of transition when the prevailing cultural forms have been breaking apart to make way for something new or when what has been marginal is moving toward the center.[23] This may explain why the grotesque is so frequently employed, whether consciously or not, by contemporary women writers. The women's movement, which challenges the hegemony of white patriarchy in every area of society, including religion, has presented the kind of threat to the established order that is associated with the grotesque. For black women writers, like Toni Morrison, the grotesque offers a method of expressing the ambiguities and contradictions involved in discovering one's identity as an African American woman in America. It also evokes connections with folk culture which Morrison tends to see as redemptive. Indeed, the grotesque is quite at home with African folk religion and its emphasis on the mixed possibilities for good and evil in the same person or event.

In Morrison's work, we can see the grotesque functioning in two primary ways, each with religious implications. First, she uses it to bring a prophetic critique to the status quo, whether social or personal. The grotesque functions as a catalyst to break up the present order and to expose whatever fears, guilt, or oppressive conditions operate to bind her characters or to keep them unfree. In this respect, she follows the model of Wolfgang Kayser: she "invokes and subdues the demonic" to confront the presence of evil in the world. Secondly, she uses the grotesque to point toward renewal and change by bringing wholeness to what has been fragmented or alienated. Sometimes termed the "positive" grotesque, this function corresponds to Bakhtin's model. This aspect of the grotesque encourages the breakup of the old self to allow for the creation of the new. This process often involves the release of the unconscious or the connection to mythic elements which point toward that mysterious larger world of

23. See Bakhtin, pp. 9, 24.

meaning — the realm of religion — that stands behind everyday human experience.

In Morrison's novel *Beloved*, set in the years shortly after the Civil War, the grotesque functions in both of these roles. On the one hand, it is involved in a redemptive process, bringing wholeness to the fragmented lives of the principal characters, Sethe and Paul D. As they confront the repressed horrors of the past they gradually become able to incorporate their fragments of memory into more coherent life histories.[24] This process brings each of them a stronger sense of self-identity and the possibility of imagining a future. At the same time, the grotesque resists any easy path to liberation or neatly unified closure. It allows the author to acknowledge the ambiguities, mysteries, and unfinished character of this process. On the other hand, the grotesque exerts a moral function by exposing the evil of slavery along with the ideologies of racism and sexism and by demonstrating how these aggressive systems have damaged lives and communities for generations.

In this novel, set in the years shortly after the Civil War, the grotesque casts a prophetic judgment on the evils of slavery and the institutions of racism and sexism, showing how these oppressive systems have damaged lives and communities for generations. In particular, the novel reveals the problems of mothers who, out of guilt over the past, can fail to develop a sense of personal boundaries and thus seriously overprotect their children. It also shows the process for renewing and restoring spiritual wholeness both to individuals and the community by disrupting the present order and forging new connections to sources of strength and renewal in the area of the nonrational, the unconscious, the body, or the mythic — that area of life not controlled by reason or by words. At the same time, the grotesque allows Morrison to acknowledge at every point the ambiguities and mysteries, the unfinished, mixed nature related to the process of change and transformation. There is no easy process of liberation in her work — no sense of completion or of reaching a neatly unified closure. Her fiction, as Flannery O'Connor said, is always pushing outward "toward the limits of mystery."

24. See Mae Henderson, "Toni Morrison's *Beloved*: Remembering the Body as Historical Text," in *Discourses of Sexuality: From Aristotle to AIDS,* ed. Domna C. Stanton (Ann Arbor: University of Michigan, 1995), pp. 312-43, for a thorough discussion of how Sethe achieves a coherent life-story.

When Toni Morrison was awarded the Pulitzer Prize for fiction in 1988, she spoke of her desire to break ground for a new generation of black writers, many of whom have felt restricted, held back by ghosts from the past, especially the mothers who have been haunted by the stories and memories of separation from their children.[25] In *Beloved* Morrison uses the grotesque to enable the protagonist Sethe to confront directly the ghost of guilt from her own past. The novel opens like a gothic horror novel. Sethe's home is haunted by a "baby ghost" who both annoys and seriously frightens the residents by causing strange voices, lights, and violent shaking. The haunting is linked to the death of Sethe's baby daughter at the age of two — a child whom she herself had murdered in horror at the certain knowledge that she would be taken back to Sweet Home, the farm where she and her fellow slaves had suffered extreme cruelties or — for some — death, at the hand of the new manager, "Schoolteacher."

Yet this is far more than an ordinary horror story. It is a narrative history of the sufferings of black Americans in the period before, during, and just after the Civil War. More than that, it is a psychological and spiritual account of the difficult, but gradually healing, process of awakening consciousness and reconnection to the past and the community. In this novel, Morrison has mixed the genres, a common feature of the grotesque, as a way of freeing the reader to see new possibilities. At one level, the grotesque confronts the readers and the characters with the shocking truth of slavery and post-slave history; at the same time, this confrontation with the grotesque initiates a process of redemption as the characters are delivered from the restrictive power of the ghosts of the past.

The most obvious grotesque figure is Beloved, the physical embodiment of the murdered baby who is able to cross the boundaries between life and death, human and nonhuman, and to change her shape and personality at will. Like all grotesques, Beloved is an ambiguous figure, functioning to bring healing and wholeness to Sethe, Paul D., and Denver by bringing them into contact with their pasts, their sensuality, their emotions. She leads both Sethe and Paul D. to the "ocean-deep place" of the unconscious where the pieces of the past are collected and constructed into a more whole identity. At the same time, she represents danger in her

25. Interview with Toni Morrison. McNeill Lehrer 6:00 p.m. Report, March 31, 1988, Public Broadcasting Network.

exaggerated desire to claim Sethe totally for herself. Sethe responds with an obsessive effort to atone for her sin by giving up her own life.

It is curious that Beloved first appears in physical form in the context of a carnival, an event closely associated with the grotesque in the Middle Ages, the kind of event that Bakhtin suggests once offered temporary liberation from the established order or hierarchy and affirmed human grounding in the body and the community.[26] Paul D., a former slave at Sweet Home, has just located Sethe after eighteen years of separation. After a particularly violent house shaking, he appears to have driven out the baby ghost. He, Denver (Sethe's daughter), and Sethe have just emerged from a scene of joy and community where 400 blacks have enjoyed the "spectacle of white folks making a spectacle out of themselves" (p. 49). The carnival has been an affirmation of black community and joy, and probably a degradation of the ideal of white supremacy by means of grotesque characters such as midgets, giants, and a two-headed man. The audience was excited at "seeing white people loose: doing magic, clowning, without heads or with two heads . . ." (47-48). Thus the carnival has disrupted the normal order of things, preparing Sethe and Paul for something new in the person of Beloved seeing reality.

As the three of them return from the carnival, looking almost like a family, Beloved appears, sitting by a tree stump, having recently walked out of the water, fully clothed. Although neither Sethe nor Denver immediately links Beloved to the murdered baby, both feel an immediate sense of personal connection. Sethe experiences physical symptoms of release, a strong, uncontrollable urge to urinate, followed by a rush of water so strange and overwhelming that she felt "freakish" (p. 51). She remembers a similar feeling as the amniotic sack broke at the time of Denver's miraculous birth in the bottom of a leaky boat. Beloved herself experiences incontinence during her four days of deep sleep after her arrival (p. 52). These images of bodily release are examples of what Bakhtin calls the grotesque body which affirms the connection with community and with the material and bodily roots of the world. In his analysis, images of open bodily orifices, images of eating and drinking or of open apertures, suggest openness to other bodies, to the world, to the underworld, and to the past.[27] Important images of cultural renewal, they signify the breaking of

26. Bakhtin, pp. 9-10.
27. Bakhtin, p. 281.

boundaries and the possibility of regeneration and new birth in the midst of horror or freakishness.

In true grotesque fashion, Beloved's presence is contradictory throughout the novel; she is both beautiful and freakish, abnormally strong with expressionless eyes, capable of changing her shape or of rendering herself invisible. Denver recognizes her true identity very early, apparently because of a moment following the murder, when she tasted Beloved's blood as she nursed from Sethe's breast. For Denver, Beloved both repels and attracts; she threatens her sole claim to her mother's attention but is magnetically attractive as a playmate. For Sethe, Beloved awakens memories as she urges her to tell stories of her past. She stimulates Sethe's memories of her childhood and of her own mother, whom she barely knew. As she tells the stories, Sethe experiences an awakening of emotions — especially pain and anger — as she recalls the mother who was unable to nurse her, the mother whose body she found hanged.

Similarly for Paul D., Beloved stimulates an awakening of emotion and sensuality. In the darkness of the cold house, Beloved's grotesque seduction of Paul D. brings a release of repressed emotions as he feels a softening of his "rusty, tobacco tin heart." He resists her overtures, just as he resists confronting the terrible memories of his last days at Sweet Home, the sight of his closest companions hung, sold, reduced to idiocy; the brutalizing experiences on the chain gang. For both Sethe and Paul D., Beloved presents a dangerous threat to the self. Sethe experiences a neck rub with invisible hands which becomes nearly a stranglehold. Paul D. is gradually driven out of the house by Beloved's presence. As a representative of the supernatural, Beloved has entered the "normal" lives of these characters and set in motion and broken apart their sense of normalcy in order to prepare for a new mode of integration. This new integration, however, is not achieved in any easy, orderly process. Until these painful memories become transformed in the unconscious, they remain deeply threatening.

Although Beloved is the most noticeably grotesque character in the novel and the one most responsible for introducing the elements of dissonance and shock into the lives of the characters, Sethe herself is also a grotesque character not only because of her shocking murder of her own child, but because of the deforming, tree-shaped scar on her back.

Like most grotesque images, this scar has both a negative and a positive meaning. On a first reading, it seems to represent primarily the

horror of Sethe's past. We learn that the scar is the result of a horrible beating by the white master at Sweet Home, a beating made more horrible by the fact that Sethe was nine months pregnant and still nursing an older baby. The reasons for this beating reveal the grotesque conditions of life under the premises of white supremacy and patriarchy: she was beaten for revealing to her invalid white mistress the details of her brother "Schoolteacher's" humiliating experiment. In order to support his theory that blacks were more nearly animal than human, Schoolteacher had ordered his nephews to "take her milk" as if she were a cow, an act not only dehumanizing and destructive, but an act that signified his ownership of her reproductive and nurturing life as well as her labor.

Despite its painful associations with the beating, the scar could seem beautiful as well as ugly. Amy Denver, the white girl who delivered Sethe's baby had described it as "a chokecherry tree. Trunk, branches and even leaves" (p. 16). It reminded Sethe of the beautiful sycamore trees of Sweet Home — beautiful in her memory despite the painful image of the boys hanging from them (p. 6). At the same time, the dead skin on her back was symbolic of her repressed feelings which she dared not release: "The picture of the men coming to nurse her was as lifeless as the nerves in her back where the skin buckled like a washboard" (p. 6). Paul D. touched the tree first with his cheek, and felt in the scar "her sorrow, the roots of it; its wide trunk and intricate branches" (p. 17). He saw it first as a sculpture which had "become like the decorative work of an ironsmith — too passionate for display" (p. 17). At another time, however, the scar appeared to him simply as "a revolting clump of scars" (p. 21). He was unable to make the positive association with trees, which in his mind were "inviting, things you could trust and be near; talk to if you wanted to" (p. 21).

These contradictory associations indicate that the grotesque scar is a significant emblem of the paradoxical nature of the past and of the painful reality of the ghosts that Morrison believes must be faced in order to experience liberation. The scar is a physical representation of suffering, degradation, and fear, but it holds within it the potential to represent the comforting, natural presence of the trees, of home, and of the ongoing, renewing process of life. As Sethe remarks, it "could have cherries too now, for all I know" (p. 16). These various perspectives on the scar suggest the possibility for the transformation of the grotesque from a negative force to a positive, redemptive force.

The scar is a sign of the degradation Sethe has suffered because of her sex and race; at the same time it is a sign of her strength and courage, the mystery and wonder of her survival, and new birth. Just after the beating, Sethe miraculously escapes from Sweet Home; gives birth to her daughter, Denver; and manages to cross the river to freedom and a reunion with her mother-in-law, Baby Suggs, a journey that radically transforms her life. It is also a sign of the mixed nature of that liberation. Even in the safety of Ohio, she is still vulnerable to the vengeance of "Schoolteacher." She can still be tracked down and dragged back. Her struggle involves a radical effort to free herself from the authority of those like Schoolteacher who had the power to define her identity: "freeing yourself was one thing; claiming ownership of the free self was another" (p. 95).

The moment of madness when Sethe determines to murder all of her children seems not mad at all in light of the circumstances she faced. Murdering the baby with whom she has struggled to be reunited seems her only way to defy Schoolteacher's claim over her reproductive life; however, by totally breaking the cultural ideals of motherhood, the action makes Sethe into a grotesque figure in the community, where she is shunned and isolated, suspected of being a witch. Although Schoolteacher, the slave-catcher, seems the epitome of evil, the community holds Sethe alone responsible for the murder. In their moral framework, the violence of a personal crime of child murder is far more serious than the violence of the social evils of slavery and oppression. They are unable or unwilling to understand Sethe's motivation.

In its connection with all of these events, the grotesque image of the scar points toward the evils of racism and misogyny which scar and deform lives psychically as well as physically; in its resemblance to the chokecherry tree, it is also an emblem of redemption connecting Sethe with her past, her home, and the sources of renewal in the natural world.

The novel also includes other images and events that suggest hope for renewed ties with the community and with the lost or repressed parts of the self.

A sign of this renewal is the emphasis on the healing power of physical touch. The time surrounding the birth of Denver and Sethe's miraculous journey to freedom is one of those times when images of physical touching are prominent. The young white girl who serves as Sethe's midwife rubs Sethe's feet and dresses her wounds. After Sethe reaches the home of her mother-in-law, Baby Suggs washes and massages

her body and dresses her wounds. Then Sethe experiences the sensual joy of nursing the older baby as well as Denver, an experience that temporarily blots out the grotesque horror with Schoolteacher's nephews. Both the nursing, when Sethe rejoices at having enough milk for all, and the celebratory feast after her arrival are images of abundance in the midst of community — a theme related to what Bakhtin calls "the grotesque body."

The feast begins with just a few blackberries donated by StampPaid, the man who ferried Sethe to freedom, but it soon grows to become a celebration for ninety, with turkey, new peas, and pies made with berries that tasted like church (p. 137). It becomes an event of "reckless generosity," recalling the biblical story of the feeding of the five thousand and representing the joyful connections of community and the pleasure of reunion and freedom. Bakhtin has noted that eating and drinking are important aspects of the grotesque body, signifying in medieval times the encounter of human beings with the world, the symbolic unity of working people, and the renewed triumph of life over death.[28]

That joy, however, is only momentary. The festive banquet intended to bring the community together has precisely the opposite effect. The jealousy and envy aroused by the banquet and unexpected arrival of Schoolteacher are signs of the simultaneous presence of sin and evil amidst the good. Schoolteacher appears in this world as a grotesque figure who has crossed the boundaries into the black community in the free state of Kentucky. Representing the overarching power of the slave system which wants to claim Sethe and her children for itself, his coming generates a shock that yields only negative effects. Soon after his arrival, Sethe has murdered her own baby, terrified her sons, and become isolated and shunned by her community.

Another image of the positive grotesque associated with the folk community, the body, and the nonrational occurs in the descriptions of Baby Suggs's religion of joy, a religion that loved and affirmed the flesh. As a self-appointed holy woman following her own liberation from slavery, Baby Suggs, Sethe's mother-in-law, formed a congregation in a clearing, a spot that came to have sacred memories for Sethe. There, drawing on African traditions of music, dance, and ecstatic possession as a means of worship, Baby Suggs exhorted her congregation to love the flesh: "Love it, love it hard. . . . Love your hands! Love them. Touch others with them.

28. Bakhtin, p. 281.

You got to love it, *you!* " (p. 88). She encouraged the people to dance, sing, and touch each other. "She did not tell them to clean up their lives or to go and sin no more. . . . She told them that the only grace they could have was the grace they could imagine" (p. 88). She understood the redemptive, healing force of the body and the flesh and urged the congregation to love their mouths, their necks, their backs, and even their inside parts, as a way of countering years of living with white masters who despised their flesh and believed that slaves were not to experience pleasure. She offered them the possibility of transforming their memories of dehumanizing experiences through the power of dance, song, and their own imaginations.

Years after Baby Suggs's death, when Sethe returns to the clearing, she relives the power of the memories of that time, and recalls her own twenty-eight days of freedom. In the midst of remembering how Baby Suggs cared for her own body and bathed her, Sethe relives a grotesque moment when the soothing touch of Baby's fingers on her neck becomes transformed to a near stranglehold (p. 96). Although the memory of Baby's religion is a source of healing power and renewal, Sethe herself is still struggling with guilt and terror at the memories that Beloved has awakened. Confronted with still new horrors at the news of her former husband's fate at Sweet Home, Sethe feels her world breaking up and is unable to experience the healing possibilities related to Baby Suggs and her religion of joy.

In order to transform these memories and esperience spiritual integration, Sethe requires a time of pleasure and play just as Baby Suggs had preached. Such a period of intense withdrawal and imaginative play begins in the novel as Sethe decides to take Baby Suggs's advice to "lay it all down" (p. 174), to cease struggling to understand or make sense of life and to allow the creative imagination to take over. It is in this section of the novel that we see how the grotesque triggers and releases the experience of the sacred through the work of the unconscious and the imagination.

After an evening of joyous ice skating with the two girls, Sethe experiences a peaceful release. As she comes to understand just who Beloved is, she feels "the click — the settling of pieces into the place designed and made especially for them" (p. 174). This initial experience leads to a period of game playing which soon becomes grotesque and exaggerated to the point where Sethe and Beloved become completely obsessed with each other. Dressing up like carnival women, they play like

children, winding flowers around the house and exchanging not only their respective roles (Beloved becomes the mother and Sethe the child) but their physical shapes: Beloved expands, indicating her growing influence and power, while Sethe seems to shrink. The references to carnival dresses and bodily transformation recall Bakhtin's positive grotesque which signals change and renewal. However, this scene conveys a typical grotesque ambivalence as Sethe's life becomes endangered. As Beloved threatens to totally consume her, Sethe withdraws from the material world and stops eating. Nonetheless, this grotesque experience of play seems to have prepared Sethe for a moment of transformation and vision at the end of the novel.

That moment comes in a final communal vision at the end of the novel as the women gather to sing and exorcise the ghost of Beloved. Until this time, Sethe has regained contact with the memories of her past but still suffers isolation from community. She has become so trapped by her guilt that she has totally withdrawn from life.

Alerted by Denver, who has finally risked moving out into the community, the women of the town march to Sethe's home to face the naked, huge Beloved and drive her out. Their presence is a sign that Sethe could become reconnected to her community, which alone has the power to subdue this demonic force, this ghost of the past. As the women recall Baby Suggs's religion in the clearing and the healing power of that almost primordial experience, they begin to pray and holler: "The holler went back to the beginning with no words, but sound" (p. 259). At that moment, Sethe was able to experience a transformation of the negative memories: "It was as though the clearing had come to her" as she heard the voices of the women, searching for "the sound that broke the back of the world. As she stood holding hands with Beloved, this sound broke over Sethe and she trembled like the baptized" in its wash (p. 261), recalling the ritual of baptism that symbolizes new birth and membership in the community.

Once again, however, a moment of redemption is balanced with one of destruction. Just as Sethe experiences the joy of connection with Baby Suggs and her healing power, the white landlord, Mr. Bodwin, enters the yard, and Sethe seems to relive the feelings she had with the coming of Schoolteacher. Feeling "hummingbird wings" in her hair, she rushes out with an ice pick to attack Bodwin, but is restrained by her daughter, Denver. At the same moment, Beloved disappears. The exorcism has

apparently succeeded, but there is a suggestion that Beloved has not left permanently. By the stream behind Sethe's house, there are later reports of "a naked woman with fish for hair" (p. 267).

The final scene with Paul D. is a beautiful example of reconciliation and hope. Paul returns to convince Sethe that she is her "best thing," and to suggest that the two of them might put their stories next to each other. He finds Sethe lying under Baby Suggs's colored quilt in a state of profound withdrawal; yet there is hope that the encounter with Beloved has served as a catalyst for change and growth for each of them. They have confronted the repressed memories and emerged with a more coherent sense of themselves. They have suffered pain, fear, and horror, but have ultimately been able to transform the grotesque experiences into a positive redemptive force.

In the spirit of the grotesque, however, the novel does not have a clear sense of closure. In fact, the final, meditative section contradicts the hopeful tone of the previous scene. It ends with a melancholy note as the narrator speaks of the loneliness of the ghost who has been forgotten by the community — "disremembered and unaccounted for" (p. 274), who still roams in the world of myth and dreams. This section brings prophetic judgment on a community that prefers not to pass on the story of Beloved, but rather prefers to let such shocking aspects of its history disappear. In this sense, in spite of some redemptive moments, the community is judged to be deficient in the virtues of love and forgiveness.

While the grotesque is prominent in all of Toni Morrison's fiction, *Beloved* is a particular example of how it can function not only to critique and expose evil or the absurd features of modern life, but to offer a vision of wholeness and renewal as characters break through the bonds of fear and guilt. I would argue that in *Beloved,* Morrison joins other twentieth-century writers[29] in employing both the negative (prophetic) and the positive (redemptive) functions of the grotesque, thus exploiting its fullest capacities as a meaning-making tool.

29. In his book *Flannery O'Connor's Religion of the Grotesque,* Marshall Bruce Gentry suggests that Flannery O'Connor has employed both the negative and positive modes of the grotesque in her works, sometimes transforming images of the negative grotesque "into part of a redemptive process" (p. 12).

10. The Dramatic Version of *Ballad of a Sweet Dream of Peace: A Charade for Easter*

ROBERT PENN WARREN

Introduction

Until my friend Amos Wilder asked me for the dramatic version of *Ballad of a Sweet Dream of Peace* for inclusion in this volume, I had not thought of it as "grotesque." Nor had I thought of it as "non-grotesque." I had thought about it simply as "poem," or later as "play-poem." It is, certainly, now that I come to it, a piece of the grotesque, and the fact that the notion had never entered my head, the fact that "grotesque" is a label attached later, may suggest, even from this modest and simple particular example, something of the impulse that, sometimes at least, lies behind the making of a thing that can be called grotesque.

The present "charade" was adapted from a longish poem, in parts, with the same title, that appeared in a volume of poems called *Promises*, published in 1957. The poem was written in the summer of 1956, in a rather (then) cutoff spot on the Italian coast, where I lived with my wife and two babies, in a ruinous old fortress. I mention these facts because they have some bearing, though I can't say exactly what kind or how much, on the topic at hand. In that period, in 1954 and again in 1956, but particularly in the summer of the latter year, I was caught up in one of my periodic "seizures" of poetry, this one springing from recollections of the past, usually of the world of my childhood and youth, and from the

very different world, external and internal, that I now inhabited, a contrast and interweaving that had spontaneously developed between the "Kentucky theme" and the "Italian theme."

One morning while I was fiddling with a poem in progress in that series, the unaimed musings (which are what is called "work" on a poem) were mysteriously interrupted by the image of a fancifully carved Victorian bureau set in a grove of trees that somehow reminded me of a spot in Central Park beside a path that at one time I had had some occasion to follow now and then, sometimes in the evening. The imagined scene, I should add, was in dusk. With the image came, quite suddenly, the first two lines:

And why, in God's name is that elegant bureau
Standing out here in the woods and dark?

And immediately, as if merely by some logic of rhyme, I had the beginning of the apparently nonsense answer:

Because, in God's name it would create a furor
If such a Victorian piece were left in the middle of Central Park,
 To corrupt the morals of young and old. . . .

I had, then, the ballad framework of question and answer, the apparent nonsense of the question-answer relationship, the repetition of "in God's name," which had come spontaneously but was to acquire, in the course of the process of composition and thematic force, a deepening significance, and a nagging, overcharged intensity of tone scarcely justified by the situation as overtly given.

The poem I had been fiddling with got left behind (what it was and whether or not I ever came back to it, I can't remember), and the new poem took over. It took over with a peculiar immediacy. Ordinarily, poems come to me with a mixture of visual and verbal imagery, with the visual usually seeming to precede the verbal, but in this instance the visual scenic element was remarkably strong: the lines coming, I should say, complete with dialogue. The stanza form, with its strict rhyme-scheme, which was developed in the first day or two, seemed to dictate thereafter, as it were, the visual content; for instance, I might find the dialogue coming according to the stanza form, with little work to be done (though sometimes I might reject a passage and have to wait for another). Meanwhile, the

apparent nonsense gave a feeling of exhilaration, of release, but at the same time I had the feeling of a satisfying but unspecified "sense" behind the nonsense. Furthermore, though during the period of composition I never planned ahead to organize the plot of the poem, I never had any doubt that it was, under its own steam, going "somewhere." I didn't even seem to care where it was going. I was content to ride with it and find out. The whole thing, in fact, moved very fast, by my standards at least.

What does all this have to do with the grotesqueness of the piece? To try to answer this, I shall have to try to answer another question: What does the *Ballad* have to do with the matrix of poems from which it so suddenly arose?

As far as I can remember, I didn't at the time of composition ask myself that question, nor in the months following when I was again immersed in the other poems that were coming. But when the time arrived to assemble the volume of poems, the question, though tangentially, did arise. Since the poems were being arranged thematically, and not chronologically (by either content or composition), where did the *Ballad* belong? I put it very near the end of the book, by that act implying that it was a sort of summarizing commentary, a thematic focus. And as I discover now, it is such a focus — in a much fuller sense than I then realized. There is, I should add, only one other "grotesque" poem in the volume, "Dragon Country: To Jacob Boehme," and this, I find, immediately precedes the *Ballad*. It is a similar commentary on the general body of poems, indirect in the same way — and "grotesque."

The relation of the *Ballad* to the other poems is, however, very indirect. Though I was aware of certain floating hints and fragments of recollection, transmuted and shadowy, absorbed into the *Ballad,* the content and the feeling were entirely foreign to the world of the other poems. The content of the other poems belongs to the literal world, while the world of the *Ballad* is distorted and incoherent; and the feeling of the poems is very far from the nagging, angry, violent temper of much of the *Ballad.* The poems turned out to represent a backward-looking reassessment of life and values, at a more or less realistic level. The *Ballad,* springing unbidden out of the world of the poems, was a shifting, shadowy phantasmagoria of episodes, encounters, reversals, and surprises, illogical and incoherent, but representing, it turned out, certain key and typical situations of the pattern of life generally conceived.

Here I am reminded of Sherwood Anderson's *Winesburg, Ohio,* in

which one of the characters composes a work called "The Book of the Grotesque," a fable of "truth." To the early days of the world, so the fable runs, there was no such thing as "truth." There were merely many vague thoughts floating about. People began to put thoughts together and make "truths," all interesting and beautiful. But they got the habit of snatching up particular truths, and as soon as an individual appropriated a truth for his very own and tried to live by it, he became a "grotesque," and his truth became a falsehood. To adapt the fable, we may say that the grotesque is a "truth" drawn out of context, isolated, brought to a sharp individual focus. By the same token, paradoxically, to assert the grotesque may be to assert a "truth" that, in its natural context, is ignored. The grotesque may be produced by the purging of details to reach the general, or by interpolating new, unexplained, and "unnatural" details that accent the "truth." For instance, in my poem my Granny represents a "generalization" (about age), and the *Ballad,* as a whole, represents a generalization about the poems of the whole volume, or rather, about their subject; and my bureau in the woods and the hogs that eat Granny every night after she has finished her chore are "unnatural details." But here I must insist that the *Ballad* is not an allegory. It did not come as a series of equivalents. It came as a little story — drama rather — with a complex and undifferentiated import which I made little effort to read for myself as the thing was being composed. If anything, the work is to be thought of, I should say, as a condensed symbol.

Another factor enters with the grotesque, in addition to what, as discussed above, we may call the structural factor. The grotesque characteristically involved certain unexpected intensities and startling varieties of response to the "truth" thus isolated for assertion. Shock is of the essence of the grotesque. The grotesque is one of the most obvious forms art may take to pierce the veil of familiarity, to stab us up from the drowse of the accustomed, to make us aware of the perilous paradoxicality of life. The grotesque evokes dormant emotions, particularly the negative ones of fear, disgust, revulsion, guilt. But it is close to the comic, and in it laughter and horror meet. We must realize that the emotions characteristically associated with the grotesque are not necessarily stable. They are subject to change. The capacity for change, for transmutation and transcendence, is, however, contingent upon the intensity with which they are evoked. The key fact is that the grotesque gets attention — emotion-charged attention. The strength, not the nature, of the emotions is what counts: it

is easier to change hate to love or love to hate than to change tepid approval or idle disapproval to either. But not only the intensity of emotion enters here. The unexpected nature of the involvement is significant, too, particularly if there are ambivalent aspects. For, if the word *grotesque* is derived from the paintings in the excavated *grotte* of old Rome, in another and more instructive sense the word is, though by accident, a good one: the grotesque draws out and reveals to us things from our own dark, inner recesses.

It may even be true that there are things a writer might never write about if he did not write about them "grotesquely."

The Ballad

On a bare stage the HANDLER appears and looks about as though preparing to make arrangements. His costume, except for a wristwatch which he frequently consults, should be abstract, no sense of style of a place or time — the impression of a being that has a function that is continuous and repetitive. He trundles out an ornate Victorian bureau and places it, making a few shifts before he is satisfied with a location center rear. Next he brings out a section of dead tree trunk with broken boughs, set on a base, and adjusts this somewhat to stage right of bureau. Then a simple bench which he adjusts at extreme stage left. He beckons the CHORUS out to take their places on the bench. The chorus is composed of four men and four women, in some variety of age and social condition, in modern dress. One knits, one reads a newspaper, one polishes her nails, etc.

Meanwhile, the HANDLER has adjusted a large easel at extreme stage right, forward. He brings out a big stack of rawly made cards, about 24 in. × 30 in., crudely lettered. He props them on the easel, exposing one which carries the title.

BALLAD OF A SWEET DREAM OF PEACE

(Music begins. He turns to the audience.)

HANDLER

Can everybody see it?

(Shifting the easel a bit.)

Is it perfectly clear now?

(The CHORUS has taken notice of the card, one person rising to make sure of what it says, then whispering to the others. One begins to sing, others join in.)

CHORUS

Where has that white foot been set —
That white foot-arch familiar to violet?
Has it been seen approaching yet?
By what path, in what place, on what property will it
Come? Coming, will stir what water, then still it?
Who has seen at that passing the field dry and abused
Wake to green, wake to life, wake to joy of the field-flowers?
Tell us, tell us that that joy may be ours!
Who has seen that strong heel that smites the stone but is not what is
 bruised,
And subdues to sweetness the pathside garbage, or that filth the body
 has refused?
Have you seen that foot that comes to redeem
And make things be what they are and not what they seem?
That foot — does it come? Have you seen it — yes, have you?

HANDLER

I've told you a thousand times, I am not here to answer questions.
Nobody pays me to answer questions. I am here to get things ready. I
am here to handle things. That is why I am called the HANDLER. I
have got things ready a million times. I could do it in my sleep. I do

the same things over and over. I put everything in place and then it happens again, over and over. Yes — look!

(An OLD LADY, with white straggly hair, barefoot, in a ragged night dress, enters and feebly begins to polish the bureau.)

There it goes again, over and over. And there will be the same old questions. But I am telling you that it is not my business to answer them. It is his business —

(Indicating the ANSWERER, who has appeared from stage left, a man of late middle years, precisely dressed, perhaps bearded, giving the impression of a doctor, minister, psychiatrist, or some such wise man. He is, despite his professionalism, capable of sympathy.)

— and that is why he is called the ANSWERER. Even if he doesn't know the answers. But whether or not he knows the answers, you ask him the questions, and don't bother me. It is not my line of work.

(A young man, perfectly ordinary, about thirty years old, rises in the audience, and with some diffidence asks a question. He is the QUESTIONER.)

QUESTIONER

Why now, in God's name, is that elegant bureau
Standing out here in the woods and dark?

HANDLER

(Wearily aside)

Yes, in God's name, here we go again.

(The ANSWERER makes a gesture of command to the HANDLER, who exposes another card

AND DON'T FORGET YOUR ORRIS ROOT SACHET

Then the ANSWERER turns back to the QUESTIONER)

ANSWERER

If you'd just repeat your question, a little more clearly.

(Beckoning)

Yes, come right up, and repeat your question.

QUESTIONER

Just why, in God's name, is that elegant bureau
Standing out here in the woods and dark?

ANSWERER

Because, in God's name, it would create a furor
If such a Victorian piece were left in the middle of Central Park.

HANDLER

(Moving toward QUESTIONER, gaily satirical in tone)

To corrupt the morals of young and old
With its marble top and drawer-pulls gilt gold
And rosewood elaborately scrolled.

ANSWERER

And would you in truth want your own young sister to see it in the
 Park?

QUESTIONER

But she knows all about it, her mother has told her,
And besides, these days she is getting much older,
And why, in God's name, is that bureau left in the woods?

HANDLER

(With gay malice)

All right, all right — tell him why!

ANSWERER

It has as much right there as you or I,
For the woods are God's temple, and even a bureau has moods.

QUESTIONER

But why, in God's name, is that elegant bureau left all alone in the
woods?

*(The CHORUS, seated on the bench, has begun to stir. There is music,
then the CHORUS sings the last line, twice.)*

CHORUS

Yes, in God's name, that elegant bureau is left all alone in the woods.

ANSWERER

*(Stepping authoritatively toward QUESTIONER, but including the
CHORUS in his answer)*

It's left in the woods for the Old Lady's sake,
For there's privacy here for a household chore,
And Lord, I can't tell you the time it can take
To apply her own mixture of beeswax and newt-oil to bring out the
 gloss once more.

HANDLER

Yes, the old girl's hands move slower each night,
And don't manage to hold the cloth very tight, —

ANSWERER

And it's hard without proper light.

QUESTIONER

But why, in God's name, all this privacy for a simple household chore?

ANSWERER

In God's name, sir, would you simply let
Folks see how naked old ladies can get?

> (The OLD LADY suddenly discovers her condition, utters a little sound,
> places her hands to cover the possibility of immodesty, and creakily scurries
> into shadow.)

QUESTIONER

Why won't the old bitch buy some clothes like other folks do?

ANSWERER

She once had some clothes, I am told,
But they're long since ruined by the damp and mold, —

HANDLER

> (Gaily beating out the meter with both hands)

And the problem is deeper when bones let the wind blow through!

> (MUSIC. The CHORUS sings the last three lines, and begins to repeat
> the last, but ANSWERER suddenly steps forward and abruptly stops them
> on the word deeper, then turns to QUESTIONER.)

ANSWERER

Look here — it's not civil to call her a bitch, and her your own grandma, too.

QUESTIONER

But how am I supposed to know that? I hadn't seen the old bag — excuse me, I mean my grandmother — since I was five years old. How was I to know her? All I remember is her breath was not good and she was always sucking peppermint and smelled like that too when she kissed you, and she was always kissing, and she had a couple of stiff hairs on her upper lip and when she kissed you — I tell you that's all I remember and —

ANSWERER

But you remember that. We all remember something. In fact, all we are is what we remember —

(He makes a little gesture to the HANDLER who exposes a card reading

KEEPSAKES

The HANDLER turns to the audience.)

HANDLER

Yes, we all have keepsakes. You are human and you hang on to something to remind you of joy and sorrow, success and failure, hope and despair, love and hate, Dickens and Thackeray, ham and eggs, Eliot and Yeats, right and left, up and down, Harvard and Yale, mother and father, brother and sister. You hang on to something to remind you, in fact, of yourself, for in certain instances —

ANSWERER

Shhh!

(Stopping HANDLER with a gesture and pointing to the OLD LADY who has timorously crept again toward the bureau to resume the polishing.)

QUESTIONER

Now what brings her back in the dark and night?

ANSWERER

She has mislaid something, just what she can't say
But something to do with the bureau all right.

QUESTIONER

Then why, in God's name, does she polish so much, and not look in a
 drawer right away?

ANSWERER

Every night, in God's name, she does look there,
But finds only a Book of Common Prayer,
A ribbon-tied lock of gold hair,
A bundle of letters —

HANDLER

— some contraceptives, and an orris root sachet.

(The OLD LADY has left off polishing, and hurriedly, as though remembering something, starts looking into the top drawer.)

QUESTIONER

Look — what is the old fool hunting for?

ANSWERER

Oh, nothing, oh, nothing that's in the top drawer,
For that's left by late owners who had their own grief to withstand,

 (As the OLD LADY takes out the Prayer Book and peers at it)

And she stands with a squinch and a frown
As she peers at the Prayer Book upside down —

HANDLER

And the contraceptives are something she can't understand —

 (She has reached into the drawer and drawn out a bundle of letters, and stands with head bowed over them.)

ANSWERER

And oh, how bitter the tears she will shed, with some stranger's old letters in hand!

 (Music, and the CHORUS sings the last line. The OLD LADY clutches the letters to her bosom, and flees. ANSWERER glances after her and shakes his head.)

Yes, oh, how bitter the tears —

QUESTIONER

She can't shed a tear!
Not with eyeballs gone, and the tear ducts too.

ANSWERER

You are trapped in a vulgar error, I fear,
For asleep in the bottom drawer is a thing that may prove instructive to you.

HANDLER

(Waltzing a few steps with an unseen partner, and singing a nasal ironic parody of a sentimental tune of the 1890s)

Just an old-fashioned doll with a china head,
And a cloth body naked and violated
By a hole through which sawdust once bled —

ANSWERER

But drop now by drop, on a summer night, from her heart it is tracle
 bleeds through.

(The QUESTIONER somewhat timorously goes to peer into the bottom drawer of the bureau, then starts back in horror)

QUESTIONER

In God's name, what! Do I see the eyes move?

ANSWERER

Of course — and it whispers, "I died for love!"

(Offstage the feeble, wailing whine of the OLD LADY, accompanied by music)

HANDLER

Oh, old Granny, she whines like a dog in the dark and shade,
For she's hunting somebody to give
Her the life they had promised her she would live —

ANSWERER

And I shudder to think what a stink and stir will be made

When some summer night she opens the drawer and finds that poor
self she's mislaid.

> *(Music, and the CHORUS sings the last line and begins to repeat it, but
> is interrupted by a bestial sound, at which HANDLER seems to come to
> himself, and quickly reveals the next card*

GO IT, GRANNY — GO IT, HOG!)

QUESTIONER

Out there in the dark, what's that horrible chomping?

ANSWERER

Oh, nothing, just hogs that forage for mast,
And if you call, "Hoo-pig!" they'll squeal and come romping,
For they'll know from your voice you're the boy who slopped them in
 dear, dead days long past.

QUESTIONER

Any hogs that I slopped are long years dead,
And eaten by somebody and evacuated,
So it's simply absurd what you said!

HANDLER

> *(Gaily)*

It's all a matter of who eats who?
Do you eat the hog or does the hog eat you?

> *(To audience)*

Has anybody here ever been eaten by a hog? Come on, come on, speak
up, it's no disgrace. It's just the way things are. Many right in this

room have had the experience, and as for those who haven't, well, Time
is the great physician and better luck next time —

(Wheeling to QUESTIONER)

Have you ever been eaten by a hog?

QUESTIONER

I told you, I haven't had anything to do with hogs since I was a boy
 and I don't even eat pork and —

ANSWERER

(Approaching QUESTIONER, not without sympathy)

You fool, poor fool, all Time is a dream, and we're all one Flesh at last,

HANDLER

(Looking at wristwatch)

Though tonight the old gal is a little bit late —

ANSWERER

But they're mannered, those hogs, as they wait for her creaky old tread.
Polite, they will sit in a ring,
Till she finishes work, the poor old thing —

HANDLER

(Gleefully)

Then old bones get knocked down with a clatter to wake up the dead —

ANSWERER

And it's simply absurd —

(Faint scream, with music, offstage)

— how loud every night she can scream with no tongue in her head.

(Music, and CHORUS sings last line. QUESTIONER is disturbed, looks toward quarter where scream had come, then sees OLD COOT approaching. The COOT wanders in, barefoot, baggy flannels, frock coat, yachting cap, with fixed stare of the obsessed, mumbling to himself.)

QUESTIONER

In God's name, who's that coming out in these woods?

(ANSWERER points to easel where HANDLER has now revealed a new card

FRIEND OF THE FAMILY, OR BOWLING A STICKY CRICKET

The QUESTIONER now reads the title aloud, somewhat puzzled, then turns toward ANSWERER, questioningly)

ANSWERER

Yes, a friend of the family whom you never saw —
Just a cranky old coot who bumbles and broods —

COOT

Law — the law — law is inscrutable — law is inscrutable — law —

QUESTIONER

What makes him go barefoot at night in God's dew?

ANSWERER

In God's name, you idiot, so would you
If you'd suffered as he had to
When expelled from his club for the horrible hobby that taught him
 the nature of law.

HANDLER

*(Approaching, leaning and leering like one about to impart an obscenity,
whispering)*

They learned that he drowned his crickets in claret.
The club used cologne, and so couldn't bear it —

QUESTIONER

But they drown them in claret in Buckingham Palace!

ANSWERER

Fool law is inscrutable, so —

*(The HANDLER has rushed to the easel and picked up from the floor
a kind of sandwich board, crudely lettered on both sides: GOD IS LAW.
Snickering he drops this over the COOT's head, and stands back with
hands on hips, happily admiring the effect. The COOT stands there
befuddled, then some awareness begins to dawn on his face, as he fingers
the letters.)*

ANSWERER

(Continuing)

Barefoot in dusk and dew he must go,
And at last each cries out in a dark, stone-glimmering place —

OLD COOT

(With lifted face, yearning, crying out)

I have heard the voice in the dark, seeing not who utters. Show me
Thy face!

*(Music, and the CHORUS repeats the last line, as the OLD COOT
stands there moving his lips soundlessly, dazed. The ANSWERER makes
a little gesture toward HANDLER, who goes and propels the OLD
COOT offstage, coming back with the air of a man who is briskly
prepared to get on to more pleasant duties, speaking to the audience)*

HANDLER

I know it is not my place and function to have opinions or to offer
value judgments. I am simply supposed to help out the natural process
of things. But I'll indulge myself by saying that I am heartily sick of
that old booger. I don't care if he is unfortunate and unhappy. I don't
care how some of the more tender-minded of those present react to his
condition. I beg you to consider that in the great economy of nature it
can be said that he had something to do with bringing it on himself.
After all, there's such a thing as cause and effect, and what is
responsibility except a metaphor for cause and effect? No matter what
degree of responsibility he bears for his present situation, he certainly
bears some. And besides, he is unwashed, does not pare his toenails,
has always had an execrable accent in French, is not constructive in
attitude, is far too self-absorbed, and smells rather like an abandoned
potato cellar. But look, I have something in mind a lot more pleasant
than he ever was, even in his prime. This is something that will remind
you that you have not lived in vain.

*(Turning, HANDLER gives a wolf whistle. Out of the shadow comes a
young girl with flowing hair, wearing a night dress, barefoot, carrying in
her hand, ritualistically, a large burdock leaf)*

QUESTIONER

Who's this, in God's name?

(He goes to the easel and reveals a new card:

YOU NEVER KNEW HER EITHER, THOUGH YOU THOUGHT YOU DID, INSIDE OUT

He points to this and leers at the QUESTIONER)

HANDLER

Now don't tell me you don't know. Something out of your memory book.

(To audience)

Listen, every man-jack of you, Democrat or Republican, shut your eyes and relax and take about three deep breaths. Now open your eyes and honestly tell me if you don't know who she is. What I mean is, be honest with yourself, even if the recollection makes your present fun-partner seem somewhat drab.

QUESTIONER

(Pointing at GIRL)

But look, in God's name — her robe de nuit,
It's torn and bedraggled, and what is that stain?

GIRL

(Appealingly, humbly, to QUESTIONER)

It's only dried blood, in God's name, that you see —

HANDLER

(Close to QUESTIONER, singing)

Oh, don't you remember Sweet Alice, Ben Bolt,
Sweet Alice with hair so brown,
Who trembled with joy when you gave her a kiss,
And trembled with fear at your frown?

QUESTIONER

(To ANSWERER)

But why does she carry that leaf in her hand? Will you try, in God's
 name, to explain?

GIRL

(yearning toward QUESTIONER)

It's a burdock leaf —

HANDLER

(Interrupting, gaily, satirically)

— under which she once found
Two toads in coitu on the bare black ground —

ANSWERER

(With a gesture to stop QUESTIONER)

So now she is nightly bound
To come forth to the woods to embrace a thorn tree —

GIRL

I must try to understand pain —

ANSWERER

Then wipes the blood from her silken hair,
And cries aloud —

GIRL

(In ecstasy)

Oh, I need not despair,
For I bleed, oh I bleed, and God lives!

ANSWERER

(Sympathetically)

And the heart may stir
Like water beneath wind's tread
That wanders whither it is not said.

QUESTIONER

(Coming out of his rapt attention, disturbed)

For the life of me, I can't identify her.

ANSWERER

She's the afternoon one who to your bed came, lip damp, the breath
 like myrrh.

QUESTIONER

(Repeating in rapt bewilderment, as she retreats, lifting his arms after her)

Lip damp, the breath like myrrh — lip damp, the breath like —

(Music, and the CHORUS sings the line. QUESTIONER hangs on their words, then turns to ANSWERER.)

QUESTIONER

I can't understand — I can't understand why I didn't know her. You'd think that, after everything there was, I'd know her, and —

(HANDLER comes and plucks his sleeve and indicates the easel, to which he goes and changes the card to

I GUESS YOU THINK YOU KNOW WHO YOU ARE

Then he points back into shadow at stage left rear)

QUESTIONER

Could that be a babe crawling there in night's black?

ANSWERER

Why, of course, in God's name, and birth-blind, but you'll see
How to that dead chestnut he'll crawl a straight track —

HANDLER

Then give the astonishing tongue of a hound with a coon treed up in a
tree!

QUESTIONER

Well, who is the brat, and what's he up to?

ANSWERER

He's the earlier one they thought would be you —

HANDLER

And perhaps, after all, it was true,
For it's hard in these matters to tell sometimes —

QUESTIONER

I'm leaving.

HANDLER

If you are, there's a letter a hog has in charge —

QUESTIONER

Look here, I'm leaving — I don't care what letter any hog has —

HANDLER

(Wheedling, insinuating)

But a gold coronet and your own name writ large,
And in French, most politely, "Repondez s'il vous plait."

(HANDLER touches QUESTIONER, who jerks away)

QUESTIONER

Repondez — like hell! I'm gone!

HANDLER

(Seizing QUESTIONER quite firmly)

Now don't be alarmed we are late.
What's time to a hog? We'll just let them wait.
But for when you are ready —

(QUESTIONER tries to pull away, but HANDLER tightens grip, as ANSWERER sympathetically leans at him)

ANSWERER

— our clients usually say
That to shut the eyes tight —

(HANDLER adroitly kicks QUESTIONER in the back of one knee, and forces him to a kneeling position, holding him there, as ANSWERER continues)

— and get down on the knees, is the quickest and easiest way.

(As QUESTIONER seems stunned, HANDLER steps back, glances at his watch, and looks toward stage left rear, calling)

HANDLER

Hoo-pig! Hoo-pig! Pig — pig — pig!

(The QUESTIONER starts up in terror, but the HANDLER turns just in time to push him back down. The ANSWERER leans over the QUES-TIONER and speaks soothingly.)

ANSWERER

Just shut the eyes tight, and get down on the knees — it's the quickest and easiest way.

CHORUS

(In a tense whisper, with a strongly marked rhythm, leaning forward toward the terrified QUESTIONER)

— the quickest and easiest way, the quickest and easiest way —

ANSWERER

(Patting the QUESTIONER on the shoulder)

Yes, clients report it the tidiest way —

HANDLER

(Looking at his watch with an air of irritation, then offstage, calling)

Hoo-pig!

QUESTIONER

(Starting up in terror)

No! No!

(The HANDLER seizes the QUESTIONER, thrusts him savagely down, and leans over him with an expression of gloating ferocity. The ANSWERER leans down, speaking more soothingly than ever.)

ANSWERER

But listen, I swear it's the easiest way,
For the first time at least when all is so strange,
And the helpers get awkward sometimes with delay —

HANDLER

(Leaning with a parody of the ANSWERER's sympathy)

But later, of course, you can try other methods that fancy suggests you
 arrange.
There are clients, in fact, who when ennui gets great,
Will struggle, or ingeniously irritate
The helpers to acts I won't state —

*(HANDLER suddenly reaches under the arms of QUESTIONER and
tickles him, as one tickles a child, and as QUESTIONER writhes and
laughs hysterically, HANDLER laughs too.)*

HANDLER

Koochie-koochie-koochie-koo!

ANSWERER

*(With a small gesture to HANDLER, who obediently stops and puts his
hands again on QUESTIONER's shoulders, by way of precaution. AN-
SWERER leans again.)*

For Reality's all, and to seek it some welcome, at whatever cost, any
 change.

QUESTIONER

(Staring imploringly up into ANSWERER's face)

Reality?

*(As ANSWERER sagely nods down at QUESTIONER, the CHORUS
leans forward toward QUESTIONER, not rising from the bench, and
with music, sing.)*

CHORUS

Reality is what draws the moth to the searing joy of flame.
Reality is what you want but you do not know its name.
Reality is what we want but we do not know its name.

We know only that had we known it things would not be the same —

QUESTIONER

(With a sudden effort jerking free from HANDLER and jumping back)

Well, I know one thing, I'm getting out of this place!

(With a savage bound and a sudden ferocity of expression HANDLER has made at him and laid hands on him. But ANSWERER makes a gesture of command, and HANDLER releases QUESTIONER. The CHORUS resumes, with music)

CHORUS

There is no other place than this place.
You see the same things no matter which way you face.

HANDLER

(Singing gaily)

Even if you manage to do what you please,
You can't see the trees for the woods or the woods for the trees!

CHORUS

(Singing)

Where you end will be the place you start.
For you walk in the imagination of the heart.

(Speaking slowly, with an inward, meditative tone)

We have walked in the sad imagination of the heart.

(QUESTIONER has turned this way and that, starting back each time in bafflement and terror. Now he adopts a tone of bluster.)

QUESTIONER

I tell you, I'm getting my lawyer. A joke is a joke, but in God's name now, this has gone too far, I tell you, I have my rights. I am a tax-payer, I am an American citizen. I'm getting my lawyer and I'm going to sue every son-of-a-bitch here. By God, I'll sue the owner of these woods. I don't care who he is, he has no right to allow this kind of disorderly goings-on on his property. It's against the public interest. It's shocking to a man's nerves. I'll sue him for his last penny. Now, who the hell owns this property?

CHORUS

(Singing)

Nobody knows — nobody knows —

ANSWERER

Nobody knows — but a rumor's astir
That the woods are sold and the Purchaser

> *(The members of the CHORUS stir and look at each other with various expressions of incredulity and timorous hope, saying, "The Purchaser? Yes? Yes? When? You mean the Purchaser?" etc. From back of the audience a WESTERN UNION BOY enters bearing an enormous yellow envelope, some 24 in. × 30 in. He approaches the HANDLER.)*

BOY

Are you Mr. Handler?

HANDLER

Yes.

BOY

(Offering envelope, then pad and pencil)

Sign.

*(He signs and begins to open envelope. BOY goes off whistling. HAN-
DLER spreads the enormous yellow sheet from the envelope over the easel.
In type, the sheet of paper displays the message*

RUMOR UNVERIFIED STOP CAN YOU CONFIRM STOP

*The ANSWERER stands looking at the message, shaking his head as the
CHORUS sings, repeating it.)*

ANSWERER

No, no — but the rumor's astir
That the deal has been made and the Purchaser
Soon comes, and if credulity's not now abused,
Will on this property set
The white foot-arch familiar to the violet
And the strong heel that, smiting the stone, is not what is bruised,
But subdues to the sweetness the pathside garbage, or that filth the
 body has refused.

*(Music, and the CHORUS sings a variation of chorus #1. Meanwhile,
one by one the other persons — OLD LADY, COOT, GIRL, etc. — all
except the HANDLER move into song. The HANDLER stands wearily
aloof, now and then glancing at his watch. As the CHORUS starts to
repeat their song, the HANDLER steps sharply forward, making a gesture
of dismissal.)*

HANDLER

Get on off — it's late — on off. In God's name, don't you know it's
late. Get on, now.

(As the cast quickly retires, HANDLER turns to the audience)

I don't want to be rude, but we've got another show on in ten minutes. Move on, please — this is not your ancestral home. This is not the place to settle down and raise a family. This is not even a motel and a one-night stand. Get the lead out, I say. Haul ass! You have had it. — Hoo-pig! Hoo-pig!

(He bursts into laughter as light is down on him. As the audience is moving out, the whole cast reappears on balcony to one side of the room and begins to sing the last section, very softly.)

END OF TEXT

Contributors

James Luther Adams was Professor of Christian Ethics at Harvard Divinity School, Cambridge, Massachusetts.

Wilson Yates is Professor of Religion, Society and the Arts at United Theological Seminary of the Twin Cities, New Brighton, Minnesota.

Roger Hazelton was Professor of Theology at Andover Newton Theological School, Newton Centre, Massachusetts.

Wolfgang Stechow was Professor of Humanities at Oberlin.

Margaret Miles is Dean of the Graduate Theological Union, Berkeley, California.

John Cook is President of the Henry Luce Foundation, New York City, and was formerly Professor of Religion and the Arts at Yale Divinity School, New Haven, Connecticut.

Susan Corey is Associate Professor of English at California Lutheran University, Thousand Oaks, California.

Yasuhiro Ogawa is Associate Professor at the Institute of Language and Culture Studies, Hokkaido University, Sapporo, Hokkaido, Japan.

Robert Penn Warren was Poet Laureate, Library of Congress, novelist, and teacher.

Permissions

Chapter 1

1. Nicholas Ponce, from the Domu Aurea engravings in *Description des bains de Titus*. Paris: Ponce, 1786, No. 22. Two details of the larger work also available. Permission obtained from the Cambridge University Library. Photography by the Library photo service.
2. Raphael, detail from a pillar of the Papal Loggia, 1515.
3. Hieronymous Bosch, *The Temptations of St. Anthony, 1500-1505,* central panel. Museu Nacional de Arte Antigua, Lisbon.
4. Francisco Goya, *Los Caprichos,* plate 43: "El Sueno de La Razon Produce Monstruos" (The sleep of reason produces monsters). Etching and aquatint. Height 8½ inches, width 6 inches. The Metropolitan Museum of Art, Gift of M. Knoedler and Co., 1918. [18.64(43)]
5. David Alfaro Siqueiros, *Echo of a Scream,* 1937. Enamel on wood, 48 × 36" (121.9 × 91.4 cm.). The Museum of Modern Art, New York. Gift of Edward M. M. Warburg. Photograph © 1997 The Museum of Modern Art, New York.
6. Francisco Goya, *Saturn Devouring One of His Sons,* 1820-23. Museo Nacional del Prado, Madrid.
7. James Ensor, *Masks Confronting Death* (Masques devant la mort), 1888. Oil on canvas, 32 × 39½" (81.3 × 100.3 cm.). The Museum of Modern Art, New York. Mrs. Simon Guggenheim Fund. Photograph © 1997 The Museum of Modern Art, New York.

8. Henry Moore, *Warrior with Shield*, 1953-54. Bronze, height 5′ 4″. Minneapolis Institute of Art, Minneapolis, Minnesota.

9. Marc Chagall, *Time Is a River without Banks* (Le Temps n'a point de rives), 1930-39. Oil on canvas, 39⅜ × 32″ (100 × 81.3 cm.). The Museum of Modern Art, New York. Given anonymously. Photograph © 1997 The Museum of Modern Art, New York.

Chapter 4

1. Giotto, *Hell*, from *Last Judgment*, Padua, Arena Chapel. Art Resource, New York.

2. *Lust*, from *Inferno*, 1396, Citta di San Gimignano, Italy. Photo courtesy of Katherine Gill.

3. Sheela-na-gig, Corbel, 1140s, Church of Saint Mary and Saint David, Kilpeck, Ireland.

Chapter 5

1. Hieronymous Bosch, *The Garden of Earthly Delights*, ca. 1510. Museo Nacional del Prado, Madrid.

Chapter 6

1. Illuminated manuscript: Ruskin Bible, ca. 1250. Bible: Latin, Vulgate. *Martyrdom of Isaiah*, f. 233, text initial. Beinecke Rare Book and Manuscript Library, Yale University.

2. *Roettgen Pieta*, ca. 1350. Landesmuseum, Bonn, Germany.

3. Detail, Last Judgement Panel, *The Garden of Earthly Delights* by Hieronymous Bosch, ca. 1510. Museo Nacional del Prado, Madrid.

Chapter 7

1. Francis Bacon, *Painting*, 1978. Magnus Konow, Monaco.

2. Nicholas Poussin, detail from *Massacre of the Innocents,* 1630-31. Musee Conde, Chantilly.
3. Sergei Eisenstein, detail of the screaming nurse from *Battleship Potemkin,* film, 1925.
4. Third panel from *Three Studies for Figures at the Base of a Crucifixion* by Francis Bacon, 1944. Tate Gallery, London.
5. Francis Bacon, *Study after Valesquez's Portrait of Pope Innocent X.* Des Moines Art Center, Des Moines, Iowa.
6. Francis Bacon, *Painting,* 1946. Oil and pastel on linen. 6' 5⅞" × 52" (197.8 × 132.1 cm.). Museum of Modern Art, New York.
7. Francis Bacon, *Crucifixion,* 1933. Private collection.
8. Francis Bacon, *Crucifixion with Skull,* 1933. Pinacoteca di Brera, Milan.
9. Francis Bacon, *Triptych Inspired by Oresteia of Aeschylus,* 1981. Marlborough International Fine Art Gallery, London.
10. Francis Bacon, *Three Studies for Figures at the Base of a Crucifixion,* 1944. Tate Gallery, London.
11. Francis Bacon, *Second Version of Triptych 1944,* 1988. Artist's collection.
12. Francis Bacon, *Fragment of a Crucifixion,* 1950. Oil and cottonwood on canvas. 139 × 108 cm. Van Abbemuseum Eindhoven, The Netherlands.
13. Francis Bacon, *Three Studies for a Crucifixion,* 1962. Oil with sand on canvas. Each panel of triptych 78 × 52". The Solomon R. Guggenheim Museum, New York City, New York.
14. Giovanni Cimabue, *Crucifixion,* 1272-74. Chesa di Santa Croce, Florence.
15. Francis Bacon, *Crucifixion,* 1965. Oil on canvas. Each panel 198 × 147 cm. Staatsgalerie Moderner Kunst, Munich.